ART DIRECTORS ANNUAL 82

EDITORIAL DIRECTOR
Myrna Davis

EDITOR
Adam Parks

DESIGN
Vertigo Design, NYC

JACKET/DIVIDER DESIGN
LOWE—New York

JACKET/DIVIDER PHOTOGRAPHY
Clive Stewart

COPY EDITING
Dessi Kirilova

CONTRIBUTING EDITOR
Mary Fichter

PHOTOGRAPHY EDITOR
Adam Parks

JUDGES' PHOTOGRAPHS
Noah Hendler

PUBLISHED AND DISTRIBUTED BY
RotoVision SA
Route Suisse 9
CH–1295 Mies
Switzerland

SALES AND EDITORIAL OFFICE
Sheridan House
112-116a Western Road
Hove, East Sussex
BN3 1DD, United Kingdom
Tel: +44 (0) 1273 727268
Fax: +44 (0) 1273 727269
Sales@RotoVision.com
www.RotoVision.com

PRODUCTION
ProVision Pte Ltd., Singapore
Tel: (665) 334 7720
Fax: (665) 334 7721

COLOR SEPARATION
Singapore Sangchoy Colour Separation Pte. Ltd.
Tel: (656) 285 0596
Fax: (656) 288 0112

PRINTING
Star Standard Industries Pte. Ltd.
Singapore

PRODUCED IN
Adobe InDesign 2.0

TYPOGRAPHY
Scala Sans

The Art Directors Club
106 West 29th Street
New York, NY 10001
United States of America

CONTENTS

Many in the creative community have been feeling the impact of the move toward digital, more specifically the multichannel integration, the increasing dependence on technology, shrinking budgets and the shortened timelines for deliverables. As a long-time board member, I realized that there was no creative organization that embraced the future transition into the new digital domain. Drawing on ADC's rich heritage, there was an opportunity to transform the organization into one that would foster a dialogue between the larger advertising community and educators, while always keeping in mind the importance of creative excellence.

The long-term plan is to restructure ADC and then implement rapid and significant change. The first step has already been accomplished, which was to change the bylaws and expand the Board in the coming year to more clearly represent the various multichannel disciplines of advertising, broadcast, copywriting, commercial production, graphic design, illustration, new media, photography, publishing and education. By broadening the Board to include additional thought leaders, I hope to create a forum for fresh ideas and inspirational thinkers that promotes the creation of a new visual language and facilitates greater access to emerging technology and digital tools.

Having modernized the structure, we are now on the road to exponentially improving ADC activities—from expanding the Lecture Series, Education outreach and the Young Guns program to continuing our commitment to the Hall of Fame and the Annual Awards. The Annual Awards show continues to showcase the best work in the industry and we intend to build on its excellent international reputation to develop an even better event in the future. I expect that over the next year there will be many more exciting changes that will encourage greater collaboration between the talented ADC membership and the overall advertising and design community.

ROBERT GREENBERG | ADC President

The design and content of this 82nd Art Directors Annual celebrate changes in the industry and in ADC itself.

Now in its 83rd year, ADC is a not-for-profit organization dedicated to recognizing and inspiring creative excellence and encouraging young people entering the field. Always current, our mandate today is to support the trend towards integrated media and provide a nerve center where creative leaders in advertising, design and interactive media can gather to explore and anticipate the direction of these rapidly changing industries.

The 82nd Annual Call for Entries drew 11,522 entries from 51 countries. Winners came to New York from around the world on June 5 to accept their honors. Ed Catmull, president of Pixar Animation Studios, accepted the Vision Award on behalf of his company and guests previewed the exhibition. Winners also are presented on the ADC Web site. Vertigo Design created a special look for the front of this book, featuring the 81st Awards Touring Exhibition in Brazil, Germany and China, as well as exhibitions, events and and programs in the ADC Gallery.

ADC's expanded educational programs include the invitational Student Portfolio Reviews, which presents the top 100 advertising students and the top 100 design students graduating from accredited art schools and colleges to advertising, editorial and corporate reviewers and recruiters from around the country. A Portfolio Workshop is being added to the Saturday Career Workshops for talented high school juniors this year and ADC Scholarships will be offered nationally for the first time. We are delighted to welcome the Miami Ad School, the Parsons School of Design and Portfolio Center in Atlanta as Institutional Members this year.

Through ADC's Annual Awards Program, Hall of Fame, Young Guns Biennale, and wide array of exhibitions, speaker events and symposia, workshops, publications, professional portfolio reviews and other projects, ADC offers a scope of activities unsurpassed by any other industry organization. Our original logo has been updated by Paula Scher of Pentagram to reflect a change in the usage of our name from Art Directors Club to ADC, integrating it with the words Advertising, Design and Community to underscore our 360-degree range of focus.

ADC thanks Adobe InDesign for its support of the 82nd Annual Awards Program, Getty Images for supporting the Hall of Fame and the Annual Awards, Corporate Members and other sponsors who have contributed throughout the year, and all the entrants to this year's competition.

MYRNA DAVIS | ADC Executive Director

hall of fame

The Art Directors Hall of Fame was established in 1971 to recognize and honor those innovators whose lifetime achievements represent the highest standards of creative excellence.

Eligible for this coveted award, in addition to art directors, are designers, typographers, illustrators and photographers who have made significant contributions to art direction and visual communications.

The Hall of Fame Committee, from time to time, also presents a Hall of Fame Educators Award to those educators, editors and writers whose lifetime achievements have significantly shaped the future of these fields.

1972
M. F. Agha
Lester Beall
Alexey Brodovitch
A.M. Cassandre
René Clark
Robert Gage
William Golden
Paul Rand

1973
Charles Coiner
Paul Smith
Jack Tinker

1974
Will Burtin
Leo Lionni

1975
Gordon Aymar
Herbert Bayer
Cipes Pineles Burtin
Heyworth Campbell
Alexander Liberman
L. Moholy-Nagy

1976
E. McKnight Kauffer
Herbert Matter

1977
Saul Bass
Herb Lubalin
Bradbury Thompson

1978
Thomas M. Cleland
Lou Dorfsman
Allen Hurlburt
George Lois

1979
W. A. Dwiggins
George Giusti
Milton Glaser
Helmut Krone
Willem Sandberg
Ladislav Sutnar
Jan Tschichold

1980
Gene Federico
Otto Storch
Henry Wolf

1981
Lucian Bernhard
Ivan Chermayeff
Gyorgy Kepes
George Krikorian
William Taubin

1982
Richard Avedon
Amil Gargano
Jerome Snyder
Massimo Vignelli

1983
Aaron Burns

Seymour Chwast
Steve Frankfurt

1984
Charles Eames
Wallace Elton
Sam Scali
Louis Silverstein

1985
Art Kane
Len Sirowitz
Charles Tudor

1986
Walt Disney
Roy Grace
Alvin Lustig
Arthur Paul

1987
Willy Fleckhaus
Shigeo Fukuda
Steve Horn
Tony Palladino

1988
Ben Shahn
Bert Steinhauser
Mike Tesch

1989
Rudolph de Harak
Raymond Loewy

1990
Lee Clow

Reba Sochis
Frank Zachary

1991
Bea Feitler
Bob Gill
Bob Giraldi
Richard Hess

1992
Eiko Ishioka
Rick Levine
Onofrio Paccione
Gordon Parks

1993
Leo Burnett
Yusaku Kamekura
Robert Wilvers
Howard Zieff

1994
Alan Fletcher
Norman Rockwell
Ikko Tanaka
Rochelle Udell
Andy Warhol

1995
Robert Brownjohn
Paul Davis
Roy Kuhlman
Jay Maisel

1996
William McCaffery

Erik Nitsche
Arnold Varga
Fred Woodward

1997
Allan Beaver
Sheila Metzner
B. Martin Pedersen
George Tscherny

1998
Tom Geismar
Chuck Jones
Paula Scher
Alex Steinweiss

1999
R.O Blechman
Annie Leibovitz
Stan Richards

2000
Edward Benguiat
Joe Sedelmaier
Pablo Ferro
Tandanori Yokoo

2001/2002
Rich Silverstein
Giorgio Soavi
Edward Sorel

2003
Michael Bierut
André François
David Kennedy

**HALL OF FAME
EDUCATORS AWARD**

1983
Bill Bernbach

1987
Leon Friend

1988
Silas Rhodes

1989
Hershel Levit

1990
Robert Weaver

1991
Jim Henson

1996
Steven Heller

1998
Red Burns

1999
Richard Wilde

2001
Philip Meggs

2003
Richard Saul Wurman

There's a big part of me that has always been suspicious of design industry awards. They can seem slightly dubious, self-serving and cliquish. The people who are honored are usually somehow connected to the people on the selection committee, and they seem to be the same people who are always honored, while more deserving people are never honored, unless they happen to be honored this one time, in which case they are inevitably connected to the people on the selection committee, but then, aren't they always honored, anyway?

The Art Directors Club Hall of Fame was created in 1972. I was a practicing designer in 1972—that's not so long ago. The first Hall of Fame honorees were famous men, the established stalwarts of design and art direction. After them came younger famous men, and then some more men, and then there was a woman, and a bit later there were more women. The honorees were art directors who designed, designers who art directed, magazine art directors, agency art directors, designers who didn't consider themselves art directors, and art directors who didn't think of themselves as designers. Then there were designers who illustrated, and illustrators who never really designed. Not to mention animators, photographers, educators, design futurists, design historians, and other people who influenced the climate of design and art direction, but really couldn't be put into any category.

Every year since 1972, two or more people have been inducted to the Hall of Fame, and after 30 years, this makes for quite a list. In total, it is an irreplaceable record of the most important visual communicators of the 20th century and on into the 21st. It includes all disciplines and will surely expand to include even more as soon as they are invented. This imperfect, dubious process of cliquish selection committees picking people they know has managed to create a great gift for future students of communication. Everybody is there. Because if they're not there—if there is an important omission—it is noticed by the next self-serving selection committee, who want to correct the mistakes to prove their own worthiness, and then go on to pick the people they know.

This year's committee was no different. We've added the missing names and some of them happen to be people we know. Richard Saul Wurman, Michael Bierut, David Kennedy and André François are unquestionably shining stars of their disciplines. They have all made important and unique contributions to the culture of visual communication. They enrich and broaden an impeccable list. I am proud to have been a part of this imperfect process.

PAULA SCHER | Chair | 2003 Hall of Fame Selection Committee

2003 Hall of Fame Selection Committee

Rick Boyko Louis Dorfsman Sara Giovanitti Robert Greenberg George Lois Jackie Merri Meyer

Tony Palladino B. Martin Pedersen Vickie Peslak Massimo Vignelli Richard Wilde

Michael**Bierut**

Michael Bierut: Formalist Elegance, Populist Wit

Michael Bierut used to open his slide lectures with a pair of maps that demonstrated his geographic connection to his then boss, hero and mentor Massimo Vignelli. Vignelli came from Milan, Italy; Bierut came from Parma, Ohio.

This little joke speaks volumes. The elegant Vignelli is an architect by training, a rationalist and formalist, a designer who employs a methodology that allows for the exclusive use of only five typefaces, applied in every instance with perfect proportion and scale.

Michael Bierut is distinctly American. He quotes the films of Preston Sturges and Billy Wilder verbatim, loves American jazz and rock 'n' roll, has a million CDs, knows everything about them, and knows everything about baseball, too.

For 10 years, Bierut was a faithful Vignelli student who absorbed Massimo's approach, first by mimicking it, then by mastering it. It has become the underlying structure of everything Bierut designs, but the work has an additional layer of wit, optimism and, sometimes, a goofy populism that can only be described as American.

Bierut was a brainy kid who, in high school, hid his smarts to maintain popularity. He discovered that he liked to draw and decided to become a graphic designer. (Unlike most suburban high school students, he actually knew what a graphic designer was because his father was a printing salesman.) Bierut studied design at the University of Cincinnati College of Design, Architecture, Art and Planning, graduating *summa cum laude* in 1980. During this period he managed to collect every *Communication Arts* and Art Directors Club annual produced and proceeded to commit every work and every credited designer to memory. He can recite them still, to this day.

Young Bierut interned for Chris Pullman at WGBH in Boston before moving to New York with his bride and high school sweetheart Dorothy Kresz in the early '80s. There he went to work for Vignelli and shortly became a sort of wunderkind. Two posters Bierut designed for the Architectural League of New York while still in his twenties ("Unfinished Modern" and "Monument Informal") have since become widely collected postmodern classics. Both posters combine decorative architectural elements with a strong grid.

MARCH OF DIMES IDENTITY **ART DIRECTOR** Michael Bierut. 1998. | TIBOR KALMAN: PERVERSE OPTIMIST **ART DIRECTOR** Michael Bierut **PUBLISHER** Booth-Clibborn Editions/Princeton Architectural Press. 1998.

The '80s were a heady and confusing time for designers. Postmodernism was in full flower. Established design rules and principles were challenged by a new generation of designers. Émigré had been publishing their typographically radical magazine. Cranbrook was teaching deconstructivism and designers were experimenting with the computer or experimenting with typefaces and design styles that were 50 years old. Bierut, now vice president of graphic design at Vignelli, appreciated it all. His affinity for the new styles had nothing to do with a rebellion to Vignelli's approach. It was simply that there was more stuff to absorb, to remember, to appreciate and maybe to spit back out. So he absorbed the new designers and their work the same way he had absorbed the *CA* annuals, the Preston Sturges movies and the baseball stories.

Bierut also immersed himself in the design community. He knew everyone, learned who they were in the annuals, saw them lecture, knew how they thought. He first became president of the New York chapter of the American Institute of Graphic Artists and then, in the late '90s, president of the national organization. He was an amazing connector. He brought disparate design groups together, fostered positive debate and strengthened the community. He also greedily used the opportunity to design a pile of postcards and other mailers for AIGA. He quickly discovered the benefit of maintaining relationships with not-for-profit groups and managed to develop an individualistic portfolio of work for innumerable not-for-profits that separated itself from the Vignelli style that he employed on commercial projects. He was developing his own visual vocabulary.

After 10 years at Vignelli, an offer to join Pentagram seemed ideal. Pentagram had no house style, no particular design ideology—it was simply a place for a designer of intelligence and determination to do his or her work with the support of myriad partners, each with individual strengths and weaknesses. Bierut never had the stomach for setting up his own business or worrying daily about the phone bill. Pentagram was already set up. There was already a desk. Bierut was Number Two at Vignelli in graphic design. At Pentagram, he would be Number One with 18 other Number Ones. He joined Pentagram in 1991.

It was as if all the collecting that Bierut had done in school, at Vignelli and through the AIGA—all that stockpiling of design and design trivia—had suddenly come in very handy, as he had always known it would.

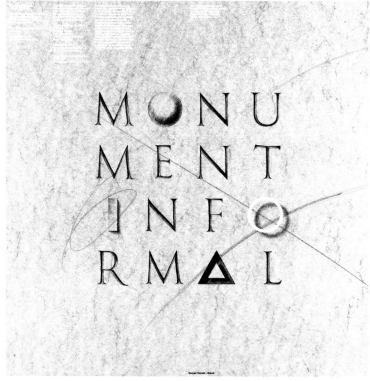

UNITED TAIL **IDENTITY CONSULTANCY** Michael Bierut **CLIENT** United Airlines. 1997-Present. | MONUMENT INFORMAL **ART DIRECTOR** Michael Bierut **CLIENT** The Architectural League of New York. 1985.

At first, he experimented as widely as possible on each new project but then found himself returning to the ever-reliable Vignelli understructure. His work for the Brooklyn Academy of Music relies on classic Vignelli formalism—the rules, the grid—but the strident cut-off type demonstrates the Bierut wit. His publication and poster system for the Yale School of Architecture pays homage to Vignelli by existing strictly in black and white with typography used in perfect proportion and scale, but gets even by using every typeface available to mankind. Michael's "Scale" poster with the great big circle and the small word scale is his unabashed love letter to Massimo.

At Pentagram, Bierut could employ all the knowledge he had stockpiled not only in his designs but also in his dialogue with clients. If the '80s and '90s had shifted design practice in terms of style, methodologies and technologies, they had also changed the ways businesses thought about and purchased design. The postwar model of a great design client was a visionary corporate giant who served as a patron to the great designer and thereby elevated the practice. Now it is far more likely that design is purchased by well-meaning, democratic committees of people with less vision but, nonetheless, great expectations for the finished product.

Here Bierut has infinite patience. His Midwestern optimism and general affability allow him to perceive clients as just good people with a job to do, informed by whatever milieu they are in. Because of his genuine curiosity and his nearly photographic memory, he knows something relevant to nearly everyone he speaks to, is capable of engaging people, connecting people and, in the process, teaching people about design.

In a Michael Bierut dialogue, design is never separate from the corporation or person purchasing it. It is not something mysterious, elite or abstract, but something human, informal and enjoyable. It can be analogous to a movie, a piece of music or a baseball game—things that real people understand.

Michael Bierut has taken pure European formalism, added a layer of American populism and made it, through warm conversation, accessible to and appreciated by those who have listened to him. They in turn have made it accessible to everyone else. Formidable.

PAULA SCHER

CLOCKWISE FROM TOP LEFT

LOOKING CLOSER: CRITICAL WRITINGS ON GRAPHIC DESIGN **ART DIRECTOR** Michael Bierut **PUBLISHER** Allworth Press. 1994-2002. | IRAN-Q
ART DIRECTOR Michael Bierut **CLIENT** The New York Times. 2003. | LEVER HOUSE **ART DIRECTOR** Michael Bierut **PHOTO CREDIT** James Shanks. 2002.

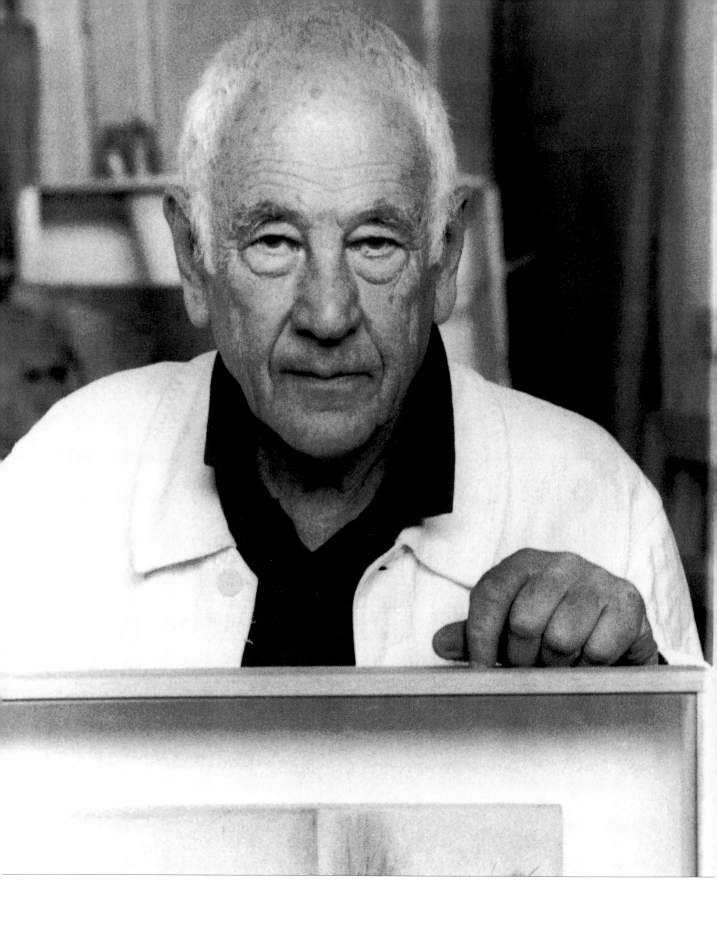

André**François**

A graphic arts master whose protean career forms a bridge from the beginnings of modern graphic design to the present, André François was born November 9, 1915 in Timisoara, a part of the Austro-Hungarian Empire that shortly afterwards became Romania. He briefly attended the Beaux-Arts school in Budapest before moving to Paris to study with the great Cassandre. On the latter's recommendation, young André designed his first posters for the famed French department store Galeries Lafayette, and then was commissioned to produce graphic works for the 1937 World Exhibition in Paris.

At that same time François also began creating cartoons. Since the 1940's, his exquisitely witty and elegantly executed illustrations have earned him an enduring international career, appearing in such well-known newspapers and magazines as *Action*, *Architecture d'Aujourd'hui*, *Elle*, *Le Fou Parle*, *Haute Société*, *Le Nouvel Observateur*, *Réalités*, *Record*, *La Tribune des Nations*, *Vogue*, *Lilliput*, *The Observer*, *Punch*, *Fortune*, *Holiday*, *Look* and *The New Yorker*, for which François created a total of 57 covers.

In 1939 François married Englishwoman Margaret Edmunds with whom he discovered a love of the sea. The sea reminded him of the great plains of his childhood, and the couple settled first in the port city of Marseilles, where two of their children were born. The war disrupted this idyll, leading them into the mountains of Hante Savoie. In 1945, François and his growing family moved to a small farming village north of Paris, Grisy-les-Platres. There, in a modest French farmhouse, its walls delightfully painted by André with tromp-l'oeil shelves of books, furniture and bric-a-brac, the artist and his wife have lived and worked, entertaining countless visitors with unforgettable warmth and hospitality. "Many are the artists and illustrators," wrote François Barré, "who were drawn and guided, like the Magi, by the constellations of Canis Major, Canis Minor, the Charioteer and Austral Pisces, to find André and his wife Marguerite in their garden under the stars at Grisy."

François has been illustrating books since 1946, including the works of Diderot, Jacques Prevert, Alfred Jarry and Boris Vian, as well as his own. Robert Delpire, with whom François has enjoyed a long friendship, publishes many of his books, including the well-known *Crocodile Tears*. Their other collaborations include numerous posters for Citroën and *Nouvel Observateur*, to name but a few.

FROM LEFT TO RIGHT

HEAD AND TORSO **ARTIST** André François. 1993. | POSTER FOR THE GEORGES VISAT STUDIO EXHIBITION **ILLUSTRATOR** André François. 1971.

In England, François became friends with Ronald Searle and Germano Facetti, art director of Penguin Books, for whom he designed countless book covers. He also designed playing cards for Natasha Kroll, art director of Simpson Piccadilly.

François designed sets and costumes for theater in England and France, including *Le Velumagique* for Roland Petit, *Pas de Dieux* for Gene Kelly's ballet at the Paris Opera, *The Merry Wives of Windsor* for the Royal Shakespeare Company, and *Brouhaha* by Georges Tabory for the Aldwych Theater in London. Since 1960, François has given most of his time to painting, engraving, collage and sculpture. He has had numerous one-man shows, including the Galerie Delpire, Museé des Art Decoratifs, and the Palais de Tokyo in Paris; the Stedelijk Museum in Amsterdam; the Wilhelm-Busch Museum in Hanover, and the Galerie Bartsch-Chariau in Munich; the Mitsukoshi Museum in Tokyo and three other museums in Japan; as well as in Belgium, Austria, other cities around France, and in Chicago. François' distinctions include an honorary doctorate from The Royal College of Art, the Grand Prix National de l'Art Graphique in Paris, and honorary membership in the Royal Society of Art, Great Britain.

CLOCKWISE FROM TOP LEFT

NUN **ILLUSTRATOR** André François. 1950. | RIDER AMONG DOGS AND CATS **ILLUSTRATOR** André François. 1977. | THE SITTER **ARTIST** André François. 1974. | SET DESIGN FOR *THE HOTEL ROOM* **ILLUSTRATOR** André François **PLAYWRIGHT** Roland Petit. 1957.

François' work and his admirable persona have been an acknowledged influence on many of the the the best-known illustrators and designers of the past five decades working in the United States, Europe and Japan, and have earned him unique affection among his peers. After a tragic fire burned his studio to the ground in mid-December 2002, including much of his original work, an outpouring of letters from colleagues around the world urged him on, among them Ronald Searle, Brad Holland, Milton Glaser, Seymour Chwast, Steven Heller, Ralph Steadman, John Collier, Henry Steiner, Dugald Stermer, Jonathan Twingley, C.F. Payne, Randall Enos, Etienne Delessert, Bfrian Ajhar, David Lesh, Yarom Vardimon, Robert Neubecker, Grzegorz Marszalek, Orosz Istvan, Philip St. Jacques, Roland Scotoni and Claude Haber. Guy Billout wrote, "As soon as I entered art school in 1956, I created my little Pantheon of Immortals, and you were part of a very short list…" His concluding sentence sums up the sentiments of the others: "Your legacy is very much in the hearts and souls of many of us, and it is eternal."

MYRNA & PAUL DAVIS

CLOCKWISE FROM TOP LEFT

EVIL HEAVENLY BODY **ILLUSTRATOR** André François. 1975. | COSTUME DESIGN FOR THE MERRY WIVES OF WINDSOR **ILLUSTRATOR** André François **PLAYWRIGHT** William Shakespeare. 1964. | THE RED CHAIR **ARTIST** André François. 1972. | THE PRICE OF GRAPHIC DESIGNERS **ILLUSTRATOR** André François. 1972. | CULTURE HOUSE **ILLUSTRATOR** André François. 1948.

David**Kennedy**

He must've wanted the hell out of Chicago is all I can figure. Because he was standing there in my office doorway wearing a three-piece pin-striped suit. It was the was the first time I ever laid eyes on David Kennedy and the last time I ever saw him in that suit.

After he got the job, he must've burned the suit or given it to Goodwill, because for the rest of his working life, with only two or three minor exceptions, this man wore blue jeans and a blue work shirt. Period. "It simplifies things," he said.

Simplifying the man is a bit more difficult. It would be easier to organize that rat's nest of papers, photos, flags, buffalo skulls, woodblock letters and other artifacts he calls an office. But there are so many facets to Kennedy, arranged in no particular order, that you cannot get a complete picture of him even after 25 years' exposure.

He is completely centered, yet a mass of contradictions. For instance, he and I will be walking back from lunch trying desperately to find a way out of a particular business crisis, and I will be doing my damnedest to articulate the issue, break it down before it broke us down. He listens, challenges, takes another line of attack and then abruptly yells, "Jesus, Wieden, look!"

There, under a tree growing out of the sidewalk is a scrap of paper with an image I can't quite make out. He bends, picks it up, brushes off the grime, flattens it out.

"Isn't that beautiful?" He gives his classic half-laugh, looks at me with a raised eyebrow. I am brought back to the present moment and that piece of flotsam is brought back to the office.

David Kennedy is addicted to beauty. He can't leave it alone. It is this obsession with craftsmanship—coupled with his startling conceptual talent—that has guided Wieden + Kennedy from the backwoods of Oregon out onto the international stage.

I owe him everything.

Apparently I also owe him a 1,000-word biography which, given his complex nature, is about 100 trillion words too short. I told him this a couple of days ago. "David," I said, "where do I start? Do you want me to do a personal history? The number of agencies you've been thrown out of would fill the entire space. Ditto your awards. Talk about the work? It talks for itself."

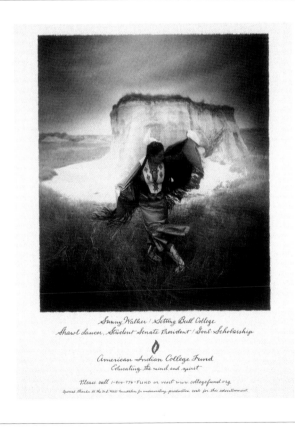

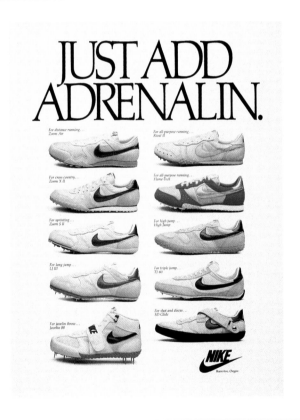

"Could you please just write down what you think is important, what you really want mentioned?"

He is going to hate me for this because he is a very private guy. He'll accuse me of being unprofessional, lazy, etc., etc., etc. But you read his raw notes. You'll get a rare glimpse of the man behind the legend. A man of incredible warmth, passion, a man deeply connected to other people. Think of it as Kennedy: The Basement Tapes.

David's notes:

"So, Wieden...if you could write a brief opening that spoke to our beginning and some kind of ending that speaks to our college fund involvement, that would be great. Some suggestions...

- How we met at McCann selling plywood for G.P. How we left to sell plywood for L.P.

- How we left to sell sneakers for Phil Knight. (Dog chases car, dog catches car, dog is running 60 miles an hour with hot muffler in mouth.)

- The environment we wanted to create...a place where people could realize their potential, slime-mold theory, rules (The Work Comes First).

- How, in the beginning, we didn't know/care anything about business or money—just wanted to make great ads.

- Maybe how I introduced you to my heroes—illustrators, photographers, directors, cameramen, etc., and how Nike allowed us (what did they know—we picked the teams) to work with all these great collaborators...Cuesta, Marco, Pytka, Annie Leibovitz, Bridges, Piestrup, Elfman, Spike Lee, Manarchy...on and on and on. How advertising is the process of collaboration—art directors, copywriters, directors, photographers, musicians, editors, typographers, retouchers, engravers, printers...blah, blah, blah.

- How I would duck out of boring client meetings, financial meetings, research/planning meetings, new business meetings (meetings, meetings, meetings!!!) to get back to the waiting board (the mistress), the pressure of the ever-present deadline, the adrenaline, the rush of it all—trying to perfect an ad at the last moment in Dennis' office with Phil Dana...lurking to tear it out of my hands to rush to the engraver's camera.

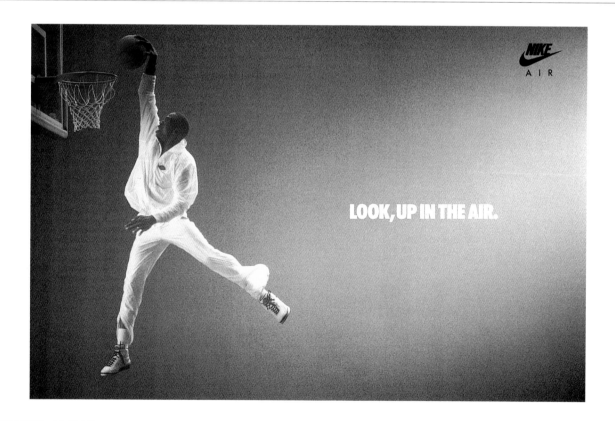

ABOVE

LOOK, UP IN THE AIR **ART DIRECTOR** David Kennedy **COPYWRITER** Jim Riswold **PHOTOGRAPHER** Bob Peterson **CLIENT** Nike. 1986.

- How I hated computers, cut and pasted by hand standing at the Ingento (cutting board) in the mount room—still do today.

- How I ended up being the worst art director in the shop, because I had to spend my time looking at work instead of making work, how it drove me crazy and how I left to make sculpture, but never left.

- My retirement party. The Harley. The piper parade down Washington Street (the piper was actually wearing a Kennedy kilt).

- The fact that you and I were basically family guys—four Wiedens and five Kennedys and Bonnie and Kathleen and Ken Wieden, and how that was part of the fabric of the agency—the kids (staff) couldn't pull things over on us, but we knew to give them the room to fall down. The terrible loss of Sandoz and Sippl and Hawthorne and even Strasser.

- The incredible people that have joined us—Kesey, Cloepfil, Bill Bradley, Phillip Glass, Galway Kinell, Redford, P.I.C.A., Michael Gray, John Sunchild, Janine Pretty-On-Top—on and on and on.

- How one day the Indians appeared at our door, as if for years they had been patiently waiting (as is their way) for the right moment to come get me. Waiting for the day that we had knowledge enough, allies enough and understanding enough to come join them. And how they changed my life."

His Indian name is Wichasha Owayakepi Chunta, which is Lakota for He Who Sees the World With His Heart.

I was there at the naming ceremony when Rick Williams first spoke the name. He Who Sees the World With His Heart. I was overcome. How do they know these things? I haven't the faintest.

He has contributed so much to this industry, so much to our agency. But of all the things he has given me, and they are many, the most enduring are those three simple words:

"Jesus, Wieden, look."

<div align="right">DAN WIEDEN</div>

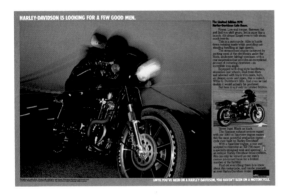

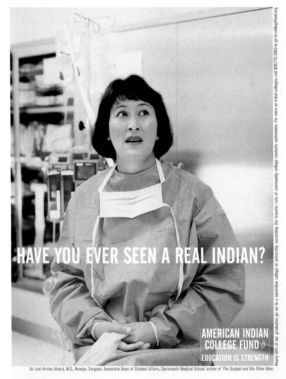

HONDA COMMERCIAL **CREATIVE DIRECTORS** David Kennedy, Dan Wieden **ART DIRECTOR** Rick McQuiston **COPYWRITER** Jim Riswold **PRODUCER** Bill Davenport **DIRECTOR** Steve Horn **CLIENT** Honda. 1985. | HAVE YOU EVER SEEN A REAL INDIAN **CREATIVE DIRECTORS** David Kennedy, Dan Wieden **ART DIRECTOR** Tim Hanrahan **COPYWRITER** Dylan Lee **PHOTOGRAPHER** Christopher Buck **CLIENT** American Indian College Fund. 2001. | A FEW GOOD MEN **ART DIRECTOR** David Kennedy **COPYWRITER** Tom Reilly **PHOTOGRAPHER** Art Kane **CLIENT** Harley-Davidson. 1977.

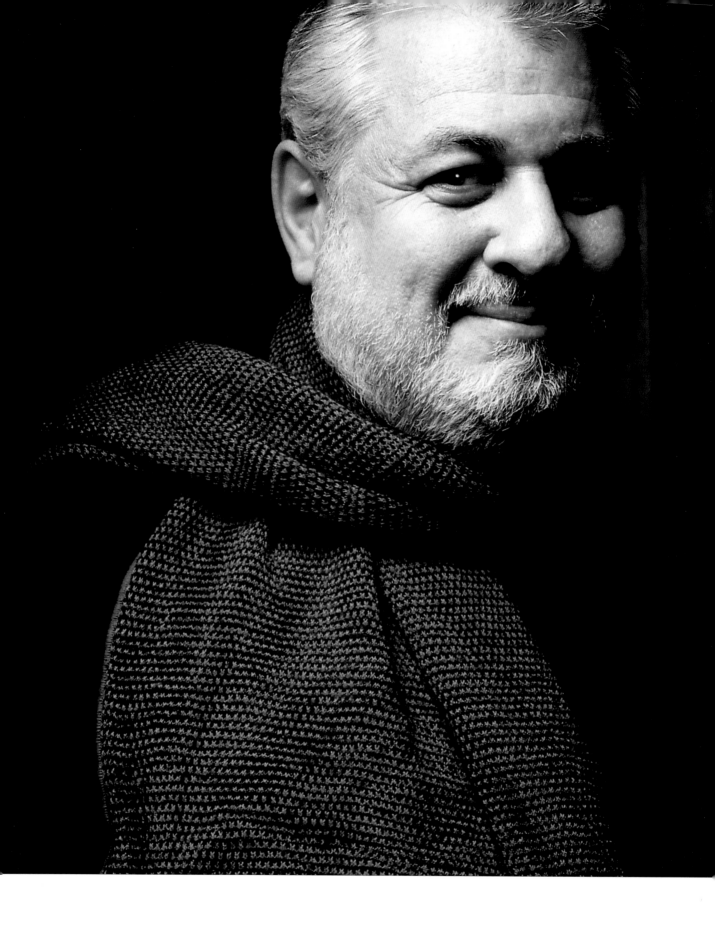

RichardSaul**Wurman**

"Was it the time that he got Microsoft Corp's research guru Nathan Myhrvold to do a speech on how dinosaurs copulated? Or when he paired brash software billionaire Larry Ellison of Oracle Corporation with Reverend Billy Graham in a speech called 'The Oracle and The Oracle'? Or the idea of getting athlete Aimee Mullins to show off new technologies in prosthetic leg design by trying on her many pairs? Or providing a venue where many got their first glimpse of the Apple Macintosh? Then again, it was probably hard to top the time when Richard Saul Wurman let the Mars Rover try to roll right over his stomach..." So wrote Kara Swisher in the Wall Street Journal about Wurman's famed TED conferences. "Over the years," she noted, "they have come in part to get a gander at early versions of the Next Big Idea, from voice recognition to virtual reality to artificial intelligence and all sorts of new hardware and software. But mixed into the quirky program is also a blend of science, art, music, exploration and plain old silliness, all brewed in the restless mind of RSW. More importantly, during the conference, he also plays the important role of No. 1 audience member, by laughing, crying, kvetching, or throwing a gimlet-eyed glance at a presentation that has displeased him from his usual roost by the side of the stage."

Recipient of the ADC Hall of Fame's special Educator's Award, Richard Saul Wurman is a master of the unexpected. Early on he coined the now popular term "information architect" to describe his unique confluence of training and talents. He has produced 81 books to date, and 21 influential conferences, including TED and TEDMED, all of which, he acknowledges, stem from "his desire to know rather than from already knowing, from his ignorance rather than from his intelligence, from his inability rather than his ability."

The publication of his first book in 1962, at the age of 26, marked the appearance of what was to become the motivating passion of his life: making information understandable. Wurman's most successful creations include the original series of *Access* Guides, and the best-selling books *Information Anxiety* (1989) and *Information Anxiety2* (2000). Among the many fans of the latter two books are former *London Times* editor Harry Evans, who called the first edition "a brilliant piece of teaching," and John Scully former chairman of Apple Computer, who praised it, "next to the Macintosh," as "the most important tool developed for understanding information in years." Of the updated version, David M. Kelley of IDEO

INFORMATION ARCHITECTS—50TH ANNIVERSARY OF POLAROID **ART DIRECTOR** Richard Saul Wurman **DESIGNER** Richard Saul Wurman
ILLUSTRATOR Richard Saul Wurman **PRODUCTION DESIGNER** J. Abbott Miller **PUBLISHERS** Richard Saul Wurman & Graphis **CLIENT** Polaroid Corporation.
1989. | INFORMATION ARCHITECTS—TOKYO ACCESS **ART DIRECTOR** Richard Saul Wurman **DESIGNER** Richard Saul Wurman **CARTOGRAPHER**
Richard Saul Wurman **PUBLISHERS** Richard Saul Wurman & Graphis **CLIENT** Access Press. 1984.

said it came "just in time to help us survive the ever increasing deluge of unintelligible stuff." In 1995, Wurman created the first annual "Design of Understanding" competition for the American Institute of Graphic Arts.

In founding the famous TED Conferences, an acronym for Technology, Entertainment and Design, Wurman created a vehicle for bringing together highly influential and disparate speakers on a wide variety of subjects with equally stellar audiences. Ray Smith, former chairman of Bell Atlantic said, "Maybe the best way to talk about him is as an enzyme. He seems to come in and out of things and he changes what takes place in the reaction of individuals and ideas, and yet he emerges from it precisely the way he was before, all of his molecules intact." In the *Wall Street Journal*, Kara Swisher wrote of attendees: "Over the years, they have come in part to get a gander at early versions of the Next Big Idea, from voice recognition to virtual reality to artificial intelligence and all sorts of new hardware and software." Participants have included the business and cultural movers and shakers, from Jeff Bezos of Amazon.com and Jeffrey Katzenberg of DreamWorks to Martha Stewart and AOL Time Warner's Steve Case. Microsoft's Bill Gates said he "wasn't prepared for this conference to be so profound," and Billy Graham told Wurman, "It was one of the highlights of my entire life."

Recently he created a new publishing company called TOP, to produce books and related media on health and well-being, the newest concerning diagnostic testing, heart disease and estate planning. Other recent publications include *Understanding USA*, *Diagnostic Tests for Men*, *Diagnostic Tests for Women*, *Heart Disease & Cardiovascular Health*, *Wills, Trusts & Estate Planning* and his latest *Understanding Children* and *The Newport Guide*. He is currently working on a new book project entitled *Understanding Healthcare* (January 2004).

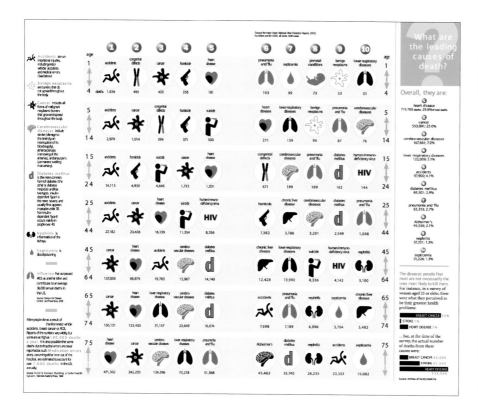

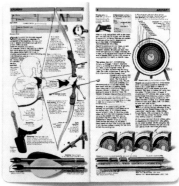

CLOCKWISE FROM LEFT

WHAT ARE THE LEADING CAUSES OF DEATH? **ART DIRECTOR** Richard Saul Wurman **DESIGNER** Nigel Holmes **ILLUSTRATOR** Nigel Holmes **PRODUCTION DESIGNER** Loren Appel **CLIENT** Richard Saul Wurman. 2004. | ARCHERY **ART DIRECTOR** Richard Saul Wurman **DESIGNER** Michael Everitt **ILLUSTRATOR** Michael Everitt **CLIENT** Access Press. 1983. | TRACK RUNNING RECORDS **ART DIRECTOR** Richard Saul Wurman **DESIGNER** Richard Saul Wurman **ILLUSTRATOR** Richard Saul Wurman **CLIENT** Access Press. 1983.

Trained as an architect, Richard Saul Wurman received Bachelor's and Master's degrees in architecture from the University of Pennsylvania, graduating in 1959 with the highest honors, among them the Arthur Spayd Brookes Gold Medal and a deep personal and professional relationship with the seminal architect and teacher Louis I. Kahn. Wurman had a 13-year architectural partnership in Philadelphia and was a director of the Group for Environmental Education. He is a fellow of the American Institute of Architects (FAIA).

Wurman was named a Fellow of the World Economic Forum in Davos, Switzerland, is a former member of the Alliance Graphique Internationale (AGI), and has been awarded numerous grants from the National Endowment for the Arts, a Guggenheim Fellowship, two Graham Fellowships and two Chandler Fellowships, a honorary Doctorate of Fine Arts by the University of the Arts in Philadelphia, as well as doctorates from the Art Center College of Design in Pasadena and the Art Institute of Boston. In 1996 he received the Chrysler Design Award, and also the Stars of Design lifetime achievement award from the Pacific Design Center. He has been a Visiting Scholar at MIT in the Department of Architecture and Planning where he received the Kevin Lynch prize, and has taught at Cambridge University in England, City College of New York, the University of California in Los Angeles, the University of Southern California, Washington University in St. Louis and Princeton. He is a consultant to major corporations in matters of design and understanding information.

He is married to novelist and lyricist Gloria Nagy. He has four children and five grandchildren. He lives in Newport, Rhode Island with Max and Abe (their dogs).

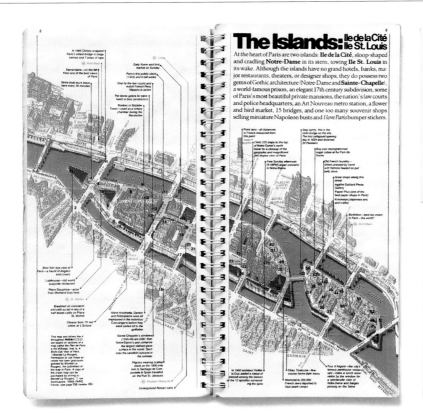

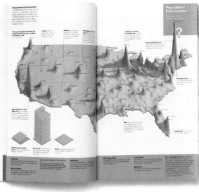

CLOCKWISE FROM LEFT

PARIS **ART DIRECTOR** Richard Saul Wurman **DESIGNER** Richard Saul Wurman **ILLUSTRATOR** Richard Saul Wurman (Original Map by Blondel La Rougery, 1739) **CLIENT** Access Press. 1992. | USA POPULATION DISTRIBUTION **ART DIRECTOR** Richard Saul Wurman **DESIGNER** Don Moyer **ILLUSTRATOR** Agnew Moyer Smith **PRODUCTION DESIGNER** Loren Appel **CLIENT** Richard Saul Wurman/TED Conferences. 1999. | DIAGNOSTIC TESTS FOR MEN & WOMEN **ART DIRECTOR** Richard Saul Wurman **DESIGNER** Nigel Holmes **ILLUSTRATOR** Richard Saul Wurman **PRODUCTION DESIGNER** Loren Appel **CLIENT** TOP Publishing. 2001.

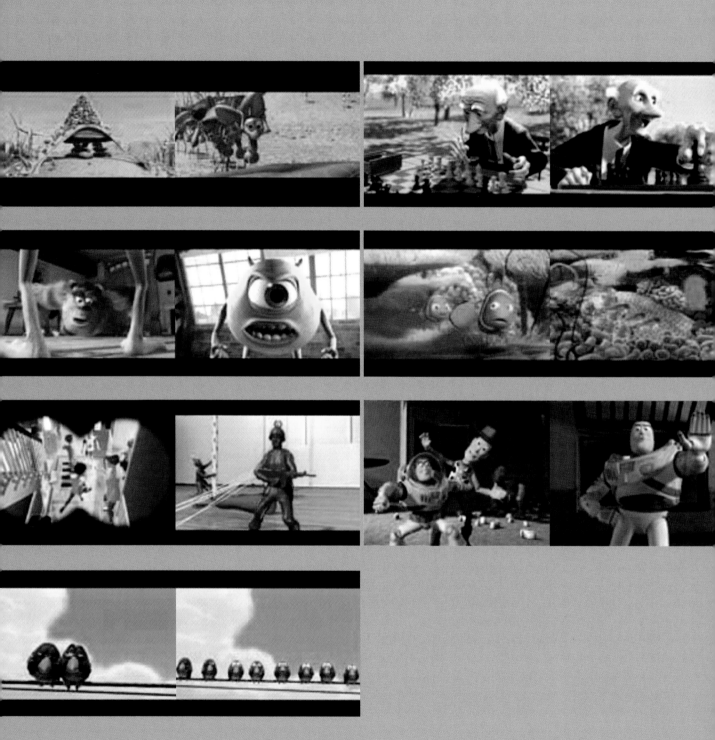

VISION AWARD PIXAR ANIMATION STUDIOS

The ADC Vision Award for 2003 was presented to Pixar Animation Studios at the Annual Awards Gala in June. Ed Catmull, president of Pixar, was on hand to receive the honor, which was created in 1954 to recognize companies that "demonstrate a commitment to design in relation to performance, thereby contributing to extraordinary creative excellence in communication, education and social awareness."

Pixar was selected for its outstanding design consciousness throughout the creative process—from direction to animation to production—for animated films, commercials and technical contributions to the visual communications industry. The company combines creative and technical artistry to create original stories in the medium of computer animation.

Pixar has created five of the most successful and beloved animated films of our time: Academy Award-winning *Toy Story* (1995); *A Bug's Life* (1998); Golden Globe-winner *Toy Story 2* (1999); *Monsters, Inc.* (2001). Pixar's latest film, *Finding Nemo*, was released in May 2003 to widespread critical acclaim. The Northern California studio's five films, produced in partnership with Walt Disney Pictures, have earned more than $2 billion at the worldwide box office to date. Pixar's next two film releases are *The Incredibles* (2004) and *Cars* (holiday season 2005).

ART DIRECTORS CLUB ANNUAL

adc now

AnnualAwards**Tour**

The 81st ADC Annual Awards Traveling Exhibition had a very successful worldwide tour during the 2002-2003 travel period. The Gold, Silver and Distinctive Merit winners were showcased at 15 host sites throughout the four continents of North America, Europe, Asia and South America where attendance was high and interest was great.

Venues included regular presenters, among them Escola Panamericana de Arte and Design in Sao Paolo, the Capital Corporation Image Institution in Beijing, Recruit Company in Tokyo and The Art Institute of Atlanta, as well as new hosts, including Academy of Art College in San Francisco, Hong Kong Baptist University and University of Applied Sciences in Wiesbaden. ADC was pleased to welcome the Association for Promotion of Visual Culture and Visual Communications in Zagreb, which was created for the purpose of presenting the ADC Traveling Exhibition this past year.

These exhibitions exemplify ADC's mission to recognize and inspire the highest standards of excellence in visual communications, and encourage young people coming into the increasingly integrated fields of advertising, graphic design, interactive media, photography and illustration.

ADC 2002/2003 Exhibition Tour

NORTH AMERICA
Columbia College Chicago
Chicago, IL

The Art Institute of Atlanta
Atlanta, GA

School of Visual Concepts
Seattle, WA

Academy of Art College
San Francisco, CA

EUROPE
Bilgi University
Istanbul, Turkey

Association for Promotion of Visual Culture
and Visual Communications (VIZUM)
Zagreb, Croatia

Creative Club Austria
Vienna, Austria

University of Applied Sciences
Wiesbaden, Germany

Escola Superior De Artes e Design
Matosinhos, Portugal

Accademia di Comunicazione
Milan, Italy

ASIA
Capital Corporation Image Institution
Beijing, China

Hong Kong Baptist University
Hong Kong, China

Bangkok University
Patumthani, Thailand

Recruit Company
Tokyo, Japan

SOUTH AMERICA
Escola Panamericana de Arte and Design
Sao Paolo, Brazil

CHINA | OCTOBER 2002–JANUARY 2003 The Capital Corporation Image Institution, Beijing, brought the 81st Traveling Exhibition to six major cities throughout China. As in the past, Secretary General Weihua Gao arranged a diverse schedule of hosts noted for their commerce and interest in international award-winning work in the fields of advertising, graphic design, new media, photography and illustration. The host cities in China this year were Beijing, Chengdu, Chongqing, Jinan, Nanjin and Wuhan. CCII has toured the ADC Traveling Exhibition for five years now and it has become a benchmark for creativity and, according to Secretary General Gao, "has brought strong visual fuel to Chinese audiences."

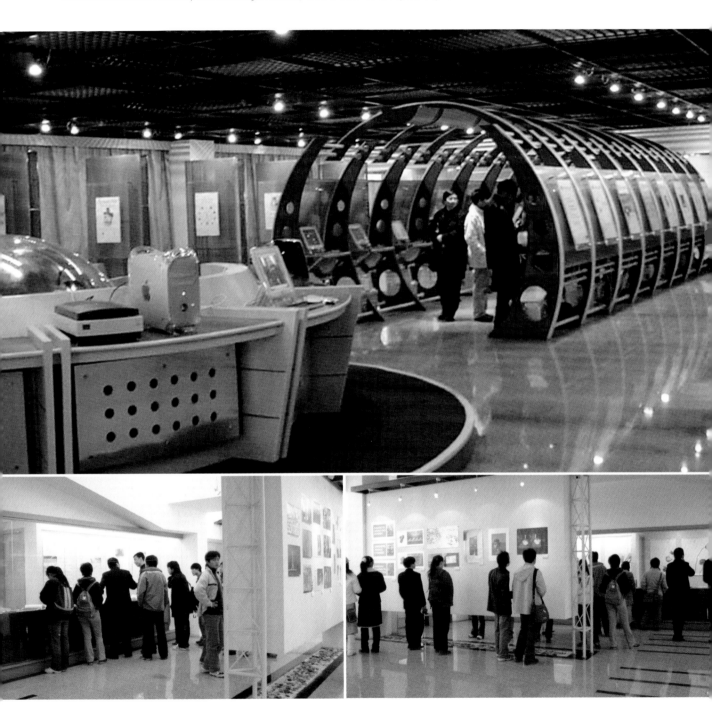

CLOCKWISE FROM TOP

Multimedia Canal, built specifically to hold the ADC exhibition | Inside the exhibition at Nanjin | Inside the exhibition at Nanjin

BRAZIL | MARCH–APRIL 2003 After six consecutive ADC exhibitions at the school, the number of visitors gets bigger every year, and on this last presentation it reached nearly 10,500 people, including 7,500 students. The rest of the attendance was made up of advertising professionals, graphic designers, photographers, architects, journalists and art critics. It is one of the most well-attended exhibitions here. The show's popularity continues to grow among universities, which adapt its concepts for educational discussion; for professionals, it functions as a reference of global quality in advertising and design; and for critics and journalists, the material presented is of great interest for publications and debates.

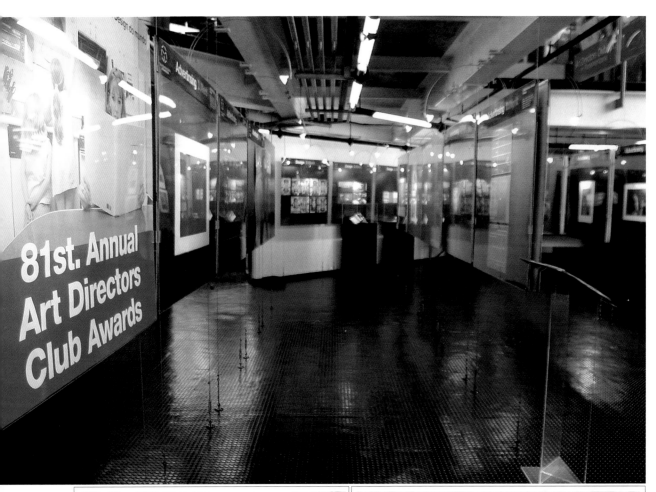

CLOCKWISE FROM TOP

Inside the exhibition at Escola Panamericana de Arte and Design | Advertisements for the exhibition produced by AlmapBBDO **CREATIVE DIRECTORS** Luiz Sanches, Roberto Pereira **ART DIRECTORS** Renato Fernandez, Luiz Sanches **COPYWRITERS** Sophie Schoenburg, Roberto Pereira

GERMANY | APRIL–MAY 2003 The ADC Exhibition was presented this year for the first time at the University of Applied Sciences in Wiesbaden, Germany. The opening ceremony included speeches by Michael Conrad, chief creative officer of Leo Burnett Worldwide and Cannes juror; Professor Kurt Weidemann, world-famous designer and typographer from Stuttgart; and Hessian State Secretary Dr. Herbert Hirschler. Conrad stated that the exhibits were exemplary proof of effective campaigns of the highest creative standards, and declared the exhibition a must-see for anyone working in the creative arena and an incentive to try harder. 3,000 visitors viewed the exhibition during its three-week schedule.

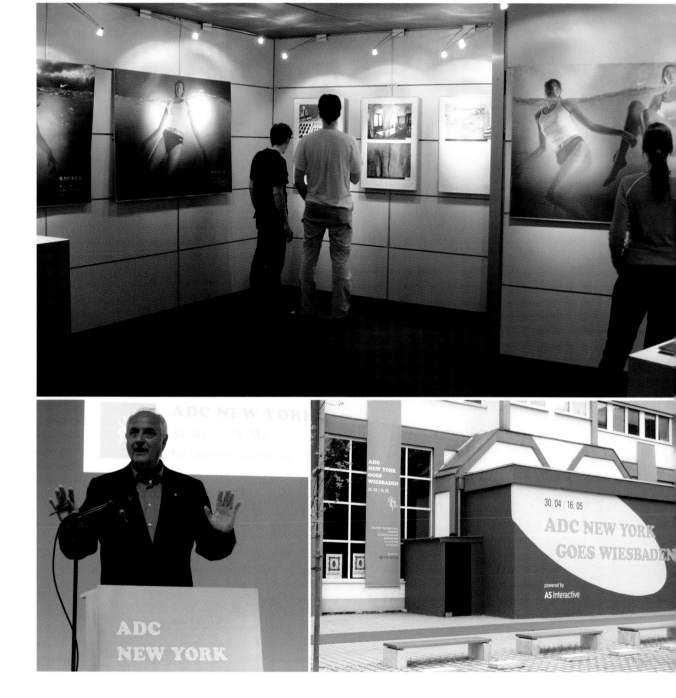

CLOCKWISE FROM TOP

Inside the exhibition, which was designed by Jürgen Grünig and Marjus Wasse | Outside the exhibition | Michael Conrad, chief creative officer of Leo Burnett Worldwide

ATLANTA | JANUARY–FEBRUARY 2003 The Art Institute of Atlanta hosted the ADC Traveling Exhibition for the fourth consecutive year. The Art Institute also hosted the Art Directors Club Hall of Fame Exhibition this year, which included the work of Rich Silverstein, Giorgio Soavi, Edward Sorel and educator Philip Meggs.

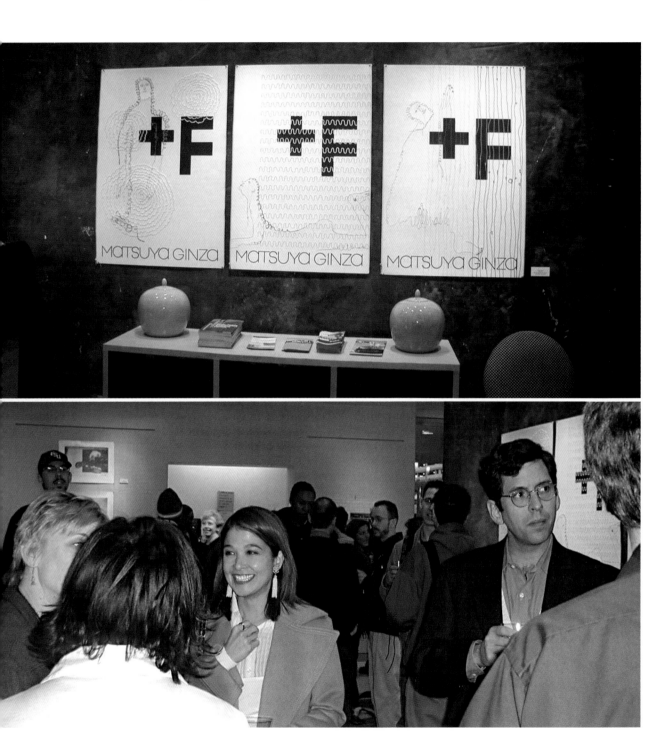

CLOCKWISE FROM TOP

Inside the exhibition at the Art Institute of Atlanta | The opening of the show at the Art Institute of Atlanta

HONG KONG | FEBRUARY–MARCH 2003 Hong Kong Baptist University was a first-time host this year. According to Dr. Russell B. Williams, assistant professor at HKBU, the opening was very successful and the exhibition was well received by professionals and students.

AUSTRIA | MARCH–APRIL 2003 The Creative Club of Austria hosted the 81st ADC Traveling Exhibition. It was the CCA's first time hosting the exhibition.

CLOCKWISE FROM TOP LEFT

Inside the exhibition in Hong Kong, China | Professor Georgette Wang, dean of School of Communication, Hong Kong Baptist University | Gerd Babits, creative director of Strobelgasse, and Tibor Bárci, president of CCA, at the opening in Vienna | Andreas Miedaner, creative director of Büro X Design, at the opening in Vienna

Scholarship**Foundation**

The 2003 Scholarship Awards Evening was held in the ADC Gallery on May 2nd. It was an exciting moment for all, as the winning students, their families and friends came to celebrate one of the organization's most rewarding events. This year, as in the past, it's interesting to note the number of recipients who come from so many parts of the world to study design in New York. In consideration of this, each winner received, in addition to a check and certificate, a statuette of Liberty, a "Libby," given in a spirit of fun. Students tell us that the honor they receive from the Art Directors Club will follow them throughout their careers.

This year's event was dedicated to the memory of Gladys Barton who was for many years a very active member of ADC and the Scholarship Foundation. The awards were also dedicated to the memory of the following art directors and designers who not only supported the Foundation, but whose work and energy contributed greatly to the field of design: William Brockmeier, Mahlon A. Cline, Gene Federico, Robert Gage, John Peter, Ikko Tanaka, William Taubin and Shin Tora.

The Art Directors Scholarship Foundation, Inc. was founded in 1977 by members of the Art Directors Club for the purpose of aiding and encouraging talented students. Again this year, the Foundation presented awards to students from each of the city's top six design schools. Each of the participating schools chose the students they considered to be the most deserving.

2003 Awards Recipients

THE COOPER UNION | Jennifer Carrow, Kathryn Cho, Sagi Haviv
FASHION INSTITUTE OF TECHNOLOGY | Rochelle Fisher, Avital Shofar, Christina Waldt Lord
NEW YORK CITY TECHNICAL COLLEGE | Elsie Aldohondo, Josephina Fuster, Norik Rizaj
PARSONS SCHOOL OF DESIGN | Bhavana Sujan, Namphuong Nguyen, Hiromi Sugie
PRATT INSTITUTE | Lorraine Abraham, Daniel Philipson, Klitos Teklos
SCHOOL OF VISUAL ARTS | Moonsun Kim, Brian Lightbody, Donna Yim

2002/2003 ADSF Board of Directors

Peter Adler, President | Meg Crane, Vice President | Lee Epstein, Second Vice President | Diane Behrens, Treasurer | Sam Reed, Assistant Treasurer | Eva Machauf, Secretary | Dorothy Wachtenheim, Assistant Secretary | David Davidian, Director | Robert Pliskin, Director | Andrew Kner, Director | Sal Lazzarotti, Advisor | Walter Kaprielian, Advisor | Kurt Haiman, ADC Liaison.

SaturdayCareer**Workshops**

This year, ADC again offered the Saturday Career Workshops program to almost 100 talented New York City high school juniors considering careers in visual communications. Thanks to the dedication of the ADC staff, our colleagues at the School Art League—Jane Chermayeff, Renee Darvin,and Naomi Lonergan—and our benefactor, the Coyne Foundation, we have been able to continue inspiring these motivated students.

Our Fall 2002 workshops were led by veterans Marshall Arisman, Steven Kroninger, Diana LaGuardia, Alex Suh and Boyoung Lee, in addition to newcomers Frank Anselmo and Jayson Atienza. We also offered our third Art College Seminar, where representatives from Cooper Union, FIT, NYC Technical College, Parsons, Pratt, SVA and the NYU School of the Arts made presentations to SCW alumni and their parents. In the Fall 2003 program, the morning seminar will be complemented by an afternoon Portfolio Review, where students will talk one-on-one with admissions counselors, and get guidance in producing competitive admissions portfolios.

Our Spring 2003 program consisted of workshops led by Frank Anselmo and Jayson Atienza, Marshall Arisman, Diana LaGuardia, Alex Suh and Boyoung Lee, and our second Computer Design Workshop at the New School's Computer Instruction Center. This workshop was developed in collaboration with Michael Randazzo, director of the CIC, and featured Adobe Instructors Scott Citron and Sandee Cohen. We thank them all for their participation.

During the year, we were assisted by current and former Parsons students Ellie Abrons, Liza Dunn, Cecilia deFreitas, Kim Grasing, Alex Kale, Svetlana Martynova, Christine Perez and Tiffany Rogers, as well as Gwen Haberman, Elisa Halperin, David Mayer and Erica Stoll. We thank them all for making the SCW a success.

I'd also like the thank the Coyne Foundation, with whose generous support we continue to expand our program. In addition to the Portfolio Review, we plan to mount our first exhibit of student work in the Spring 2004 workshop, and initiate an internship program for SCW alumni and ADC members in the Summer 2004 workshop.

None of the above would have been possible without the enthusiastic participation of Laura Parker, our new education coordinator. We thank her for her dedication to our students, and her vision for their future.

If any of our members would like to assist during the weekly workshops or lead a workshop, please get in touch with me.

SUSAN MAYER | Program Director | Saturday Career Workshops

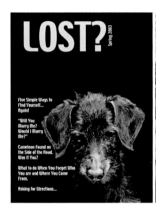
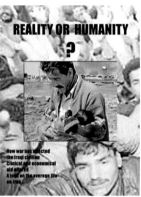
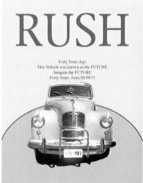
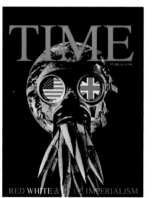

ADCGallery**Exhibitions**

CLOCKWISE FROM TOP

From Moon Man chandeliers hanging in the living room to Moon Man foosball tables in the den—the MTV Video Award trophy icon "Moon Man" was found in every corner of the exhibition MOONLIGHTING, designed by SVA's 3D Design class.

MOONLIGHTING | SEPTEMBER 2002 School of Visual Arts 3D Design students transformed the ADC Gallery into a house of monochromatic rooms decorated with household products they made from the mold of MTV's "Moon Man".

MIRAMAX | OCTOBER 2002 An immersed media exhibition of mesmerizing images, *The Qatsi Trilogy* celebrated the completion of Godfrey Reggio's landmark film series: *KOYAANISQATSI* (1982), *POWAQQATSI* (1988) and most recently *NAQOYQATSI*, released by Miramax. Accompanied by an interactive digital music installation from trilogy composer Philip Glass.

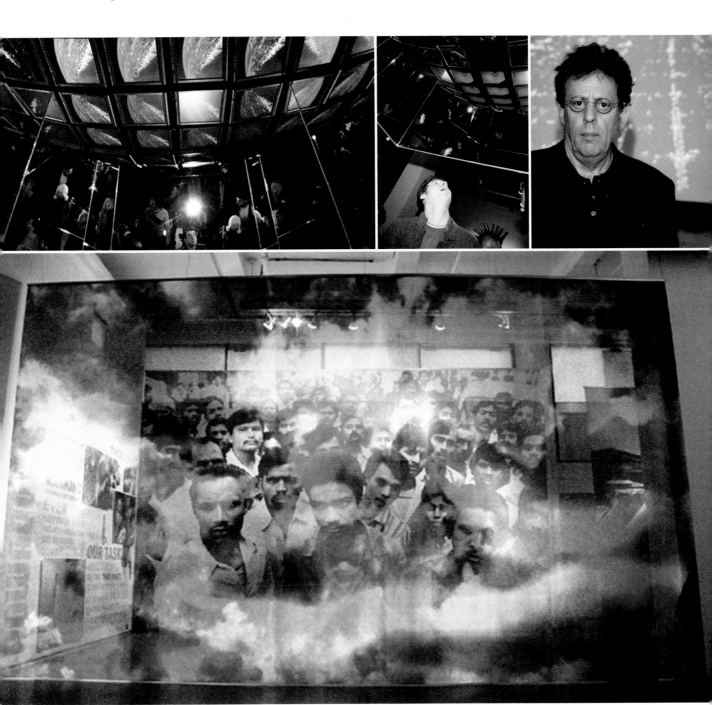

CLOCKWISE FROM TOP LEFT

Suspending multi-panel displays and large-scale projections, as well as state-of-the-art digital printing, reflected the spectacular visual language of Reggio's broadly influential work. Sponsored by Getty Images.

FAAR OUT | MARCH 2003 Fellows of the American Academy in Rome (FAAR) gathered in New York to install their work and ultimately encourage other American designers, illustrators and photographers to apply for the six-month residency to pursue independent art projects.

CLOCKWISE FROM TOP

FAAR Out was designed by Paul Lewis, FAAR Fellow '99 and partner of architectural firm Lewis. Tsurumaki. Lewis. | Celebrated industrial designer Kevin Walz ('94) cornered the ADC with textiles and furniture. | Lighting designer Heather Carson ('99) stopped traffic with her site-specific window piece.

ADC 82ND ANNUAL EXHIBITION | JUNE–JULY 2003 Out of the 12,000 entries received from 43 countries, a selective jury chose only 25 to win ADC Gold Cubes. All Gold, Silver and Distinctive Merit award-winning works were included in the 82nd Annual Exhibition, which travels around the world for one year thereafter.

The Aquent Room at the ADC was transformed into a screening room for award-winning videos including "All That I Perceive," the only student entry to win a Gold, by Lindsay Daniels. | The 3D design section of the exhibition included books, catalogs and annual reports. | International winners in the poster and print ad category literally jumped off the walls. Behind the column, visitors were invited to watch broadcast winners on a series of monitors in ADC's Kodak Room.

ADC**Events**

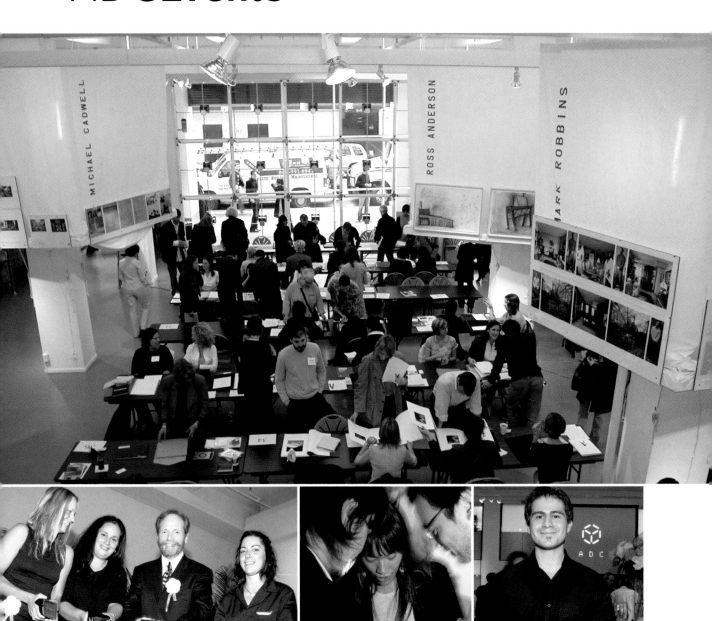

ADC organizes two portfolio reviews a season: a career-boosting opportunity for established ad up-and-coming illustrators and photographers to meet with the industry's leading art buyers and art directors, all under one roof, for one day each. | Gold Medalists at the ADC 82nd Annual Gala included Ogilvy Brasil's Milton Correa Jr., proudly posing with his Gold Cube. | For Office Use Only's Ahn Taun Pham and Ben Aranda showed off their Silver Cube. | Kevin O'Callahan with MTV Crew Jen Roddie, Romy Mann and Laura Murphy.

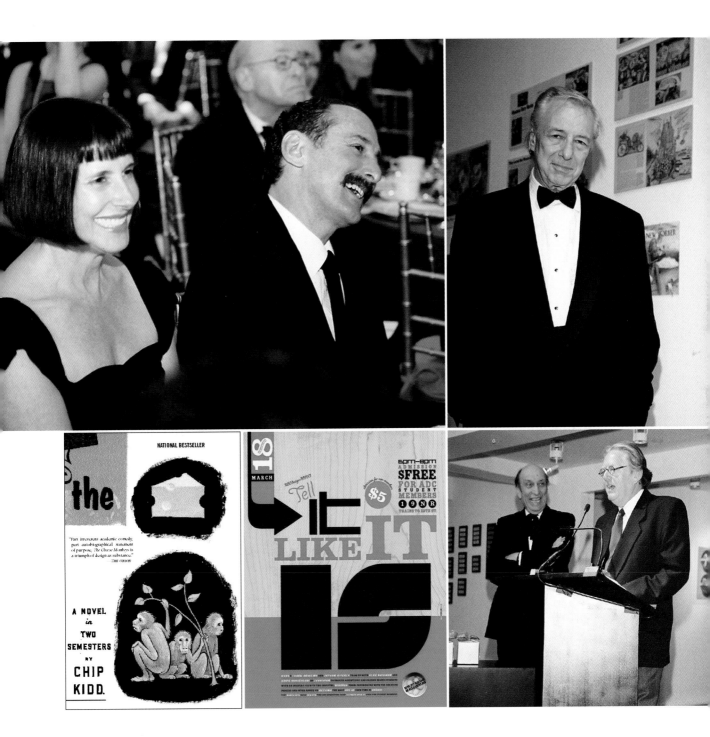

ADC Hall of Famer Rich Silverstein and his wife enjoy "I remember when..." remarks presented by his longtime business partner, Jeff Goodby, at the ADC Hall of Fame dinner. | Laureate Ed Sorel stands tall beside his work for *The New Yorker* and *Atlantic Monthly*. | Milton Glaser (left) enjoys Paul Davis' story about his first meeting with ADC Hall of Fame laureate Giorgio Soavi. | Tell It Like It Is poster designed by 280 to promote their ADC student event with BBDO young guns Frank Anselmo and Jayson Atienza. | Book cover designer Chip Kidd reads from his book *The Cheese Monkeys* at ADC.

NNUAL

TV VOLUME 20

COMMUNICATION ARTS

COMMUNICATION ARTS

advertisi

When the ADC asked me to assemble this year's advertising judging panel, I was told, "Anyone you want—completely up to you."

Great opportunity. And huge responsibility. Because it's the judging panel more than anything that establishes the credibility of any award show. So, how did I want this panel, and by extension this year's show, to be defined? The biggest names? The award show regulars? The hot young guns? My friends?

I decided to stick to basics. I called on the guys responsible for the best creative right now, from the U.S. and from abroad; the people who still live and breathe this stuff, who still sweat the most ridiculous details, who work at the best creative shops despite the fact that they could be making more money elsewhere. People who aren't going to let a little "Level Orange" terrorist alert keep them from coming to New York to see great advertising.

As a result, this year's show featured a particularly ruthless judging process. Which, of course, is what it's all about—to honor only the very best our business had to offer in 2002.

Congratulations to the winners. You've earned it.

KEVIN MCKEON | Executive Creative Director, Bartle Bogle Hegarty | Advertising Chair

KEVIN MCKEON In early 2001, in an act equal parts boldness and desperation, Kevin sent an unsolicited e-mail to John Hegarty, and shortly thereafter, assumed the job of executive creative director of BBH—New York. Kevin began his advertising career in 1980, and along the way has worked at some of the best agencies in New York, including Ammirati & Puris, BBDO, Scali McCabe Sloves and LOWE. His work on brands like Sony, Mercedes-Benz, Dupont, Virgin Atlantic, Schweppes, Heineken and Perdue has been recognized by every major advertising award show.

CARLOS COELHO Carlos Coelho is a creative director at Bates Brasil. His career began as a copywriter for Gang (which became Scali McCabe Sloves) and then for Núcleo/FCB and Salles DMB&B. Then he moved to Leo Burnett as a creative director and later to LOWE. He worked on various accounts such as Ford, Fiat, Renault, Nissan, Air France, Mercedes-Benz, Nestlé, Bayer, BankBoston, United Distillers, Folha de São Paulo and TAM airlines. The best commercial and the best billboard of the year are a few of his most prestigious national awards. Clio, Fiap, New York Festivals and Cannes are some of his international awards.

KEVIN MCKEON

CARLOS COELHO

BOBBY PEARCE

BILL OBERLANDER

WILLIAM GELNER

BOBBY PEARCE Bobby Pearce is currently a group creative director at Fallon in Minneapolis. In his 10-year career as a copywriter, he has worked in Fallon's New York office, as well as Goodby, Silverstein & Partners in San Francisco, Carmichael Lynch in Minneapolis and a bunch of other places you've never heard of.

BILL OBERLANDER Bill joined Ogilvy & Mather—New York in September 2001 as senior partner, executive creative director. Current clients include: Motorola, Arthur Andersen, Perrier, San Pellegrino and Starwood Resorts & Hotels. Before Ogilvy, Bill spent eleven years as executive creative director, managing partner at Kirshenbaum Bond & Partners working on brands Target, Snapple, LVMH and Citigroup to name a few. From 1997–2000, Bill was president of the Art Directors Club, where he helped reposition the club as the only industry organization to represent the convergence of creative talent. Just for fun, Bill and his wife Dale are raising their two young sons William and Bertram.

WILLIAM GELNER Before joining BBH, William worked at Cliff Freeman & Partners, Fallon, JWT and McCann-Erickson, all in New York. He has worked on a number of clients including Axe, Johnnie Walker, Mike's Hard Lemonade, Conseco, Miller Lite, Holiday Inn, The American Red Cross, Fox Sports Net and Budget Rent-A-Car. William has received national and international recognition for his work from Cannes, The One Show, *Communication Arts*, the Clios, the Art Directors Club, the ANDY Awards, D&AD, the ADDY Awards, AICP, The Minneapolis Show and the Effies.

ARI MERKIN Ari Merkin is creative director of Fallon NY. Ari started his career working on Land Rover at Grace and Rothschild. In 1998 he moved on to Crispin Porter + Bogusky where he worked on MINI, IKEA, GT Bicycles, and was a group creative director on the "truth" campaign. After that, he spent some time working for one of his heroes, Cliff Freeman. Ari's work has made regular appearances at Cannes, the One Show and the Clios, and he has won best of show honors in each. Ask what he's most proud of, he'll be happy to tell you: his daughter Sara and his two boys Sam and Ben.

DAMON COLLINS Damon began his career at FCB in 1986. He has since had spells at Gold Greenlees Trott, Leagas Shafron Davis Chick where he was deputy creative director, Saatchi & Saatchi as a group head and Abbott Mead Vickers. He joined LOWE in 2000 and was made creative director in 2002. Damon's work for accounts such as Yellow Pages, Anti-Smoking and Heineken has been recognised at numerous industry awards.

ARI MERKIN

DAMON COLLINS

KIM SCHOEN

GERRY GRAF

KIM SCHOEN Kim Schoen is an associate creative director at Wieden + Kennedy—New York, where she works on ESPN, Nike, Avon and the School of Visual Arts. Her campaigns for Nike and ESPN have won awards in *Communication Arts*, D&AD, The One Show and Cannes. Her campaign for Levi's was voted one of *Rolling Stone* magazine's "Favorite Things" in August of 1997. Before moving to New York, she had a one-person show entitled "Praha: Photographs from the Czech Republic" at The Focus Gallery in San Francisco, and has recently completed a life-sized photo installation in the streets of Manhattan entitled "Compartments," which enjoyed a solo show at The National Arts Club in December of 2001.

GERRY GRAF Gerry joined BBDO in 1994 as a copywriter and was quickly promoted to creative supervisor in 1995 and associate creative director in 1997. He left BBDO in 1997 to join Goodby, Silverstein & Partners and returned to BBDO in 2000 as an executive creative director. Gerry oversees creative development on the FedEx account, which includes the award-winning "Great Idea" commercial for FedEx.com as well as the popular "There's a FedEx for That" campaign. During his prior stint at BBDO, Gerry made a bold impact with his contributions to Snickers and M&M's, including the successful launch of M&M's Blue in 1995.

JO MOORE Jo has been working as a copywriter in London for nearly 15 years. Her career started in 1988 as a junior creative at Bartle Bogle Hegarty. Jo stayed at BBH for ten years working on many clients including Levi's, Boddington's beer, Electrolux and Swinton Insurance. Four years ago, Jo moved with her long-suffering art director across Carnaby Street to join WCRS. Here, she's been awarded three coveted D&AD pencils for a commercial for the Orange mobile phone network. Jo is currently creative director on one of WCRS's most notable pieces of business, BMW.

PAUL RENNER Paul Renner is a Jersey boy. Exit 10 to be exact, but so far nobody has held that against him. Paul landed his first job at Wieden + Kennedy—Philadelphia in 1991. From there he ventured to Goodby, Silverstein & Partners and, after that, Butler, Shine & Stern—Sausalito where he produced some work which won a bunch of awards. But his most prized achievement from the left coast was his first-born son. And, yearning to get closer to family, Paul was eventually drawn back to the East coast. He took a senior art director's position on Converse at Houston Herstek Favat—Boston. He then went to Arnold Worldwide in 1998 where he is an associate creative director on the Volkswagen account. Paul and his lovely wife Jackie now have one boy, two girls and a dog named Oscar. They live happily (but headhunters are always welcome to call) on the North Shore of Boston. Exit 44 to be exact.

JO MOORE

PAUL RENNER

ALAN MOSELEY

SHALOM AUSLANDER

ALAN MOSELEY Alan has worked at several agencies in his 12 years in advertising, most recently moving to Mother in April last year from TBWA\London. He has worked on accounts as varied as Playstation and the Labour Party and has won several awards and slaps on the back.

SHALOM AUSLANDER Shalom joined McCann three years ago as a senior creative director and is currently responsible for nothing. He goes through life as if in a fog. It's anyone's guess why they hired him. Previously, Shalom spent time at Chiat\Day and Mad Dogs and Englishmen, which he thinks impresses people. "Yeah, I was there when they were funny, man." He has received many advertising awards which he sullenly keeps in a box in the basement. In addition to his agency duties, Shalom is a contributing writer for *Esquire*, where he wrote and edited the 2001 Esquire Dubious Achievements Awards. He has a collection of short stories coming out next year (shameless plug).

ADAM GOLDSTEIN Adam Goldstein joined BBDO as senior vice president, senior creative director in August 1999. At BBDO, Adam has worked on and managed such clients as FedEx, Visa, Schwab, 7-Up International, Office Depot, Pepsi and Diet Pepsi. Prior to coming to BBDO, Adam was a group creative director at Ammirati Puris Lintas, where he led a 20-person, $300-million creative group with responsibility for accounts such as GMC, RCA, UPS, and Labatt USA's Rolling Rock, Labatt Blue, Lowenbrau and Dos Equis beer brands.

JEFF KLING Born in D.C. and grew up in Baltimore. Graduated from Duke. Was not a "Cameron crazy." Began work in advertising in New York, as a writer and director of radio spots with Are These My Shoes? productions. Moved from there to Wieden + Kennedy—Portland, where he served as copywriter and creative director for six short years. Currently a creative director with Wieden + Kennedy in Amsterdam. Is very fond of his three sisters, who are rad. And just became dad to a daughter. Who is rad.

DEAN HACOHEN Dean Hacohen is executive vice president/executive creative director at LOWE—New York. Prior to joining LOWE in 1996, Dean was associate creative director at Goldsmith/Jeffrey, which he joined shortly after it opened in 1987. Prior to that, Dean was vice president, senior copywriter at Doyle Dane Bernbach. In 1994, Adweek named him a National Creative All Star. He has won awards from the One Show, the Art Directors Club, the ANDY Awards, Cannes and the Clios. His work has appeared in *CA* and *Graphis*. He is a 1980 *summa cum laude* graduate of Boston University.

TIM CAWLEY Tim Cawley was an art director at Carmichael Lynch in Minneapolis at the time of the judging.

JEFF KLING

DEAN HACOHEN

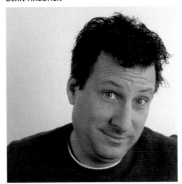

TIM CAWLEY

JOEL CLEMENT

STEVE STONE

JOEL CLEMENT Joel recently returned to Goodby, Silverstein & Partners from a two-and-a-half year stint in Southeast Asia. It began in Singapore, where he freelanced at BBH for a while on several local accounts as well as a project for their Japan office. After another Singapore agency, and some work in Vietnam, Joel eventually settled in as a creative director in Thailand where he won Asia's only Cannes Lion for television that year. Prior to the Asia experience, Joel was a senior art director at Goodby for almost three years where he was voted San Francisco's Art Director of the Year for his work on Nike. In addition to being recognized by the One Show, Clio Awards and CA, he also won the Athena $100,000 grand prize for a Hewlett-Packard campaign.

STEVE STONE Steve Stone, founding partner/executive creative director, sets the aesthetic sense at Black Rocket, establishing the highest levels of taste in everything from long-form cinema advertising to shelf talkers. Yahoo!, Discover Brokerage, Ben & Jerry's, Conde Nast's *Wired* and *Lucky* magazines, have all benefited from Steve's touch. Before starting Black Rocket, Steve was creative director at Hal Riney & Partners where he led the creative team for Saturn and projects for PepsiCo and Starbucks. Steve refuses to drive any car built after 1969 and lives in Piedmont, CA with his wife Bridget and three daughters Ella, Ruby and Pearl. No, he's not planning on having a son and naming him "Miles."

NOAH

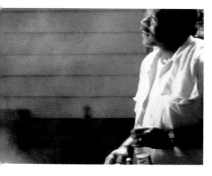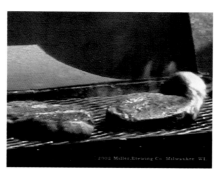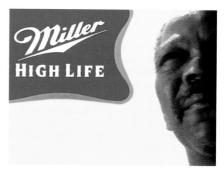

Open on close-up of man's head and jacket, far right. Camera pans up a bit to catch man's mustache. VO: I bet you Noah got pretty hungry staring at those two cows. **Cut to pile of steaks, bowl; arm lifts another steak.** VO: While holed up on that boat. **Cut to neck-down shot of man in white shirt; puts steak on grill. Cut to profile of man considering steaks, beer. Cut to close-up of his nose, mustache, mouth and neck; smoke from grill wafts by.** VO: Probably thought to himself: "There are a lot of other animals..." **He lowers his gaze. Cut to close-up of steaks on grill being flipped; camera pans to steak.** VO: "...Who's gonna miss 'em?" **Close-up of man's head, taking sip from bottle. Close-up of his waist, belt, hand on hip, other hand holding bottle, part of grill.** VO: Hats off, Noah. **Close-up of man's head on right.** VO: You're a stronger man than me. **LOGO: Miller High Life.**

CASANOVA

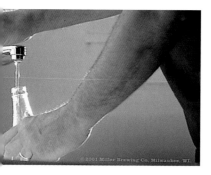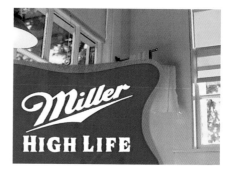

Open on frame of man filling a bottle with water. VO: Here's a lesson for the would-be Casanova. **Cut to top of his bald head. Cut back to sink shot, man finishes filling the bottle.** VO: Every so often... **He sets the bottle down on the counter.** VO: ...It's advantageous to remind the little lady she hasn't fallen off the radar. **Hard cut to man putting a flower in the bottle. He lifts the bottle to reveal that it's a High Life bottle.** VO: Well, well, well. **He adjusts the flower so that it is just right.** VO: Two-to-one, you'll be living the high life tonight. **He walks out of frame with the bottle in his hand. LOGO: Miller High Life.**

MOTHER-IN-LAW

Open on close-up of guy's face in lower part of frame. He is clearly looking up at someone who is speaking to him. VO: Tread lightly, son-in-law—there are more traps lying ahead than in the deep woods of Montana. **Cut to a medium shot of guy in recliner in foreground with mother-in-law in background standing over him. She crosses her arms as if impatient with him.** VO: One false step and she'll have your head mounted on her parlor wall. **Cut to son-in-law. Mother-in-law exits frame. Son-in-law picks up Miller High Life Light, pours it into his glass on the table.** VO: That's the right idea. Keep light on your feet and you just might emerge from this encounter in one piece. **Close-up of glass, hand grabs the glass. Cut to close-up of son-in-law; he looks up at mother-in-law.** VO: Good thing there's also a light way to live the high life. **Mother-in-law re-enters frame and stops in front of him. Again she crosses her arms as if impatient with him.** LOGO: Miller High Life Light.

MULTIPLE AWARDS

Gold Medal TV: 30 Seconds, Campaign **Noah • Casanova • Gossip** | **Gold Medal** Copywriting **Gossip • Mother-in-Law • Noah**

ART DIRECTOR Jeff Williams **CREATIVE DIRECTORS** Susan Hoffman, Dan Wieden **COPYWRITERS** Jed Alger, Brant Mau **DIRECTOR** Errol Morris **PRODUCER** Jeff Selis **PRODUCTION** Radical Media **AGENCY** Wieden + Kennedy **CLIENT** Miller Brewing Company **COUNTRY** United States

This beer thrived when there were men to drink it. In this once proud nation, every second fridge boasted a steady, fresh supply. You couldn't swing your toolbelt without knocking over a six-pack. Where have they gone, those who dared bear the title "man"? They've headed for the hills—the hills now dotted with strip-mall coffee bars and yogurt shops. Time to remember why a man has feet. No, not to prance around in awe of the next fad. To walk the higher path. Tall. Erect. Not scared to live...the high life.

LIVING ROOM

unböring.com © Inter IKEA Systems B.V. 2002 Assembly required.

We open in a living room where we see a daughter and a mother having a conversation. MOTHER: Tell me what's wrong. DAUGHTER: I'm pregnant. MOTHER: Oh my. **The father enters the room.** FATHER: I knew it! I knew it! It's that creepy boyfriend of yours, isn't it. **(To the mother)** I told you this would happen. DAUGHTER: Dad, stop. MOTHER: So, it's my fault now. FATHER: Where do you think she learns this kind of behavior? Not from me. You're the one that smoked pot in college. **Just then an IKEA employee walks into frame.** IKEA MAN: So, what do you think? **The family quits arguing and looks at one another for a moment. We pull wide to reveal that we are actually at an IKEA store and in one of their displays.** MOTHER: I like it. We'll take it. **LOGO: IKEA. shop unböring.**

Gold Medal TV: 30 Seconds **Living Room**

ART DIRECTOR Paul Stechschulte **CREATIVE DIRECTOR** Alex Bogusky **ASSOCIATE CREATIVE DIRECTOR** Paul Keister **COPYWRITER** Tom Adams **AGENCY PRODUCER** Rupert Samuel **DIRECTOR** Wes Anderson **PRODUCTION** MOXIE **AGENCY** Crispin Porter + Bogusky **CLIENT** IKEA **COUNTRY** United States

IKEA wanted to get across the idea that their furniture is designed with real life in mind. One of the unique things about the IKEA stores is their built-in showcase rooms. These rooms feel so comfortable you can actually picture yourself living in one. Which led us to the thought of what would happen if shoppers became so comfortable in one of these rooms that real life peeked out.

SHEET METAL

Open on a man jogging backwards out of his driveway. Cut to scenes of people moving through areas where cars should be. A group of people shuffle toward a traffic light. A crowd of people moves down a street at night, all holding flashlights where car headlights might be. Hundreds of people hurry down a highway. VO: When we design our cars, we don't see sheet metal. We see the people who may one day drive them. Introducing the redesigned L, the VUE, and the all-new ION. It's different in a Saturn. SUPER: **It's different in a Saturn.**

Gold Medal TV: Over 30 Seconds **Sheet Metal**

ART DIRECTOR Mark Wenneker **CREATIVE DIRECTOR** Jamie Barrett **COPYWRITER** Jamie Barrett **AGENCY PRODUCER** James Horner **PRODUCER** Jay Veal
DIRECTOR Noam Murro **EDITOR** Avi Oron **PRODUCTION** Biscuit Filmworks **AGENCY** Goodby, Silverstein & Partners **CLIENT** Saturn **COUNTRY** United States

Saturn has always been a car company that puts people first. Ask someone who works there what Saturn is all about, and they'd probably use that very phrase. The idea behind "Sheet Metal" was to bring the notion of "people first" to life. Visually, not verbally. We asked ourselves, "If Saturn looks at cars and sees people, what exactly would that look like?" The first image that sprung to mind was the scene of the man jogging backwards out of his driveway. From there, it was pretty much a matter of taking every driving scenario we could think of and removing the car. We probably shot 25 different scenes. Maybe one day Saturn will buy a two-and-a-half minute spot and we'll get a chance to show the rest.

ANGRY CHICKEN

 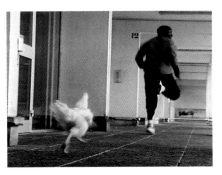 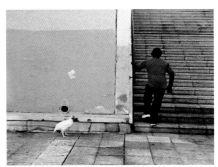

**SUPER: Le Poulet en Colere. SUBTITLE: Angry Chicken. Open on apartment buildings. A young man jumps off a balcony
and rolls into a patch of grass. A chicken flies out of the balcony. The chicken lands on grass as man begins to run. Man
runs over a wall.** VO: A young man is being chased by... **Chicken runs around wheel of motorcycle. Cut to chicken's eye view
reverse shot.** VO: ...A chicken. **Chicken runs past bike.** VO: The chicken is angry. **The man leaps and flies across an overpass
and lands on a platform. The chicken runs after him. The man slows into a walk on sidewalk, trying to blend in, hands in
pockets, head down.** VO: When a chicken in this neighborhood gets angry, it will chase you down. **The chicken is on the side-
walk. The chase picks up, the man jumps a hydrant. The man rappels off a wall onto another wall, runs across the tops of
the walls and leaps. He lands short and hoists himself up on the wall.** VO: There goes the young man. **He runs onto a plaza.
Cut to aerial shot of him in plaza. He looks around. Cut to chicken riding up an escalator.** VO: Okay, there is the chicken.
**The man spots the chicken and runs, jumping over the top of the escalator. He checks for the chicken in pursuit. The man
backs down stairs, but the chicken is waiting at bottom. He sees chicken and runs.** VO: No, he cannot fool the chicken. **He
runs and jumps into a balcony and through a room with kids on couch. He jumps over a driveway as a car comes out. The
man suspends himself between two walls, above the sidewalk.** VO: But wait. **The chicken is walking below the man, on the
sidewalk. The man walks up the wall backwards and eludes the chicken.** VO: Alright, he has fooled the chicken. **SUPER: Presto**

SCARY CAT

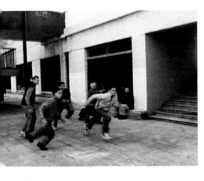 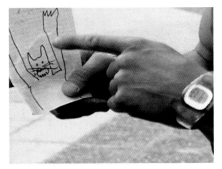 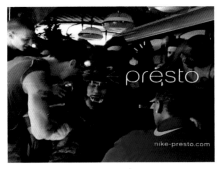

**SUPER: Le Chat Effrayant. SUBTITLE: The Scary Cat. Open on wide shot of apartment buildings. Several men are leaping
from the balconies.** VO: Their cat has escaped. **From behind a wall a man leaps over it, followed by another. They leap onto
the sidewalk and run into town. One of the men makes the scary cat gesture to an old lady, holding his hands in the air in a
menacing fashion.** VO: They must now... **The lady points and they run in that direction.** VO: ...Find the cat who scares people.
Garbage men scream. VO: With its large paws and razor-sharp teeth and claws. **The guys jump off another balcony. School
girls scream on playground. People turn in alarm, confusion. The men run by the garbage truck and rappel off a yellow wall.
They leap off a railing onto the roof of a building. They run away from camera across the gravel top of the building. One of
them pulls out a piece of paper to show to a girl. Cut to a close-up of paper with scary cat picture on it.** VO: Wait, he is over
there in the café. **She points. We see the back of a man in a big costume, seated. Cut to front view of scary cat at table, chat-
ting. The men surround the cat. SUPER: Presto**

YOUNG LOVE

SUPER: Premier Amour. SUBTITLE: Young Love. **Open on a modern apartment building. Cut to a man and woman standing on a balcony. She plays with her hair and pulls out, and drops, her barrette.** <u>VO</u>: He is in love. **She looks at him pleadingly. He runs around her and mounts balcony and jumps back and forth between the balconies, all the way to the ground. He picks up the barrette. He jumps up on lowest stairwell and makes his way back up. Cut to old man yelling. Young man arrives at top balcony and returns the barrette.** <u>VO</u>: Returning it to her just like that. **She smiles, holds out her handbag. He looks down, dismayed. She drops her handbag. He hurdles over balcony and starts his descent again. He lands on ground and grabs the purse. With purse in mouth, he again scales the wall, and jumps into her balcony.** <u>VO</u>: Returning it to her just like that. **He hands her the bag. The old man yells. Young man shrugs. She removes, and drops, her dentures. He looks at her in dismay. He refuses and steps away from her. The old man grins and laughs, placing the dentures in his mouth.**

MULTIPLE AWARDS

Gold Medal TV: Over 30 Seconds **Angry Chicken** | **Gold Medal** TV: Spots of Varying Length **Presto—Angry Chicken** ▪ **Scary Cat** ▪ **Young Love**
ART DIRECTOR Danielle Flagg **COPYWRITER** Mike Byrne **PRODUCER** Jennifer Smieja **AGENCY** Wieden + Kennedy **CLIENT** Nike **COUNTRY** United States

Our objective was to expand the idea of sport through the Presto brand. A tough job considering Nike is built on traditional sports—that's their expertise. But along came Presto. This young, eclectic, curious, physical child of Nike, who's had a bit of a hard time fitting in because it's not a jock and it's not one-dimensional. Presto sees something in all sport—movement. And it's not how you move. It's *why* you move. This is the spirit of Presto. Presto knows one thing to be self-evident—when people move, they are happy. It's just that simple. Our ads needed to be spontaneous and quirky to capture and depict this spirit. Thus each TV spot highlighted an official Parkour (French urban sport) move within the context of a simple story: problem (angry chicken) plus solution (zig-zag move up wall to escape chicken) leads to instant happiness, which is Presto.

LAMP

 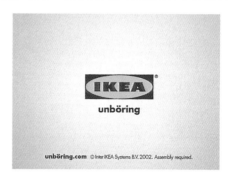

Open on a woman carrying a small adjustable lamp outside to the trash. MUSIC: Sad piano music begins. **From the lamp's point of view, we see the woman walk away and go back into the house. Cut to a close-up of the lamp. It is tilted upward as if it has just watched the woman walk away. Time passes and now it is night. It has started to rain on the little lamp. The light from a house window gently illuminates the scene. Cut again to the lamp's point of view and see the woman in the living room window of her warm home enjoying the light of a new IKEA lamp. She switches off the new lamp and lovingly touches it. Cut back to the cold, lonely, wet lamp on the curb with the trash. A quirky Swedish man enters frame and begins talking to camera.** SWEDISH MAN: Many of you feel bad for this lamp. This is because you are crazy. It has no feelings. And the new one is much better. **LOGO: IKEA. unböring.**

MOO COW

 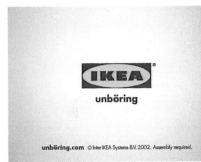

MUSIC: Opera music throughout. **Open on a couple playfully making out in the dining room. They naturally move on top of the dining room table. Cut to a close-up of the woman's face as she notices something in the corner of her eye. A little ceramic cow creamer lovingly staring up at her. With reckless abandom, she pushes everything off the table, including the little cow creamer.** MUSIC: The opera music grows more tragic. **The cow creamer goes crashing down to the hard wood floor, shattering to pieces. Cut to the couple now making out even more furiously. Cut to a broken piece of the cow creamer's face staring up at the couple. A single drop of milk oozes from its tiny little mouth. Cut to the outside of the house where a quirky Swedish man has just pulled up with his bicycle.** SWEDISH MAN: You feel sad for the little creamer? That is because you are crazy. Tacky items can easily be replaced with better IKEA items. **LOGO: IKEA. unböring.**

MULTIPLE AWARDS

Gold Medal TV: Over 30 Seconds **Lamp** | **Distinctive Merit** TV: 30 Seconds, Campaign **Lamp** • **Moo Cow**

ART DIRECTORS Steve Mapp, Mark Taylor **CREATIVE DIRECTOR** Alex Bogusky **ASSOCIATE CREATIVE DIRECTOR** Paul Keister **COPYWRITER** Ari Merkin
PRODUCER Rupert Samuel **DIRECTORS** Spike Jonze, Clay Williams **PRODUCTION** Morton Jankel Zander **AGENCY** Crispin Porter + Bogusky **CLIENT** IKEA
COUNTRY United States

BIRTHMARK/LOADED

Open on Greg and Leslie having dinner with the in-laws. GREG: This is just a wonderful home you have. I could really see myself living here with Leslie, when the two of you pass on. **Cut to wide shot of table. Everyone looks around in uncomfortable silence.** GREG: Not that you're going to pass on anytime soon, cause you both still look great...for your age. You both still have your motor skills, got your dexterity, you know, you can still function, you can still lift stuff, which is great! **Cut to more uncomfortable looks.** GREG: So, Leslie tells me you're loaded. **LOGO: Budweiser Millenium script logo. SUPER: TRUE. www.budweiser.com.**

BIRTHMARK/DINNER'S READY

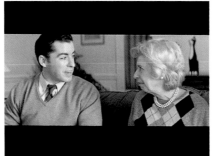

Open on Greg and Leslie sitting on the couch with Leslie's parents. MOM: Greg, this one you've gotta see. **Cut to Leslie, who looks embrassed.** LESLIE: Oh, Mom. MOM: That's Leslie's first bath. Look at her little tushy. **Greg looks at the picture.** GREG: That's...! That's her little tushy, alright. That cute little tushy that belongs to such an attractive, beautiful woman. 'Cause it's grown up into something else...a nice, big, round tushy, you know? **Cut to uncomfortable silence in the living room.** GREG: Have you seen it? Have you seen it lately? **LOGO: Budweiser Millenium script logo. SUPER: TRUE. www.budweiser.com. Cut back to Greg, still on the couch.** GREG: Is dinner coming soon, or...

BIRTHMARK

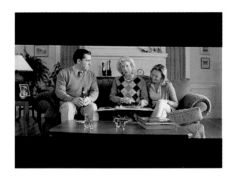 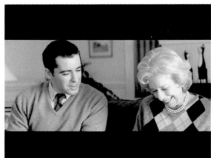

Open on Greg and Leslie sitting on the couch with Leslie's parents. MOM: Greg, this one you've gotta see. That's Leslie's first bath. Look at her little bottom! **Greg looks at the picture.** GREG: That's...! That's her little bottom, alright. Who would've thought that little bottom would've grown up into such a nice, big, full-body bottom, you know? **Cut to uncomfortable silence in the living room. Greg addresses Leslie's father.** GREG: She's grown into quite a woman. Just like your wife, your wife is very attractive. You know, I look at her and think, "I would date you." I wouldn't date her because you're dating her—you're married to her, actually... **More uncomfortable silence. LOGO: Budweiser Millenium script logo. SUPER: TRUE. www.budweiser.com. Cut back to Greg, still on the couch.**

Gold Medal Television and Cinema Crafts: Copywriting **Birthmark/Loaded** | **Silver Medal** Copywriting **Birthmark/Loaded** • **Birthmark/Dinner's Ready** • **Birthmark**

CHIEF CREATIVE OFFICER Bob Scarpelli **GROUP CREATIVE DIRECTOR** John Immesoete **CREATIVE DIRECTORS** Barry Burdiak, John Hayes **COPYWRITER** John Immesoete **GROUP EXECUTIVE PRODUCER** Greg Popp **PRODUCER** Gary Gassel **DIRECTORS** Kuntz & Maguire **PRODUCTION** Morton Jankel Zander **AGENCY** DDB Chicago **CLIENT** Anheuser-Busch/Budweiser **COUNTRY** United States

The "Birthmark" guy was a simple idea—what happens when an innocent guy meets his girlfriend's parents for the first time and surrenders a little too much information, i.e. that he's already seen their daughter quite naked. It got better when we found the lead actor Jason Jones, who plays Greg. He was a fantastic improv actor—so much so, that we could change the story every take and get almost a completely different spot. We cut seven different versions of the original spot.

AMS—VOICE MACHINE

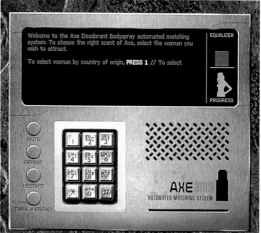

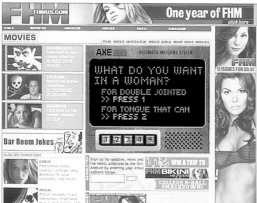

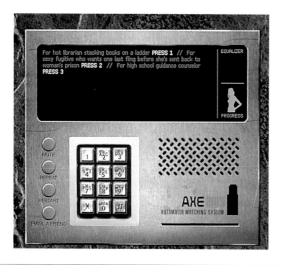

Gold Medal Interactive Advertising: Online Commercial **AMS—Voice Machine** | **Merit** Online Commercial, Campaign **AMS Campaign**

GROUP CREATIVE DIRECTOR William Gelner **EXECUTIVE CREATIVE DIRECTOR** Kevin McKeon **COPYWRITER** Peter Kain **DIGITAL DIRECTOR** Matt Campbell **FLASH ARTIST** Chris Franceze **AGENCY** Bartle Bogle Hegarty **CLIENT** Unilever—Axe **COUNTRY** United States

Earlier in the year, we created some really compelling radio for the brand that was run locally supporting a promotion. It was based on the AMS idea, and everyone absolutely loved it. While we didn't have a larger radio buy in our plan, the client really wanted us to develop a way that we could get similar work in front of more consumers—without breaking the bank. This was right at the time the interactive viral campaign was running on all cylinders, and driving a ton of traffic to the Web site. So we developed the AMS, and re-wrote the radio copy to be a bit more racy. We created some banners and bought very limited support, just to give it a jump start. And it has performed very strongly for us ever since.

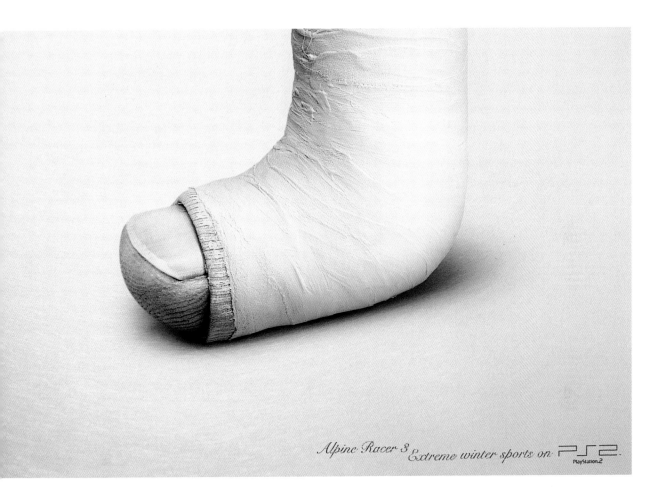

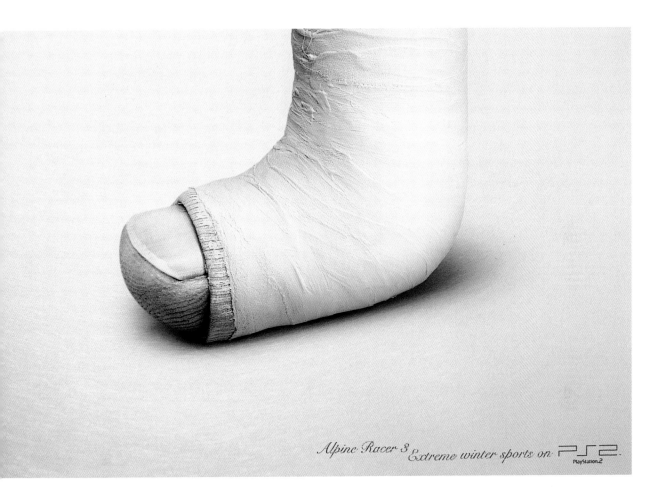

Gold Medal Posters: Point-of-Purchase **Broken Thumb** | **Silver Medal** Trade Magazine: Spread **Broken Thumb**

ART DIRECTORS Stephen Cafiero, Jorge Carreño **COPYWRITER** Vincent Cobelle **PHOTOGRAPHER** Olivier Reindorf **AGENCY** TBWA\Paris **CLIENT** Sony Playstation
COUNTRY France

SQUARES

MUSIC: Up and throughout, building to a crescendo. **Open on a square clock. Cut to square electrical outlet. Cut to various other squares. An apartment building. A box. A slice of processed cheese. A bar code. A fish tank. A ceiling tile. A fluorescent light. A window. A doorway. An overhead shot of a telephone booth. A slice of toast. A computer disk. A picture frame. A computer key. A filing cabinet. The final cut is of a round Volkswagen New Beetle. SUPER: Drivers Wanted.**

BUBBLE BOY

MUSIC: ELO's "Mr. Blue Sky." **Story: This is a day, a week, a year in the life of Bill Briggs, a young man literally trapped inside the bubble of corporate America. Glass walls, cubicles and disillusion block his entrance to the outside world. Until the day our hero spies a Volkswagen New Beetle Convertible at the very moment its roof is retracted, letting the outside in. The bubble is burst. A glimmer of hope emerges on Bubble Boy's face as the New Beetle Convertible pulls away leaving him alone but enlightened. SUPER: The New Beetle Convertible. Coming soon. SUPER: Drivers wanted.**

CHAIN REACTION

MUSIC: John Dragonetti composition. **Story: A sunny afternoon in San Francisco. A woman walking down the street spies something, causing her to smile. Her joy becomes contagious and spreads down the street from person to person in the form of friendly gestures and happy accidents. Suddenly, the action freezes and reverses through all the different happy people until returning to our original girl. The camera pulls out, revealing the catalyst for this chain reaction of smiles: a Volkswagen New Beetle Convertible. The action rolls forward again.** VO: The New Beetle Convertible. One good thing leads to another. **SUPER: Drivers Wanted.**

MULTIPLE AWARDS

Silver Medal TV: 30 Seconds **Squares** | **Silver Medal** TV: Spots of Varying Length, Campaign **Squares • Bubble Boy • Chain Reaction** | **Distinctive Merit** Cinema: Over 30 Seconds **Bubble Boy**

ART DIRECTOR Don Shelford **ART DIRECTOR (SQUARES)** Kevin Dailor **CHIEF CREATIVE OFFICER** Ron Lawner **GROUP CREATIVE DIRECTOR** Alan Pafenbach **COPYWRITER (BUBBLE BOY, CHAIN REACTION)** Joe Fallon **COPYWRITER (CHAIN REACTION)** Susan Ebling Corbo **COPYWRITER (SQUARES)** Tim Gillingham **AGENCY PRODUCER (SQUARES)** Keith Dezen **PRODUCER (BUBBLE BOY, CHAIN REACTION)** Bill Goodell **DIRECTOR (BUBBLE BOY, CHAIN REACTION)** Mike Mills **DIRECTOR (SQUARES)** Malcolm Venville **PRODUCTION (BUBBLE BOY, CHAIN REACTION)** The Directors Bureau **PRODUCTION (SQUARES)** Anonymous Content **AGENCY** Arnold Worldwide **CLIENT** Volkswagen of America **COUNTRY** United States

HAPPY DOG

Open on a big, lovable furry dog drinking water rapidly. The shot widens to reveal that he is drinking out of the toilet. After a couple of seconds, we hear a key in a door in the distance. The dog pauses and looks up. The front door opens. Mom and son enter house. The dog scrambles happily down the stairs to greet the mom. The mom kneels down and the dog licks her eagerly and sloppily all over her face and neck as the woman laughs and pets the dog. WOMAN: Hi, boy! **SUPER: You're not as clean as you think.** Cut to bar of Dial soap. SFX: Shower sound.

COPIER ROOM

Open on the interior of the copy room in an office. An office party is going on outside the door. A guy ducks into the copy room, and looks around mischievously. He lowers his pants, jumps up on the copy machine and photocopies his butt. He jumps down and retrieves the copy, then quickly exits the room. After a brief pause, a different guy enters the copy room, looks around to make sure no one is watching, and smushes his face down on the glass and makes a copy of it. SUPER: You're not as clean as you think. Cut to bar of Dial soap. SFX: Shower sound.

SAUNA

Open on the locker room of a health club. A towel is hanging on a hook next to the door of the sauna. A sweaty man dressed in workout clothes enters. He grabs the towel and proceeds to thoroughly wipe off his sweaty face and body with it. He then hangs the towel back on the hook and exits. A brief pause, then a different man exits the sauna, grabs the used towel, and presses his face into it. SUPER: You're not as clean as you think. Cut to bar of Dial soap. SFX: Shower sound.

MULTIPLE AWARDS

Silver Medal TV: 30 Seconds, Campaign **Happy Dog** • **Copier Room** • **Sauna** | **Distinctive Merit** TV: 30 Seconds **Copier Room** | **Distinctive Merit** TV: 30 Seconds **Happy Dog**

ART DIRECTOR Demian Fore **GROUP CREATIVE DIRECTORS** Tom Gilmore, Rich Tlapek **COPYWRITERS** Carole Hurst, Rich Tlapek **AGENCY PRODUCER** Khrisana Edwards **DIRECTOR** Daniel Kleinman **EDITOR** Adam Pertofsky **EDITING** Rock Paper Scissors **PRODUCTION** Ritts Hayden **AGENCY** GSD&M Advertising **CLIENT** Dial **COUNTRY** United States

Dial's objective was to increase the relevancy of the antibacterial protection their soap provides. In focus groups, we found most people felt they were "already clean enough." Our solution was to develop a campaign that reminded people it's a dirty world, and you aren't always as clean as you think. The real situations make the spots both relatable and effective.

IRON

SUPER: Game 1. Open on a guy at home, ironing his shirt while watching a hockey game. He accidentally bumps his arm on the hot iron. His flesh sticks to the iron. He pulls his arm away without showing any pain and turns back to the game. SUPER: Game 15. Cut to the same guy edging his lawn. A mad dog is biting his leg. He barely notices. SUPER: Game 61. Cut to the same guy in a car park, loading groceries in to the back of his car. A van unknowingly reverses into his car, pinning his legs between the two bumper bars. The van drives away quickly. The guy dusts his pants and continues with his groceries. SUPER: The more hockey you watch the tougher you get. SUPER: Florida Panthers vs. Avalanche, Friday 7 p.m. NHL on FOX SPORTS NET.

NOSE HAIR

 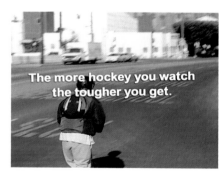

SUPER: Game 1. Cut to a guy plucking out a stubborn nose hair. His eyes water a little, but he barely reacts. In the background there's a TV with hockey on. SUPER: Game 16. Cut to the same guy kneeling in front of a fireplace reading the newspaper sports section. A burning log rolls out of the fireplace. Without hesitating, he picks up the smoldering log with his bare hand, and places it back in the fireplace. SUPER: Game 45. Cut to a parked truck on a busy street. The same guy zips past on a little gas-powered scooter. The truck driver opens the door. The guy on the scooter slams into it. He gets up off the ground, dusts himself off and continues on his journey. SUPER: The more hockey you watch the tougher you get. SUPER: Red Wings vs. Stars, Friday 7 p.m. NHL on FOX SPORTS NET.

DUMPSTER

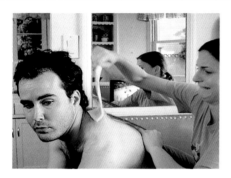 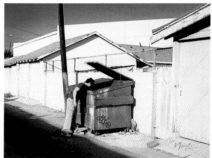 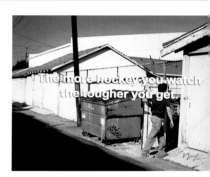

SUPER: Game 1. Cut to a woman pulling a strip of hot wax off her boyfriend's hairy back. This leaves an obvious empty section with no hair. She is shocked. He doesn't even wince. In the background there's a TV with hockey on. SUPER: Game 17. Cut to the same guy playing foosball in a friend's game room. A stray dart hits the guy in the neck and sticks. He looks over his shoulder to see who lost their dart. SUPER: Game 56. Cut to the same guy in an alley, dropping a bag of trash into a dumpster. This causes the dumpster's heavy metal lid to slam down on his head. He pulls his head out and calmly walks away. SUPER: The more hockey you watch the tougher you get. SUPER: Bluejackets vs. Avalanche, Friday 7 p.m. NHL on FOX SPORTS NET.

MULTIPLE AWARDS

Silver Medal TV: 30 Seconds **Dumpster** | **Silver Medal** TV: 30 Seconds **Iron** | **Silver Medal** TV: 30 Seconds, Campaign **Iron** • **Nose Hair** • **Dumpster** | **Merit** TV: 30 Seconds **Nose Hair**

ART DIRECTORS Eric King, Ben Nott **EXECUTIVE CREATIVE DIRECTOR** Chuck McBride **CREATIVE DIRECTOR** Todd Grant **COPYWRITERS** Eric King, Susan Treacy **EXECUTIVE PRODUCER** Richard O'Neill **DIRECTOR** Rocky Morton **EDITOR** Tom Muldoon **SOUND DESIGN** Nomad **PRODUCTION** Morton Jankel Zander **ACCOUNT SUPERVISOR** Kelly Clifford **AGENCY** TBWA\Chiat\Day—San Francisco **CLIENT** Fox Sports **COUNTRY** United States

Ice hockey is considered one of the toughest sports. Ice hockey's fans are considered tough, too. This campaign portrays ice hockey fans not reacting to various degrees of pain. The amount of pain a fan can withstand is proportional to the amount of hockey they have watched throughout the season. The thought is: "The more hockey you watch, the tougher you get." The end title of each commercial reminds fans which teams are playing each night on the Fox channel. Each commercial is tailored to the fans of the region in which the commercial is appearing.

SQUEEZE TOY

Open on a man opening the car door for his date. She smiles and gets in. He walks to the driver's side and gets in. Unfortunately, as he's easing into the seat, we hear a loud fart noise. SUPER: Mello Yello asks: How would you stay smooth? VO: Mello Yello asks: "How would you stay smooth?" SUPER: a. MAN: Hang on, I think I can do better than that. **Man rips another one. SUPER: b.** MAN (CRYING): This ruins everything! SUPER: c. Man pulls a squeeze toy out from underneath him. MAN: One of the kids from the orphanage must have left it. **Cut to woman, who is very impressed. SUPER: MelloYello.com. Smooth. Very Smooth.** VO: Mello Yello. Smooth. Very smooth.

Silver Medal TV: 30 Seconds **Squeeze Toy**

ART DIRECTORS Howard Jordan, Neil Riley **CREATIVE DIRECTOR** Izzy DeBellis **COPYWRITERS** Howard Jordan, Neil Riley **AGENCY** Frank Todaro **CLIENT** Mello Yello **COUNTRY** United States

SCURVY

 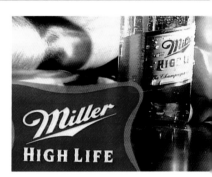

Open on extreme close-up of a half-full beer bottle with a lime in it. <u>VO:</u> Your British sailor circa 1740 knew that citrus fruit could prevent scurvy. **Cut to close-up of a man's head. Back away to shot of man's head with bottle in foreground.** <u>VO:</u> Now that's gotta be the only conceivable reason that a man would put a lime in his beer. **Cut to close-up of bottle with lime. Same shot pans left to bar as bottle is put down. Cut to blurry shot of part of head in left corner.** <u>VO:</u> Then again, how bad can scurvy be? **Cut to close-up hand holding a beer with no lime in it.** <u>VO:</u> A certain amount of risk goes hand in hand with living the high life. **LOGO: Miller High Life.**

Silver Medal TV: 30 Seconds **Scurvy**

ART DIRECTOR Jeff Williams **COPYWRITER** Jed Alger **PRODUCER** Jeff Selis **AGENCY** Wieden + Kennedy **CLIENT** Miller Brewing Company **COUNTRY** United States

AMNESIA

CEO, Dan and second executive walk down hallway. CEO: So, Dan, do we have everything we need for this meeting? **Dan points to head.** DAN: It's all right here, sir. **Turning the corner, Dan walks directly into a file cabinet drawer, blacking out.** VO: Is your data-backup as reliable as it should be? **CEO walks into meeting and sits down with other executives.** SECOND EXECUTIVE: Don't worry, sir. He told me everything. **Second executive slips and hits chin on table.** VO: Ours is. BrightStor™ Storage Software. **SUPER: BrightStor™ Storage Software.** VO: From Computer Associates. **LOGO: Computer Associates.**

Silver Medal TV: 30 Seconds **Amnesia**

ART DIRECTOR Ahmer Kalam **JUNIOR ART DIRECTOR** Jeremy Lamin **CREATIVE DIRECTOR** Ann Hayden **COPYWRITER** Rachel Howald
JUNIOR COPYWRITER Jason Hunter **AGENCY** Young & Rubicam—NY **CLIENT** Computer Associates **COUNTRY** United States

DIGITAL CRIME FIGHTING

Three thieves are discussing their next heist after hours inside a Parisian restaurant. Suddenly, a computer arrow (exactly like the one on your computer) grabs one of the crooks by the shirt and drags him out through the restaurant doors. The arrow continues to drag the crook down the street, around a corner and then throws him into the back of a police van, where he belongs. <u>VO:</u> Using hp technology to get information quickly and easily, the world's leading police forces now fight crime digitally. **SUPER: Crime fighters + hp = everything is possible.**

Silver Medal TV: Over 30 Seconds **Digital Crime Fighting**

ART DIRECTOR Joel Clement **CREATIVE DIRECTORS** Steve Luker, Steve Simpson **COPYWRITER** Matt Elhardt **AGENCY PRODUCER** Colleen Wellman **PRODUCERS** Nellie Jordan, Clarissa Troop **DIRECTOR** Frederik Bond **EDITOR** Angus Wall **PRODUCTION** Morton Jankel Zander **AGENCY** Goodby, Silverstein & Partners **CLIENT** Hewlett-Packard **COUNTRY** United States

This entry was one of the launch commercials demonstrating how hp is helping the world's biggest companies, governments and organizations with cutting-edge technology. "Digital Crime Fighting" is a dramatic visual metaphor that describes how police forces all around the world use technology behind the scenes to help locate and capture evil-doers.

BEFORE

Open on boy's face. <u>SFX:</u> Music under, throughout. **Cut to Alfonso Soriano. Cut to Walter Davis spitting. Cut to female swimmer spitting. Cut to Randy Johnson on mound. Cut to Felix Sanchez at starting block. Cut to track shoe. Cut to male swimmer stretching. Cut to Nikolai Khabibulin stretching in front of net. Cut to Jason Giambi on deck. Cut to Lleyton Hewitt playing with the strings on his racket. Cut to sumo wrestler's hand throwing rice. Cut to Jen Holdren's hand. Cut to Gail Devers jumping behind hurdles. Cut to female boxer in corner. Cut to Vince Carter praying. Cut to Walter Davis practicing approach. Cut to Alfonso Soriano's batting glove. Cut to Adam Nelson's hand spinning shot put. Cut to male handball player stretching jaw. Cut to Marion Jones stretching jaw. Cut to Lisa Leslie putting in mouthpiece. Cut to cross-country race starting line. Cut to youth soccer penalty kick. Cut to Marshall Faulk. Cut to Adam Nelson. Cut to Shox D product shot. Cut to male arm wrestler. Cut to street basketball players. Cut to Cary Kolat preparing to start wrestling match. Cut to Hicham el-Gourreuj. Cut to Jen Holdren spinning ball. Cut to cross-country start line. Cut to Jason Kidd kissing his hand prior to free throw. Cut to Nikolai Khabibulin's goalie mask. Cut to Lance Armstrong at the starting gate. Cut to male high diver. Cut to kids' neighborhood soccer game. Cut to kid balancing on dock. Cut to female archer. Cut to Alfonso Soriano awaiting pitch. Cut to male street performer/gymnast. Cut to Randy Johnson's eyes. Cut to female diver's eyes between her legs. Cut to stickball bat hands. Cut to Stacy Dragila raising pole. Cut to Jason Giambi's eyes. Cut to Marion Jones's eyes. Cut to drag strip starting lights. Cut to Walter Davis beginning approach. Cut to backstroke swimmers preparing to start.** SUPER: Just Do It. LOGO: Nike Swoosh.

Silver Medal TV: Over 30 Seconds **Before**

ART DIRECTOR Storm Tharp **COPYWRITER** Jonathan Cude **PRODUCER** Henry Lu **AGENCY** Wieden + Kennedy **CLIENT** Nike **COUNTRY** United States

The challenge was to create an execution that celebrated the art of competition as one of the core elements of sport, no matter the level. Past creative has showcased athletes and sport (i.e. physical movement), yet there are always aspects of sport we feel we still have not touched upon. In this case it was those critical, crazy moments before competition. The time right before an athlete attempts to do something amazing, there are several moments when their hopes, fears, dreams, doubts, anger, frustration, contemplation and desire are evident. On their faces and in their eyes. In their nervous rituals and superstitions. In the way their bodies coil, about to explode. This spot captured this energy and the emotion of competition in a most unexpected way, by showcasing athletes of all forms, focusing on the moment before the start of competition.

BOX OF POISON

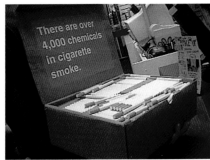

Open interior of independent mail service company. Two teens with hidden cameras walk in carrying a big brown box, and approach the counter. TEEN 1: Good morning, I'd like to ship this arsenic- and cyanide-spreading mechanism. **Clerk 1 points to the manager for help.** MANAGER: Arsenic and cyanide? TEEN 1: Right. TEEN 2: Yup. MANAGER: You're going to ship that? TEEN 1: Right, but it's packaged pretty good. It's not like it's leaking out. MANAGER: I mean, it's hazardous materials. CLERK 1: It's illegal, isn't it? MANAGER: Yeah, I mean that's just ridiculous. TEEN 1: I'm not trying to do anything illegal. MANAGER: Spreading arsenic and cyanide isn't illegal? **Quick cuts to on-lookers.** CLERK 1: I don't think that they're going to let you ship it. TEEN 1: I just want to ship these cigarettes. **Teen opens box. Teen 1 reveals that the big brown box is filled with cigarettes. Cut to a close-up shot of a sticker on the box reading: "There are over 4,000 chemicals in cigarette smoke." SUPER: Asterisks appear beside the clerk and the people waiting in line. SUPER: ☆ Knowledge is contagious. Infect truth.**

Silver Medal TV: Public Service/Nonprofit **Box of Poison**

ART DIRECTOR Amee Shah **GROUP CREATIVE DIRECTORS** Alex Bogusky, Pete Favat **EXECUTIVE CREATIVE DIRECTOR** Ron Lawner **CREATIVE DIRECTORS** Roger Baldacci, Ari Merkin **COPYWRITER** Scott Linnen **PRODUCER** Spring Clinton-Smith **DIRECTOR** Baker Smith **EDITOR** Carlos Arias **EDITING** Final Cut **PRODUCTION** harvest **AGENCIES** Arnold Worldwide, Crispin Porter + Bogusky **CLIENT** American Legacy Foundation **COUNTRY** United States

When it comes to Truth, the goal is always the same—to simply tell people the truth about the tobacco industry. People know cigarettes are bad for you. But most probably don't know exactly what kind of lethal potpourri of toxins really ends up in every puff. The tobacco companies could eliminate a lot of them, but choose not to because it's cheaper to just do nothing and then lie about it. When this spot aired, the anthrax mail scare of 2002 was still very much on people's minds. So in the end, maybe that insanity will help save a few lives.

SQUADRON

Open on a plane taking off pulling a banner as a woman looks on. SUPER: sponsored by truth. ©2001 truth. The plane flies over a beach. The beach is covered with people sunbathing and throwing a Frisbee around. The people look up to read the banners. Numerous planes appear in the sky with banners flying behind them. Each plane that passes overhead has three or four ingredients on its banner. BANNER #1: What's in cigarette smoke? BANNER #2: Arsenic, Carbon Monoxide, Ammonia. BANNER #3: Formaldehyde, Styrene, Lead. BANNER #4: Polonium 210, Cadmium, Cyanide. Overhead shot of beach populated with people as asterisks slowly pop up on their heads. The asterisks designate that the people have just been "infected" with the truth. SUPER: ✳ Knowledge is contagious. Infect truth. infect-truth.com

BABY ALONE

We see a teen girl pushing a baby carriage toward a busy street corner. She runs away, abandoning the carriage. Cut to a shot of baby carriage alone, baby still crying inside. People go up to the carriage and peer inside. Cut to shot of inside carriage. We see a baby doll holding an orange sign that reads: "Every year, cigarettes leave 12,000 kids motherless." An asterisk appears over the people who have just read the sign; they have been "infected" with knowledge. SUPER: ✳ Knowledge is contagious. Infect truth. infect-truth.com.

DOOR HANGER

Open on a white van pulling up outside a hotel lobby. TRUTH KIDS: Here we go. **See Truth Kids walking through lobby hotel towards elevator. Kids get in elevator and press all the floors. Each Truth Kid gets off a different floor and starts hanging door hangers on each guest's door. Cut to a close-up of a door hanger which reads: "Disturbing—everyday tobacco products kill enough people to fill this hotel." Cut to a room service guy reading the door hanger message.** SUPER: ✳ Knowledge is contageous. Infect Truth. infect-truth.com.

MULTIPLE AWARDS

Silver Medal TV: Public Service/Nonprofit **Squadron** | **Distinctive Merit** TV: Public Service/Nonprofit **Baby Alone** | **Distinctive Merit** TV: Public Service/Nonprofit, Campaign **Baby Alone** ▪ **Squadron** ▪ **Door Hanger**

ART DIRECTORS Rob Baird, Tony Calcao, Mike Martin, Ryan O'Rourke **CHIEF CREATIVE OFFICER** Ron Lawner **GROUP CREATIVE DIRECTORS** Alex Bogusky, Pete Favat **CREATIVE DIRECTORS** Roger Baldacci, Ari Merkin **COPYWRITERS** Roger Baldacci, Steve O'Connell, Rob Strasberg **PRODUCERS** Holly Archiband, Spring Clinton-Smith, Rupert Samuel **DIRECTOR** Baker Smith **PRODUCTION** Chelsea Pictures, Harvest Films **AGENCIES** Arnold Worldwide, Crispin Porter + Bogusky **CLIENT** American Legacy Foundation **COUNTRY** United States

The "Squadron" spot is part of the "infect truth" campaign. Our research showed that many teens believed that cigarettes were little more than tobacco rolled in paper. So the goal of this specific campaign was to counteract this fallacy by delivering powerful facts in provocative ways to reach the masses. The idea is that "knowledge is contagious" and that if teens learned something interesting, perhaps they would spread the word "virally" to their friends. With "Squadron," we infected an entire beach with knowledge by flying planes with banners detailing the toxic ingredients of cigarette smoke. Since there are over 4,000 ingredients, we needed a lot of planes.

DEVIL'S ISLAND

A prisoner finds himself onboard a ship bound for Devil's Island. But fortune smiles, as during the voyage a bottle of Stella Artois comes his way. We watch as he continually tries to open the precious beer without being seen by his fellow prisoners. Finally, he opts to strike a guard, knowing full well his punishment will be the bliss of solitary confinement. SUPER: Stella Artois. Reassuringly expensive.

MULTIPLE AWARDS

Silver Medal Cinema: Over 30 Seconds **Devil's Island** | **Distinctive Merit** TV: Over 30 Seconds **Devil's Island**

ART DIRECTOR Vince Squibb **COPYWRITER** Vince Squibb **DIRECTOR** Jonathan Glazer **PRODUCTION** Academy **AGENCY** LOWE **CLIENT** Interbrew UK—Stella Artois **COUNTRY** United Kingdom

The ad is the latest installment in the highly successful "Reassuringly Expensive" cinema and TV campaign that has been running since 1992. As ever, the challenge was in creating a film that was true to the campaign, yet also fresh and surprising. The result is an execution that takes the traditional themes of the campaign out of their provincial habitat, playing them out on a bigger scale than ever before.

WILD HORSES

Open on a pastoral scene. We hear the sound of a herd of wild horses running. Cut to see that it is actually a "herd" of people running over the hills. Close-up of runners. Runners split into two groups to go through trees. Cut to individual shots of runners. LOGO: Nike Apparel. SUPER: made to move

Silver Medal Television and Cinema Crafts: Cinematography **Wild Horses** | **Silver Medal** Television and Cinema Crafts: Editing **Wild Horses** | **Distinctive Merit** TV: Over 30 Seconds **Wild Horses**

ART DIRECTOR Monica Taylor **AGENCY CREATIVE DIRECTOR** Hal Curtis **COPYWRITER** Mike Byrne **AGENCY EXECUTIVE PRODUCER** Ben Grylewicz **EXECUTIVE PRODUCERS** Fabyan Daw (GDT), Kerstin Emhoff (HSI) **AGENCY PRODUCER** Andrew Loevenguth **DIRECTOR** Gerard De Thame **DIRECTOR OF PHOTOGRAPHY** Fraser Taggert **EDITORS** Rick Lawley, Neil Smith **EDITING** The White House **PRODUCTION** GDT Films, HSI Productions **AGENCY** Wieden + Kennedy **CLIENT** Nike **COUNTRY** United States

The challenge was to communicate the fact that Nike apparel is made to move. The obstacle was making the apparel look great while showing it in an authentic athletic movement—something that would clearly demonstrate the fact that it was made to move. The result was a creative idea that focused on the beauty and power of the body while engaged in athletic movement. In doing this, we were able to show the apparel in a fresh and dynamic way and communicate our desired objective. The "Wild Horses" spot opens to the sound of wild horses running through the hills of northern California. As the stampede rounds a corner, we reveal that the "wild horses" are actually a pack of runners assembled in a herd. Everything about the runners is designed to resemble the look and feel of wild horses, from their formation to their running styles and the distinct sound of their feet hitting the ground. In the end, we see the pure power and beauty of running in a way that hasn't been shown before.

MR. ALL YOU CAN EAT BUFFET INVENTOR

ANNOUNCER: Bud Light presents—Real Men of Genius. SINGER: Real men of genius! ANNOUNCER: Today we salute you, Mr. All You Can Eat Buffet Inventor. SINGER: Mr. All You Can Eat Buffet Inventor! ANNOUNCER: You've given us the real American dream—a tray, 15 feet of food and a little sign that says, "Go nuts, buddy!" SINGER: Pinch me, I'm dreaming! ANNOUNCER: Pushing side dish innovation to its limits, you offer creamed everything and 400 flavors of gelatin. SINGER: Feeding frenzy! ANNOUNCER: If there's beef, you'll chip it. If there's chicken, you'll fry it. And if there's gravy, well, then everything's going to be OK. SINGER: Thank God for the gravy! ANNOUNCER: So crack open an ice cold Bud Light, buffet boy. You know the way to a man's heart, and a few hundred tasty ways to challenge it. SINGER: Mr. All You Can Eat Buffet Inventor! ANNOUNCER: Bud Light Beer. Anheuser-Busch. St. Louis Missouri.

MR. GIANT INFLATABLE PINK GORILLA MAKER

ANNOUNCER: Bud Light presents—Real Men of Genius. SINGER: Real men of genius! ANNOUNCER: Today we salute you, Mr. Giant Inflatable Pink Gorilla Maker. SINGER: Mr. Giant Inflatable Pink Gorilla Maker! ANNOUNCER: The automotive industry's most convincing marketing tool: the giant, gas-filled, pink gorilla. SINGER: Such a big monkey! ANNOUNCER: Factory rebates, 0% financing—poppycock! Nothing sells cars like a helium-happy primate. SINGER: You said it, brother! ANNOUNCER: Why a gorilla? Because who'd buy a car from a dealer with a giant inflatable hamster. SINGER: Not gonna buy it! ANNOUNCER: So crack open an ice cold Bud Light, oh, King of the Automotive Jungle. When we say you're the greatest, we're not just blowing hot air. SINGER: Mr. Giant Inflatable Pink Gorilla Maker! ANNOUNCER: Bud Light Beer. Anheuser-Busch. St. Louis, Missouri.

MR. USED CAR LOT AUTO SALESMAN

ANNOUNCER: Bud Light presents—Real Men of Genius. SINGER: Real men of genius! ANNOUNCER: Today we salute you, Mr. Used Car Lot Auto Salesman. SINGER: Mr. Used Car Lot Auto Salesman! ANNOUNCER: Slicked-back hair, a sharkskin suit, alligator boots—you cultivate a look that oozes "trust me." SINGER: I think that I can trust you! ANNOUNCER: You stand behind every car you sell, because if you stood in front and the brakes failed, you'd be crushed. SINGER: You better watch out now! ANNOUNCER: Oil leak? What oil leak? That puddle under the car is just sweat from all that horsepower. SINGER: Let the horses out now! ANNOUNCER: So crack open an ice cold Bud Light, Mr. Peddler of the Sheet Metal. When life hands you lemons, you sell them. SINGER: Mr. Used Car Lot Auto Salesman! ANNOUNCER: Bud Light Beer. Anheuser-Busch. St. Louis, Missouri.

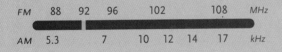

FM	88	92	96	102	108	MHz
AM	5.3		7	10 12 14	17	kHz

Silver Medal Radio: Over 30 Seconds **Genius—Mr. All You Can Eat Buffet Inventor** | **Silver Medal** Radio: Over 30 Seconds, Campaign **Genius—Mr. All You Can Eat Buffet Inventor** ▪ **Mr. Giant Inflatable Pink Gorilla Maker** ▪ **Mr. Used Car Lot Auto Salesman** | **Merit** Radio: Over 30 Seconds **Genius—Mr. Giant Inflatable Pink Gorilla Maker**

CHIEF CREATIVE OFFICER Bob Scarpelli **GROUP CREATIVE DIRECTOR** John Immesoete **CREATIVE DIRECTORS** Bill Cimino, Mark Gross **COPYWRITERS** Bill Cimino, Mark Gross, John Immesoete, Bob Winter **EXECUTIVE PRODUCER** Sam Pillsbury **PRODUCER** Sally Naylor **MUSIC** Sandy Turano **SOUND ENGINEER** Dave Gerbosi **AGENCY** DDB Chicago **CLIENT** Anheuser-Busch/Bud Light **COUNTRY** United States

The Genius campaign is essentially a parody of old classic American beer advertising—proud, chest-pumping salutes to the ordinary hard-working man. This campaign turned that on its ear and allowed us to laugh at all the ridiculous things we Americans do.

MR. BEACH METAL DETECTOR GUY

ANNOUNCER: Bud Light presents—Real Men of Genius. SINGER: Real men of genius! AN-NOUNCER: Today we salute you, Mr. Beach Metal Detector Guy. SINGER: Mr. Beach Metal Detec-tor Guy! ANNOUNCER: Some seek their fortune on the stock market, others in real estate. But you, you look for loose change in the sand. SINGER: Hitting the jackpot! ANNOUNCER: Armed with a five-foot geiger counter and the world's largest set of earphones, you live your life with a simple code of honor—finders keepers, losers weepers. SINGER: Finders keepers! ANNOUNCER: Sure people mock you, but he who holds 92 cents, a gold-plated earring and a steel-toed boot gets the last laugh. SINGER: Who's laughing now? ANNOUNCER: So crack open an ice cold Bud Light, oh, Sultan of the Sand. We'd give you a medal, but you probably already found one. SINGER: Mr. Beach Metal Detector Guy! ANNOUNCER: Bud Light beer. Anheuser-Busch. St. Louis, Missouri.

Silver Medal Radio: Over 30 Seconds **Genius—Mr. Beach Metal Detector Guy**

CHIEF CREATIVE OFFICER Bob Scarpelli **GROUP CREATIVE DIRECTOR** John Immesoete **CREATIVE DIRECTORS** Bill Cimino, Mark Gross **COPYWRITERS** Bill Cimino, Mark Gross **PRODUCER** Sally Naylor **MUSIC** Sandy Turano **SOUND ENGINEER** Dave Gerbosi **AGENCY** DDB Chicago **CLIENT** Anheuser-Busch/Bud Light **COUNTRY** United States

MR. FANCY COFFEE SHOP COFFEE POURER

ANNOUNCER: Bud Light presents—Real Men of Genius. SINGER: Real men of genius! AN-NOUNCER: Today we salute you, Mr. Fancy Coffee Shop Coffee Pourer. SINGER: Mr. Fancy Coffee Shop Coffee Pourer! ANNOUNCER: What do you do with a Master's degree in Art History? You get a nose ring and pour coffee for a living. SINGER: Pour it on now! ANNOUNCER: Why is it called a latte? Maybe because it costs a lot-ay and it takes a lot-ay time to make. SINGER: Whole lot o' latte! ANNOUNCER: Someone ordered a cappuccino? Step aside, let the man who works the milk foamer take over. SINGER: Step aside! ANNOUNCER: So crack open an ice cold Bud Light, Guru of the Ground Roast, because it's not the caffeine that gives us the buzz, it's you. SINGER: Mr. Fancy Coffee Shop Coffee Pourer! ANNOUNCER: Bud Light Beer. Anheuser-Busch. St. Louis, Missouri.

| FM | 88 | 92 | 96 | 102 | | 108 | MHz |
| AM | 5.3 | | 7 | 10 | 12 | 14 | 17 | kHz |

Silver Medal Radio: Over 30 Seconds **Genius—Mr. Fancy Coffee Shop Coffee Pourer**

CHIEF CREATIVE OFFICER Bob Scarpelli GROUP CREATIVE DIRECTOR John Immesoete COPYWRITER John Immesoete PRODUCER Sally Naylor MUSIC Sandy Turano SOUND ENGINEER Dave Gerbosi AGENCY DDB Chicago CLIENT Anheuser-Busch/Bud Light COUNTRY United States

NIKE PRESTO

Silver Medal Interactive Advertising: Web Site **Nike Presto**

ART DIRECTOR Kris Kiger **CREATIVE DIRECTOR** Nick Law **DESIGNERS** David Alcorn, Johanna Langford, David Morrow, Len Small, Garry Waller **COPYWRITERS** Jason Marks, Jean Railla **FLASH PROGRAMMER** Noel Billig **PROGRAMMERS** John Jones, Charoonkit Thahong, Stan Wiechers **VIDEO EDITOR** Stephen Barnwell **EXECUTIVE PRODUCER** Kip Voytek **PRODUCER** Julia Clark **AGENCY** R/GA **CLIENT** Nike **COUNTRY** United States

Presto is not burdened by the traditional definitions and boundaries of vertical sport. Born of running, but free of restrictions, Presto is about unexpected movement, a curiosity about life and culture and experiences that surprise the senses. The Nike Presto brand and Web site are a celebration of movement— movement that is outside the traditional realm. The content on Nike-presto.com originates from a group of unconventional artists who transcend borders. Their mediums vary widely but they are all loosely united by their nontraditional approach to art, which includes anything from video and performance art to downloadable music. The artists include Le Parkour—a group of urban gymnasts who focus on minimalist movement; Nerv1—a graffiti artist (the site shows a video of the work); and Addie—a hip-hop dancer. Both the visually compelling site and navigation reflect the simple and clean lines of the brand. The site represents a fresh approach for Nike by defining sport in terms of movement and cross-cultural artistic expression.

BIRTHDAY

Silver Medal Interactive Advertising: Online Commercial **Birthday**

ART DIRECTOR Jeff Church **GROUP CREATIVE DIRECTOR** William Gelner **EXECUTIVE CREATIVE DIRECTOR** Kevin McKeon **COPYWRITER** William Gelner **DIGITAL DIRECTOR** Matt Campbell **DIRECTOR** Noam Murro **AGENCY PRODUCER** Christian Busch **PRODUCTION** Biscuit Filmworks **AGENCY** Bartle Bogle Hegarty **CLIENT** Unilever—Axe **COUNTRY** United States

The brief was simple. Let's demonstrate the Axe effect (girls being exaggeratedly attracted to guys) in a way that makes the target want all their friends to check it out. We came up with an idea that, as far as we know, no brand has done before. We produced three intentionally low-budget videos that "document-ed" the consequences of using Axe. We closed each spot with a simple title reading "The Axe Effect." Then we created some very low-budget, wacky-looking banners. Some were designed to look like actual content on the site on which we were advertising. Basically, we made ads that don't look like ads, each featuring a small snippet of one of our videos enticing the target to "click for video clip." The fact that no one had heard of Axe was actually going to work to our advantage as it allowed us to include the brand name without giving away the fact that these were ads. When consumers finished watching the films, they were left definitely entertained and intrigued. At that point, they were given an option to go to our Web site to learn more. We had over a million first-time visitors to the site the first week.

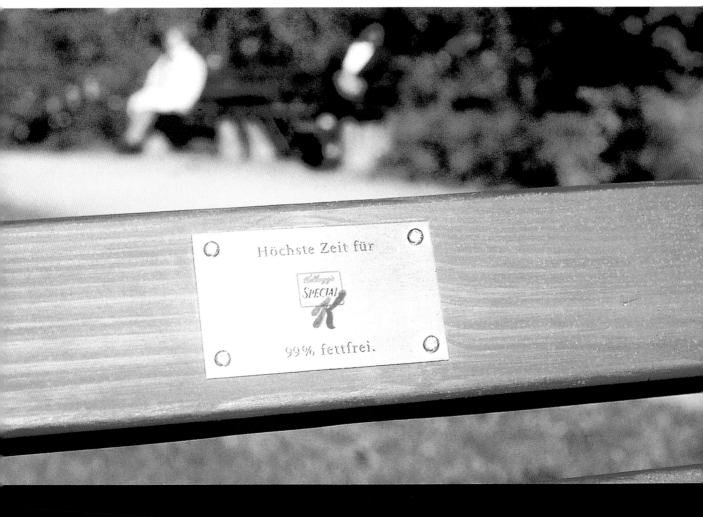

: High time for Kellogg`s Special K. 99% fat-free.

Silver Medal Guerrilla Advertising/Unconventional Media **Park Bench**

ART DIRECTORS Alexander Michaelopoulos, Peter Steger **COPYWRITERS** Anne Hampel, Andreas Heinzel **AGENCY** Michael Conrad & Leo Burnett —Frankfurt
CLIENT Kellogg Company—Germany **COUNTRY** Germany

The objective was to convince people that it is high time for a 99% fat-free diet. We produced a bench which at first glance only differs from an original bench by a small plate on the back. The plate carries the message "High time for Kellogg's Special K—99% fat-free." The difference from a regular bench can only be noticed by sitting down on it. It is then that our bench demonstrates what happens if you don't care about a low-fat diet. And it does so to those sitting down on the bench, as well as to those passing by. It's a perfect demonstration for a product benefit you usually can't demonstrate. And of course, a park bench is a medium that has never been used before.

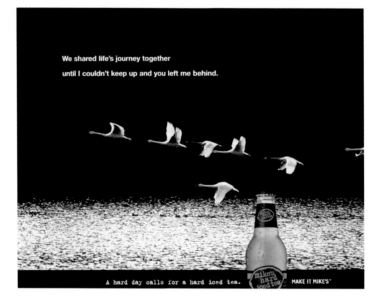

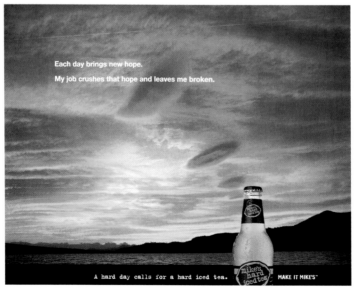

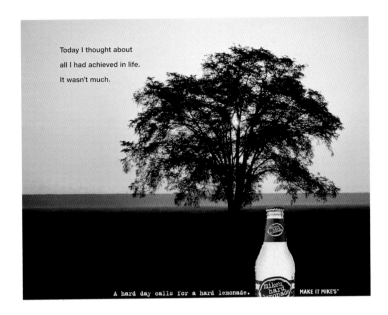

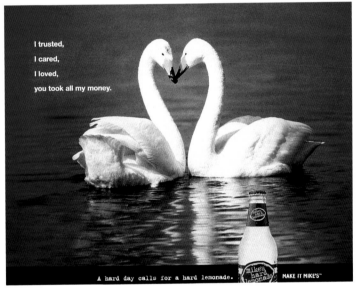

Silver Medal Guerrilla Advertising/Unconventional Media **Mike's Calendar**

ART DIRECTORS Richard Bullock, Taras Wayner **CREATIVE DIRECTOR** Eric Silver **COPYWRITERS** Richard Bullock, Taras Wayner **AGENCY** Cliff Freeman and Partners
CLIENT Mike's Hard Lemonade **COUNTRY** United States

Since the alcoholic beverage market is dominated by men, we felt that Mike's Hard Lemonade needed to be positioned as a viable alternative to beer for males. To do this we created a campaign that made the brand appeal to men through humor. This calendar is an extension of that idea and that campaign.

PUB CARRY

We open on a relatively empty pub. A young man approaches the bar, but it's as if he's trying to get though a crowd of people. He places his order. As he is served the drinks, he hoists them high above his head before making his way back though the imaginary crowd. SUPER: Heineken Green Energy is back. SUPER: Are you festival fit?

MIRROR

We open on a young man, seemingly talking to the camera. YOUNG MAN (SERIOUS): I'm on the guest list. YOUNG MAN (NONCHALANT): I'm on the guest list. YOUNG MAN (MENACING): I'm on the guest list. Camera pulls away to reveal that he is practicing in front of his bedroom mirror. YOUNG MAN (WITH SUNGLASSES): I'm on the guest list. SUPER: Heineken Green Energy is back. SUPER: Are you festival fit?

LOO

 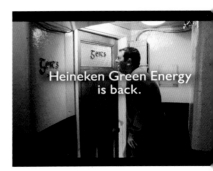

We open on the outside of a pub loo door. We see a young man crossing his legs trying desperately not to pee. An old fella enters the frame and stands behind him, waiting for his turn. The young man nods at him to go ahead. The old man tries the door to the loo, which is unlocked and unoccupied. The old man looks strangely at him, but the young man just smiles and carries on wriggling. SUPER: Heineken Green Energy is back. SUPER: Are you festival fit?

Distinctive Merit TV: Under 30 Seconds, Campaign **Pub Carry** ▪ **Mirror** ▪ **Loo**

ART DIRECTOR Simon Butler **COPYWRITER** Gethin Stout **AGENCY PRODUCER** Thea Selvin **DIRECTOR** Calle Astrand **AGENCY** LOWE—London
CLIENT Heineken—Ireland **COUNTRY** United States

Open on a beautiful, professionally dressed spokeswoman holding a can of Axe and standing in front of a male mannequin. MODEL: Here's a new deodorant called Axe. **She sprays the mannequin.** MODEL: Spray it under your arms and across your chest to stay fresh all day. **She gets a whiff of the Axe scent and turns to the mannequin and gently caresses its nipple area.** MODEL (SEDUCTIVELY): You like that? SUPER: **The Axe effect. Cut to a shot of the product.** VO: Mmmmm...Axe.

Distinctive Merit TV: Under 30 Seconds **Like That**

ART DIRECTOR Gerald Lewis GROUP CREATIVE DIRECTOR William Gelner EXECUTIVE CREATIVE DIRECTOR Kevin McKeon COPYWRITER Matt Ian AGENCY PRODUCER Leticia Jacobs DIRECTORS Rick LeMoine, Steve Miller EDITOR Dick Gordon EDITING Mad River MUSIC Endless Noise PRODUCTION Radical Media AGENCY Bartle Bogle Hegarty CLIENT Unilever—Axe COUNTRY United States

FAST FOOD

Open in a fast-food restaurant. WORKER: Welcome to Bugle Burger. Can I help you? CUSTOMER: I'll have a number two and an iced tea. **We are looking at it from the perspective of the customer. We see several teenage employees walking around very slowly with great care. One of the employees begins to wobble and slip about, while the others quickly follow. One grabs the hamburger bun tray and buns start to fly. Condiments are tossed about while the employees try to gain their balance.** SUPER: **Let's see you do your job on ice.** SFX: Buzzer and crowd cheering. LOGO: **Southwest Airlines®.** SUPER: **Official airline of the NHL. southwest.com.**

Distinctive Merit TV: 30 Seconds **Fast Food**

ART DIRECTOR Kristen Hanson **GROUP CREATIVE DIRECTORS** Brent Ladd, Steve Miller **COPYWRITER** Gerard Seifert **EXECUTIVE PRODUCERS** Gregg Carlesimo, Jon Kamen **AGENCY PRODUCER** Karen Jacobs **DIRECTOR** Frank Todaro **EDITORS** Stephen Bohls, Frank Todaro **EDITING** Matchframe, Outpost Digital **PRODUCTION** Radical Media **AGENCY** GSD&M Advertising **CLIENT** Southwest Airlines **COUNTRY** United States

INTERVIEWS

SUPER: 1999. Cut to a kiosk at a job fair. INTERVIEWER: Do you have any software experience at all? WOMAN: No. INTERVIEW-ER: It's not really important. Welcome aboard! **Now he's looking at someone's resume.** INTERVIEWER: So you haven't worked since 1982? GUY: So? INTERVIEWER: So...I bet you're rearing to go! **Now he's interviewing someone else.** INTERVIEWER: No references at all? MAN: I know. Isn't that crazy? INTERVIEWER: Who's crazy? I'm crazy, you're crazy. Welcome aboard! **SUPER: Times have changed. So have we. SUPER: The new E*TRADE. More of what you need for today's economy.** VO: The new E*TRADE. More of what you need for today's economy. **LOGO: E*TRADE Financial.**

SECRETARY

SUPER: 1999. Cut to a secretary at work. Her boss drops papers off. BOSS: File this. SECRETARY: Sure! Thank you! **She's smiling while she fixes the copier. She's in her boss's office holding his shirts.** BOSS: Heavy starch. SECRETARY: Heavy starch it is! **She's smiling as she replaces the toliet paper in the bathroom. She walks past the lobby security guard.** SECRETARY: How's the company stock doing? GUARD: Up again! **She walks into the garage and bleeps the alarm of her outrageously expensive sports car. SUPER: Times have changed. So have we. SUPER: The new E*TRADE. More of what you need for today's economy.** VO: The new E*TRADE. More of what you need for today's economy. **LOGO: E*TRADE Financial.**

PITCH

SUPER: 1999. Cut to a venture capitalist's office with two young dot-comers pitching to executives. EXECUTIVE 1: Is it a...chip? GUY 1: I hesitate to call it a chip. EXECUTIVE 2: And it fuels the internet? GUY 1: Helps to fuel the internet. EXECUTIVE 4: Do you guys have a Web site? GUY 1: Yeah. EXECUTIVE 1: So you're on the World Wide Web? EXECUTIVE 2: Fantastic! EXECUTIVE 4: We'd be idiots not to fund this. GUY 1: Really? **SUPER: Times have changed. So have we. SUPER: The new E✳TRADE. More of what you need for today's economy.** VO: The new E✳TRADE. More of what you need for today's economy. **LOGO: E✳TRADE Financial.**

MULTIPLE AWARDS

Distinctive Merit TV: 30 Seconds **Interviews** | **Distinctive Merit** TV: 30 Seconds, Campaign **Interviews** • **Secretary** • **Pitch**

ART DIRECTOR Sean Farrell **CREATIVE DIRECTORS** Jeffrey Goodby, Rich Silverstein **ASSOCIATE CREATIVE DIRECTOR** Dave Gray **COPYWRITER** Colin Nissan **AGENCY PRODUCER** Cindy Fluitt **PRODUCER** Jay Veal **DIRECTOR** Noam Murro **EDITOR** Jim Hutchins **PRODUCTION** Biscuit Filmworks **AGENCY** Goodby, Silverstein & Partners **CLIENT** E✳TRADE **COUNTRY** United States

DISTANCE

MUSIC THROUGHOUT: "Don't Fence Me In" as performed by The Mooney Suzuki. **Open on several shots of a batter taking batting practice in Yankee Stadium. Exactly who the batter is, we can't tell. Cut to shots of the large white distance markers on the outfield wall—314 FT, 385 FT, 399 FT. Cut to numerous locations around New York City. Each is marked with large white numbers (exactly like the ones on the outfield wall) that reveal its distance in feet from home plate at Yankee Stadium. The distances are tremendous. Cut back inside Yankee Stadium to reveal that the batter is slugger Jason Giambi. He takes a mighty swing and smacks the ball into the ether.** LOGO: Nike Swoosh.

Distinctive Merit TV: 30 Seconds **Distance**

ART DIRECTOR Ted Royer **COPYWRITER** Jeff Bitsack **AGENCY PRODUCER** Gary Krieg **DIRECTOR** Jake Scott **DIRECTOR OF PHOTOGRAPHY** Alex Barber
EDITOR Kirk Baxter **MUSIC** Mooney Suzuki **PRODUCTION** RSA **AGENCY** Wieden + Kennedy—NY **CLIENT** Nike **COUNTRY** United States

USA

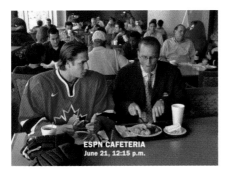 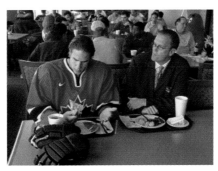 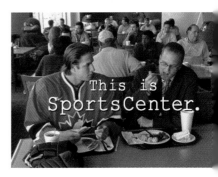

Open on Scott Van Pelt eating in the ESPN cafeteria with Simone Gagne. SUPER: ESPN Cafeteria, 12:15 p.m. Simone is speaking from the heart. SIMONE: You can't imagine how big that was for Canada to win that gold medal. We waited a long time and now, after 50 years, the gold medal is back. **Scott abruptly interrupts this thoughtful reminiscing.** SCOTT: Tell me something, what kind of cheese you got there? SIMONE (CONFUSED): What kind of cheese? SCOTT: Yeah, what kind of cheese? SIMONE: American? SCOTT: That's right, American cheese. American cheese. **Simone is completely baffled, but Scott goes back to eating his lunch, confident his point has been made. SUPER: This Is SportsCenter.**

Distinctive Merit TV: 30 Seconds **USA**

ART DIRECTOR Bill Lee **COPYWRITER** Ilicia Winokur **AGENCY PRODUCER** Temma Shoaf **DIRECTOR** David Shane **DIRECTOR OF PHOTOGRAPHY** Joe DeSalvo **EDITOR** Dave Koza **PRODUCTION** Hungry Man **AGENCY** Wieden + Kennedy—NY **CLIENT** ESPN **COUNTRY** United States

ROADSIDE MEMORIAL

A roadside memorial with a white wooden cross and flowers has been placed near a busy intersection. SUPER: Sponsored by truth ©2001 truth. Several people walk by and stop to read the sign on the memorial. A group walks up to the sign and a boy reads the sign to his family. Close-up of the sign on the memorial. SIGN: Every day tobacco kills 1,070 more people than auto accidents. Asterisks pop up on the people who are looking at the sign. The asterisks designate that the people have just been "infected" with the truth. SUPER: ✳ Knowledge is contagious. Infect truth. infect-truth.com.

POOP

 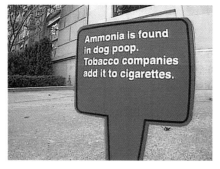

Open on a Truth Kid walking several dogs down a city street. SUPER: Sponsored by truth ©2001 truth. As one dog takes its morning crap, another Truth Kid sticks a flag in it. People walking by look on as the Truth Kid puts flags in poop along the sidewalk. Close-up of the flag. FLAG: Ammonia is found in dog poop. Tobacco companies add it to cigarettes. Shot of a woman noticing the flag sticking out of the poop. She leans in to read the flag. An asterisk is placed on the woman's head. The asterisks designate that the woman has just been "infected" with the truth. SUPER: ✳ Knowledge is contagious. Infect truth. infect-truth.com.

BABY INVASION

 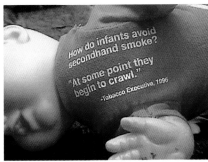

Open on a mechanical baby crawling along the sidewalk. Cut to a large group of babies crawling all around and into each other. Some pedestrians walk right past the dolls. Some pick them up. Cut to a close-up of the baby's t-shirt. T-SHIRT: "How do infants avoid secondhand smoke? At some point they begin to crawl." –Tobacco executive, 1996. Cut to a wide area where there are hundreds of crawling babies and lots of people checking them out. Asterisks appear by the people's heads. SUPER: ✴ Knowledge is contagious. Infect truth. infect-truth.com.

Distinctive Merit TV: 30 Seconds, Campaign **Roadside Memorial** • **Poop** • **Baby Invasion**

ART DIRECTORS Alex Burnard, Tony Calcao, Ryan O'Rourke **CREATIVE DIRECTORS** Alex Bogusky, Pete Favat **COPYWRITERS** Steve O'Connell, Rob Strasberg, Brian Tierney **PRODUCER** Rupert Samuel **DIRECTOR** Pete Favat **PRODUCTION** Chelsea Pictures **AGENCIES** Arnold Worldwide, Crispin Porter + Bogusky **CLIENT** American Legacy Foundation **COUNTRY** United States

ANTI-FREEZE

SUPER: Game 1. Cut to a guy standing in his kitchen holding a lobster over a pot of boiling water. He lets the lobster go, but it clamps on to his arm and hangs there. He doesn't react. SUPER: Game 18. Cut to a woman closing a door to a house. It doesn't shut. She continually keeps slamming the door, but it still won't shut. We see that our guy's hand has been is in the door jamb while he reads his mail. He calmly removes his hand and apologizes. SUPER: Game 59. Cut to the same guy parked in the breakdown lane of a highway. The hood of his car is open and the anti-freeze cap is aggressively hissing. He opens the cap. Burning-hot, lime-green antifreeze sprays all over him. He just stands in the hot, sizzling spray without reacting. As the spray slows, he replaces the cap and checks the oil. SUPER: The more hockey you watch the tougher you get. SUPER: Islanders vs. Panthers, Friday 7p.m. NHL on FOX SPORTS NET.

Distinctive Merit TV: 30 Seconds **Anti-Freeze**

EXECUTIVE CREATIVE DIRECTOR Chuck McBride **CREATIVE DIRECTOR** Todd Grant **COPYWRITER** Eric King, Susan Treacy **EXECUTIVE PRODUCER** Richard O'Neill **EDITOR** Tom Muldoon **AGENCY** TBWA\Chiat\Day—San Francisco **CLIENT** Fox Sports **COUNTRY** United States

UNDER FIVE

Open on a child walking alone down a street. **Cut to shots of children on the streets. Cut to children sleeping in an abandoned church. Cut to children bathing on a pier. Cut to children giving each other haircuts in abandoned buildings. Cut to shots of children around a fire, cooking dinner. Cut to young child pushing another in a stroller.** VO: AIDS has created over 14 million orphans worldwide. That's the equivalent of every child under five in America. **Cut to girl abandoning the stroller in the middle of the street.** VO: With no one to watch over them. **SUPER: AIDS is preventable. Apathy is lethal.** VO: Please, won't you help? **LOGO: United Nations Foundation. Ad Council. apathyislethal.org.**

Distinctive Merit TV: Over 30 Seconds **Under Five**

ART DIRECTOR Per Jacobson EXECUTIVE CREATIVE DIRECTOR Mark Tutssel CREATIVE DIRECTORS John Condon, Per Jacobson COPYWRITER John Condon PRODUCER Mike Antonucci DIRECTOR Ralf Schmerberg AGENCY Leo Burnett Company CLIENT United Nations Ad Council COUNTRY United States

TRICKS

Open on a man in an electric chair. SUPER: asbestos work suit. Cut to man impaled through the head. SUPER: computer animation. Cut to man's hand being crushed by a hammer. SUPER: rubber hand. Cut to zombie writhing in a bed. SUPER: latex and make-up. Cut to man with the top of his head removed. SUPER: silicone and artificial blood. Cut to soldier with his guts hanging out of his stomach. SUPER: cow's guts. SUPER: You know all the tricks. Your children don't. SWR Television against violence on TV.

Distinctive Merit TV: Over 30 Seconds **Tricks**

ART DIRECTOR Minh Khai Doan CREATIVE DIRECTORS Helmut Himmler, Lars Huvart COPYWRITER Lars Huvart AGENCY Ogilvy & Mather—Frankfurt CLIENT SWR Television Station—Baden-Baden COUNTRY Germany

SCUM

TRUTH BEHIND THE CURTAIN

SUPER: **Truth behind the curtain. Open on an orange velvet curtain. The orange curtain is pulled back by a teenage guy.** KID: This is my friend Donald. DONALD: According to recently uncovered documents, a well-known tobacco company planned on boosting sales of cigarettes, in the mid-90s, by specifically targeting gays and homeless people. What did they call their little plan? Project Sub-Culture Urban Marketing, also known as...Project SCUM. **Kid approaches camera and holds up document that says "Project SCUM." Camera zooms in on it.** DONALD: But I'm sure they meant that in a good way. **Orange curtain closes.** SUPER: **This is what we know. Imagine what we don't.** LOGO: **truth.**

Distinctive Merit TV: Public Service/Nonprofit **SCUM**

ART DIRECTORS Mike Martin, Ryan O'Rourke CHIEF CREATIVE OFFICER Ron Lawner GROUP CREATIVE DIRECTORS Alex Bogusky, Pete Favat CREATIVE DIRECTORS Roger Baldacci, Ari Merkin COPYWRITERS Chris Edwards, Steve O'Connell AGENCIES Arnold Worldwide, Crispin Porter + Bogusky CLIENT American Legacy Foundation COUNTRY United States

BURNS

Spot is shot like a bad used car commercial. Open on SuperSonics' Yugoslavian center, Peja Drobnjak. SUPER: Drobnjak's
Super Sonic Seat Sale!!! VO: It's Peja Drobnjak's Super Sonic Seat Sale! With his cat, Jinkies! **Cut to Jinkies the Cat. Cut to Peja
on the phone, his head wrapped in medical gauze.** PEJA: Hello, ambulance? Come now! **Pull back to see Peja surrounded by
flaming stadium seats.** PEJA: Because the Sonics action from these seats is so hot, it burns me! But don't trust my words—see
this! **We see game highlights as Peja stands at the bottom of the screen. He writhes in pain with each highlight.** PEJA: Ouch!
Help! Spray me with the water! **Cut to Peja holding a large tub of aloe vera.** PEJA: See, I'm not pretending! **Cut to a flurry of
starbursts and a rotating stadium seat.** SUPER: SuperSonics. 3rd Degree Action! Buy Now! Supersonics.com. **Cut to close-up
of Peja with flames shooting out of his ears.** PEJA: Ouch!

Distinctive Merit TV: Low Budget (Under $100,000) **Drobnjak/Burns**

ART DIRECTOR Pam Fujimoto **CREATIVE DIRECTOR** Tracy Wong **COPYWRITERS** Ian Cohen, Matt McCain **EXECUTIVE PRODUCER** Craig Potter **AGENCY PRODUCER**
Dax Estorninos **DIRECTOR** Craig Potter **EDITOR** Alan Nay **ACCOUNT SUPERVISOR** Jason Gearhart **PRODUCTION COMPANY** Leon Films **AGENCY** Wongdoody
CLIENT Seattle SuperSonics **COUNTRY** United States

HEADS

A woman and her boyfriend are having dinner in a swank loft apartment. The boyfriend is blabbing away about his job while she stares at him with contempt. BOYFRIEND: So then I say to Warren, "Warren, it's not a matter of requisitioning plastic fasteners, clearly, it's just a matter or protocol. And what's more, these forms need to be filled out in triplicate, so don't look at me like it's my problem, mister." I think I made my point. **Suddenly she gets up and pops off his head and grabs a new head from her closet. The new head adjusts to the boyfriend's body and gives her a sexy smile. She smiles back. SUPER: Find your style. LOGO: IKEA.**

Distinctive Merit Television and Cinema Crafts: Animation **Heads**

ART DIRECTOR Steve Angel **DIRECTOR** Steve Angel **ANIMATOR** Drew Lightfoot **AGENCY** Carmichael Lynch **CLIENT** IKEA **COUNTRY** Canada

FRENCH DICTIONARY

Open on a shipping yard. A man and woman are chased by a menacing-looking van. Hiding in the shadows, they evade the van. They push the car into the water. The guy's expression changes, like he's just remembered something. The man dives after the car. From under the seat he retrieves a book and tucks it into his backside waistline. The woman waits. Seconds later the man surfaces and joins her. WOMAN: Qu'avez-vous oublié? (What did you forget?) As they depart, the camera reveals a pocket English-to-French dictionary peeking between his back and waistline.

MULTIPLE AWARDS

Distinctive Merit Television and Cinema Crafts: Cinematography **French Dictionary** | **Merit** TV: 30 Seconds **French Dictionary**

ART DIRECTOR John Hobbs **GROUP CREATIVE DIRECTOR** Thomas Hayo **EXECUTIVE CREATIVE DIRECTOR** Kevin McKeon **COPYWRITER** Peter Rosch **AGENCY PRODUCER** Mary Cheney **DIRECTOR** Ivan Zacharias **EDITOR** Filip Malasek **EDITING** Final Cut **MUSIC** Sound Lounge **PRODUCTION** Smuggler/Stink **AGENCY** Bartle Bogle Hegarty **CLIENT** Levi Strauss & Co. **COUNTRY** United States

MR. TINY THONG BIKINI WEARER

ANNOUNCER: Bud Light presents—Real Men of Genius. SINGER: Real men of genius! ANNOUNCER: Today we salute you, Mr. Tiny Thong Bikini Wearer. SINGER: Mr. Tiny Thong Bikini Wearer! ANNOUNCER: Beach-goers the world over see you coming and say, "Hey, check out the woolly mammoth in the rubber band." SINGER: Giant woolly mammoth! ANNOUNCER: Defying the natural laws of physics, you manage to squeeze a 46-inch waist into a 30-inch suit. SINGER: Tight, tight, tighty-tight! ANNOUNCER: Like ground meat crammed into a sausage skin, you take to the beach and proudly strut your stuff. SINGER: Yeah! ANNOUNCER: If you've got it, flaunt it. That's your motto, which is ironic, because you haven't got it. ANNOUNCER: So crack open an ice cold Bud Light, Sweetcheeks, and know that if you weren't wearing that suit, we'd ask you to take a bow. SINGER: Mr. Tiny Thong Bikini Wearer. ANNOUNCER: Bud Light Beer. Anheuser-Busch. St. Louis, Missouri.

| FM | 88 | 92 | 96 | 102 | 108 | MHz |
| AM | 5.3 | | 7 | 10 12 14 | 17 | kHz |

Distinctive Merit Radio: Over 30 Seconds **Genius—Mr. Tiny Bikini Thong Wearer**

CHIEF CREATIVE OFFICER Bob Scarpelli **GROUP CREATIVE DIRECTOR** John Immesoete **CREATIVE DIRECTORS** Bill Cimino, Mark Gross **COPYWRITERS** Bill Cimino, Mark Gross **PRODUCER** Sally Naylor **MUSIC** Sandy Turano **SOUND ENGINEER** Dave Gerbosi **AGENCY** DDB Chicago **CLIENT** Anheuser-Busch/Bud Light **COUNTRY** United States

FLAVOR

<u>SFX:</u> Phone ringing. <u>MAN:</u> Hello? <u>JEFF:</u> My name is Jeff and I am taking a 60-second survey about a well-known product today. <u>MAN:</u> Okay. <u>JEFF:</u> I'd like to get your opinion on some flavors currently added to this product. Please rate them on a scale of 1 to 10 with 10 as most delicious.Cocoa. <u>MAN:</u> 5. <u>JEFF:</u> Licorice. <u>MAN:</u> Ah, 7. <u>JEFF:</u> Peppermint. <u>MAN:</u> Ah, 4. <u>JEFF:</u> Ammonia. <u>MAN:</u> 0. <u>JEFF:</u> Methylbutyric acid. <u>MAN:</u> 0. <u>JEFF:</u> 6-10 Di-menthyl-5-9 undecadien-2-one. <u>MAN:</u> What kind of stupid questions are these? <u>JEFF:</u> Well these are just ingredients some tobacco companies say they add to cigarettes for flavor, sir. <u>MAN:</u> Oh, is that right? <u>JEFF:</u> Yes, sir. Well, thank you for your time today. <u>MAN:</u> Okay. <u>JEFF:</u> Your opinion matters. <u>SFX:</u> Dial tone. <u>VO:</u> Knowledge is contagious. Infect truth.

DOWNSIDE

<u>WOMAN:</u> Hello? <u>TRUTH:</u> Hi. I have a quick product survey. Would you mind participating? <u>WOMAN:</u> Okay. <u>TRUTH:</u> This widely used product has a few downsides I am going to tell you about. You tell me whether you don't care, care, or care a lot. <u>WOMAN:</u> Okay. <u>TRUTH:</u> Okay. This product may wrinkle your skin. <u>WOMAN:</u> I care about that. <u>TRUTH:</u> Okay. This product smells bad to some people. <u>WOMAN:</u> I don't care. <u>TRUTH:</u> This product exposes people who use it to radiation. <u>WOMAN:</u> Well, I care about that. <u>TRUTH:</u> Okay. This product can cause a few things. I'll list them, okay? <u>WOMAN:</u> Okay. <u>TRUTH:</u> Erectile Dysfunction. <u>WOMAN:</u> A who? Erectile Dysfunction? <u>TRUTH:</u> Yes. <u>WOMAN:</u> Oh, I care about that. <u>TRUTH:</u> Okay. Sudden Infant Death Syndrome. <u>WOMAN:</u> And I care about that. That's dangerous. <u>TRUTH:</u> And every fifth death in America. <u>WOMAN:</u> I care about that. <u>TRUTH:</u> Are you familiar with this product? <u>WOMAN:</u> No. I don't know what you are talking about. <u>TRUTH:</u> It's cigarettes. <u>WOMAN:</u> Oh. <u>TRUTH:</u> Thanks for your time. <u>VO:</u> Knowledge is contagious. Infect truth.

POSITIVE

<u>WOMAN:</u> Hello? <u>TRUTH:</u> Hi. I'm taking a quick survey about a well-known product. Would you mind participating? <u>WOMAN:</u> Ah-ha. <u>TRUTH:</u> Okay. Please rate the following statements as positive, negative or neutral. This product comes in different flavors. <u>WOMAN:</u> Positive. <u>TRUTH:</u> This product fits in your pocket. <u>WOMAN:</u> Positive. <u>TRUTH:</u> This product gives off cyanide. <u>WOMAN:</u> Ewwh. Oh, terrible. No. Negative. <u>TRUTH:</u> This product kills people who use it. <u>WOMAN:</u> Negative. <u>TRUTH:</u> How about, this product kills people who don't even use it. They just have to stand nearby. <u>WOMAN:</u> Oh, negative. <u>TRUTH:</u> Do you know what the product is? <u>WOMAN:</u> I have no idea. <u>TRUTH:</u> Cigarettes. Thank you for sharing your opinions today. <u>WOMAN:</u> Ah, OK. <u>VO:</u> Knowledge is contagious. Infect truth.

FM 88 92 96 102 108 MHz

AM 5.3 7 10 12 14 17 kHz

Distinctive Merit Radio: Public Service/Nonprofit **Flavor · Downside · Positive**

CHIEF CREATIVE OFFICER Ron Lawner **GROUP CREATIVE DIRECTORS** Alex Bogusky, Pete Favat **CREATIVE DIRECTORS** Roger Baldacci, Ari Merkin **COPYWRITER** Annie Finnegan **AGENCY PRODUCER** Chris Jennings **RECORDING ENGINEER** Joe O'Connel **RECORDING STUDIO** Blast Audio **AGENCIES** Arnold Worldwide, Crispin Porter + Bogusky **CLIENT** American Legacy Foundation **COUNTRY** United States

GAME

Distinctive Merit Interactive Advertising: Online Commercial, Campaign **Game** | **Distinctive Merit** Interactive Advertising: Online Commercial **Game**
ART DIRECTOR Jeff Church **GROUP CREATIVE DIRECTOR** William Gelner **EXECUTIVE CREATIVE DIRECTOR** Kevin McKeon **COPYWRITER** William Gelner **DIGITAL**
DIRECTOR Matt Campbell **AGENCY PRODUCER** Christian Busch **DIRECTOR** Noam Murro **PRODUCTION** Biscuit Filmworks **AGENCY** Bartle Bogle Hegarty
CLIENT Unilever—Axe **COUNTRY** United States

FAMILY REUNION

Distinctive Merit Interactive Advertising: Online Commercial **Family Reunion** | **Merit** Interactive Advertising: Online Commercial, Campaign
Family Reunion

ART DIRECTOR Jeff Church **GROUP CREATIVE DIRECTOR** William Gelner **EXECUTIVE CREATIVE DIRECTOR** Kevin McKeon **COPYWRITER** William Gelner **DIGITAL
DIRECTOR** Matt Campbell **AGENCY PRODUCER** Christian Busch **DIRECTOR** Noam Murro **PRODUCTION** Biscuit Filmworks **AGENCY** Bartle Bogle Hegarty
CLIENT Unilever—Axe **COUNTRY** United States

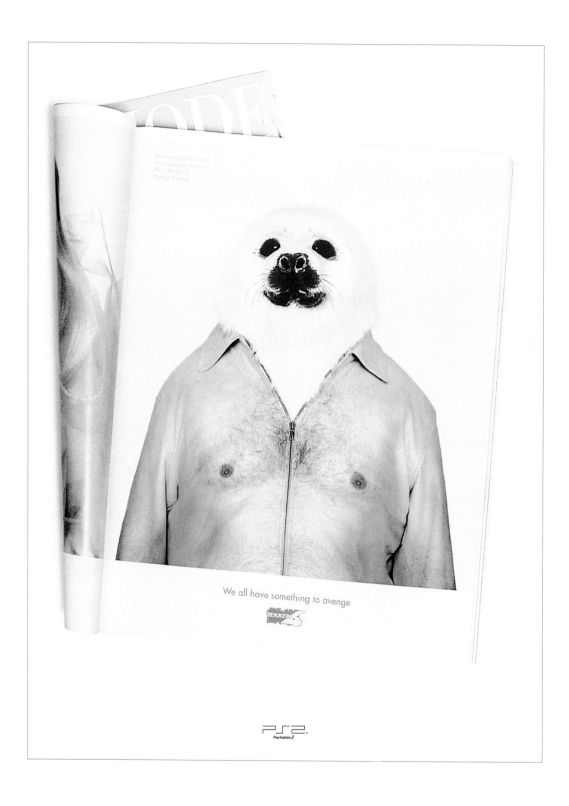

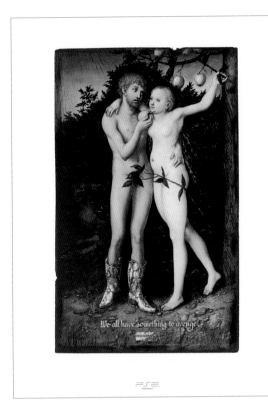

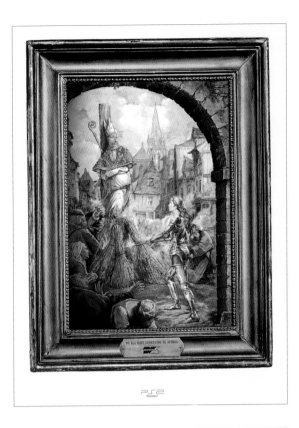

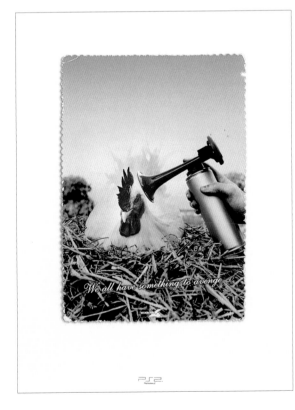

Distinctive Merit Consumer Newspaper: Full Page, Campaign **Tekken 4—The Seal** • **Adam and Eve** • **Joan of Arc** • **The Rooster** • **Three Little Pigs**
ART DIRECTORS Emmanuel Bougneres, Thierry Buriez, Jessica Gerard-Huet, Philippe Taroux, Stéphanie Thomasson **COPYWRITERS** Jean-François Bouchet, Mathieu Elkaim, Alain Jalabert, Benoit Leroux **ILLUSTRATORS** Jean François Campos, Alain Dercourt, André Vayssade **AGENCY** TBWA\Paris **CLIENT** Sony Playstation **COUNTRY** France

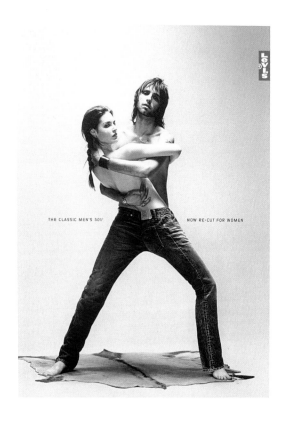

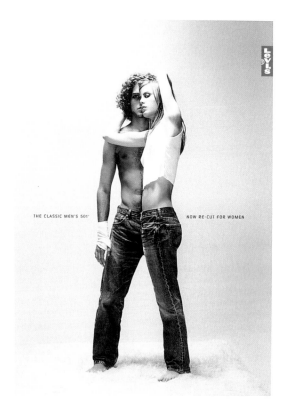

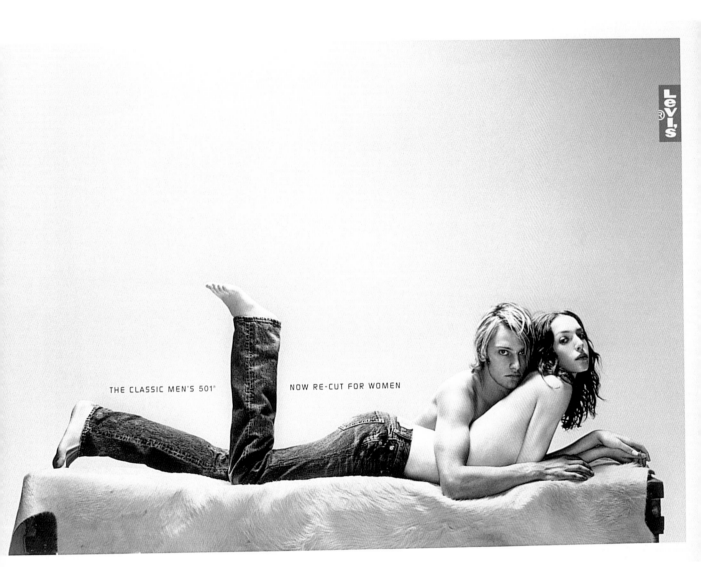

THE CLASSIC MEN'S 501® NOW RE-CUT FOR WOMEN

MULTIPLE AWARDS SEE ALSO PHOTOGRAPHY

Distinctive Merit Consumer Magazine: Full Page **Hugging** | **Distinctive Merit** Posters: Point of Purchase **Hugging** | **Merit** Consumer Magazine: Full Page **Lying** | **Merit** Consumer Magazine: Full Page **Standing** | **Merit** Consumer Magazine: Full Page, Campaign **Standing • Hugging • Lying** | **Merit** Posters: Point of Purchase, Campaign **Standing • Hugging • Lying** | **Merit** Billboard/Diorama/ Painted Spectacular, Campaign **Standing • Hugging**

ART DIRECTORS Thye Aun, Alex Lim **COPYWRITER** Marthinus Strydom **PHOTOGRAPHER** Nadav Kander **AGENCY** Bartle Bogle Hegarty Ltd.—Asia Pacific **CLIENT** Levi Strauss Japan **COUNTRY** Singapore

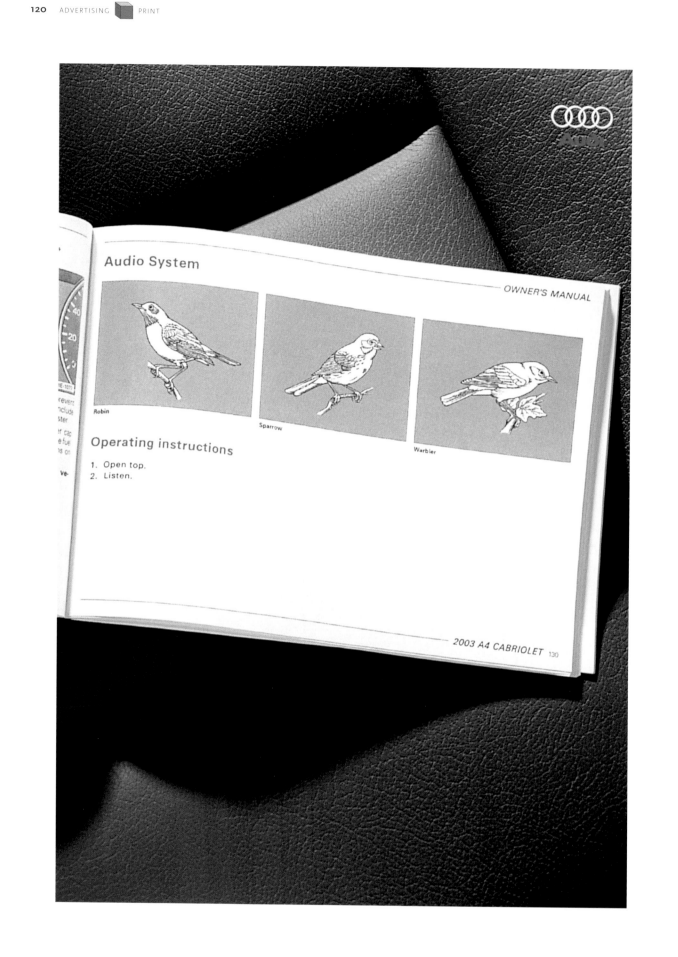

Distinctive Merit Consumer Magazine: Full Page, Campaign **Audi-Cabrio—Birds • Flowers • Stars**

ART DIRECTORS Bob Ranew, Tony Simmons **COPYWRITER** Lara Bridger **ILLUSTRATOR** Jim Brown **PHOTOGRAPHER** Michael Lewis **AGENCY** McKinney & Silver
CLIENT Audi of America, Inc. **COUNTRY** United States

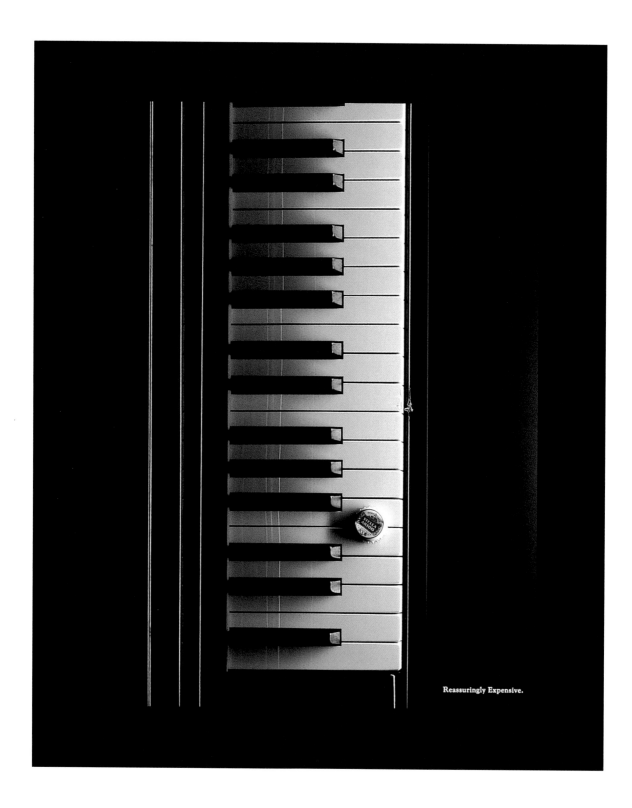

Reassuringly Expensive.

Distinctive Merit Consumer Magazine: Full Page **Piano**

ART DIRECTORS Mary-Ann Schmittzehe, Steve Williams **COPYWRITER** Holly Budgen **PHOTOGRAPHER** Coppi Barbieri **AGENCY** LOWE **CLIENT** Interbrew UK—Stella Artois **COUNTRY** United Kingdom

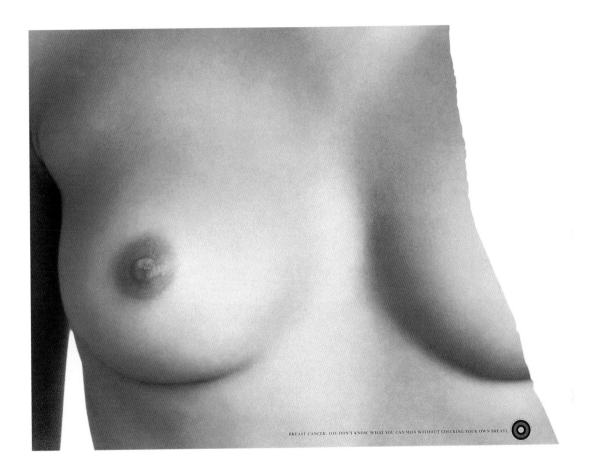

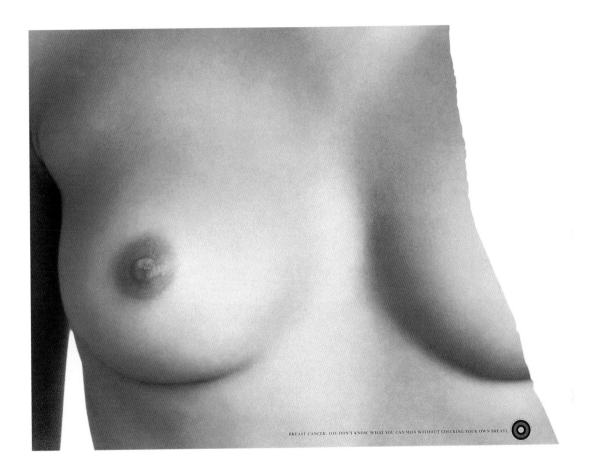

BREAST CANCER: YOU DON'T KNOW WHAT YOU CAN MISS WITHOUT CHECKING YOUR OWN BREAST.

Distinctive Merit Consumer Magazine: Spread **Breast**
ART DIRECTOR Virgilio Neves **COPYWRITER** Lilian Lovisi **AGENCY** Ogilvy—Brazil **CLIENT** José Carlos Muoio **COUNTRY** Brazil

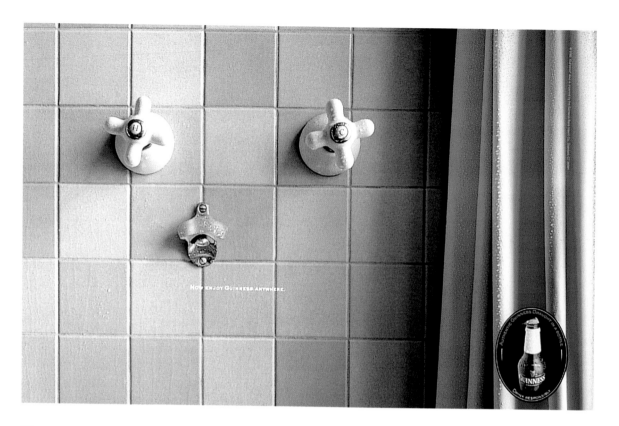

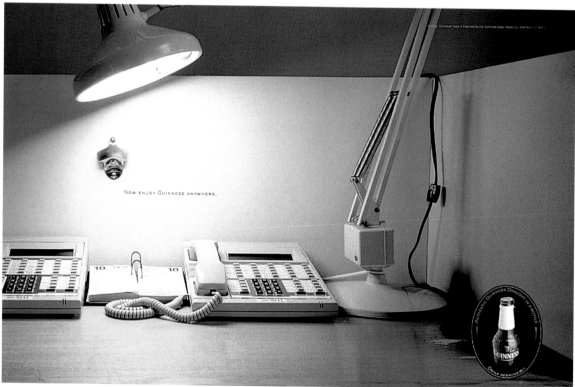

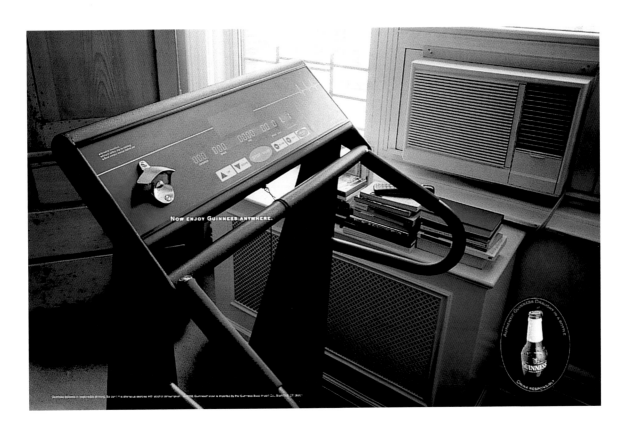

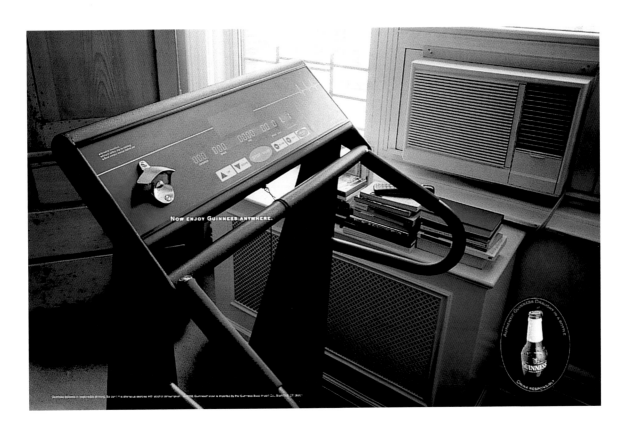

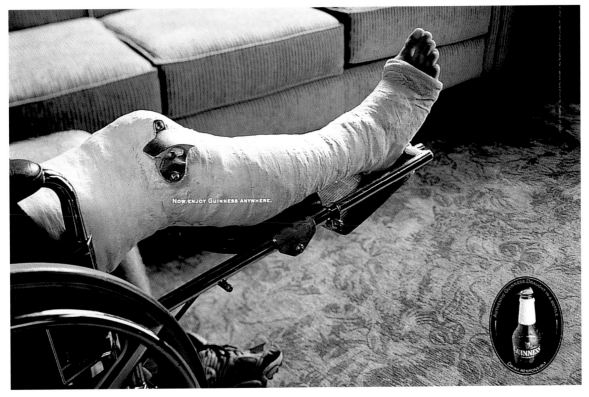

Distinctive Merit Consumer Magazine: Spread, Campaign **Shower** ▪ **Office** ▪ **Treadmill** | **Merit** Consumer Magazine: Full Page, Campaign **Shower** ▪ **Office** ▪ **Cast** | **Merit** Consumer Magazine: Spread **Cast**

ART DIRECTOR Joel Rodriguez **CHIEF CREATIVE OFFICER** Ted Sann **EXECUTIVE CREATIVE DIRECTOR** Gerry Graf **COPYWRITERS** Harold Einstein, Gerry Graf **AGENCY** BBDO—New York **CLIENT** Guinness **COUNTRY** United States

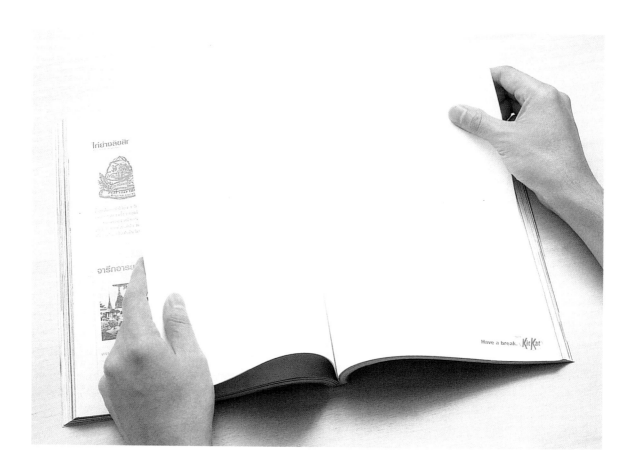

Distinctive Merit Consumer Magazine: Spread **Blank Page**
ART DIRECTOR Vancelee Teng **COPYWRITER** Subun Khow **PHOTOGRAPHY** Yin-Yang Studio **AGENCY** LOWE—Bangkok **CLIENT** Nestle Kit Kat **COUNTRY** Thailand

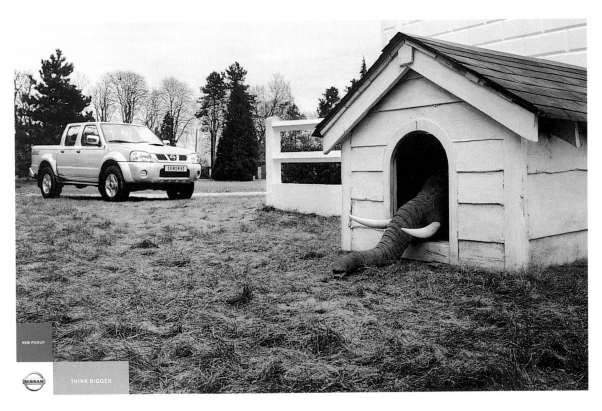

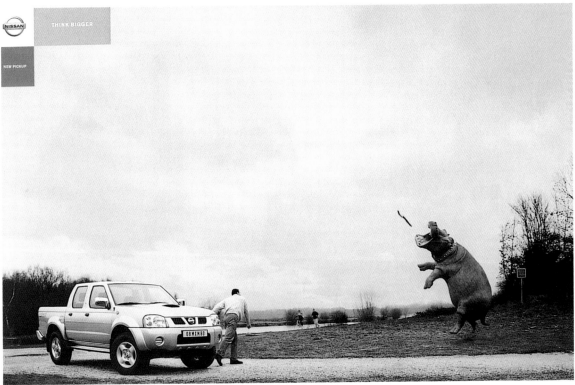

Distinctive Merit Trade Magazine: Spread, Campaign **Pick-up—Elephant • Hippopotamus**
ART DIRECTOR Stephen Cafiero **COPYWRITER** Vincent Lobelle **PHOTOGRAPHER** Marc Gouby **AGENCY** TBWA\Paris **COUNTRY** France

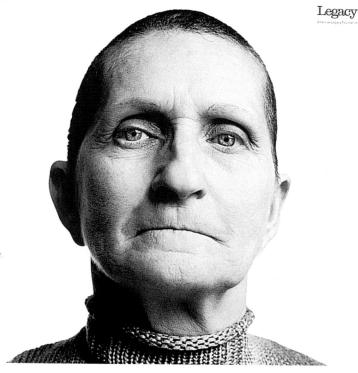

To my daughter JC,
My love for you is unconditional,
and remains so to the end. My only
heartbreak is that I probably will not
be around to help raise my little
grandchild, Ally

Love Mom

To Pat,
I really don't know how much
time I have left, but I would
like to tell you what a good friend you
are and have been. Thanks again
my long time pal.

Love Linda

To Ally,
You're only 2½ years old now,
but in the event I don't see you
grow up to adulthood, please
don't ever take up smoking.
I smoked for 40 years. I have lung cancer.
You know your grandma would never
lie to you, but other people will.

Love Grandma

For information on quitting smoking,
call 1-800-4-A-LEGACY
or visit www.americanlegacy.org.
Every second counts

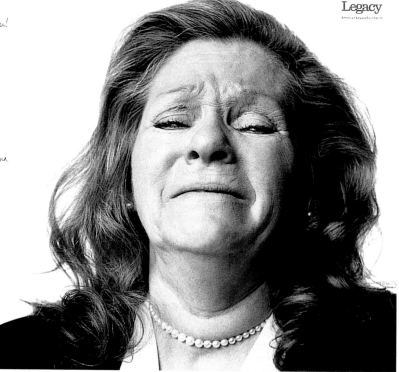

To my Children - David, Diana, Michael,
We're running out of tomorrows. I'm so proud of you!
I always loved you and always will.
Good bye my darlings.

Mom

Dearest Jon,
I am so sorry my smoking will cheat us
out of 20 or 30 more years together. Remember
the fun we had every year at the lake. I will
ALWAYS love and treasure you.

Linda

To the TOBACCO Companies,
My name is Linda. I'm dying from emphysema
from smoking. We know you are in this for the
money. We are in it for our lives and the lives
of our loved ones. AND WE WILL WIN!

For information on quitting smoking,
call 1-800-4-A-LEGACY
or visit www.americanlegacy.org.
Time is important.

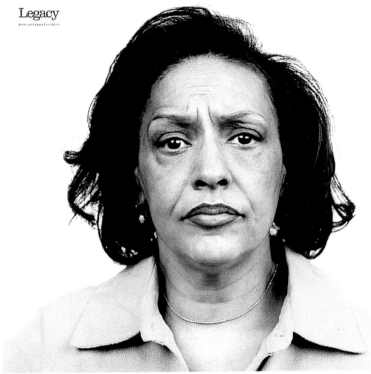

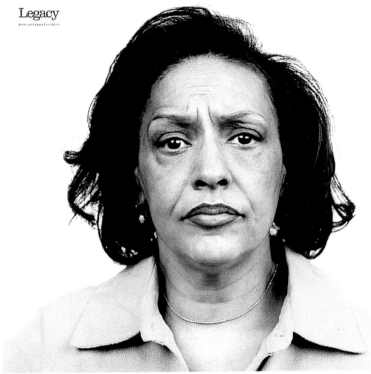

Legacy
American Legacy Foundation

To my family,
Smoking is taking years of my life. Years
I should be spending with you. I'm sorry.
My love for you will not go with me, it will
grow inside you all.

To my children,
I don't want you to be sad! Remember me,
and forgive me for leaving you so soon. When
it's over, mom will just be sleeping.

To the tobacco companies,
My name is Desmonda.
I have emphysema from smoking. You
stole my dignity. You killed the spirit of a
beautiful young woman. And the worst is
yet to come. For that, you should be sorry.

For information on quitting smoking,
call 1-800-4-A-LEGACY
or visit www.americanlegacy.org.
Every breath counts.

Distinctive Merit Public Service/Nonprofit Magazine: Spread, Campaign **Linda Costigan • Linda Marshall • Desmonda**
CHIEF CREATIVE OFFICER Ron Lawner **GROUP CREATIVE DIRECTOR** Pete Favat **CREATIVE DIRECTOR** Roger Baldacci **COPYWRITER** Roger Baldacci
PHOTOGRAPHER Richard Avedon **AGENCY** Arnold Worldwide **CLIENT** American Legacy Foundation **COUNTRY** United States

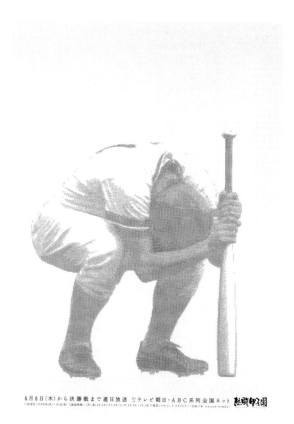

8月8日(木)から決勝戦まで連日放送 ☆テレビ朝日・ABC系列全国ネット 熱闘甲子園

8月8日(木)から決勝戦まで連日放送 ☆テレビ朝日・ABC系列全国ネット 熱闘甲子園

8月8日(木)から決勝戦まで連日放送 ☆テレビ朝日・ＡＢＣ系列全国ネット 熱闘甲子園

◉放送日／8月8日(木)〜21日(水) ◉放送時間／(月〜金)23:10〜23:40(土・日)23:00〜23:30 ◉提供／コカ・コーラ ◉キャスター／長島三奈 ※全14日間、雨天順延あり

Distinctive Merit Posters: Promotional, Campaign **Characters**

ART DIRECTORS Yasuhiro Hayashi, Daisuke Takagi **CREATIVE DIRECTOR** Takeshi Matsumoto **COPYWRITER** Takeshi Matsumoto **DESIGNER** Daisuke Fujiwara
AGENCY Dentsu Inc. Kansai/Nakano Naoki Advertising Office **CLIENT** Asahi Broadcasting Corporation **COUNTRY** Japan

Distinctive Merit Posters: Promotional **The City—Right Now**

ART DIRECTOR Bent Lomholt **COPYWRITER** Thomas Fisker **ACCOUNT EXECUTIVE** Louis Ebler **CLIENT** Jyllands-Posten **COUNTRY** Denmark

week 1

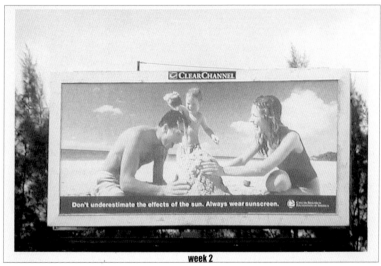

week 2

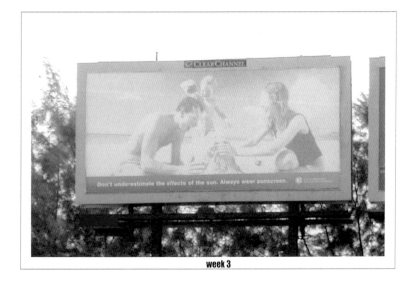

week 3

Distinctive Merit Posters: Public Service/Nonprofit/Educational **Sun Damage**

ART DIRECTOR Simon McQuoid **COPYWRITER** John Patroulis **PHOTOGRAPHY** Getty One Images **AGENCY** TBWA\Chiat\Day **CLIENT** Cancer Research Foundation of America **COUNTRY** United States

Six million Americans are losing their sight
to retinal degenerative diseases.
With your donation, we can restore it.
Call 800 683 5555 or visit blindness.org
Foundation Fighting Blindness

Distinctive Merit Posters: Public Service/Nonprofit/Educational **Dandelion**

ART DIRECTORS Jan Jacobs, Eider Suso **GROUP CREATIVE DIRECTOR** Jan Jacobs **EXECUTIVE CREATIVE DIRECTOR** Tony Granger **COPYWRITER** Dave Holloway
PHOTOGRAPHER Andy Roberts (Getty Images) **ART PRODUCER** Evan Forman **AGENCY** Bozell—New York **CLIENT** Foundation for Fighting Blindness
COUNTRY United States

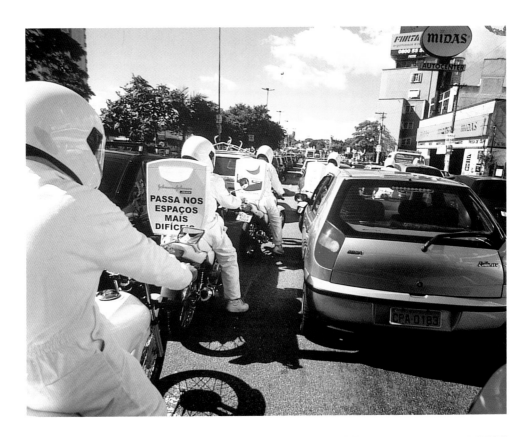

Distinctive Merit Posters: Transit **Moto Reach**

ART DIRECTOR Bruno Ribeiro **CREATIVE DIRECTOR** Carlos Silverio **COPYWRITER** Tomas Correa **PHOTOGRAPHER** Lucio Cunha **AGENCY** DPZ
CLIENT Johnson & Johnson **COUNTRY** Brazil

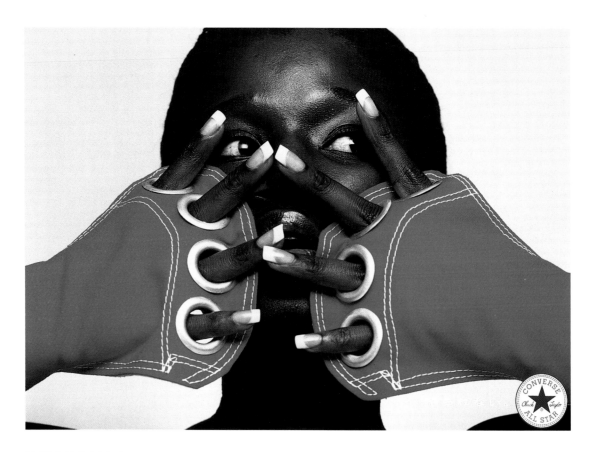

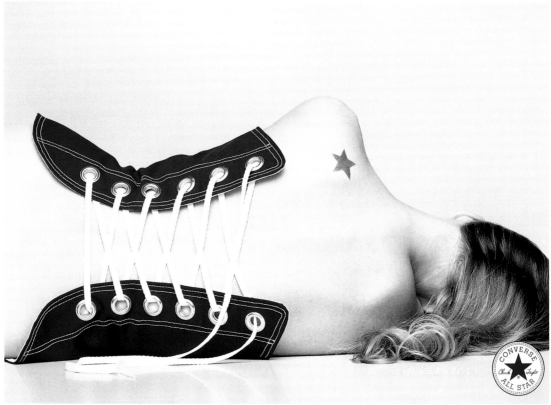

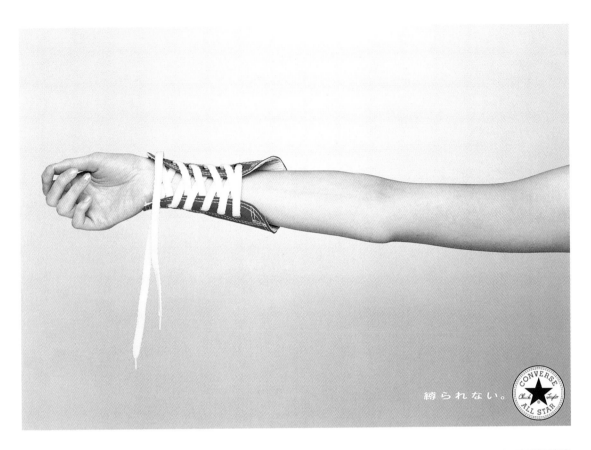

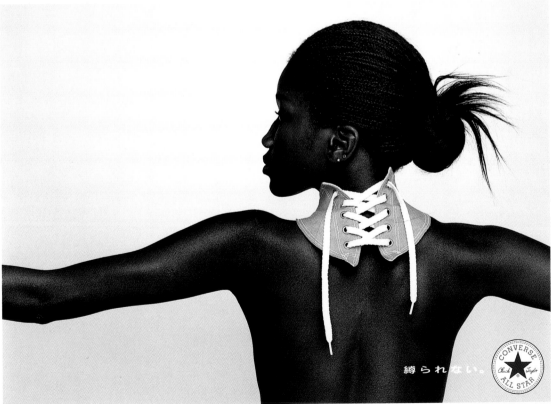

Distinctive Merit Posters: Transit, Campaign **Don't Get Tied Down**

ART DIRECTOR Toru Fujii **COPYWRITER** Tomoko Hasegawa **PHOTOGRAPHER** Aqua Disapora **DESIGNER** Akiko Shimojo **AGENCY PRODUCER** Midori Tamaki
AGENCY Dentsu Inc. **CLIENT** Converse Japan Co., Ltd. **COUNTRY** Japan

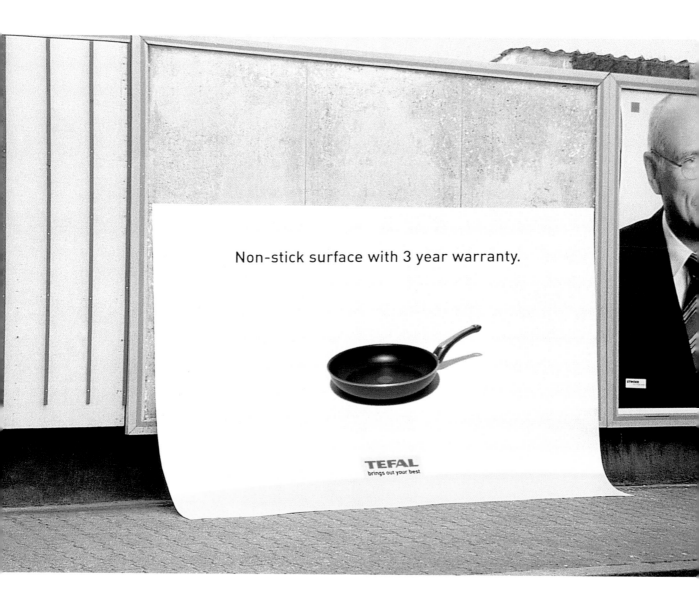

Distinctive Merit Billboard/Diorama/Painted Spectacular **Non-Stick Surface**

ART DIRECTOR Daniel Wudtke EXECUTIVE CREATIVE DIRECTOR Ljubomir Stoimenoff COPYWRITER Christoph Tratberger AGENCY Publicis Werbeagentur GmbH CLIENT Groupe SEB COUNTRY Germany

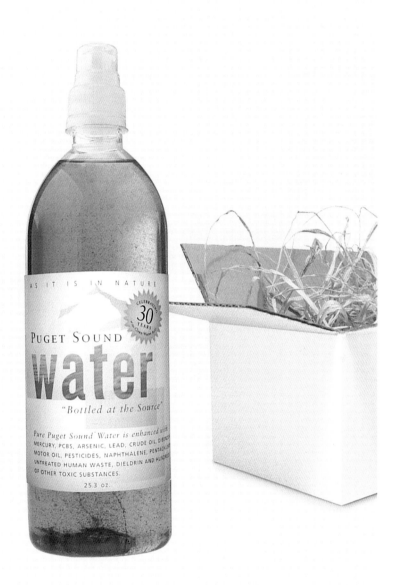

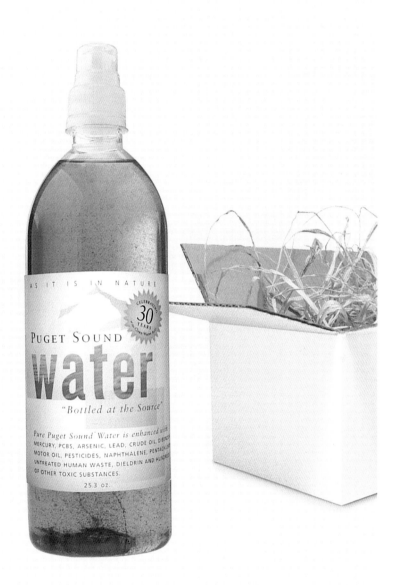

Distinctive Merit Direct Mail **Bottle**
ART DIRECTOR Pam Fujimoto **COPYWRITER** Cal McAllister **AGENCY** FUJICAL **CLIENT** People for Puget Sound **COUNTRY** United States

Distinctive Merit Point-of-Purchase Display **Squares**

ART DIRECTOR Kevin Dailor **CHIEF CREATIVE OFFICER** Ron Lawner **GROUP CREATIVE DIRECTOR** Alan Pafenbach **COPYWRITER** Tim Gillingham **PRODUCER**
Aidan Finnan **AGENCY** Arnold Worldwide **CLIENT** Volkswagen of America **COUNTRY** United States

Distinctive Merit Guerrilla Advertising/Unconventional Media **Ford Door Lock Promotion—Don't Drink and Drive**
ART DIRECTOR Alexander Heil **COPYWRITER** Cora Walker **AGENCY** Ogilvy & Mather—Frankfurt **CLIENT** Ford AG—Cologne **COUNTRY** Germany

Distinctive Merit Guerrilla Advertising/Unconventional Media **Bar-Bell Subway Promotion**

ART DIRECTORS Peter Steger, Klaus Trapp **COPYWRITERS** Andreas Heinzel, Mathias Henkel **AGENCY** Michael Conrad & Leo Burnett—Frankfurt
CLIENT Fitness Company **COUNTRY** Germany

Distinctive Merit Guerrilla Advertising/Unconventional Media, Campaign **Amnesty International—Street Activity for Human Rights**
ART DIRECTORS Hans-Jürgen Kämmerer, Uwe Marquardt **CREATIVE DIRECTORS** Hans-Jürgen Kämmerer, Uwe Marquardt **COPYWRITER** Robert Junker **DESIGN** Clay Art **PHOTOGRAPHERS** Elisabeth Herrmann, Hans-Jürgen Kämmerer **AGENCY** Michael Conrad & Leo Burnett—Frankfurt **CLIENT** Amnesty International **COUNTRY** Germany

FINGERS

Open on a regular guy sitting in his car, finishing a taquito and happily licking his fingers. **Pull back to reveal that he is actually licking the fingers of his buddy, the driver. The driver yanks his hand away.** VO: Maybe 7-Eleven's new Go-Go Taquitos are a little too tasty. **Cut to hero shot of Go-Go Taquitos.** VO: Go-Go Taquitos. They're a fresh new take on food to-go. **SUPER: 7-Eleven logo. Oh Thank Heaven.** SFX: Slurp. Aaah.

Merit TV: Under 30 Seconds **Fingers**

ART DIRECTOR Lou Flores **CREATIVE DIRECTORS** Brent Ladd, Mark Ray **COPYWRITERS** Cameron Day, Bill Johnson **EXECUTIVE PRODUCER** Lisa Rich **AGENCY PRODUCER** Khrisana Edwards **DIRECTOR** Craig Gillespie **EDITORS** John Hopp, Adam Parker **EDITING** Jigsaw **PRODUCTION** Morton Jankel Zander **AGENCY** GSD&M Advertising **CLIENT** 7-Eleven **COUNTRY** United States

BOYFRIEND

A beautiful, professionally-dressed spokeswoman stands in front of a male mannequin holding a can of Axe Deodorant Spray. SPOKESWOMAN: Here's a new deodorant called Axe. **Spokeswoman sprays the mannequin.** SPOKESWOMAN: Spray it like this to stay fresh all day. **She smells the mannequin and stares seductively at him. Then, a guy runs on camera and punches the mannequin in the face, knocking its head off. Horrified, the spokeswoman jumps in between the jealous guy and the mannequin.** SPOKESWOMAN: Roger! We were just talking! **SUPER: The Axe Effect. Cut to a shot of the product.** VO: Hey, careful with that Axe, tiger.

Merit TV: Under 30 Seconds **Boyfriend**

ART DIRECTOR Gerald Lewis **GROUP CREATIVE DIRECTOR** William Gelner **EXECUTIVE CREATIVE DIRECTOR** Kevin McKeon **AGENCY PRODUCER** Leticia Jacobs **DIRECTORS** Rick LeMoine, Steve Miller **EDITOR** Dick Gordon **EDITING** Mad River **MUSIC** Endless Noise **PRODUCTION** Radical Media **AGENCY** Bartle Bogle Hegarty **CLIENT** Unilever—Axe **COUNTRY** United States

PORTRAIT STUDIO

Open on a portrait photographer's studio that you would find in any typical mall. The photographer is slowly stepping away from a family he's just set up. As he steps away, he begins to slide around wildly. He knocks into the camera, which begins to go off. He then slides around the rest of the studio, tearing down various backdrops to keep himself from falling. In the end he completely ruins his set. Throughout all of this the family continues to sit still, smiling the entire time as the camera flashes. ANNOUNCER: Okay, now. Big smiles. Yes! Now, nobody move. **SUPER: Let's see you do your job on ice.** SFX: Buzzer and crowd cheering. **LOGO: Southwest Airlines.** SUPER: **Official airline of the NHL. southwest.com.** ©2003 NHL.

Merit TV: 30 Seconds **Portrait Studio**

ART DIRECTOR Kristen Hanson **GROUP CREATIVE DIRECTORS** Brent Ladd, Steve Miller **COPYWRITER** Gerard Seifert **EXECUTIVE PRODUCERS** Gregg Carlesimo, Jon Kamen **AGENCY PRODUCER** Karen Jacobs **DIRECTOR** Frank Todaro **EDITOR** Frank Todaro **EDITING** Matchframe, Outpost Digital **PRODUCTION** Radical Media **AGENCY** GSD&M Advertising **CLIENT** Southwest Airlines **COUNTRY** United States

GUTTER

Open on a shot of a home satellite dish. A golf ball hits it dead-center. We watch the ball roll down the roof and into the gutter. Cut to inside the house, where a woman and her son follow the noise of the ball across the roof. The ball eventually pops out of the gutter in the front yard and lands at the feet of a golfer, who immediately chips it back into the satellite dish. LOGO: PGA Tour. SUPER: These Guys Are Good.

Merit TV: 30 Seconds **Gutter**

ART DIRECTOR Tim Cole GROUP CREATIVE DIRECTORS Tom Gilmore, Rich Tlapek COPYWRITER Allen Hannawell EXECUTIVE PRODUCER Jay Wakefield PRODUCER Jeff Johnson DIRECTION Dom & Nic EDITOR Angelo Valencia EDITING 501 Post PRODUCTION Oil Factory AGENCY GSD&M Advertising CLIENT PGA Tour COUNTRY United States

The power of the written word.

A "pull" sign on a university door is changed to "push." We then see people desperately trying to move through the door—without any success, of course. A striking example of the power of the written word. **SUPER: The power of the written word.**

Merit TV: 30 Seconds **Come In**
ART DIRECTOR Erik Hart **COPYWRITER** Alexander Baron **STUDIO** 539090 Productions **AGENCY** Kolle Rebbe **CLIENT** Die Tageszeitung **COUNTRY** Germany

RUDE AWAKENING

A woman sits at a kitchen table reading a newspaper. Her husband walks in wearing boxers and a t-shirt. He opens the fridge, takes out a carton of milk, pauses to see his wife is not watching and drinks straight from the carton. He spits out the sour milk. WIFE (CASUALLY): The fridge is broken. **SUPER: Refrigerators on sale.** VO: Refrigerators on sale. **SUPER: Sears. Where else?**

Merit TV: 30 Seconds **Rude Awakening**

ART DIRECTORS Stuart Cohn, Mitch Gordon **EXECUTIVE CREATIVE DIRECTOR** Joe Sciarrotta **CREATIVE DIRECTOR** Mitch Gordon **COPYWRITER** Josh Kemeny
PRODUCER Ray Lyle **EDITOR** Tom Pershke **CLIENT** Sears, Roebeck and Co. **COUNTRY** United States

NORTH BRISTOL FORTY—RAGE

Open on Dr. Steven Singer, the SportsCenter team physician, talking to camera. Cut to anchor Kenny Mayne struggling to get out of bed. Cut back to Dr. Singer talking to camera. Cut back to Kenny collapsing in his bedroom. Cut back to Dr. Singer talking to camera. Cut to a close-up of Dr. Singer dispensing Flintstones children's vitamins. Cut to Dr. Singer in the examining room with anchor Rich Eisen. Cut back to Dr. Singer talking to camera. Cut to anchors Chris McKendry and a freakishly muscular and hairy Trey Wingo on the SportsCenter set. For no reason whatsoever Trey screams at Chris. Cut back to Dr. Singer talking to camera.

Merit TV: 30 Seconds **North Bristol Forty—Rage**

ART **DIRECTOR** Ted Royer **COPYWRITER** Jeff Bitsack **AGENCY PRODUCER** Chris Noble **DIRECTOR** David Shane **DIRECTOR OF PHOTOGRAPHY** Joe DeSalvo **EDITOR** Dave Koza **PRODUCTION** Hungry Man **AGENCY** Wieden + Kennedy—NY **CLIENT** ESPN **COUNTRY** United States

SIP, NOT GUZZLE

 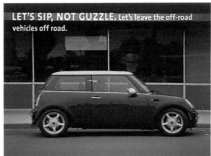 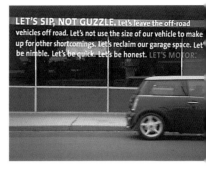

We see footage of the side of a building. Jazz music kicks in. The MINI enters frame and stops. Line by line, the supers fade up and stay up: Let's sip, not guzzle. Let's leave the off-road vehicles off road. Let's not use the size of our vehicle to make up for other shortcomings. Let's reclaim our garage space. Let's be nimble. Let's be quick. Let's be honest. Let's motor. The MINI drives off. LOGO: MINI.

BURN THE MAPS

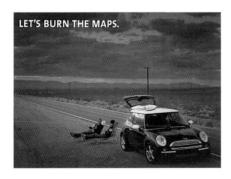 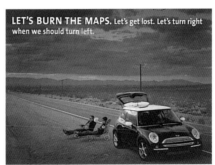 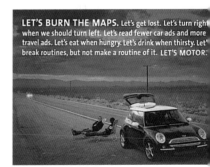

We see footage of two guys hanging out on the side of the road next to their parked MINI. Line by line, the supers fade up and stay up: Let's burn the maps. Let's get lost. Let's turn right when we should turn left. Let's read fewer car ads and more travel ads. Let's eat when hungry. Let's drink when thirsty. Let's break routines, but not make a routine of it. Let's motor. LOGO: MINI.

Merit TV: 30 Seconds, Camaign **Sip, Not Guzzle • Burn the Maps**

ART DIRECTORS Alex Burnard, Mark Taylor CREATIVE DIRECTOR Alex Bogusky ASSOCIATE CREATIVE DIRECTOR Andrew Keller COPYWRITERS Ari Merkin, Steve O'Connell DIRECTOR PLUS AGENCY Crispin Porter + Bogusky CLIENT MINI COUNTRY United States

SODA

 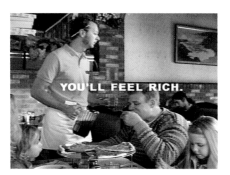

Open on a family having dinner in a pizza parlor. A waiter walks over with a pitcher of soda and begins to fill the glasses. The father motions for him to stop. He picks up the glass and looks down his nose at it, while swirling the soda around. He sniffs the bouquet. He takes a sip and swishes it around in his mouth. Finally, he decides that it will not do, and he hands it back to the waiter, who is not quite sure what to do. SUPER: You'll feel rich. LOGO: Value City Department Stores.

MEN'S ROOM

Open on a man washing his hands in a public restroom. We hear a toilet flush and another man begins to wash his hands at the other sink. The first man finishes and goes to the paper towel dispenser. The second man finishes, turns around, and holds out his hands, apparently waiting for the first man to dry them. The first man looks very confused, but eventually hands him a paper towel anyway. The second man proceeds to dry his hands. SUPER: You'll feel rich. LOGO: Value City Department Stores.

CAR

Open on a garage door opening. A couple is getting into their car. When we see the inside of the car, we notice that the wife has gotten into the back seat. The husband notices this and looks confused. The wife is sitting leisurely in the back, reading the newspaper. The husband turns around and starts the car. SUPER: You'll feel rich. LOGO: Value City Department Stores.

Merit TV: 30 Seconds, Camaign **Soda • Men's Room • Car**

ART DIRECTORS Rob Carducci, Dan Kelleher CREATIVE DIRECTORS Arthur Bijur, Cliff Freeman COPYWRITER Adam Chasnow AGENCY Cliff Freeman and Partners CLIENT Value City COUNTRY United States

VERY RICH

 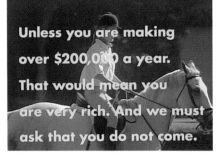 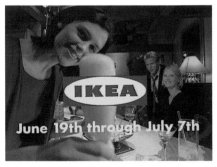

Open on a woman skillfully riding a beautifully groomed white horse. Type begins to scroll up the screen read by a dry, Swedish announcer. ANNOUNCER: We would like to invite everyone to the IKEA Summer Sale Event. Unless you are making over $200,000 a year. That would mean you are very rich. And we must ask that you do not come. You do not need to save up to 50% on select items throughout the store. You obviously have enough money to purchase IKEA items at the regular everyday low price. LOGO: IKEA. SUPER: The IKEA Summer Sale Event, June 19th through July 7th.

SPECIAL

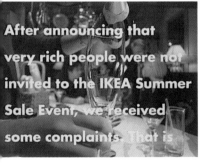 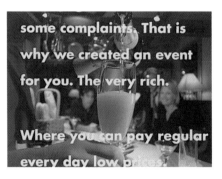 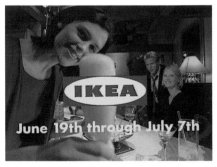

We open on slow motion footage of a glass of champagne being poured at a dinner party. Type begins to scroll up the screen read by a dry, Swedish announcer. ANNOUNCER: After announcing that very rich people were not invited to the IKEA Summer Sale Event, we received some complaints. That is why we created an event for you. The very rich. Where you can pay regular everyday low prices. It will begin one day after the IKEA Summer Sale Event. To which you are not invited. LOGO: IKEA. SUPER: The IKEA Summer Sale Event, June 19th through July 7th.

$190,000

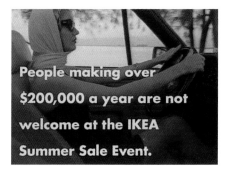

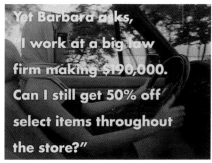

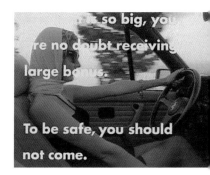

We open on a fancy-looking lady driving a fancy-looking car on a fancy-looking street. Type begins to scroll up the screen read by a dry, Swedish announcer. ANNOUNCER: People making over $200,000 a year are not welcome at the IKEA Summer Sale Event. Yet Barbara asks, "I work at a big law firm making $190,000. Can I still get 50% off select items throughout the store?" Well, Barbara, if your law firm is so big, you are no doubt receiving a large bonus. To be safe, you should not come. LOGO: IKEA. SUPER: The IKEA Summer Sale Event, June 19th through July 7th.

Merit TV: 30 Seconds, Camaign **Very Rich • Special • $190,000**

ART DIRECTOR Mark Taylor CREATIVE DIRECTOR Alex Bogusky ASSOCIATE CREATIVE DIRECTOR Paul Keister COPYWRITER Ari Merkin AGENCY Crispin Porter + Bogusky CLIENT IKEA COUNTRY United States

BEAR'S CHOICE

Open on a group of women gathered around a bear in what looks like a zoo. The bear looks very threatening and some of the women look worried. WOMAN: Are we going to be eaten? 'Cause we look so delicious? The women and the bear are caught in some sort of standoff. SUPER: Women's pride matters over life. SUPER: For your skin condition.

Merit TV: Over 30 Seconds **Bear's Choice**
ART DIRECTOR Masahiro Izuo CREATIVE DIRECTOR Ichiro Kamata COPYWRITER Masahiro Izuo AGENCY PRODUCER Koji Wada DIRECTOR Gen Sekiguchi
PRODUCTION Paradise Café Inc. AGENCY Dentsu Inc. CLIENT Chrystal Jemmy Cosmetics Inc. COUNTRY Japan

SMART ARSE

Open on a man walking into a record store. MAN: Have you got the new Björk CD? CLERK: Sorry? MAN: The new Björk CD? **The clerk is obviously "busy" with his Rubik's Cube.** CLERK: No, sorry, haven't got the new Björk CD. **Clerk looks annoyed.** CLERK: Got the new Björk CD, though (pronouncing it "Bjerk"). MAN: Yeah, I think that's what I just said. CLERK: No, you said "Björk." **Man looks confused. Another customer walks up to the counter.** CUSTOMER: New Bjerk CD please (pronouncing it "correctly"). **Clerk happily hands it to him.** MAN: He said Björk. CLERK: No, he didn't. He asked for the Bjerk CD. MAN: Well, can I have the Bjerk CD? CLERK: Just sold the last one. **Man picks up an album and hits the clerk with it, then runs out of the store. SUPER: The Observer. This Sunday.** VO: An exclusive new Bjerk CD. Free this week with every copy of the Obs-yerver.

Merit TV: Over 30 Seconds **Smart Arse**

CREATIVE DIRECTOR Jim Thornton **CREATIVES** Joe Desauza, Sam Walker **EXECUTIVE PRODUCERS** Matt Buels (UK), Stephen Orent (NY) **DIRECTOR** Owen Harris
DIRECTOR OF PHOTOGRAPHY Ray Coates **PRODUCTION** Hungry Man **AGENCY** Mother—London **CLIENT** Observer **COUNTRY** United Kingdom

CEMENTERIO

Open on an old lady kneeling down, praying by her husband's grave in the cemetery. As we see her praying, we start to hear the sound of a watch's alarm. She hears that and starts looking around her, as if looking for someone wearing that watch, but she finds no one. She even puts her own watch close to her ear to check if that sound is coming from there, but it isn't. Suddenly, she looks at her husband's grave and starts bending down until her ear is close to the ground, only to find out that the noise becomes clearer when she does that.

Merit TV: Over 30 Seconds **Cementerio**

ART DIRECTOR Javier Busto **EXECUTIVE CREATIVE DIRECTORS** Juan Cravero, Dario Lanis **CREATIVE DIRECTOR** Gustavo Reyes **COPYWRITER** Mariano Duhalde **AGENCY** CraveroLanis Euro RSCG **CLIENT** Philips Bateria Larga Vida **COUNTRY** Argentina

TENNIS COURT

Open on a group of girls on a tennis court warily approaching a giant egg. One of the girls cautiously touches it with her racket. **Suddenly it breaks open and two men jump out.** MAN 1: Real figures! MAN 2: Internet games! They repeat this back and forth. **SUPER: Twice the surprise.** MEN (TOGETHER): New Kinder surprise!

Merit TV: Spots of Varying Length **Tennis Court** ▪ **Girls High School** ▪ **Kindergarten**
ART DIRECTOR Tomoaki Tsuji **COPYWRITERS** Osamu Inagaki, Tomoaki Tsuji **DIRECTOR OF PHOTOGRAPHY** Naoki Matsumoto
PRODUCTION Toei Commercial Film Co., Ltd. **AGENCY** Dentsu Inc. Kansai **CLIENTS** Ezaki Glico Co. Ltd., Ferrero Japan Ltd. **COUNTRY** Japan

TED WASHINGTON

Open on Ted Washington with a group of kids in the woods. VO: This is Ted Washington of the Chicago Bears. **Cut to shots of Ted showing them how to use a map, start a fire, and tie a knot.** TED: This is how you start a fire. VO: Ted helps the United Way build stronger communities by participating in programs that promote confidence and self-sufficiency. **Cut to shot of Ted catching a youngster as he falls backward.** TED: OK. That's what we call the trust game. Billy trusted me to catch him, so now I'm going to trust Mike to catch me. **Mike, who is the smallest kid there, walks behind Ted. Ted falls backward, while Mike stares at him. Ted hits the ground hard. Mike looks around as the other kids applaud nervously.** LOGO: NFL. United Way. VO: Trust takes time.

ISSUES BOOK

Open on an orange velvet curtain. SUPER: Truth Behind the Curtain. **The orange curtain is pulled back to reveal a teenage girl standing on Park Avenue in New York City. There are corporate skyscrapers lining the block.** TEEN: This is a CEO issues book. It was used by a tobacco company in 1996 so their executives would know the right answers to all the tough questions they got asked. **She opens it up. She gives a "you've-got-to-be-kidding" glance to the camera.** TEEN: Like "In light of health studies, why do you stay in the tobacco business?" Their official answer: "We believe we can continue to operate our business successfully." **She thinks for a second.** TEEN: So, 440,000 people die each year, and that's a success? SUPER: **This is what we know. Imagine what we don't.** LOGO: truth.

[T] **Merit** TV: Public Service/Nonprofit **Ted Washington**

ART DIRECTOR David Skinner CREATIVE DIRECTOR Jim Ferguson COPYWRITER Darren Wright PRODUCER Charlie Capuano AGENCY Young & Rubicam—NY CLIENT United Way COUNTRY United States

[B] **Merit** TV: Public Service/Nonprofit **Issues Book**

ART DIRECTORS Rob Baird, Ryan O'Rourke CHIEF CREATIVE OFFICER Ron Lawner GROUP CREATIVE DIRECTORS Alex Bogusky, Pete Favat CREATIVE DIRECTORS Roger Baldacci, Ari Merkin COPYWRITERS Roger Baldacci, Steve O'Connell AGENCIES Arnold Worldwide, Crispin Porter + Bogusky CLIENT American Legacy Foundation COUNTRY United States

POLITICAL AD

ANNOUNCER: Jim Perdue has a mission. A mission about chicken. JIM: My Oven Stuffer Roaster is bigger than your average chicken. So you can cook it once and have meals for days. ANNOUNC-ER: What this country needs is a chicken you can cook once, and have meals for days. JIM: You can have meals like chicken fajitas... ANNOUNCER: ...chicken fajitas... JIM: ...chicken roll-ups... AN-NOUNCER: ...chicken roll-ups... JIM: Why do you keep repeating everything I say? ANNOUNCER: Why do I keep repeating everything Jim Perdue says? JIM: This is annoying. ANNOUNCER: Jim Perdue finds this annoying. JIM: No, I find you annoying. ANNOUNCER: No, I find you annoying. JIM: I know you are, but what am I? ANNOUNCER: I know you are, but what am I? JIM: Okay, um—I'm an idiot. ANNOUNCER: (Pauses) Okay. JIM: I should have seen that coming. Try my Oven Stuffer Roaster—you can cook it once and have meals for days. ANNOUNCER: ...meals for days... JIM: Oh, brother.

FM 88 92 96 102 108 MHz

AM 5.3 7 10 12 14 17 kHz

Merit Radio: Over 30 Seconds **Political Ad**

CHIEF CREATIVE OFFICER Gary Goldsmith **EXECUTIVE CREATIVE DIRECTOR** Dean Hacohen **CREATIVE DIRECTORS** Simon Bowden, Eddie Van Bloem **COPYWRITER** Eddie Van Bloem **AGENCY PRODUCER** David Gerard **PRODUCTION** McHale Barone **AGENCY** LOWE—New York **CLIENT** Perdue Farms, Inc. **COUNTRY** United States

THE AXE EFFECT PUBLIC SITE

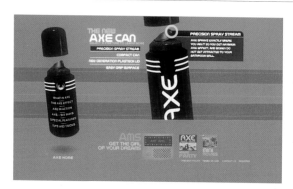

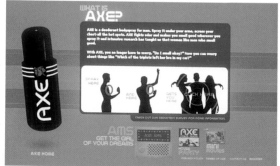

Merit Interactive Advertising: Web Site **The Axe Effect Public Site**

GROUP CREATIVE DIRECTOR William Gelner EXECUTIVE CREATIVE DIRECTOR Kevin McKeon COPYWRITER Peter Kain DIGITAL DIRECTOR Matt Campbell
AGENCY Bartle Bogle Hegarty CLIENT Unilever—Axe COUNTRY United States

GROSSMOKE

Merit Interactive Advertising: Web Site **Grossmoke**

ART DIRECTOR Tim Varner **EXECUTIVE CREATIVE DIRECTOR** Tom Hudder **COPYWRITER** Mike Dillon **PROJECT MANAGER** Mark Loucks
ACCOUNT EXECUTIVE Crystal Merritt **STUDIO** Atomic Dust **AGENCY** Rodgers Townsend **CLIENT** American Lung Association of Eastern Missouri
COUNTRY United States

NIKE BASKETBALL

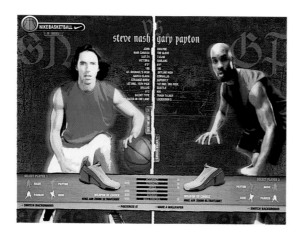
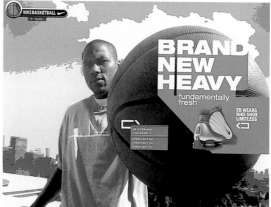
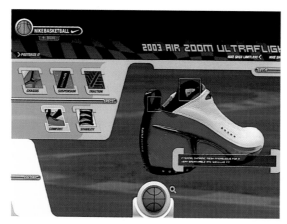
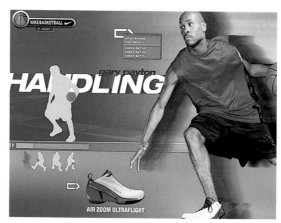

Merit Interactive Advertising: Web Site **Nike Basketball**

ART DIRECTOR Nathan Iverson **COPYWRITER** Jason Marks **FLASH DESIGNERS** Andrew Hsu, David Morrow **EXECUTIVE PRODUCER** Kip Voytek
PRODUCER Shawn Natko **AGENCY** R/GA **CLIENT** Nike **COUNTRY** United States

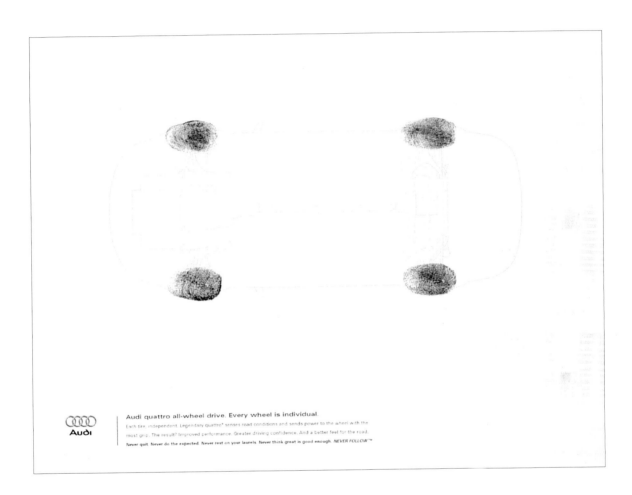

Audi quattro all-wheel drive. Every wheel is individual.

Each tire, independent. Legendary quattro® senses road conditions and sends power to the wheel with the most grip. The result? Improved performance. Greater driving confidence. And a better feel for the road.

Never quit. Never do the expected. Never rest on your laurels. Never think great is good enough. *NEVER FOLLOW™*

Merit Consumer Newspaper: Less Than a Full Page **Fingerprint**

ART DIRECTOR Dino Valentini **COPYWRITER** Jon Wagner **AGENCY** McKinney & Silver **CLIENT** Audi of America, Inc. **COUNTRY** United States

A big fat thanks to record execs

Thank you for fighting the good fight against Internet MP3 file-swapping. Because of you, millions of kids will stop wasting time listening to new music and seeking out new bands. No more spreading the word to complete strangers about your artists. No more harmful exposure to thousands of bands via Internet radio either. With any luck they won't talk about music at all. You probably knew you'd make millions by embracing the technology. After all, the kids swapping were like ten times more likely to buy CD's, making your cause all the more admirable. It must have cost a bundle in future revenue, but don't worry – computers are just a fad anyway, and the Internet is just plain stupid.

Rolling Stone

Live fast, die a senior citizen

Burn out or fade away? How about burn brightly for dozens and dozens of years. Drugs, debauchery, trashed hotels, women half your age; today's flash-in-the-pan rock star needs a role model to keep the dream alive! We give you, Keith Richards. The gnarly 508 is an incredible guitarist, and he's written dozens of songs that knock you on your ass. Never so desperate for a hit that he and his cohorts bring in some bubble gum pop producer to craft something radio friendly. Is he a geriatric? Technically. But what's he supposed to do – dig a six-foot hole and throw himself in? Hell, at some point he probably did. You don't like him, you think he can't rock because he's pushing 60 – guess what? He doesn't give a shit.

Rolling Stone

Squeaking by on a 4000% mark-up

Somewhere in Malibu, a music exec lies on his $7000 Mies Van Der Rohe daybed, whimpering because album sales are down. A CD costs roughly 40¢ to produce and package, and despite charging twenty bucks for it, he's losing his Commes Des Garcons shirt. Premature releases featuring one good song plus forty minutes to forget won't garner much sympathy. Won't fill that six car garage either. Maybe you should charge more. No wait, you already tried that.

Rolling Stone

Merit Consumer Newspaper: Less Than a Full Page, Campaign **A Big Fat Thanks** ▪ **Live Fast, Die a Senior Citizen** ▪ **4000% Mark-Up**
ART DIRECTOR John Hobbs **EXECUTIVE CREATIVE DIRECTOR** Kevin McKeon **COPYWRITER** Peter Rosch **AGENCY** Bartle Bogle Hegarty **CLIENT** Rolling Stone
COUNTRY United States

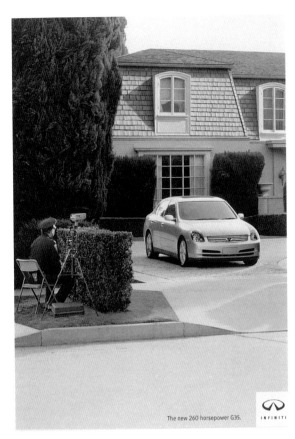

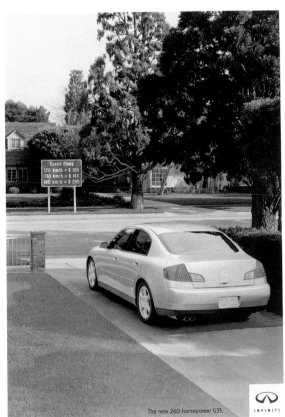

Merit Consumer Newspaper: Full Page, Campaign **Speed Bump · Cop · Speed Fines**
ART DIRECTOR Benjamin Vendramin **COPYWRITER** Pat Pirisi **AGENCY** TBWA\Chiat\Day **CLIENT** INFINITI **COUNTRY** Canada

The New York Times

The New York Times

The New York Times

The New York Times

The New York Times

Merit Consumer Newspaper: Full Page, Campaign **Fishnets** ▪ **Sports Fan** ▪ **Guggenheim** ▪ **Confederate Flag** ▪ **Burka**
ART DIRECTORS Jan Jacobs, Molly Sheahan **GROUP CREATIVE DIRECTOR** Jan Jacobs **EXECUTIVE CREATIVE DIRECTOR** Tony Granger **COPYWRITER** Amber Logan
ART PRODUCER Maggie Meade **AGENCY** Bozell—New York **CLIENT** The New York Times **COUNTRY** United States

Merit Public Service/Nonprofit Newspaper: Full Page, Campaign **How to Create a Newspaper Ad by Luke Sullivan** • **How to Create a Newspaper Ad by Mike Hughes** • **How to Create a Newspaper Ad by Lee Clow**

ART DIRECTORS Mark Braddock, Michael Wright CREATIVE DIRECTOR Alon Shoval COPYWRITERS Lee Clow, Mike Hughes, Alon Shoval, Luke Sullivan
ILLUSTRATORS Paul Davis, Brad Holland, Jack Unruh STUDIO ARTIST Ben Eley PRINT PRODUCER Jenny Schoenherr ACCOUNT MANAGER Lawson Waring
AGENCY The Martin Agency CLIENT Newspaper Association of America COUNTRY United States

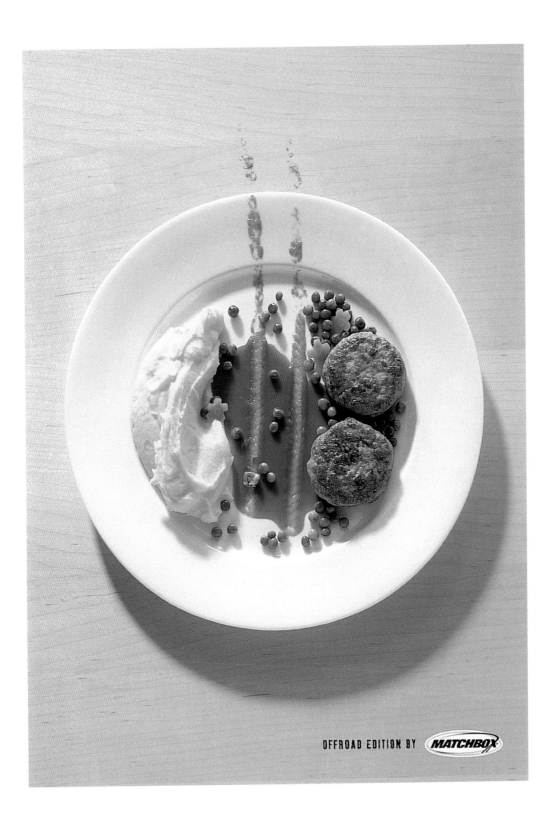

OFFROAD EDITION BY *MATCHBOX*

Merit Consumer Magazine: Full Page **Offroad on the Plate** | **Merit** Posters: Point-of-Purchase **Offroad on the Plate**

ART DIRECTOR Alexandra Brunner **CREATIVE DIRECTORS** Bernd Lange, Gregor Seitz **COPYWRITER** Silja Spranger **PHOTOGRAPHER** Wolfgang Usbeck
AGENCY Ogilvy & Mather—Frankfurt **CLIENT** Mattel—Germany **COUNTRY** Germany

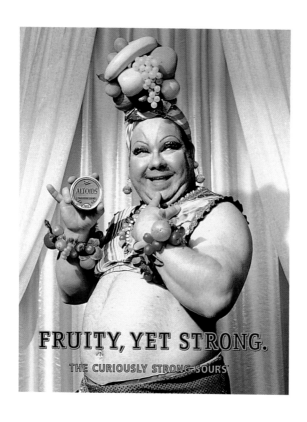

Where are the ugly rockstars?

they were once a shining beacon of hope to oddballs everywhere who figured, "man if I'm ever going to get laid I'd better grab a guitar." All you see on music television these days are models, socialites, and "the beautiful people." If this trend continues millions of uglies everywhere will be left in the dark, never aware that they too can "get some" with-dizzying regularity. If you're remotely ugly, please get back in the game.

Rolling Stone

L **Merit** Consumer Magazine: Full Page **Fruity Boy**

ART DIRECTOR Noel Haan **EXECUTIVE CREATIVE DIRECTORS** Mark Faulkner, Steffan Postaer **CREATIVE DIRECTORS** Noel Haan, G. Andrew Meyer
COPYWRITER G. Andrew Meyer **PHOTOGRAPHER** Tony D'Orio **AGENCY** Leo Burnett Company **CLIENT** Kraft—Altoids Sours **COUNTRY** United States

R **Merit** Consumer Magazine: Full Page **Ugly Rock Stars**

ART DIRECTOR John Hobbs **EXECUTIVE CREATIVE DIRECTOR** Kevin McKeon **COPYWRITER** Peter Rosch **AGENCY** Bartle Bogle Hegarty **CLIENT** Rolling Stone
COUNTRY United States

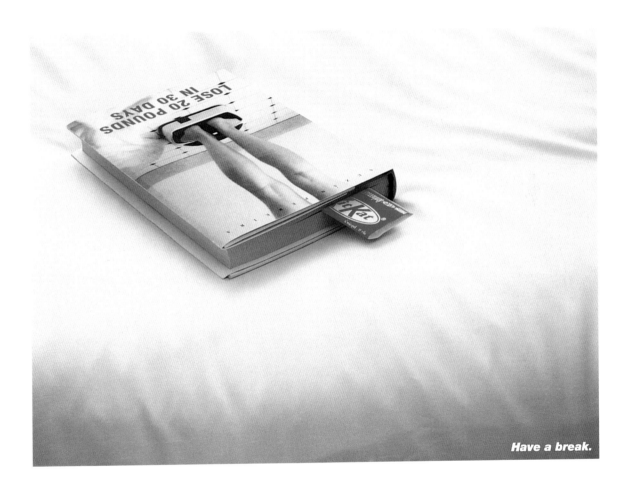

Have a break.

Merit Consumer Magazine: Full Page **Bookmark**

ART DIRECTORS Thanapong Suplealai, Vancelee Teng **COPYWRITER** Sairoong Mahapaurya **PHOTOGRAPHER** Niphon Baiyen **AGENCY** LOWE—Bangkok
CLIENT Nestle—Kit Kat **COUNTRY** Thailand

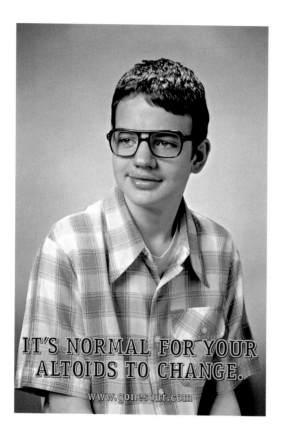

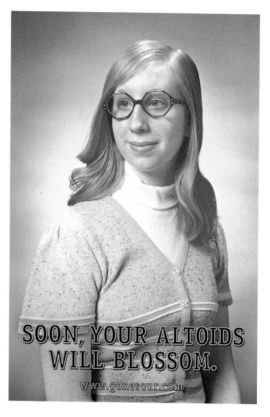

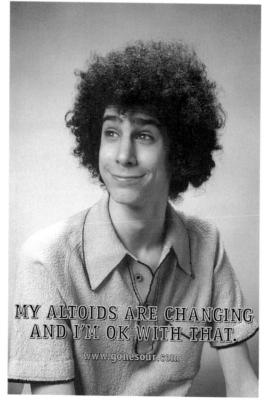

Merit Consumer Magazine: Full Page, Campaign **Normal** • **Blossom** • **OK with That** • **Explore**
ART DIRECTOR Noel Haan **EXECUTIVE CREATIVE DIRECTORS** Mark Faulkner, Steffan Postaer **CREATIVE DIRECTORS** Noel Haan, G. Andrew Meyer
COPYWRITER G. Andrew Meyer **PHOTOGRAPHER** Tony D'Orio **AGENCY** Leo Burnett Company **CLIENT** Kraft—Altoids Sours **COUNTRY** United States

Merit Consumer Magazine: Full Page, Campaign **Schmock Israeli Restaurant**

ART DIRECTOR Stefan Melzer **CREATIVE DIRECTOR** Niels van Hoek **COPYWRITER** Niels van Hoek **PHOTOGRAPHER** Jan Frommel **ACCOUNT MANAGER** Joerg Brenner
AGENCY Hinterm Mond **CLIENT** Schmock Israeli Restaurant **COUNTRY** Germany

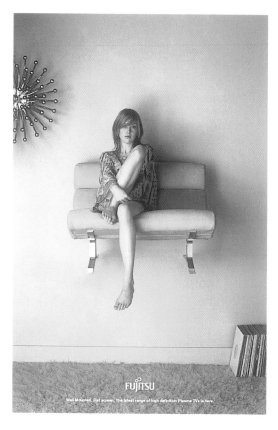

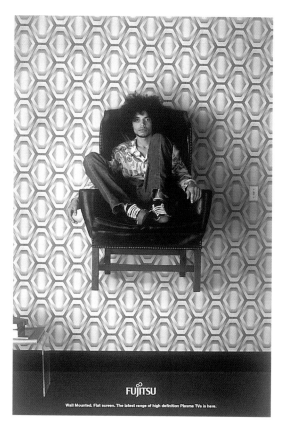

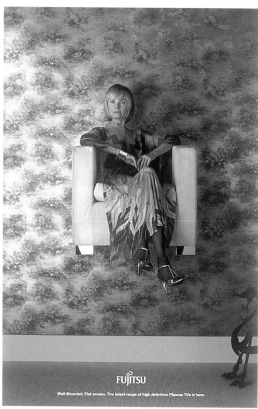

Merit Consumer Magazine: Full Page, Campaign **Young Girl** ▪ **Young Guy** ▪ **Older Woman**

ART DIRECTOR Glen Jacobs GROUP CREATIVE DIRECTOR Glen Jacobs EXECUTIVE CREATIVE DIRECTOR Tony Granger COPYWRITER David Nobay
PHOTOGRAPHER John Offenbach ART PRODUCER Hillary Frileck AGENCY Bozell—New York CLIENT Fujitsu, Ltd. COUNTRY United States

Merit Consumer Magazine: Full Page, Campaign **Gary Panter** ▪ **Mary Ellen Mark** ▪ **I Am Part Human**

ART DIRECTOR Danielle Flagg **COPYWRITER** Derek Barnes **PHOTOGRAPHER** Grant Delin **AGENCY** Wieden + Kennedy **CLIENT** Allsteel **COUNTRY** United States

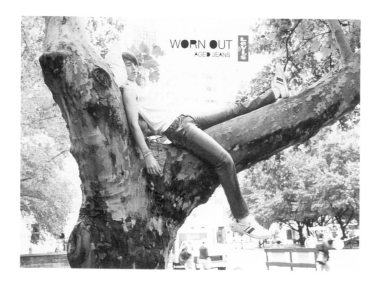

Merit Consumer Magazine: Full Page, Campaign **Traffic** ▪ **Phone** ▪ **Tree**

ART DIRECTOR Scott McClelland **COPYWRITER** Parag Tembulkar **PHOTOGRAPHER** Clang **AGENCY** Bartle Bogle Hegarty Ltd.—Asia Pacific **CLIENT** Levi Strauss—Asia Pacific **COUNTRY** Singapore

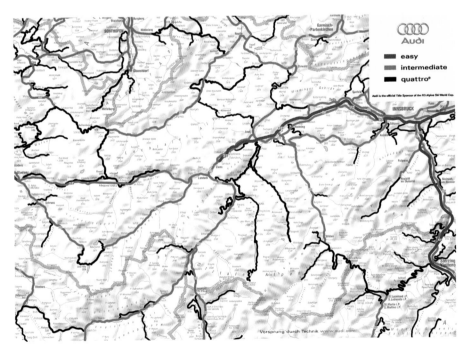

T **Merit** Consumer Magazine: Full Page **Blow Pipe**
ART DIRECTOR Remy Tricot COPYWRITER Olivier Couradjut PHOTOGRAPHER Renault Loisy AGENCY BDDP & Fils CLIENT MINI COUNTRY France

B **Merit** Consumer Magazine: Spread **Ski-Tracks**
ART DIRECTORS Anne Petri, Volker Schrader COPYWRITERS Anne Petri, Tom Tilliger AGENCY Saatchi & Saatchi—Frankfurt CLIENT Audi AG COUNTRY Germany

Design proposal No.6

Please note we didn't carry the re-design thing too far [see exhibit at left].
Our idea was simpler. We're introducing a new section three days a week, Personal Journal,
featuring articles on personal finance, health and family, travel, cars and gadgets.
We've also tweaked the layout for easier navigation and readability —
and, oh yes, we've added just the most judicious hint of color.
Otherwise, it's the same old brilliant rigorous shrewd witty authoritative Journal.

Coming April 9.

Design proposal No.4

Please note we didn't carry the re-design thing too far [see exhibit at left].
Our idea was simpler. We're introducing a new section three days a week, Personal Journal,
featuring articles on personal finance, health and family, travel, cars and gadgets.
We've also tweaked the layout for easier navigation and readability —
and, oh yes, we've added just the most judicious hint of color.
Otherwise, it's the same old brilliant rigorous shrewd witty authoritative Journal.

Coming April 9.

Design proposal No.3

On April 9, you'll discover a Wall Street Journal that bears
absolutely no resemblance to the exhibit at left. Our idea was simpler.
We're pleased to introduce an expanded and enhanced Journal,
covering not only business but the business of life. We're publishing a new section
three days a week, Personal Journal, featuring articles on personal
finance, health and family, travel, cars and gadgets.
We've also tweaked the layout for easier navigation and readability.
And, oh yes, we've added just the most judicious hint of color.
Otherwise, it's the same old brilliant rigorous shrewd witty authoritative Journal.

Coming April 9.

(Details TBD)

Merit Consumer Magazine: Spread, Campaign **The Wall Street Journal Teaser Campaign**

ART DIRECTORS Keith Anderson, Christopher Gyorgy, Paul Hirsch COPYWRITERS Christopher Gyorgy, Paul Hirsch, Steve Simpson PRINT PRODUCER
Michael Stock AGENCY Goodby, Silverstein & Partners CLIENT The Wall Street Journal COUNTRY United States

Merit Consumer Magazine: Spread, Campaign **Options 1, 2, 3**
ART DIRECTOR Carlos Andre Eyer **COPYWRITERS** Fernando Campos, Alexandre Motta **PHOTOGRAPHER** Mauro Risch **CLIENT** S.C. Johnson **COUNTRY** Brazil

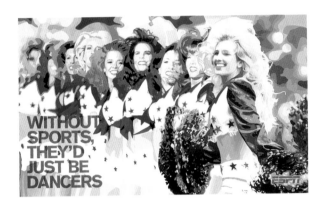

WITHOUT SPORTS, THEY'D JUST BE DANCERS

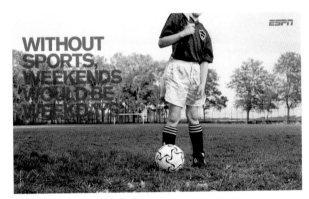

WITHOUT SPORTS, WEEKENDS WOULD BE WEEKDAYS

WITHOUT SPORTS, THERE D ONLY BE GUM

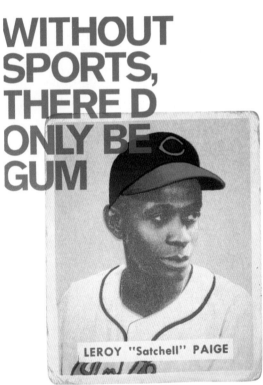

LEROY "Satchell" PAIGE

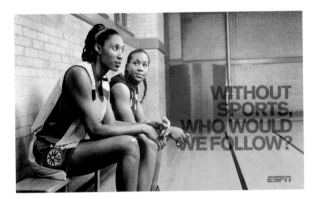

WITHOUT SPORTS, WHO WOULD WE FOLLOW?

Merit Consumer Magazine: Spread, Campaign **Dancers** • **Weekends/Weekdays** • **Follow** • **Gum**

ART DIRECTOR Kim Schoen **COPYWRITER** Keven Proudfoot **PHOTOGRAPHERS** Dana Lixenburg (Follow), Collier Schorr (Weekends/Weekdays)
ILLUSTRATOR Deanna Cheuk **AGENCY** Wieden + Kennedy—NY **CLIENT** ESPN **COUNTRY** United States

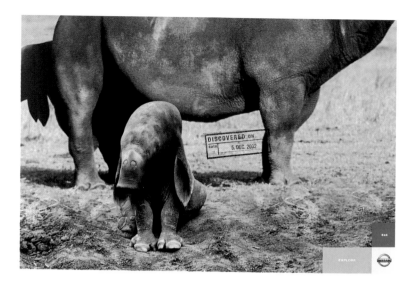

Merit Consumer Magazine: Spread, Campaign **Explore—Caprimulgus • Urubu • Aracari**

ART DIRECTOR Sebastien Vacherot **COPYWRITER** Manoelle van der Vaeren **PHOTOGRAPHERS** Eastcott Mamatiuk, Art Wolfe **PHOTOGRAPHY** Getty Images
AGENCY TBWA\Paris **CLIENT** Nissan **COUNTRY** France

Congratulations to the 2002 Cannes winners.

Leo Burnett

Merit Trade Magazine: Full Page **Pat on the Back**

ART DIRECTOR Brian Shembeda **EXECUTIVE CREATIVE DIRECTOR** Mark Tutssel **CREATIVE DIRECTORS** Jeff Labbe, Kash Sree **COPYWRITER** Avery Gross
AGENCY Leo Burnett Company **CLIENT** Leo Burnett Company **COUNTRY** United States

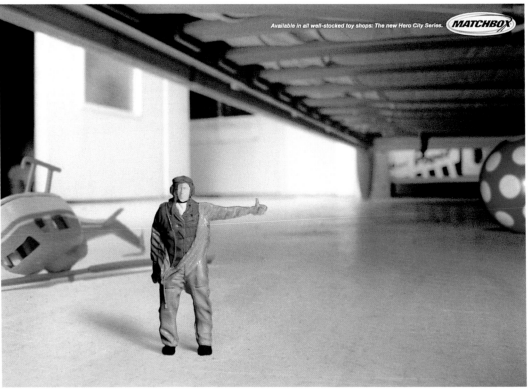

Merit Trade Magazine: Spread, Campaign **Matchbox—Indian ▪ Pilot**

ART DIRECTOR Evi Nern CREATIVE DIRECTORS Simon Oppmann, Peter Römmelt COPYWRITER Olga Potempa DESIGNER Dominik Kentner PHOTOGRAPHERS
Paul von Mühlendahl, Evi Nern AGENCY Ogilvy & Mather—Frankfurt CLIENT Mattel—Germany COUNTRY Germany

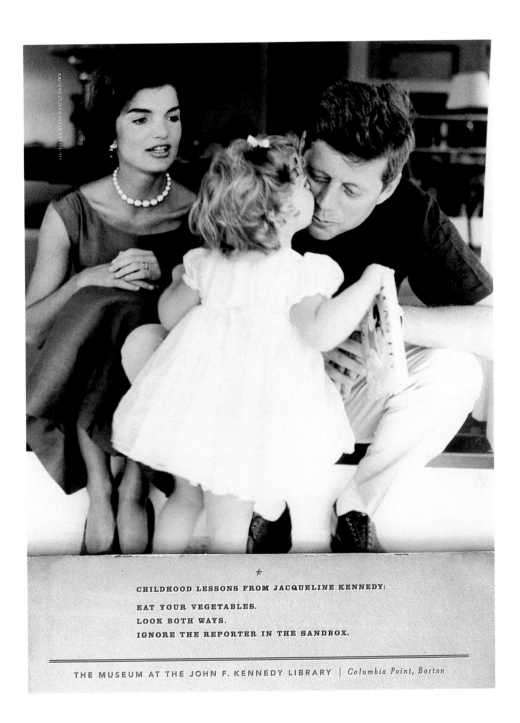

Merit Public Service/Nonprofit Magazine: Full Page **Childhood Lessons from Jacqueline Kennedy: Eat Your Vegetables, Look Both Ways, Ignore the Reporter in the Sandbox**

ART DIRECTOR Tom Gibson **CREATIVE DIRECTOR** Joe Alexander **COPYWRITERS** Joe Alexander, Josh Gold **PHOTOGRAPHER** Jacques Lowe **STUDIO ARTIST** Greg Cassidy **PRINT PRODUCER** Linda Locks **ART PRODUCER** Cindy Hicks **ACCOUNT EXECUTIVE** Jackie Gelman **CLIENT** John F. Kennedy Library Foundation **COUNTRY** United States

Issued in the public interest by Khaleeji

Merit Public Service/Nonprofit Magazine: Full Page **Loading Cancer**

ART DIRECTORS Vitthal Deshmukh, Arun Divakaran **CREATIVE DIRECTORS** Vitthal Desmukh, John Mani **COPYWRITERS** John Mani, Uday Narasimhan
ILLUSTRATOR Jomy Varghese **AGENCY** The Classic Partnership **CLIENT** Khaleeji Magazine **COUNTRY** United Arab Emirates

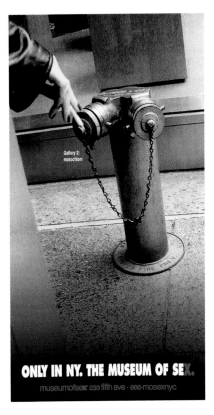

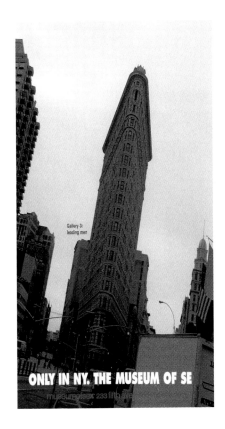

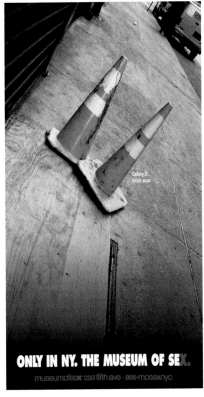

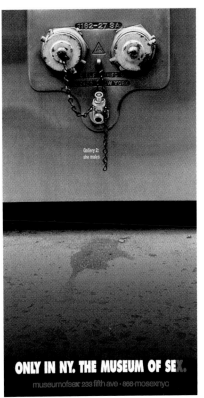

Merit Posters: Promotional, Campaign **Leading Men** ▪ **Masochism** ▪ **Fetish Wear** ▪ **She-Males** ▪ **The Germans**

ART DIRECTOR Earl Cavanah **CHIEF CREATIVE OFFICER** Gary Goldsmith **EXECUTIVE CREATIVE DIRECTOR** Dean Hacohen **CREATIVE DIRECTORS** Earl Cavanah, Lisa Rettig-Falcone **COPYWRITER** Lisa Rettig-Falcone **PHOTOGRAPHER** Lisa Rettig-Falcone **AGENCY** LOWE—New York **CLIENT** Museum of Sex **COUNTRY** United States

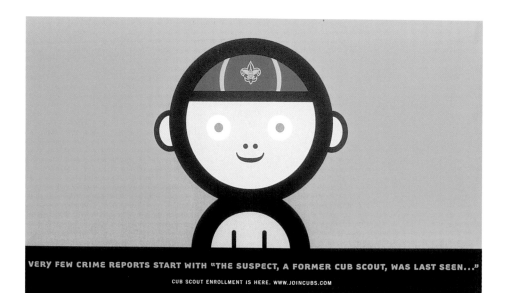

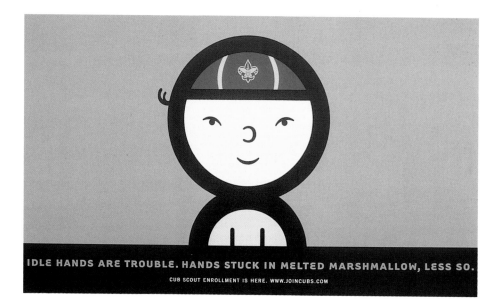

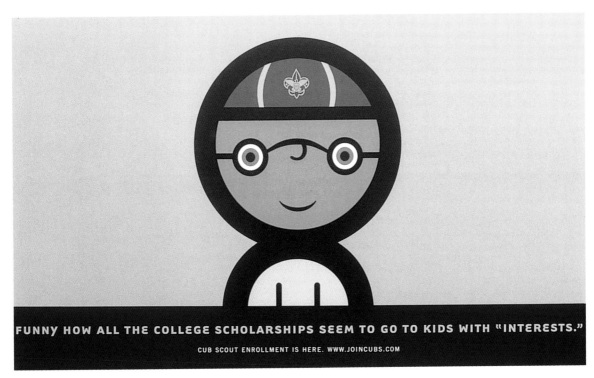

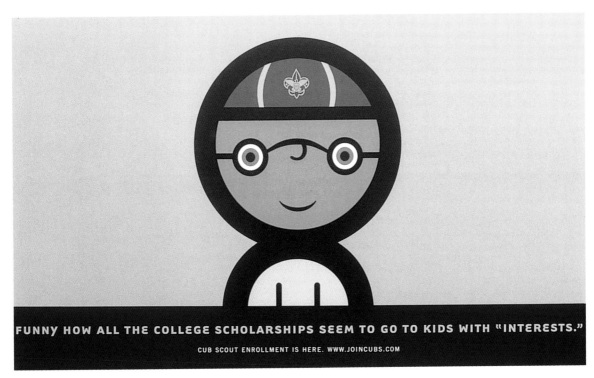

FUNNY HOW ALL THE COLLEGE SCHOLARSHIPS SEEM TO GO TO KIDS WITH "INTERESTS."

CUB SCOUT ENROLLMENT IS HERE. WWW.JOINCUBS.COM

AS LONG AS THERE ARE OLD LADIES WHO STINK AT CROSSING STREETS, WE'LL BE HERE.

CUB SCOUT ENROLLMENT IS HERE. WWW.JOINCUBS.COM

Merit Posters: Point-of-Purchase, Campaign **Crime Reports**

ART DIRECTOR James Clunie **COPYWRITER** Tim Cawley **ILLUSTRATOR** James Clunie **AGENCY** Carmichael Lynch **CLIENT** Cub Scouts **COUNTRY** United States

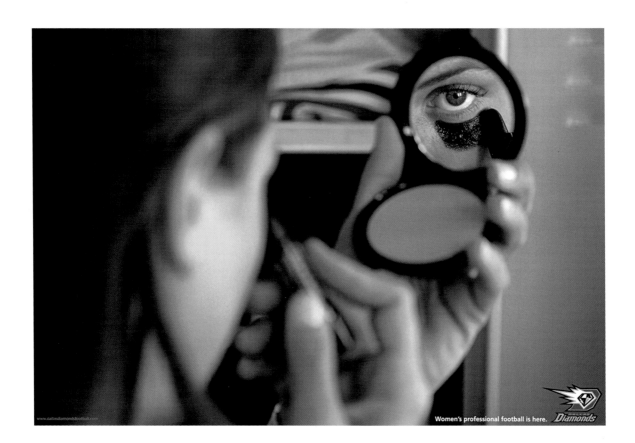

Merit Posters: Point-of-Purchase **Compact**

ART DIRECTOR Pete Voehringer **COPYWRITER** Steve Grimes **PHOTOGRAPHER** Scott Harbin **AGENCY** Publicis—Mid-America **CLIENT** Dallas Diamonds Women's Football **COUNTRY** United States

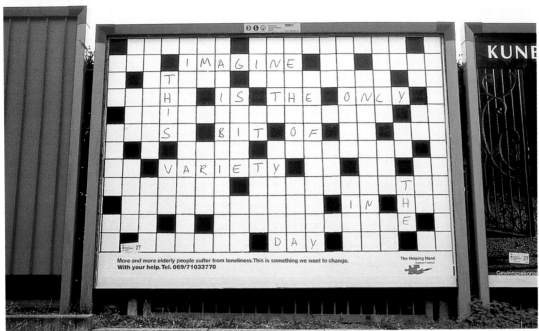

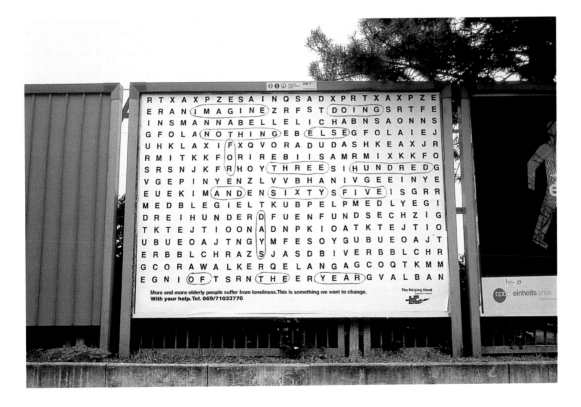

Merit Posters: Public Service/Nonprofit/Educational, Campaign **Malteser Help Service Is Looking for Volunteers—Crossword Puzzle •**
Find the Word Puzzle

ART DIRECTOR Alexander Heil **COPYWRITER** Cora Walker-Minneker **AGENCY** Ogilvy & Mather—Frankfurt **CLIENT** Malteser Help Service—Frankfurt
COUNTRY Germany

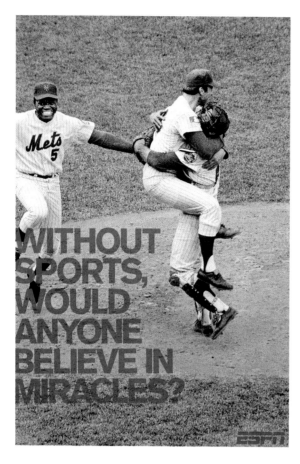

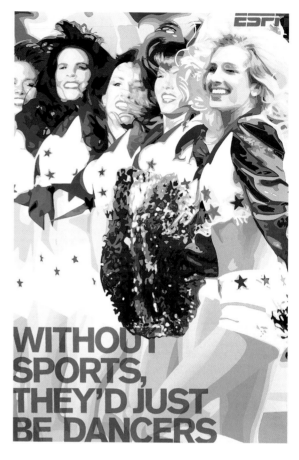

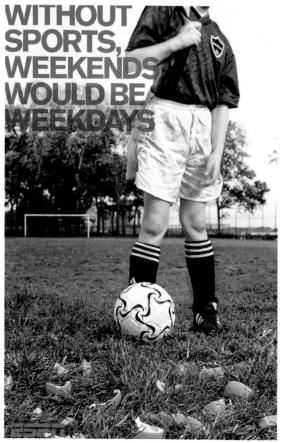

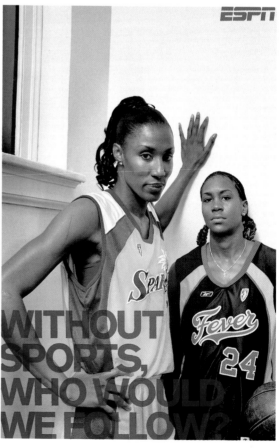

WITHOUT SPORTS, THERE'D ONLY BE GUM

LEROY "Satchell" PAIGE

Merit Wild Postings, Campaign **Miracles (41s)** ▪ Dancers ▪ Weekends/Weekdays ▪ Follow ▪ Gum

ART DIRECTOR Kim Schoen **COPYWRITER** Kevin Proudfoot **PHOTOGRAPHERS** Dana Lixenburg (Follow), Collier Schorr (Weekends/Weekdays)
ILLUSTRATOR Deanna Chent (Dancers) **AGENCY** Wieden + Kennedy—NY **CLIENT** ESPN **COUNTRY** United States

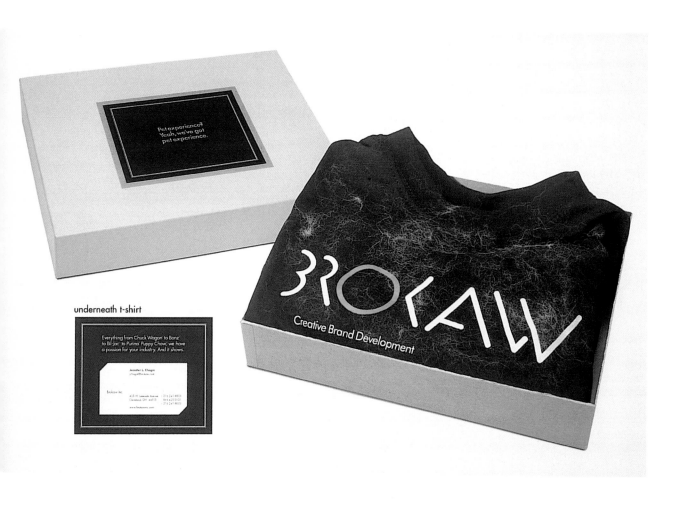

underneath t-shirt

Merit Agency Self Promotion **Pet Hair Mailer**

ART DIRECTOR Brian Gillen **CREATIVE DIRECTOR** Greg Thomas **COPYWRITER** Tim Brokaw **CLIENT** Brokaw Inc. **COUNTRY** United States

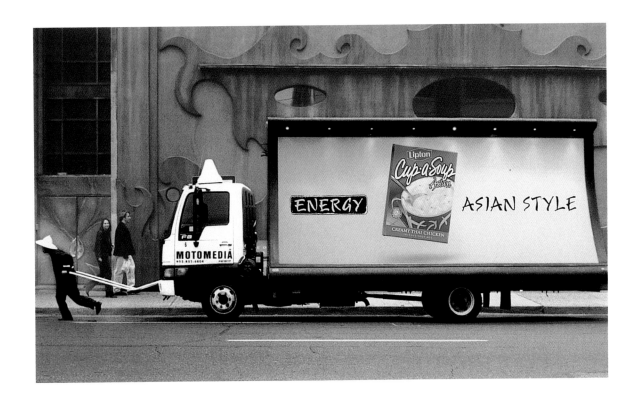

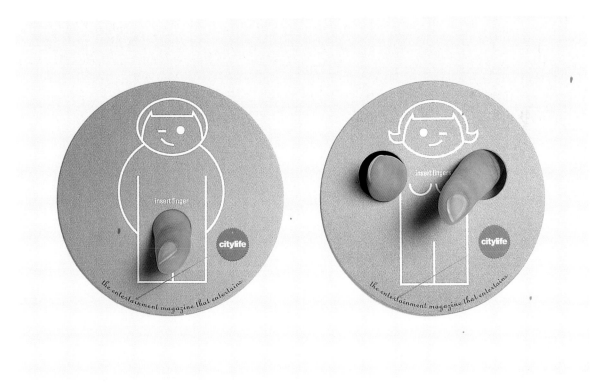

⊤ **Merit** Guerrilla Advertising/Unconventional Media **Asian Energy Rickshaw Truck**
ART DIRECTORS Melanie Hurst, Stephen Leps **CREATIVE DIRECTORS** Elspeth Lynn, Lorraine Tao **COPYWRITER** Aaron Starkman **PHOTOGRAPHER** Philip Roston
CLIENT Unilever **COUNTRY** Canada

ⓑ **Merit** Guerrilla Advertising/Unconventional Media **Coasters for Citylife Magazine**
DESIGNERS Heidi Chisholm, Peet Pienaar **STUDIO** Daddy Buy Me A Pony **CLIENT** Citylife Magazine **COUNTRY** South Africa

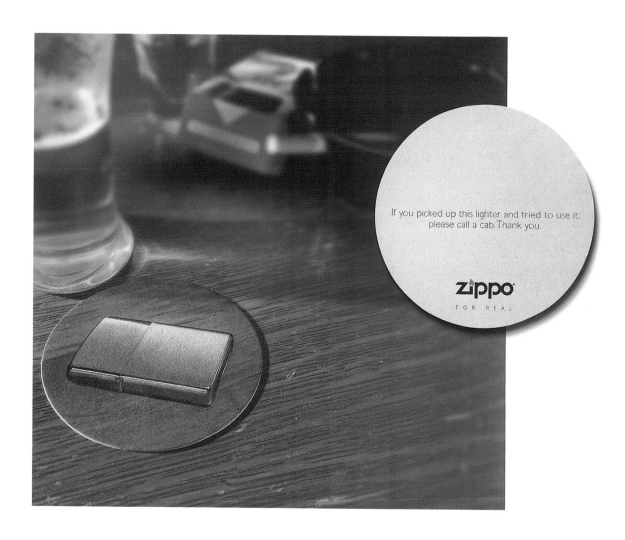

Merit Guerrilla Advertising/Unconventional Media **Zippo Coaster**

ART DIRECTOR David Hughes **COPYWRITER** Bill Garrison **AGENCY** Blattner Brunner **CLIENT** Zippo Manufacturing, Inc. **COUNTRY** United States

Merit Mixed Media Advertising Campaign **Rheingold Mixed Media Ad Campaign**

ART DIRECTOR Neil Powell **COPYWRITER** Josh Rogers **DESIGNER** Neil Powell **PHOTOGRAPHER** Landon Nordeman **STUDIO** Powell **CLIENT** The Rheingold Brewing Co.
COUNTRY United States

new media

Chairing this year's New Media awards was a refreshing and rewarding experience. Going into this, I promised Myrna to put together a group of judges the ADC had never seen before...designers not just from agencies, but also from the client side, design educators, a better balance between female and male judges, and just overall great people, who have been there, done it and seen it all. I found them, many of them dear friends, who committed to doing this months earlier. They showed up, they were passionate, they were fair, they were fun, and they all wished they'd seen more ground-breaking work (who wouldn't, right, Chee?). It was a lot of fun, but a long and quite tiring day; yet in the end we found our winners. After much good discussion and debate throughout the day, we ultimately honored 44 New Media Professional winners, plus two student winners, which translated into four gold, seven silver, 11 distinctive merit and 22 merit awards...who would have thought weeks earlier when we started with 644 New Media entries.

THOMAS MUELLER | Executive Creative Director, Razorfish | New Media Chair

THOMAS MUELLER Thomas Mueller ensures that the user experience group at Razorfish always aims for the highest balance between beauty and utility for its clients. Thomas oversees the disciplines of information architecture, interaction design, content strategy and development, visual systems design, interface development and user research. For the past six years at Razorfish, he has pioneered methods that inform the user experience and brand design process by understanding user behavior and perceptions. Thomas has driven successful design solutions for AT&T, America Online, Avaya, CBS, Charles Schwab, Ford Motor Company, Gloss, Manulife Financial, Microsoft, Simon & Schuster, Sony, Time Warner and Razorfish's own brand and visual identity system.

JEFFREY ZELDMAN Jeffrey Zeldman is among the Web's best-known designers, authors and lecturers. His personal site at zeldman.com has welcomed over 17 million visitors and is a daily industry read. Jeffrey is the founder of Happy Cog Studios, author of *Designing With Web Standards* (Indianapolis: New Riders Press, 2003), publisher of *A List Apart* magazine, and cofounder of The Web Standards Project, a grassroots coalition that helped end the browser wars and change the face of web development. He smells faintly of musk and dew.

THOMAS MUELLER

JEFFREY ZELDMAN

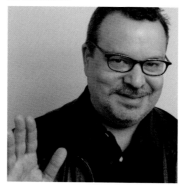

CHEE PEARLMAN

ROBERT WONG

SIGI MOESLINGER

CHEE PEARLMAN Chee Pearlman, a member of the ADC Board, is working on a number of editorial and design-related projects, including a design conference for Art Center College in Pasadena to be held in 2004, the annual Chrysler Design Awards, a special design issue for *Newsweek* and a design competition for *Popular Science* magazine. She also—when she feels really inclined to lose money—writes an occasional column for the *New York Times*. She is the former Editor of *I.D. Magazine*, which won five national magazine awards under her direction.

ROBERT WONG Robert was born Chinese, grew up Dutch, and is now Canadian on his way to becoming American. About to finish a degree in Accounting, Robert woke up one morning, flew to New York, and became a graphic designer instead. He has since helped build some of the world's most loved brands, integrating strategy, corporate identity, design, advertising and new media for Audi, Crunch, Harley-Davidson, Starbucks, IBM, MTV, NPR and other acronyms. For most of his life, the only thing he had ever won was a pair of Cheap Trick tickets from the radio. Those have been joined with awards from every imaginable design and advertising competition. Robert has no plans of returning to the accounting profession. And he loves Renee.

SIGI MOESLINGER Sigi Moeslinger is a partner at Antenna Design New York, a company she co-founded with Masamichi Udagawa in 1997. Antenna is behind award-winning projects such as the new New York City subway trains and ticket vending machines as well as ground-breaking interactive installations at venues such as Creative Time's Anchorage show and Artists' Space. Sigi is also an associate professor at New York University's Interactive Telecommunications Program teaching interaction design. Before forming Antenna, Sigi was an interval research fellow at NYU and at Interval in Palo Alto. Prior to that, she was a senior industrial designer at Ideo Product Development in San Francisco.

HILLARY EVANS Hillary Evans is creative director of all things digital for Y&R's Brand Buzz group, providing clients with strategic thinking and creative solutions. Before Brand Buzz, she was the creative director for Y&R 2.1, where she developed concepts, interactive strategies and architectures for clients such as Sony, Xerox and MetLife. Hillary began her career building digital solutions for Razorfish, Inc. in 1995. She led design and creative direction for such clients as GE Equity Capital, Pepsi and Revlon, then later served as an executive producer for the Razorfish Subnetwork, overseeing the development of digital entertainment properties.

DAVID YOUNG David Young is founder and principal at Triplecode. The studio's work is a combination of code and design talents—attempting to merge the disciplines in order to create unique work. Their projects approach interactive design as a way to empower users to explore and discover according to their own interests. He has been a faculty member at Art Center College of Design, where he was also on their new media curriculum committee and a former director of their new media research group. Previously he worked in the experimental psychology and artificial intelligence departments at BBN. He is on the board of the Los Angeles chapter of the AIGA. He was recently the keynote speaker at the AIGA/Seattle's Activ8 New Media Conference.

HILLARY EVANS

DAVID YOUNG

ROSHI GIVECHI

DAVID WARNER

ROSHI GIVECHI Since joining IDEO in 1998, Roshi Givechi designs for and leads projects, defining how people interact with objects, services and space. She frequently teaches IDEO U Innovation Workshops and speaks at design conferences. Clients include Full Audio, Medtronic, McDonald's, NASA, Philips, Teleportec and United Media (Dilbert's Ultimate Cubicle). Before IDEO, Roshi art-directed children's educational software and designed news and entertainment-based Web sites while at Microsoft, MSNBC and RealNetworks.

DAVID WARNER David Warner is head of experience design and creative director for Oyster, an interactive communications consultancy based in London. He has daily input into directing the creative vision of Oyster at a strategic level, including involvement in major projects—overseeing the work of a 30-person team of experience architects, designers and copywriters. Oyster creates interactive solutions for clients such as Orange, British Telecom, Go-Fly, Mercedes-Benz and the Victoria & Albert Museum, spanning Web, kiosks, iDTV and mobile media. David has worked for the past 12 years designing for both print and interactive media

JOSHUA DAVIS Joshua Davis is a New York artist and technologist producing both public and private work on and off the Web. His site praystation.com was the winner of the 2001 Prix Ars Electronica Golden Nica in the category "Net Excellence," the highest honor in international net art and design. He is currently an instructor at the School of Visual Arts in New York City and lectures globally on his work, inspirations and motivations.

SASHA KURTZ As creative director of Dotglu, Sasha brings an unparalleled passion for all things digital. Her extensive interactive experience and love of design play a critical part in helping to fulfill the company vision: to combine cutting-edge creativity and technology with superior business strategy. Prior to joining Dotglu, Sasha worked for more than five years at R/GA Digital Studios in New York for the legendary Robert Greenberg. As R/GA's acting creative director, Sasha gained recognition as one of the pioneers of interactive design. Her work has been featured in countless publications and has received more than 30 design and advertising awards for clients like Levi Strauss, IBM, The Discovery Channel, Bed Bath & Beyond and the Brooklyn Academy of Music.

LISA WALTUCH Lisa Waltuch has been working as a creative director with interactive media for the last 10 years. Her projects include laser disks on women's health, educational CD-ROMS for at-risk youth, interactive television for Nippon Telephone and Telegraph in Japan, Web sites for Discovery Channel and the Metropolitan Museum of Art and in-store kiosks for Walmart.com. She also teaches User Experience Design in NYU's Interactive Telecommunications Program and is a board member for Women's Law Initiative, an online resource for victims of domestic violence.

SASHA KURTZ LISA WALTUCH

CLAUDIA FRANZEN VIKTOR CEA MATT OWENS

CLAUDIA FRANZEN Claudia Franzen's interactive focus began in 1995, when she founded Primary Group, a boutique Web consultancy catering to image-led clients. Client highlights include Benetton, Cartier Inc. and Art + Commerce. Claudia and partners later sold the business to Agency.com, in 1998. Claudia stayed on as creative director to develop Gucci's first international award-winning Web site. Building on her luxury goods expertise, Claudia then moved client-side as vice president creative for the interactive arm of Sephora, LVMH's international beauty retailer. Claudia has since been recruited by Tiffany & Company in New York, and serves as director of interactive media in marketing.

VIKTOR CEA As vice president of design and development for Gartner News, Viktor Cea leads the team that conceptualizes designs and builds projects for gartner.com and other Gartner media products. Since joining Gartner in 2001, Viktor has been instrumental in the redesign of the site and the development of the prototype of the next generation gartner.com. A skilled multimedia producer, Viktor has spent the last nine years honing his craft as a designer, art director and creative director in New York City. He's held positions at various media companies including Fox, CBS, UPN and TechTV.

MATT OWENS Matt Owens grew up in Texas, spending his formative years in Austin designing punk rock records and flyers for local bands. In September 1997 Matt launched volumeone, a design studio dedicated to exploring narrativity on the Internet and to pushing the limits of available design technologies on and offline. In June of 1999, Matt joined forces with Cranbrook Alumn Warren Corbitt to establish onegine, a design firm specializing in visual communications for print, broadcast and interactive media. Current onegine clients include Bartle Bogle Hegarty, Museum of Modern Art, Cooper-Hewitt National Design Museum, Universal Music, Sony and Wieden + Kennedy. Matt also runs a a small record label called The Buddy System with his twin brother Mark.

COLLEEN STOKES Colleen Stokes began working in the new media design space in 1992. She worked on a television interface/brand experience for Disney with Colossal Pictures. At CKS Partners, Colleen created online stores for Levi's and Apple, as well as Nike, Williams Sonoma, Pottery Barn, The Sharper Image and Toys "R" Us. She is currently the creative lead for The Catalog for Living division of Martha Stewart Omnimedia where she is responsible for the print catalog and marthastewart.com. She focuses primarily on how new media can enhance a user's experience with a brand.

NEVILLE BRODY Neville Brody studied Graphic Design at the London College of Printing before immersing himself in the independent music scene of the early 1980s. As an art director for Fetish Records, he was able to experiment with a graphic language that amalgamated painting with a new sense of architecture. This he was later able to exploit in a more commercial setting for *The Face* between 1981 and 1986 where his typographic experimentation, a medium he had hitherto avoided, transformed the look of magazines, advertising and retail outlets worldwide. In 1990, he opened FontWorks with Stuart Jensen and became a director of FontShop International. Together with Jensen, Brody also launched the experimental type magazine, *FUSE*. Brody's work is now focused upon the evolution of a new visual language that questions and creates a dialogue on the role of electronic design in communication.

COLLEEN STOKES

NEVILLE BRODY

ANGELA SHEN-HSIEH

TY MONTAGUE

DOUG JAEGER

ANGELA SHEN-HSIEH Since receiving a Master in Architecture degree from Harvard in 1991, Angela Shen-Hsieh has been pursuing forms of communication that can intrigue, inform and prompt people to think. As a partner at Visual I/O, Angela has been developing innovative ways of representing and navigating information for enterprise applications. Her work has helped large organizations like Nestlé and Johnson & Johnson gain insights into their businesses and has provided quicker and more informed views of the criteria impacting critical decisions. Angela is a board member of AIGA Boston (American Institute of Graphic Arts) and frequently lectures about data visualization, design and business topics.

TY MONTAGUE Ty joined Wieden + Kennedy in September of 2000. As co-creative director, Ty takes on the challenging role of ensuring the agency continues to push its groundbreaking creative standard. He continues to be a driving force on ESPN, Nike, Jordan and Avon/beComing. Most recently, Ty was creative director at Bartle Bogle Hegarty—New York. In 1998, he helped to establish BBH's New York office and built the current client roster, which includes Bolt, Reebok Classic, Johnny Walker and several Unilever assignments. Throughout his career, Ty's work has received many creative accolades from clients and from the industry. Most notable awards include the One Show, Cannes, *Communication Arts* and the Clios.

DOUG JAEGER Doug joined TBWA\Chiat\Day as interactive creative director at age 25. Doug has overseen breakthrough work for Absolut Vodka, Doctors without Borders, Office.com and Orbitz, among others. At age 20, Doug designed the Web site for Lucent Technologies while at Agency.com. At 23, Doug established the Interactive Creative Department for J. Walter Thompson's (Digital@JWT) and became the company's youngest partner. While at J. Walter Thompson, he worked on Merrill Lynch, J&B Scotch, Elizabeth Arden, Trident, Qwest Communications and DeBeers' diamondisforever.com.

FREE THE CODE

"APPROXIMATELY 12 YEARS AGO,
CODES WERE MONOPOLISED SYSTEMS.
THE WORLD WAS OBLIGED TO
SUCCUMB TO IMPOSED PLATFORMS.
THEN ONE DAY, IN THE FAR AWAY
PLAINS OF FINLAND..."—

Gold Medal Banners **Free the Code**

ART DIRECTORS Milton Correa Jr., Sérgio Mugnaini **CREATIVE DIRECTORS** Luis Delboy, Paulo Sanna **COPYWRITER** Luciana Haguiara **AGENCY** Ogilvy—Brazil
CLIENT IBM **COUNTRY** Brazil

The challenge was to introduce the IBM commitment to Linux, the revolutionary open-source platform that was born to end the technology monopoly.
The creative idea was to picture the whole art direction in ASCII art. In this manner we represent the open-source code that is what Linux is all about. The
action starts with a brief introduction of the Linux history, which is suddenly interrupted by "ASCII Man." We see him running for his freedom. We can
read the messages on his body through close-ups. And it signs off with "Free the code" and then, "IBM supports Linux".

FLY GUY

Gold Medal Self-Promotion **Fly Guy**
ART DIRECTOR Trevor Van Meter **PROGRAMMER** Jason Krogh **MUSIC** Vas Kottas, Brian McBrearty **CLIENT** Trevorvanmeter.com **COUNTRY** United States

CHOICES

Gold Medal Public Service/Nonprofit **Choices**

ART DIRECTORS Joanna Perry, Damon Troth **CREATIVE DIRECTOR** Jon Williams **COPYWRITERS** Joanna Perry, Damon Troth **AGENCY** Publicis Limited **CLIENT** The Depaul Trust **COUNTRY** United Kingdom

The brief was to produce a challenging piece of communication for The Depaul Trust, a charity set up to help homeless kids. The challenge is that people are hardened to seeing homeless people on the street and think, "If I were him, I wouldn't just sit there—I'd pick myself up and turn things around. In fact I wouldn't let myself sink so low in the first place." We needed to show that it is rarely that straight-forward. Our solution was a two-minute interactive commercial where the viewers, via their TV remote, could make key choices for a kid who is rapidly heading towards a life on the streets. Being actively involved in the kid's decision-making process, the viewer gained a deeper understanding of the realities that can lead to homelessness. The film had four possible story paths. At the end of the ad you could enter a micro-site to find out more about the charity and make an instant donation.

THEBAN MAPPING PROJECT

Gold Medal Web Application **Theban Mapping Project**

ART DIRECTOR Brad Johnson DESIGNERS Brad Johnson, Martin Linde COPYWRITER TMP Team ILLUSTRATOR Matt Arnold PHOTOGRAPHER Francis Dzikowski
AGENCY Second Story CLIENT Theban Mapping Project COUNTRY United States

Since 1978, the Theban Mapping Project, under the direction of well-known egyptologist Dr. Kent Weeks, has been working to prepare a comprehensive archaeological database of the Valley and the entire Theban Necropolis. With information about every archaeological, geological and ethnographic feature in the Valley of the Kings, nearly 2,000 photographs and illustrations, over 250 detailed maps, elevations and sections, exhaustive bibliographic resources, articles, glossaries and timelines, this Web site sets a new standard for archeological publishing. Visitors unfamiliar with the subject matter can go on a virtual tour in 3D or watch narrated movies, while advanced academics can research the architecture and decoration of every chamber in every tomb in the Valley of the Kings. The interactive atlas displays movies, information and images in context to detailed maps and measured drawings in a stand-alone multimodal tool. The HTML site provides access to printable versions of the same dynamic, database-driven content which will be continually updated with new data.

THE FAMOUS GROUSE EXPERIENCE

Silver Medal Product/Service Promotion **The Famous Grouse Experience**

DESIGNERS Robin Clark, Peter Higgins, Pavel Mayer **LIGHTING DESIGN** David Atkinson **PRODUCERS** Sue Joly, Lol Sargent **STUDIOS** Art + Com—Berlin, Land Design Studio **CLIENT** Highland Distillers, Ltd. **COUNTRY** United Kingdom

This immersive brand experience fulfills the need to present The Famous Grouse brand in a contemporary and imaginative way. A "walk-in ad" has been conceived as a follow-up to the highly successful TV advertising campaign. Visitors to this converted Victorian house engage with the sensory environment as a series of narratives evolve. Initially they are encouraged to splash through digital water or crack digital ice along with the animated grouse. More dynamic activity involves building an interactive jigsaw constructed from the iconic bottle label that eventually enables the group to take flight across spectacular panoramas over Scotland using satellite imaging and specially commissioned aerial photography.

ELVIS NUMBER ONES

Silver Medal Product/Service Promotion **Elvis Number Ones**

ART DIRECTOR David McManus **CREATIVE DIRECTOR** Bob Holmes **LEAD DESIGNER** Arnold Hidaka **FLASH PROGRAMMER** Graeme Hoffman **ANIMATOR** Asif Mian **EXECUTIVE PRODUCER (BMG)** Kieve Huffman **SENIOR PRODUCER** Rob Watts **DIRECTOR OF PRODUCTION** Catherine Gray Shandler **TECHNICAL DIRECTOR** Michael Hoffman **STUDIO** Sudden Industries **CLIENT** RCA/BMG **COUNTRY** United States

Our goal was to create an Elvis site that attracted and retained a younger, music-buying audience rather than solely catering to the die-hard Elvis fans. Our strategy focused on developing a site that played down the historical dimension of Elvis's legacy while emphasizing the cultural significance of his contributions. We accomplished this objective by presenting the 30 singles not only from a historical perspective, but also within the context of their impact on pop culture trends like fashion, movies, music videos and performance. The result was an overwhelming success. The site became the number one Elvis Web destination, as well as BMG's most popular Web site to date.

MOMA—THE RUSSIAN AVANT-GARDE BOOK 1910–1934

Silver Medal Institutional Promotion **MoMA—The Russian Avant-Garde Book 1910–1934**

ART DIRECTOR Anh Tuan Pham PROGRAMMER Anh Tuan Pham CONCEPT DESIGNER Ben Aranda PRODUCER (MOMA) George Hunka ASSOCIATE PRODUCER (MOMA) Ellen Lindner STUDIO For Office Use Only CLIENT The Museum of Modern Art COUNTRY United States

FROST DESIGN WEB SITE

Silver Medal Self-Promotion **Frost Design Web Site**

ART DIRECTORS Fred Flade, Vince Frost **DESIGNERS** Fred Flade, Vince Frost **STUDIO** De-Construct **CLIENT** Frost Design **COUNTRY** United Kingdom

Vince Frost, the respected graphic designer, required an online presence to promote the work of his studio. The brief was to capture Frost's individual approach to print design while allowing his body of work to stand out. The design of the site had to be simple, exciting and impactful, communicating both to prospective clients and the design community. The concept of the typographic landscape was developed out of the observation that when entering Frost's studio, the space itself was a landscape of his work, with sketches, printouts, photocopies, photographs and other items forming key landmarks. This metaphor allowed us to develop a simple to use navigational system that encourages the user to explore. The bigger projects in the "landscape" represent Frost's favorite pieces of work. The design of the Web site was inspired by Frost's work, using just one typeface throughout the entire Web site, only one color and no imagery (except to illustrate the projects) to represent Frost's strong typographic approach.

CYBERKUMAKO.COM/JUNKO OTSUKI WORKS

Silver Medal Self-Promotion **Cyberkumako.com/Junko Otsuki Works**

ART DIRECTOR Junko Otsuki **DESIGNER** Junko Otsuki **SOUND DESIGN** Michael Sweet **STUDIO** Cyberkumako.com **CLIENT** Cyberkumako.com
COUNTRY United States

Cyberkumako.com is the portfolio Web site of Junko Otsuki, an interactive/graphic designer. Her objective was to showcase her various skill sets, which range from visual and interactive design to programming and informational organization. While the site explores an edge of design that is central to her interests, cyberkumako.com also acts as a bridge when approaching new clients. For the site's overall interface, Otsuki created a multiple-category system which would arrange the portfolio pieces in four distinct ways—time, location, design category, and media. After a user clicks on one of the four organizational choices, the individual case studies dynamically re-sort into the proper categories.

NIKE LAB

 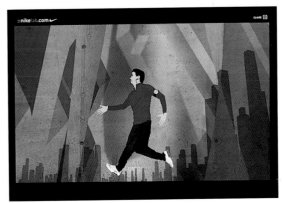

Silver Medal Game/Entertainment **Nike Lab**

LEAD ART DIRECTOR Rei Inamoto **ART DIRECTOR** Winston Thomas **CREATIVE DIRECTOR** Nick Law **SENIOR DESIGNERS** David Alcorn, Marlon Hernades **DESIGNERS** Cassandra Brown, Mikhail Gervits, Mini Ham, Jeannie Kang, Arnold Marzan **COPYWRITER** Jason Marks **EXECUTIVE PRODUCER** Kip Voytek **PRODUCER** Sheila DosSantos **AGENCY** R/GA Interactive **CLIENT** Nike **COUNTRY** United States

Nikelab.com is Nike's showcase of performance innovation—a completely interactive experience that lets customers learn about Nike's latest performance products through cutting-edge graphics and original episodic content. Using filmstrips as a narrative device to convey the innovation and inspiration behind Nike's most performance-driven products, nikelab.com allows consumers to interact with Nike products on a new level. The site features a breakthrough interface and unique product display, combining computer graphics, sound effects and motion graphics in a truly interactive way. R/GA used the latest digital design tools of Flash MX and Shockwave to build nikelab.com, an immersive environment that breaks through the traditional page-based, linear Web experience. In conjunction with Tronic, R/GA created 3D product presentations that let users "peel away" layers of the products to reveal the underlying structure and technology. R/GA also acted as digital art curator, uncovering some of the world's most influential artists and working with them to develop unique online content for the site. Some of the best digital engineers in the world were involved in this project, charged with the task of developing interactives that explore Nike products in a new and unique way.

IMAGINING THE CITY

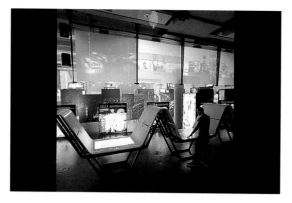

Silver Medal Interactive Kiosk/Installation **Imagining the City**

CREATIVE DIRECTOR Peter Higgins **DESIGNER** Robin Clark **MEDIA DESIGNERS** Indi Hans, Dietmar Offenhuber **CREATIVE MEDIA DIRECTOR** Lol Sargent
CREATIVE PROJECT MANAGER Louise King **STUDIO** Land Design Studio Ltd. **CLIENT** Manchester City Council—Special Projects **COUNTRY** United Kingdom

The brief was to enable visitors to explore the work of visionaries who have investigated the concept of the modern city over the past 200 years. Horizontally projected streaming images representing the work of artists, architects, filmmakers, photographers, composers and writers are accessed and investigated by touching the virtual arrows, words or images projected onto an electromagnetic tabletop surface. The selected material is symbolically re-mediated into an evolving overhead imaginary future-scape. A key objective of this installation is to intrigue and inspire the user and in consequence challenge traditional uses of interactivity in museums.

EAGLE F1 WEB SITE

Distinctive Merit Product/Service Promotion **Eagle F1 Web Site**

ART DIRECTOR John Nussbaum **CREATIVE DIRECTORS** Keith Anderson, Chris Ford, Dave Gray, Rich Silverstein **COPYWRITER** Aaron Griffiths
PRODUCER Victoria Brown **AGENCY** Goodby, Silverstein & Partners **CLIENT** Goodyear **COUNTRY** United States

SHIMANO XTR

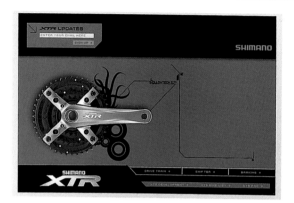

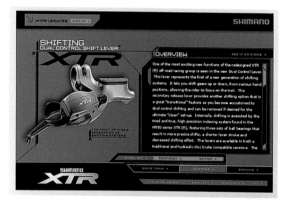

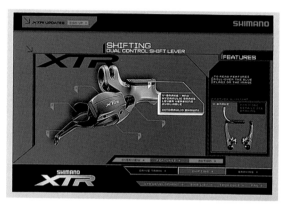

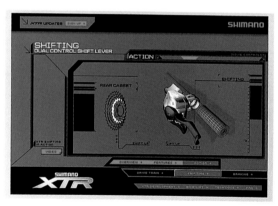

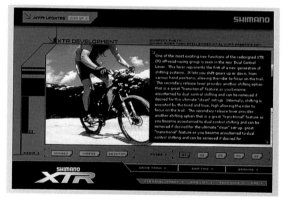

Distinctive Merit Product/Service Promotion **Shimano XTR**

ART DIRECTOR Todd Purgason **STUDIO** Juxt Interactive **CLIENT** Shimano **COUNTRY** United States

A revolutionary micro-site promoting Shimano's XTR component series redefines product marketing on the Web. Combining Flash, 3D and video, the site is geared to cycling enthusiasts and novices alike, allowing the user to interact with the brand in a unique and powerful way. Creatively, the execution strategy was to provide a balance of information, interaction and branding to communicate that with XTR, Shimano has redefined how to ride a bike, i.e. that XTR is powerful, technically superior and unbelievably cool. Because many of XTR's features are very technical, we used an innovative user interface to point out new features, essentially "showing and telling" at the same time. The end result is a fluid, empowering experience for cycling novices and enthusiasts alike.

SHAWN'S FOLK ART

Distinctive Merit Self-Promotion **Shawn's Folk Art**

ART DIRECTOR Shawn Murenbeeld **DESIGNER** Shawn Murenbeeld **PROGRAMMERS** Edward Apostol, Tony Lei **ILLUSTRATOR** Shawn Murenbeeld
PHOTOGRAPHER Shawn Murenbeeld **ANIMATOR** Tony Lei **DEVELOPER** Edward Apostol **STUDIO** Touchwood Design **CLIENT** Shawn's Folk Art **COUNTRY** Canada

The goal was to showcase my work and spread the word on outsider art while having it look like an untrained person designed the site. I like to call it "Tastefully Done By the Insane." The pieces were shot at weird angles and floated in front of handmade backgrounds to create the 3D look that I was after. In the end it proved to be the next best thing to being there. The site had to capture the spirit of the art that it was meant to showcase. It was important not to overpower the carvings with too many bells and whistles. It also had to be very naive and slapped together. The entire site was built with things lying around the floor of my office. Torn paper, old boxes and grocery lists. Even though the site took ten months to create from initial meeting and concept through to final approved live site, it had to look as if it were done in one sitting. The same way I carve—fast and spontaneous. The client was a pain in the ass! Nit picky, obsessed and, at times, over the top—that's me with my client hat on. Everyone knows that the hardest projects to work on are your own. This wasn't a self-promotional site for my design work, but for my alter ego, the simple folk artist. The personality I slip into every weekend. Shawn, the person who works on his carvings from morning till night with no pee breaks and the occasional snack delivery from my wife for sustenance.

FACE TO FACE—STORIES FROM THE AFTERMATH OF INFAMY

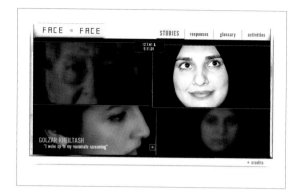
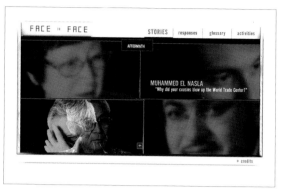

Distinctive Merit Public Service/Nonprofit **Face to Face—Stories from the Aftermath of Infamy**

DESIGNER Jeff Faulkner **COPYWRITER** Sally Anderson **PHOTOGRAPHER** Rob Mikuriya **AGENCY** Second Story **CLIENT** Fun + Mental Media, ITVS
COUNTRY United States

What does it mean to be an American with the face of the enemy? Face to Face explores first-person stories connecting the experiences of Japanese
Americans following the attack on Pearl Harbor on December 7, 1941 with the experiences of Arab and Muslim Americans following the events of
September 11, 2001. The stories of 18 people are woven together in a poetic narrative that provides unexpected connections between individuals from
different backgrounds, ages, ethnicities and genders. The site represents a special new media venture presented by the Independent Television Service.
Collaborating with documentary filmmaker Rob Mikuriya, the site is designed to meld traditional filmmaking with the strengths of interactive media in
an original program format distributed exclusively online. Linear narratives edited from interview footage are joined together in a non-linear format that
enables visitors to make their own connections and unexpected discoveries. The visitor can choose to watch and listen to stories in an autoplay mode,
or jump thematically through clusters of different individuals speaking about similar experiences of fear, anger, loyalty and other topics. An index of clips
allows the user to find specific people, themes and clips.

THETRUTH

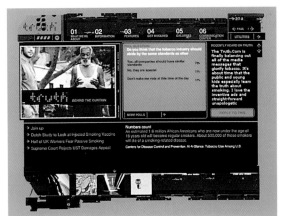

Distinctive Merit Public Service/Nonprofit **thetruth**

ART DIRECTORS Rob Baird, Meghan Boardman, Nathan Wray **CHIEF CREATIVE OFFICER** Ron Lawner **GROUP CREATIVE DIRECTORS** Alex Bogusky, Pete Favat
CREATIVE DIRECTORS Roger Baldacci, Jim Marcus, Ari Merkin **PROGRAMMERS** Ebbey Mathew, Doug Smith **COPYWRITERS** Roger Baldacci, Mike Howard
PHOTOGRAPHER Jim Marcus **PRODUCERS** Cybil Ciavarra, Eric Decker, Barry Frechette **AGENCIES** Arnold Worldwide, Crispin Porter + Bogusky **CLIENT**
American Legacy Foundation **COUNTRY** United States

Distinctive Merit Reference/Education **Digital Snow**

ART DIRECTORS Éric Dubois, Jean-Christophe Yacono **CREATIVE DIRECTORS** George Fok, Daniel Fortin, Jean-Christophe Yacono **DESIGNER** Éric Dubois
PROGRAMMERS Adrien Claude, Melanie Holder **COMPUTER GRAPHIC DESIGNER** André Renaud **EXECUTIVE PRODUCER** Daniel Fortin **PRODUCER** Jean Gagnon
ASSOCIATE PRODUCER Olivier Sirois **AGENCY** Époxy Communications **COUNTRY** Canada

Digital Snow is an interactive application to explore Michael Snow's work, as well as an educational and didactic tool. It allows you to discover the work
of one of the most significant artists in contemporary art and cinema over the past 50 years. Six interfaces give you access to the complete content as well
as original interviews and rarely seen documentaries. Records of more than 700 work pieces—pictorial, sculptural, photographic, aural and musical—
can be accessed through the various interfaces. Digital Snow is at once a vehicle for discovery and a complex, interactive experience, as daring as it is
innovative. We did not try to explain the work of Michael Snow, but rather to plumb its scope, diversity, intelligence and complexity, both formally and
conceptually. With an artist as difficult to place as Snow, we began by questioning the very idea of a representative portfolio of work. We rejected precon-
ceived ideas and began at ground zero, as it were, continuously reminding ourselves that what's navigable isn't necessarily interactive. We're now asking
you to exercise a similar freedom and rigor, viewing this work as you would avant-garde film or poetry.

YIN YU TANG

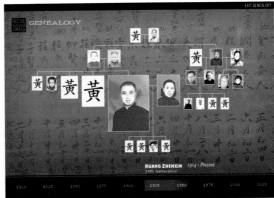

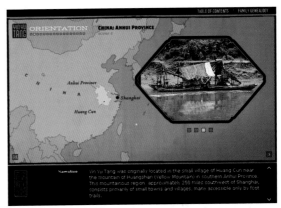

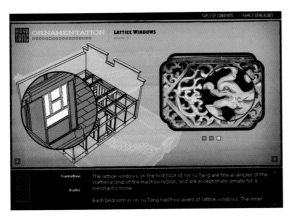

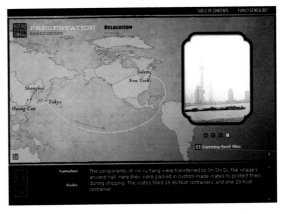

Distinctive Merit Reference/Education **Yin Yu Tang**

ART DIRECTOR Brad Johnson **DESIGNERS** J.D. Hooge, Brad Johnson, Martin Linde **COPYWRITERS** Nancy Berliner, Paula Noyes **ILLUSTRATORS** Matt Arnold, Andrew Kudless **AGENCY** Second Story **CLIENT** Peabody Essex Museum **COUNTRY** United States

Yin Yu Tang is an elegant, rural home originally located in a small, remote village in the southeastern region of Huizhou in China's Anhui province. Built in the late Qing dynasty (1644-1911), by a Chinese merchant surnamed Huang, the residence was home to the Huang family for over 200 years. Through this media-rich interactive experience, Web site visitors and kiosk users can explore the house to discover this rare example of the region's renowned architecture and learn about the daily life of the Huang family. The heart of the experience is comprised of five thematic sections that provide a unique lens through which the house can be examined—orientation, construction, ornamentation, belongings and preservation. Content is segmented into distinct scenes within each theme; as visitors navigate between scenes, a persistent 3D model view of Yin Yu Tang reacts to reveal different features of the house. A visual interactive family tree, dozens of audio interviews, hundreds of historical and contemporary photographs, and many videos are sprinkled throughout the experience to make this Chinese home a "living house."

Distinctive Merit Game/Entertainment **www.bzzzpeek.com**

ART DIRECTORS Agathe Jacquillat, Tomi Vollauschek **DESIGNERS** Agathe Jacquillat, Tomi Vollauschek **AGENCY** FL@33 **CLIENT** FL@33 **COUNTRY** United Kingdom

Bzzzpeek.com is presenting a collection of onomatopoeia from around the world, using sound recordings from native speakers imitating the sounds of animals and vehicles. This self-initiated project focuses on the pronounciation and comparison of these sounds by presenting them side-by-side, as each language expresses them differently. Bzzzpeek.com is an interactive experience inviting everybody to contribute. Submissions of additional recordings representing missing languages are more than welcome. Concept generation and design have been developed with a family experience in mind. The menu is easy to use and is based on a largely visual approach to invite a truly international audience to interact. Our audience is mainly parents with their kids, designers/artists and musicians/sound artists. At this moment (March 2003) the project has been visited by more than 100,000 unique visitors from around the world since its launch in September 2002.

SONY ADTV—CAMCAM TIME

Distinctive Merit Game/Entertainment **Sony AdTV—CamCam Time**

ART DIRECTOR Yugo Nakamura **CREATIVE DIRECTORS** Shinzo Fukui, Koshi Uchiyama **DESIGNER** Daisuke Horiuchi **FLASH PROGRAMMERS** Daisuke Horiuchi, Yugo Nakamura **PROGRAMMER** Keita Kitamura **COPYWRITERS** Kaoru Chono, Koshi Uchiyama **ACCOUNT EXECUTIVE** Harunobu Deno **CLIENT** Sony Corporation **COUNTRY** Japan

This is a screensaver developed for Sony's broadband contents site, adTV. It emphasizes the value of continuous connection, and the interactivity that allows users to participate in the communication via broadband. It is "expression-ware" rather than "software," a tool that allows users to express themselves in the community on the network. When a user downloads CamCam Time, it installs the screensaver software and software for uploading images. Users can upload captured image clips (five seconds in length), with their names and simple messages, to Sony's central server. The clips are then compressed to 1 second and saved on the server. Sixty of them are randomly selected and allocated to the face of the clock, and these sixty clips are updated once every minute. When the screensaver is launched, it accesses the server and retrieves the most up-to-date data. The data is saved on the client's cache and is reproduced as the clock on the client machine.

REPERCUSSION

Distinctive Merit Hybrid/Art/Experimental **Repercussion**

ART DIRECTOR Carla Diana **DESIGNER** Carla Diana **CLIENT** Carla Diana **COUNTRY** United States

The design problem was to create a unique and engaging visual representation of a musical composition where the position of objects on the screen would match a certain rhythm or melody. The main objective was to make these engaging enough to encourage the viewer to experiment, while at the same time being sophisticated enough to allow for a great deal of variation in the sound being generated. The actual musical compositions were to be generated in real-time through algorithms that mapped the on-screen graphics to the sound arrangement. The graphics were to be designed with a wide audience in mind, such that the concepts represented were accessible to viewers regardless of their level of musical training, while at the same time matching the artist's idea of a basic kit of musical instruments for jamming: some drums, some melodies, and a way to create chords.

HALL OF IDEAS™

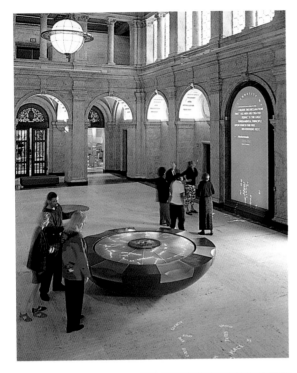

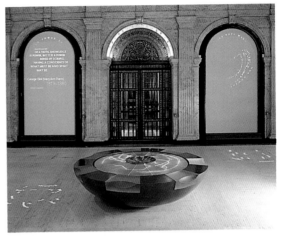

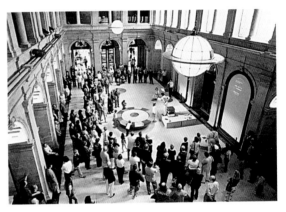

Distinctive Merit Interactive Kiosk/Installation **Hall of Ideas™**

ART DIRECTORS Michael McKenna, David Small **ENVIRONMENTAL DESIGN** Krent/Paffett/Carney, Inc. **SOFTWARE DESIGN** Eric Gunther **TYPE DESIGN** Timon Botez **ELECTRONICS DESIGN** Sloan Kulper **CONTENT DEVELOPMENT (MBEL)** Jim Albins **EDITOR (MBEL)** Beth Johnson **EXHIBITS MANAGER** Heather Zurlo **SCULPTOR** Howard Ben Tré **CLIENT** The Mary Baker Eddy Library for the Betterment of Humanity **COUNTRY** United States

The Hall of Ideas™ at The Mary Baker Eddy Library for the Betterment of Humanity celebrates the ideas that have inspired individuals and shaped history. Small Design Firm, working with exhibit designers Krent/Paffett/Carney, created a unique and engaging welcome for visitors. A work of art by acclaimed glass sculptor Howard Ben Tré is the centerpiece of the magnificently restored neoclassical space. The cast glass and bronze sculpture is both a traditional fountain of water and a "fountain of quotes." Using state-of-the-art computer programming, animated typography is projected onto the architectural surfaces of the Hall. The words, quotes from history's great thinkers, bubble up and flow outwards to the rim of the fountain, gravitating toward observers. They then spill onto the floor, dissolve into single words, and undulate across the Hall, ultimately re-forming on two large archways. Visitors of all ages are captivated by the immersive content and form of this installation.

SUPER MINI-GAMES

Merit Banners **Super Mini-Games**

ART DIRECTOR Jesse McGowan CREATIVE DIRECTOR Vincent Lacava DESIGNER Scott Gursky PROGRAMMER Howard Wakefield GAME DESIGNER Frank Lantz
SOUND DESIGNER Michael Sweet EXECUTIVE PRODUCER Kelly Galligan PRODUCER Demetri Detsaridis AGENCY POP & COMPANY CLIENT Cartoon Network
COUNTRY United States

+HP BANNER CAMPAIGN

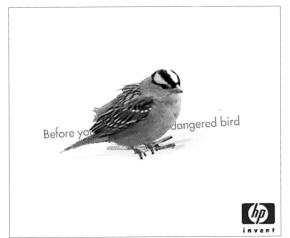

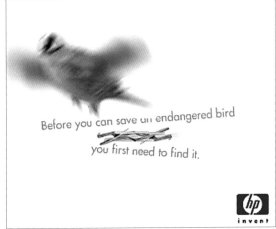

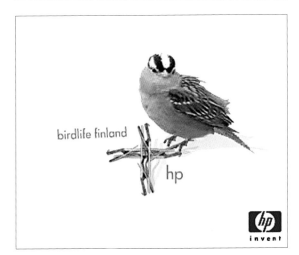

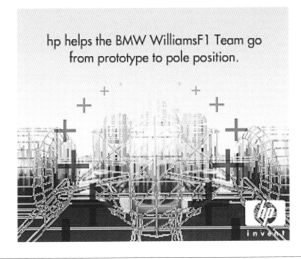

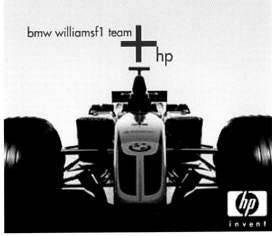

Merit Banners, Campaign **+hp Banner Campaign**

ART DIRECTOR Jeff Benjamin CREATIVE DIRECTORS Keith Anderson, Steve Luker, Rich Silverstein, Steve Simpson COPYWRITER Peter Rudy
PRODUCER Kris Smith AGENCY Goodby, Silverstein & Partners CLIENT Hewlett-Packard Company COUNTRY United States

TELEKOM T-DSL—CATCH

Merit Banners **Telekom T-DSL—Catch**

ART DIRECTORS Paul Apostolou, Oliver Viets **DESIGNER** Jan Hellberg **COPYWRITER** Florian Matthies **ACCOUNT MANAGER** Özgür Turhan **AGENCY** Elephant Seven **CLIENT** Deutsche Telekom AG **COUNTRY** Germany

The assignment was to create a banner that shows the advantage of the product using the medium itself. The USP of the product is the fast broadband internet access. The idea was to show, in a very direct way, what the advantage of the product is going to be. Simply: Faster is better.

NIKE PRESTO—SPIRIT OF MOVEMENT

Merit Product/Service Promotion **Nike Presto—Spirit of Movement**

ART DIRECTORS Jason Mohr, Yoshi Sodeoka **AGENCIES** Neverstop, Wieden + Kennedy **CLIENT** Nike **COUNTRY** United States

C404, hired by Wieden + Kennedy and Neverstop, designed the menu interface, provided DVD authoring, created disc art and contributed an audio/video piece for the Nike Presto "Spirit of Movement" DVD. The disc, a giveaway that was part of Presto's 2002 U.S. campaign, features short videos by nine video and animation artists who were asked to work with the theme of movement. C404's three-menu interface solution houses the videos in three distinct, lively and slightly warped animated environments. Additionally, C404 created an opening sequence, end credits and artist piece intros that mix audio, graphics and live-action video.

ERIC MYER PHOTOGRAPHY WEB SITE

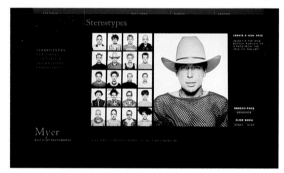

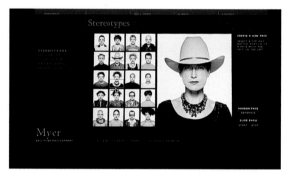

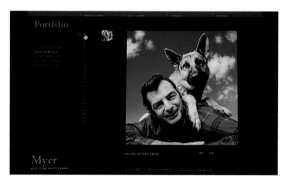

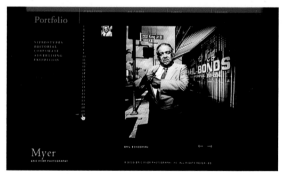

Merit Product/Service Promotion **Eric Myer Photography Web Site**

CREATIVE DIRECTOR Kerry Leimer **PHOTOGRAPHER** Eric Myer **STUDIO** Eric Myer Photography **COUNTRY** United States

As a portrait photographer, I have always been intrigued with the "landscape" of the human face and our prejudices regarding appearance. I question why certain facial attributes attract or repel us, and why the perception of beauty varies in different cultures. This concept originally started as a book idea. I photographed a wide range of individuals with the idea of juxtaposing the tops and bottoms of different portraits. Many seemingly incompatible pairings resulted in humorous or disturbing faces. The concept then developed into an interactive medium which I integrated into my Web site introduction.

HARLEY-DAVIDSON AD PLANNER

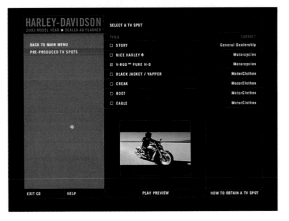

Merit Product/Service Promotion **Harley-Davidson Ad Planner**

CREATIVE DIRECTOR Dave Ritter **DESIGNER** Dave Ritter **GRAPHIC DESIGN** VSA Partners **INTERACTIVE DESIGN** Oncall Interactive, LLC **COPYWRITER** Reid Armbruster **PROGRAMMER** David Scott **PHOTOGRAPHER** Charlie Simokaitis **MUSIC** Angelo Bosco **PROJECT MANAGER (ONCALL)** Jerry Scott **PROJECT MANAGER (VSA)** Jackie Kravick **CLIENT** Harley-Davidson **COUNTRY** United States

The Harley-Davidson 2003 Ad Planner provides the national network of Harley-Davidson dealers with an intuitive resource for developing customized marketing materials consistent with corporate standards. Faced with the challenge of harmonizing the marketing efforts of manufacturers and distributors in a cost-effective manner, the ideal solution would align corporate goals with the needs of individual dealers while preserving the bottom line. Enter the Harley-Davidson 2003 Ad Planner. Distributed via CD and designed for ease-of-use, it generates printer-ready materials that can be previewed and downloaded or e-mailed without leaving the application. Pre-produced radio and television spots, numerous graphics and marketing guidelines were included. Dealerships and headquarters alike appreciated the fact that the marketing process could be streamlined and coordinated, all on a single innovative CD. Success bears the test of time: for a second consecutive year, VSA Partners and Oncall Interactive have collaborated on the Harley-Davidson Ad Planner.

NIVEA: THE SHOWER POWER GAME

Merit Product/Service Promotion **NIVEA: The Shower Power Game**

ART DIRECTOR Christophe Stoll **DESIGNER** David Schellnegger **COPYWRITER** Roman Hilmer **PROGRAMMER** Jan-Michael Studt **ILLUSTRATOR** David Schellnegger **AGENCY** Fork Unstable Media **CLIENT** Beiersdorf AG **COUNTRY** Germany

Fork Unstable Media and NIVEA teamed up for the World Cup 2002. While everyone was trying to bend it like Beckham, Fork Unstable Media and NIVEA had taken a different strategy on the tired football game genre, focusing on changing-room antics. The goal of the Java-based game is to get one's players clean and out of the men's showers as fast as possible—and most importantly, faster than the computer opponents. To boost chances of victory, NIVEA has installed cabinets of their NIVEA For Men product range so the footballers can grab some on their way into the shower, helping their strikers to get cleaner quicker.

PASSAT W8

Merit Product/Service Promotion **Passat W8**

ART DIRECTORS Nicole McDonald, Will McGinness **CHIEF CREATIVE OFFICER** Ron Lawner **GROUP CREATIVE DIRECTOR** Alan Pafenbach **CREATIVE DIRECTORS** Chris Bradley, Tim Brunelle **DESIGNER** Will McGinness **COPYWRITER** Rob Thompson **FLASH PROGRAMMING** The Barbarian Group **TECHNICAL MANAGER** Roy Wetherbee **PRODUCER** Jennifer Iwanicki **AGENCY** Arnold Worldwide **CLIENT** Volkswagen of America **COUNTRY** United States

WWW.HONDAF1.COM

Merit Product/Service Promotion **www.hondaf1.com**
DESIGNERS Stuart Bowler, Chris Randall, Jon Shanks **CLIENT** Honda **COUNTRY** United Kingdom

NIKE RUNNING

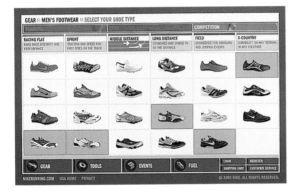

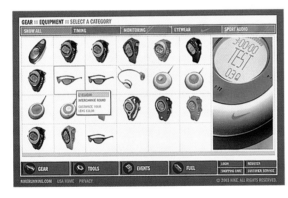

Merit Product/Service Promotion **Nike Running**

ART DIRECTOR Rei Inamoto **CREATIVE DIRECTOR** Nick Law **SENIOR DESIGNER** Jerome Austria **JUNIOR DESIGNERS** Mini Ham, Rich Mains **COPYWRITER** Joshua Bletterman **SENIOR FLASH DESIGNERS** David Morrow, Mathew Ranauro **SENIOR FLASH DEVELOPER** Noel Billig **SENIOR SOFTWARE PROGRAMMER** Stan Wiechers **ILLUSTRATOR** Mini Ham **PRODUCER** Amy Weidberg **AGENCY** R/GA Interactive **CLIENT** Nike **COUNTRY** United States

Nikerunning.com was developed to provide optimum service to runners and assist them in achieving their personal best. A variety of tools were developed using Flash to create a graphically rich interface but not at the expense of functionality. One innovative feature is the Footwear Finder that replicates the personalized experience of going to a running specialty store. Based on their specific performance needs, runners can compare the attributes of Nike running shoes and then purchase them online or locate a retailer nearby. Other key features include TOOLS—the most innovative is the Training Log where runners can log a variety of athletic activities. The Training Log then graphs the runner's progress over time and tracks the cumulative mileage. Marathon-specific pace calculators, each based on the actual racecourse elevation, downloadable training schedules, interactive event coverage and a monthly newsletter, packed with tools, training and details about the latest technology, are all available for runners.

THE HEART OF MAKEUP

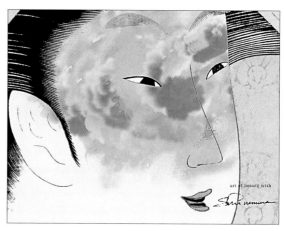

Merit Institutional Promotion **The Heart of Makeup**

ART DIRECTORS Kengo Iizuka, Hisamoto Naito **DESIGNERS** Yoko Hamane, Mika Takahashi, Takeshi Tune, Shinya Yamamoto **COPYWRITER** Teruo Otsubo
PROGRAMMING Yoppa.org **PHOTOGRAPHER** Yutaka Mori **PRODUCER** Hiroshi Uemura **ADVERTISING SUPERVISORS** Miyuki Murayama, Hiroko Yuasa
CLIENT Shu Uemura Cosmetics, Inc. **COUNTRY** Japan

INSIDE THE PEACE CORPS EXPERIENCE

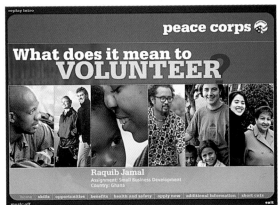 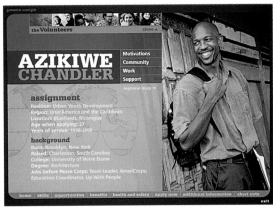

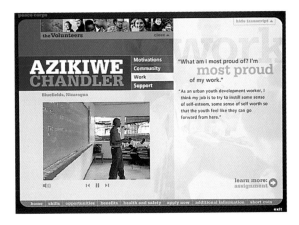 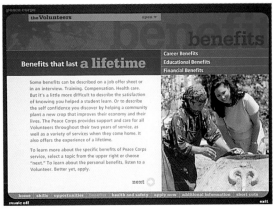

Merit Institutional Promotion **Inside the Peace Corps Experience**

ART DIRECTOR Amanda Grupe Otter **CREATIVE DIRECTOR** David Belman **DESIGNERS** William Colgrove, Phil Gosier, Amanda Grupe Otter **COPYWRITER** David Belman **PROGRAMMER** Geoffrey Bishop **AGENCY** Threespot Media **CLIENT** Peace Corps **COUNTRY** United States

Threespot Media worked with the Peace Corps to conceive, define and develop an interactive, self-running recruitment CD-ROM. This CD-ROM is an engaging take-away that recruiters hand out to potential volunteers to supplement and extend the experience of the recruiting event. The take-away features an in-depth look into the stories and experiences of seven former volunteers and an aesthetic that is derivative of Threespot's design of the Peace Corps Web site. Threespot leveraged existing Peace Corps photos, volunteer stories and video footage to minimize production costs. These pre-existing video and image assets were never developed to support the creation of a CD-ROM, and therefore required significant editing and massaging to tie volunteer stories together through graphic interfaces, screen text, video editing and narrative voice-over. The new product proved so successful that additional runs were requested. More than 100,000 CDs have been distributed to date.

THE COOPERSTOWN COLLECTION

Merit Institutional Promotion **The Cooperstown Collection**

ART DIRECTORS Kevin Dorry, Tara Giacomozzi **DESIGNERS** Kevin Dorry, Tara Giacomozzi, Chris Milnes **PROGRAMMER** Hudson Choi **SITE DESIGN** Axis 360 **INFORMATION ARCHITECT** Chris Milnes **PRODUCTION ARTIST** Nick Greif **PRODUCER** John Milnes **AUDIO PRODUCER** Jack Pitzer **CLIENT** Major League Baseball **COUNTRY** United States

In the case of this project, our marching orders were clear: "Create a new online style guide that not only integrates into the larger system, but is also visually exciting, user-friendly and able to generate more usage of the Cooperstown Collection artwork. Oh, and do it in four weeks." In the end, we all decided that a historical timeline would be the best way to go. It not only provided historical context for the artwork, but it also became a perfect navigational tool. Everyone on the creative team had specific baseball moments that they wanted to include in the timeline. So, we listed each moment on a grid and voted. With that problem solved, our final challenge was to assemble the photos and illustrations into an engaging timeline. Because it scrolls horizontally, we had to make sure it always looked balanced, even if people could only see part of a larger piece of art, it had to work on its own. In the end we more than exceeded expectations. Licensee use increased by more than ten times and the feedback was overwhelming.

+HP WEB SITE

Merit Institutional Promotion **+hp Web Site**

ART DIRECTOR Jeff Benjamin **CREATIVE DIRECTORS** Keith Anderson, Steve Luker, Rich Silverstein, Steve Simpson **COPYWRITER** Peter Rudy
PRODUCER Victoria Brown **AGENCY** Goodby, Silverstein & Partners **CLIENT** Hewlett-Packard Company **COUNTRY** United States

SAVE THE CHILDREN WEB SITE

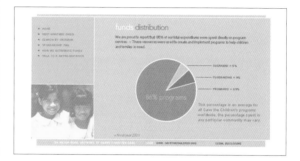

Merit Public Serice/Nonprofit **Save the Children Web Site**

ART DIRECTOR Fanny Krivoy **CREATIVE DIRECTOR** Fanny Krivoy **COPYWRITER** Michael Barnwell **AGENCY** Organic New York **CLIENT** Save the Children
COUNTRY United States

3D&I

Merit Reference/Education **3d&i**

ART DIRECTOR Brian Jacobs **CREATIVE DIRECTOR** John Sharp **DESIGNERS** Brian Jacobs, Douglas McDonald, Matthew Rogers, Holger Struppek **PROGRAMMER** Catherine Herdlick **EDITORS** Anne-Lise Breuning, Hannah Ireland **EXECUTIVE PRODUCER** Chichi Pierce **CO-EXECUTIVE PRODUCER** Immy Humes **AGENCY** Pentagram Design—San Francisco **CLIENT** Doc Tank, Inc. **COUNTRY** United States

3d&i is a project of The Doc Tank, Inc. The 3d&i Web site is funded by The Corporation for Public Broadcasting. Supercosm, LLC and Pentagram—San Francisco created the information architecture; Supercosm, LLC did the technical direction; and Pentagram—San Francisco designed the look and feel.

IN MEMORIAM: 9/11 NEW YORK CITY

Merit Reference/Education **In Memoriam: 9/11 New York City**

CREATIVE DIRECTOR Dan Sacher **EXECUTIVE PRODUCER** Patricia Wagstaff **COUNTRY** United States

Mirroring the collaborative spirit of the HBO documentary, *In Memoriam: 9/11/01 NYC*, this companion site allowed viewers to create and submit their own memorials and recollections. By supplying an online Flash application with hundreds of photos and simple manipulation tools, the tribute submission process was easily accessible. These tribute "tiles," in concert with audio submissions solicited through a toll-free voicemail line, formed a continuous montage of randomly selected audio and visuals. Additional scenes and interviews that did not meet the time restraints of the documentary were streamed on the site, enabling a deeper analysis of the day from key figures featured in the film.

Merit Game/Entertainment **Clue in to Safety**

ART DIRECTOR Michelangelo Cicerone **DESIGNER** Justin Mysza **COPYWRITER** Antonio Vasquez **AGENCY** J. Walter Thompson **CLIENT** Ford Motor Company **COUNTRY** United States

Clue in to Safety is a national awareness campaign designed to educate parents and their children on the importance of safety. At the heart of the effort is clueintosafety.com, a world where grown-ups can read important safety information and kids can go on interactive safety adventures. The overall design speaks to a child's sensibilities and the interactive games are simple enough for the kids ages 2-5 who visit Safety Blue's Neighborhood. Parents and other caregivers who visit the Front Seat for Parents area can acquire valuable information on subjects such as fire safety, water safety, and vehicle safety. This section also allows visitors to send safety articles to their friends via an E-mail a Friend function. Clueintosafety.com is one component of a much larger integrated communications effort to promote safety.

WUNSCHWALD 2002

Merit Game/Entertainment **Wunschwald 2002**

CREATIVE DIRECTOR Anette Scholz **DESIGNERS** Jenny Fitz, Anne Wichmann **COPYWRITER** Katharina Schlungs **FLASH PROGRAMMERS** Duc-Thien Bui, Duc-Thuan Bui, Mario Dold, Joachim Fraatz, Sebastian Klein, Christian Leitschuh **PROGRAMMER** Thorsten Kraus **PROJECT MANAGER** Alexander Bregenzer **AGENCY** Scholz & Volkmer **CLIENT** Mercedes-Benz **COUNTRY** Germany

The game invites the Internet community to plant a virtual tree and to connect a wish to it. Scholz & Volkmer designed the second edition of the popular Christmas game, which last year enthused more than 50,000 players. Every player plants a tree for his/her wish in the wish forest. In addition to that, he/she can reward the best wishes of the others by watering their trees. All participants can also commit themselves offline, the motto being "Wishes Become Reality." By e-mail, you can offer your help as a sponsor for the fulfilment of a wish. Every day, new questions refer to the Mercedes-Benz Portal. You can increase the water supply by answering them. Apart from that, the diligence of every player is rewarded—action games are not only for the player's diversion but also serve to accumulate water. The players get bonus points if they send e-cards to friends or if they recommend the game.

Merit Interactive Kiosk/Installation **MoMA—The Russian Avant-Garde Book 1910–1934**

ART DIRECTOR Yoshi Sodeoka **CLIENT** The Museum of Modern Art **COUNTRY** United States

C404 designed and programmed three touch-screen kiosks for the "The Russian Avant-Garde Book 1910–1934," an exhibition at the Museum of Modern Art on view March 28 to May 21, 2002. The three kiosks allow visitors to virtually page through five rare illustrated books in their entirety. C404, whose goal was to design a naturalistic interface, dispensed with icons so that visitors simply touch the pages to turn them and move through each book.

GOLD ON GOLD

GOLD ON GOLD from Lyon
Norwegian and High
Quality Gold

CUT and Polished
Round

Melted & Joints
Carat Gold
Settings

GOLD ON GOLD ❖

THE ON

GOLD ON

ADVERTISING'S BEST PRINT, RADIO, TV. VOL.22

graphic design

After I've judged a competition like the ADC, I'm always asked a few questions. How was the work? What were the trends? It turns out that the two questions cancel each other out. Most of the work submitted is what most of the rest of the world is: average. And one of the characteristics that the average things share is that they've taken an innovation from the day before yesterday and turned it into yesterday's trend. In contrast, the best work stands out. It doesn't partake of trends. Sometimes it starts a new trend. But you can't tell right now. So, although the jury has completed their work, we won't really know the verdict on this show until about 2008. Thanks for your patience!

MICHAEL BIERUT | Partner, Pentagram | Graphic Design Chair

MICHAEL BIERUT Michael Bierut is a partner in the New York office of the international design consultancy Pentagram. His clients have included The Council of Fashion Designers of America, Walt Disney Company, The Brooklyn Academy of Music, The Museum of Sex and the New York Jets. He has won many design awards and his work is represented in the permanent collections worldwide. He is president emeritus of the American Institute of Graphic Arts and senior critic at the Yale School of Art.

BRIDGET DE SOCIO Bridget de Socio, founder of the design firm Socio X, concentrated in pre-veterinary medicine as an undergrad before transferring to Parsons School of Design where she became the protégé of Henry Wolf. Art director of extremes, de Socio's passion for visual culture ranges from hipster *Paper* magazine to ultra-chic Vera Wang. Her unmistakable trademarks are sexy photography and a fetish for tech-with-taste surface. De Socio bills herself as a semiologist, motivating desire and studying the commercial why. "I dress scantily clad content with style, in order for the global audience to get it, feel it, smell it and want it."

MICHAEL BIERUT

BRIDGET DE SOCIO

BILL GRANT

CLIVE PIERCY

HALEY JOHNSON

BILL GRANT Bill Grant is president and creative director of Grant Design Collaborative in Canton, GA. Grant's work encompasses corporate identity, strategy and research, print, advertising, Web sites, interiors and exhibits, product design and publication design. Grant has created strategic design programs for clients such as Adobe, Herman Miller, Steelcase, AIGA, Smart Papers, Blue Ridge Commercial Carpet and Mohawk Paper Mills. Grant's work has been recognized by AIGA, *Communication Arts*, *I.D.*, *Print*, HOW, Graphic Design America Two, Graphic Design:usa, Step-by-Step, *Metropolis*, *Interior Design*, *Interiors*, *Contract* and IIDA, among others.

CLIVE PIERCY Clive is a founder and partner, along with Michael Hodgson, of Santa Monica-based Ph.D, A Design Alliance, involved in design and communications for such diverse clients as Nordstrom, Herman Miller, Chronicle Books and Quiksilver. Since 1988 Ph.D's work has won awards from most of the major national and international design competitions. Piercy graduated with honors from Brighton School of Art in England and was a designer at BBC Television for four years before moving to America to become creative director of the Rod Dyer Group. He is on the faculty of Art Center College of Design, and is married to illustrator Ann Field.

HALEY JOHNSON Haley Johnson is president and senior designer of the Haley Johnson Design Company in Minneapolis. The studio was established in 1992 and focuses on brand, packaging and product development. Johnson's work has appeared in both national and international design publications since 1986 and her designs have been accepted into the permanent collections of the Smithsonian Institute, Cooper-Hewitt National Design Museum and Museum Für Kunst und Gewerbe. Long term, much cherished clients include: Blue Q, Peace Coffee, Girl Babies, Inc. and Jane Jenni, Inc.

CHRIS PULLMAN Since 1973, Chris Pullman has served as vice president for design for WGBH public broadcasting in Boston, which supplies about a third of both the PBS prime time schedule and associated Web sites on pbs.org. He and his staff of 40 designers are responsible for the visual personality of WGBH, as expressed through the design of its branding, on-air titles and animation, promotional and sales support, curriculum materials and interactive media. He received his MFA from Yale, where he has taught since 1966. WGBH was recognized in 1985 by the AIGA with its Design Leadership Award and in 2002, Chris was honored as an AIGA Medalist.

EMILY OBERMAN Emily Oberman founded Number 17 in the summer of 1993 with Bonnie Siegler. Number 17 is a small(ish) studio that has big(ish) ideas for clients of all shapes and sizes. Like the opening titles for NBC's *Will and Grace*, *Saturday Night Live*, and Oxygen's *Isaac Mizrahi Show*. And design of Condé Nast's magazine about shopping, *Lucky* (which they also helped invent), André Balazs' Mercer Hotel in NYC and Chateau Marmont in L.A. They are currently designing everything from soup to nuts (chocolate covered ones, at that) for a new national chain of independent movie theaters and a book about the television show *Sex and the City* for HBO.

CHRIS PULLMAN

EMILY OBERMAN

FERNANDO GUTIÉRREZ

ROBIN LYNCH

KEITH YAMASHITA

FERNANDO GUTIÉRREZ Fernando Gutiérrez worked for seven years in the design firm of Carroll, Dempsey and Thirkell, where he collaborated with Mike Dempsey on a wide range of projects, including the new image for the English National Opera. In 1993 he joined forces with Spanish designer Pablo Martin to form the company that would later become Grafica. Widely regarded as the up-and-coming design firm of Spain, Grafica has already garnered three Gold Awards (1994, 1998) from the Spanish Art Directors Club. In October 2000 Fernando was made a partner of Pentagram Design and was officially made creative director of *Colors* magazine in November 2000.

ROBIN LYNCH Robin's work in graphic design has received awards from AIGA, *ID*, ACD, CEBA and *Graphis*. Her work in other media includes the design and creation of opening title sequences for films and computer games, as well as music video direction. She has served as a vice president on the Board of Directors for the New York Chapter of AIGA. She has been an art director at Warner Bros. Records in Los Angeles, director of design at Elektra Records, and vice president of creative services at GRP Records in New York. She is currently an adjunct faculty member at Yale University and is creative director of her own Negerkunst Digital Design Studio in New York.

KEITH YAMASHITA Keith Yamashita founded Stone Yamashita Partners to enable companies to incorporate strategic vision in their cultures and to become stronger competitors. The firm helps leaders take advantage of the five elements of sustained competitive advantage: vision, communications, culture, brand experience and leadership. Yamashita is an established strategist and writer with more than 15 years of experience in articulating the visions of CEO's and companies such as America Online, Apple Computer, Hewlett-Packard, IBM, Kodak, Mercedes-Benz, Netscape, Nike, PBS, Saturn and Sony.

KARIN FONG Karin Fong is a designer and director at Imaginary Forces, a design and production company in Hollywood and New York. Feature film projects include title sequences for *Daredevil*, *Bedazzled*, *Dead Man on Campus*, *The Truman Show*, *The Avengers* and *Charlie's Angels*. Broadcast clients include MTV, the Cartoon Network and PBS. Her work for Masterpiece Theatre's American Collection won an Emmy for main title design. Karin recently led a team that created tour visuals for DJs Sasha and Digweed. Other projects include a short film for Herman Miller, a Power Puff Girls music video and numerous commercials. Her influences include Saul Steinberg, Schoolhouse Rock and her many collaborators.

MASSIMO VIGNELLI Massimo Vignelli's work includes graphic and corporate identity programs, publication designs, packaging, architectural graphics, exhibition, interior, furniture and consumer product designs for many leading American and European companies and institutions. His work has been published and exhibited throughout the world and entered in the permanent collections of several museums. A major exhibition of Vignelli Associates' work toured Europe's most important museums between 1989 and 1993. He has received seven Honorary Doctorates in Fine Arts; the 1983 AIGA Gold Medal; and the 1985 USA President's Design Excellence Award and is a member of the Art Directors Club Hall of Fame.

KARIN FONG MASSIMO VIGNELLI

RICK POYNOR MAIRA KALMAN CHERYL TOWLER WEESE

RICK POYNOR Rick Poynor founded *Eye* magazine in London in 1990, edited it for seven years and now writes a regular column for *Eye* and its Web site. He is a columnist for *Print* and has written about design, media and visual culture for *I.D.*, *Blueprint*, *Metropolis*, *Graphis*, *Harvard Design Magazine*, *Adbusters*, and many other publications. His books include *Typographica* (2001) and two collections of essays, *Design Without Boundaries* (1998) and *Obey the Giant: Life in the Image World* (2001). He lectures widely in Europe and the US and is a former Visiting Professor at the Royal College of Art, London.

MAIRA KALMAN Maira Kalman is an award-winning author/illustrator of 12 children's books. Her illustrations frequently grace *The New Yorker*, *New York Times* and other publications. She designs products distributed by MoMA, has designed fabrics for Isaac Mizrahi and sets for Mark Morris Ballet Group. She is working on her 13th book and is preparing for a one-woman show at the Julie Saul gallery opening late April 2003. She is on the board of the AIGA—NY and lives in New York.

CHERYL TOWLER WEESE Cheryl Towler Weese began her design discipleship at age nine, when she learned to proofread galleys at her parents' weekly newspaper. Along with her partner Kathy Fredrickson, she runs studio blue, a firm that develops and designs books, environmental design, identities and a range of Web and printed matter. The studio focuses on projects that involve close collaboration between client and designer, the opportunity to develop content, and innovative ways of communicating with the public. It grounds its work in the liberal arts, incorporating both culture and context.

SEAN ADAMS Sean Adams is a partner at AdamsMorioka in Los Angeles. Sean has been globally recognized by every major competition and publication including *Communication Arts*, AIGA, *Graphis* and the Art Directors Club. The San Francisco Museum of Modern Art recently exhibited AdamsMorioka in a retrospective. Adams has been named to the ID40, as one of the 40 most important people shaping design internationally. He is a former member of the AIGA National Board, a fellow of the Aspen Design Conference and a faculty member at CalArts. AdamsMorioka's clients include ABC, Gap, Old Navy, Frank Gehry Associates, Nickelodeon, Oxygen, VH1 and Sundance.

TOMMY STEELE Tommy Steele has served as vice president, creative services at Capitol/Virgin Records, managing the company's worldwide entertainment packaging, including compact discs, record sleeves and box sets, television, film and special projects. The six-time Grammy-nominated art director also supervised all merchandising, advertising, media and print operations for the labels. As head of EMI's in-house team, he spearheaded creative campaigns for such renowned artists as Radiohead, Tina Turner, Bonnie Raitt, Bob Seger, The Beach Boys, Frank Sinatra, The Rolling Stones, Beastie Boys, The Beatles and Capitol's 50th Anniversary book/CD set. Tommy is now with Team One Advertising as creative director of the design group.

SEAN ADAMS | TOMMY STEELE

MICHAEL VANDERBYL | CARIN GOLDBERG | JACK SUMMERFORD

MICHAEL VANDERBYL Michael Vanderbyl has gained international prominence in the design field as a practitioner, educator, critic and advocate. Since being established in San Francisco in 1973, his firm, Vanderbyl Design, has evolved into a multidisciplinary studio with expertise in graphics, packaging, signage, interiors, showrooms, retail spaces, furniture, textiles and fashion apparel. Michael is the recipient of the Gold Medal award from The American Institute of Graphic Arts; he is a member of the Alliance Graphique Internationale (AGI) and presides as dean of design at the California College of Arts and Crafts.

CARIN GOLDBERG With 25 years experience in graphic design, Carin Goldberg's background includes design and advertising for major publishing, music and television corporations. From the mid-1970s to the early 1980s she worked as a staff designer for CBS Television Network, CBS Records and Atlantic Records. In 1982 she established Carin Goldberg Design. Some of her clients have included Simon & Schuster, Random House, Harper Collins, Hyperion, Doubleday, Time Inc. and Nonesuch Records. Carin is design director at Time Inc. Custom Publishing and has recently designed and authored her first book titled *Catalog* published by Stewart, Tabori and Chang.

JACK SUMMERFORD Jack Summerford founded Summerford Design, Inc. in 1978 after 13 years with other design and advertising firms. He studied design at Washington University in Saint Louis graduating from there in 1965. His work has been represented in shows, feature articles and museum exhibitions, such as The Art Directors Club Annual Awards, various AIGA shows, *Communication Arts*, *Graphis*, *Interiors*, *Print*, The Library of Congress, The Smithsonian Institution, Brandenburgische Kunstsammlungen Cottbus, Musée de la Poste and The Grand Palais. Currently, Jack's work is divided into design, consulting, teaching and writing.

Paintings and Sculpture 1961-1963

WARHOL

01

THE ANDY WARHOL CATALOGUE RAISONNE

PHAIDON

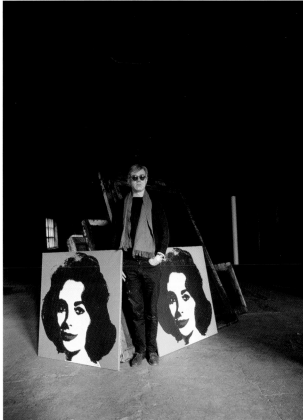

Gold Medal Special Trade Book (Image Driven) **Andy Warhol Catalogue Raisonne**

ART DIRECTOR Julia Hasting **EDITORS** Georg Frei, Neil Printz **PROJECT EDITOR** Megan McFarland **PUBLISHER** Phaidon Press **COUNTRY** United States

THE CONDÉ NAST PUBLICATIONS *Inc.*

To	BARON DE GUNZEURG MRS. SIMPSON	**From**	MRS. VREELAND	**Date** DECEMBER 6, 1966
Copy to	MRS. SCHIFF	**Subject:**		

MRS. SCHIFF
MRS. MELLEN
MRS. DI MONTEZEMOLO
MISS MILINAIRE
MISS DONOVAN
MR. DUHÉ
MRS. INGERSOLL
MISS HARLOW
MISS MC KENNA
MISS WINKELHORN
MISS HAYS
MISS PHILLIPS
MRS. BLACKMON
MISS MIRABELLA

RE: <u>COVER SITUATION</u>

Our cover situation is drastic...

I do not hear from anyone an idea or a suggestion of either a face
or something that would be suitable...

We are on the verge of a drastic emergency.

Gold Medal Limited Edition/Private Press/Special Format Book **Visionaire 37: Vreeland Memos**
ART DIRECTORS Greg Foley, Stephen Gan **DESIGNERS** Jason Duzansky, Tatiana Gaz **PUBLISHER** Visionaire **COUNTRY** United States

One day a mysterious package arrived at the Visionaire offices. It was a large box containing more than 400 original memos from Diana Vreeland to her staff at *Vogue*. The package had been sent to us by a contributor who preferred to remain anonymous. In some ways, the experience was like stumbling upon fashion's Holy Grail. We had heard stories about these memos but were stunned to find out that they actually existed. Dating from 1966 to 1972, the memos, which were dictated to Vreeland's secretary from the sanctuary of her bathroom each morning, covered topics ranging from the wacky (the use of freckles or the utter importance of dog collars, for example) to the divine (the genius of Halston). But more importantly, the Vreeland memos provide a rare glimpse inside the mind of one of the most influential women in fashion history. We received permission from Condé Nast to publish nearly 150 of the memos in an edition of 4,000.

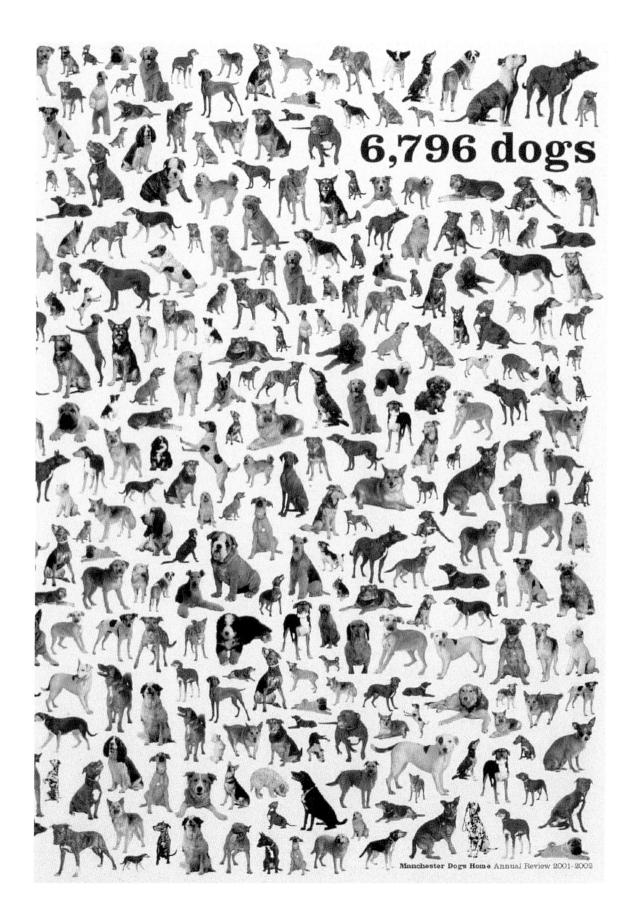

6,796 dogs

Manchester Dogs Home Annual Review 2001-2002

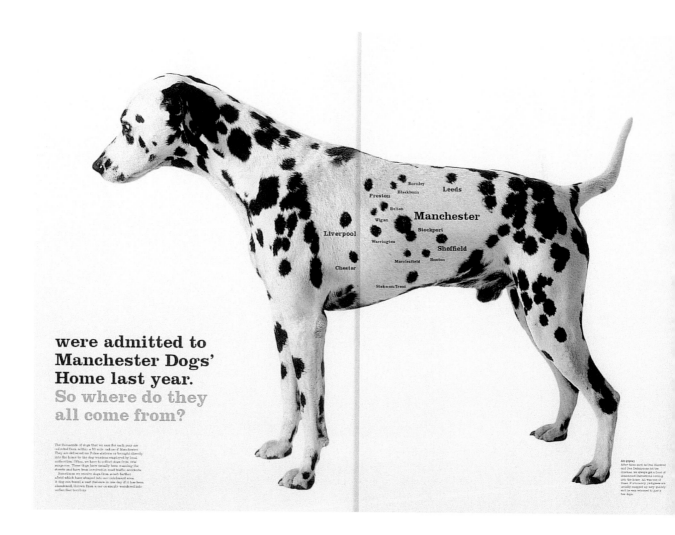

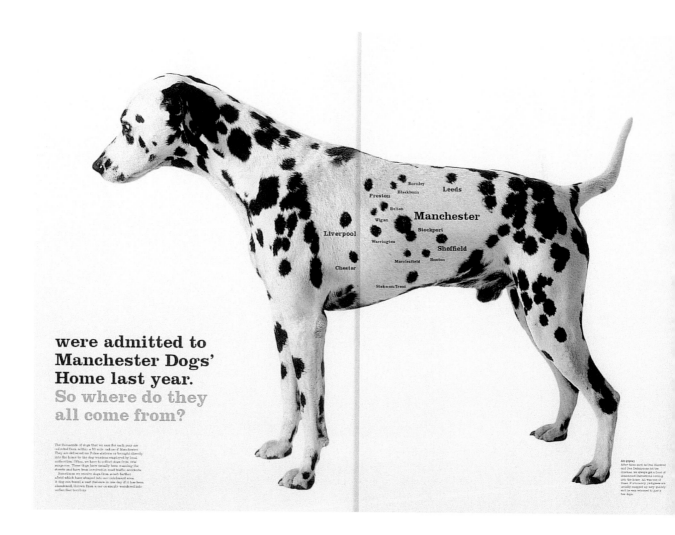

were admitted to
**Manchester Dogs'
Home last year.**
So where do they
all come from?

Gold Medal Self-Promotion: Print **Manchester Dogs' Home R+A 2001-2002**

ART DIRECTOR Harriet Devoy **DESIGNERS** Harriet Devoy, Steve Royle **PHOTOGRAPHER** Matt Wright **CLIENT** Manchester Dogs' Home **COUNTRY** United Kingdom

Manchester Dogs' Home is a charity which rescues lost and abandoned dogs in and around the Manchester area. It is the largest home in the U.K., but is critically under-funded and has little or no budget for promotional material or advertising. The brief was to design a report that could work really hard for them as an annual review but also as a brochure that can be left in the waiting rooms of veterinarians for people to take away. It was critical that we didn't alienate an audience that isn't familiar with annual reports so key messages are delivered in an engaging and sometimes entertaining way.

Moss green, brown, lilac, shocking pink, scarlet and other great colours on Munken Print Extra 18 150 g/m²

Gold Medal Booklet/Brochure **DM: Colourbook**

ART DIRECTORS Andreas Kittel, Anders Kornestedt **DESIGNER** Andreas Kittel **COPYWRITER** Björn Engström **ILLUSTRATOR** Io **AGENCY** Happy Forsman & Bodenfors
CLIENT Munkedals AB **COUNTRY** Sweden

Gold Medal Annual Report **Zumtobel Annual Report**

ART DIRECTOR Stefan Sagmeister **DESIGNERS** Matthias Ernstberger, Stefan Sagmeister **COPYWRITER** Otto Riewoldt **PHOTOGRAPHER** Bela Borsodi **STUDIO** Sagmeister Inc. **CLIENT** Zumtobel **COUNTRY** United States

Zumtobel is a leading European manufacturer of lighting systems. The cover of this annual report features a heat-molded relief sculpture of five flowers in a vase, symbolizing the five sub-brands under the Zumtobel name. All images on the inside of the annual report are photographs of this exact cover, shot under different light conditions, illustrating the incredible power of changing light.

**FILMPODIUM
JULI-AUG.02**

Gold Medal Posters: Promotional **NY**

ART DIRECTOR Ralph Schraivogel **DESIGNER** Ralph Schraivogel **COPYWRITER** Ralph Schraivogel **SILKSCREEN PRINTER** Albin Uldry **STUDIO** Schraivogel Design
CLIENT Film Podium Zurich **COUNTRY** Switzerland

The poster "NY" was commissioned by the Zurich Film Podium, a repertory cinema, for their film series on New York City. Because film stills generally focus on actors, the challenge was to make them evoke a street-life ambiance reflective of New York City in film. I used the close-up stills to build an architectonic quality into the poster, a "typotecture" describing tall buildings. The photographs' flat surfaces become the building facades on big-city street ravines and the edges of the individual photographs become the edges of the buildings. The image then becomes an optical contradiction, what we call a "Vexierbild"—it vexes.

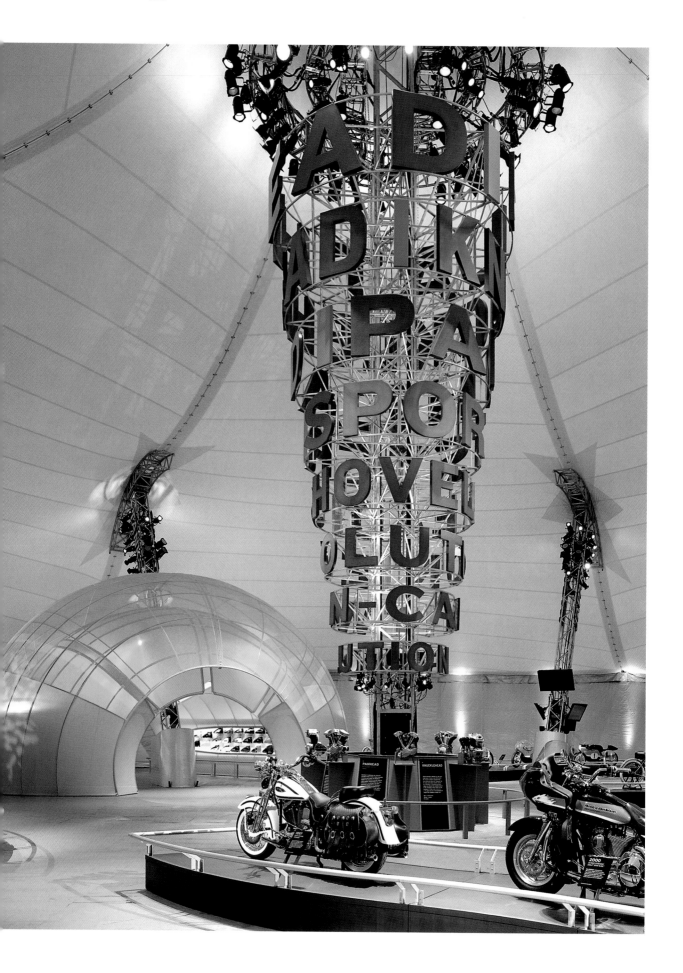

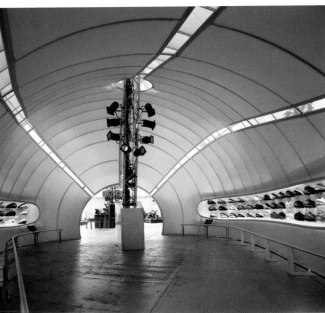

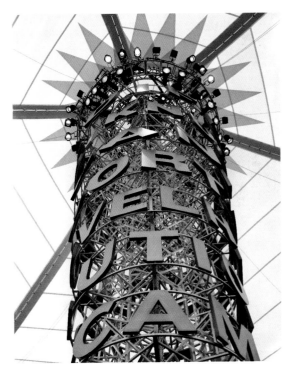

Gold Medal Gallery/Museum Exhibit/Installation **Harley-Davidson: The 100th Anniversary Open Road Tour**

ART DIRECTOR Abbott Miller **DESIGNERS** James Hicks, Jeremy Hoffman, Abbott Miller **STUDIO** Pentagram Design **CLIENT** Harley-Davidson Motor Co. **COUNTRY** United States

The 100th Anniversary Open Road Tour is Harley-Davidson's massive centennial exhibition, traveling to ten cities around the world. The 60,000-square-foot exhibition is the centerpiece of a wider festival site that includes demo rides, food and retail. Harley-Davidson saw the tour as an opportunity to celebrate with its extended family of loyal enthusiasts while also engaging the broader public. The designers' challenge was creating a flexible, large-scale, museum-quality exhibition that would capture the Harley experience in a way that had a grassroots feel. The exhibition is organized thematically in three large tents, and the design seeks to affirm the status of the Harley as an iconic design object by using its formal vocabulary to shape the show's context. For instance, the circular "Machine" tent and its interior tank-graphics gallery both employ fabric structures, but they do so in curved forms borrowed from Harley designs. Large-scale typography was used to animate the exhibits and structures, and to communicate the strength of Harley's image.

Gold Medal TV Identities/Openings/Teasers **Video Music Awards Nominee Packages**

3D ART AND DESIGN DIRECTOR Kevin O'Callaghan **CREATIVE DIRECTOR** Jeffrey Keyton **SENIOR DESIGN DIRECTOR** Romy Mann **DESIGNERS** Luke H. Choi, Clint Woodside **PRODUCER** Jen Roddie **DIRECTOR** Jen Roddie **DIRECTOR OF PHOTOGRAPHY** Todd Antonio Somodevilla **SOUND DESIGN** Ohm Lab **WRITER** Laura Murphy **CLIENT** MTV Networks **COUNTRY** United States

In packaging the category nominees, we explored how to have fun with the statue by putting an MTV twist to it. The technical challenge in doing this was making the statues into fully functioning appliances and products and creating infomercials that conceptually suited each category.

Gold Medal Cinema: Opening Title Sequence "**One Hour Photo**" Main Titles

CREATIVE DIRECTOR Kyle Cooper DESIGNERS Ellerey Gave, Matt Tragesser 2D ANIMATOR Matt Tragesser DIRECTOR Mark Romanek EXECUTIVE PRODUCER Peter Frankfurt HEAD OF PRODUCTION Chip Houghton PRODUCER Keith Bryant PRODUCTION Fox Searchlight/Killer Films STUDIO Fox Searchlight DESIGN STUDIO Imaginary Forces COUNTRY United States

Gold Medal Animation **Burberry Rain**

ART DIRECTOR Elliot Harris **CREATIVE DIRECTOR** Robin Weeks **COPYWRITER** Ben Carson **AGENCY PRODUCER** Claire Sparksman **AGENCY** Springer & Jacoby—UK
CLIENT Burberry **COUNTRY** United Kingdom

The client asked the agency to create an ambient film to run as a loop on plasma screens inside the trench coat departments of Burberry stores across
the world. This two-minute film immerses the viewer in the world of the Burberry check and celebrates its fundamental connection with rain. The viewer
is taken on a journey through a city in the rain in which gutters, sewers, rivers, umbrellas, windows and raindrops are all animated from the abstract
shapes of the Burberry check.

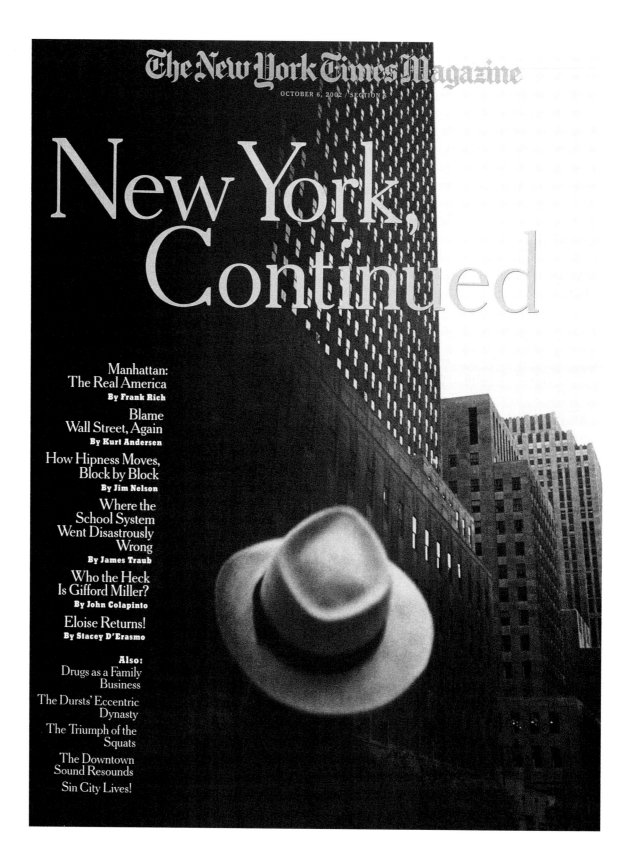

The New York Times Magazine

OCTOBER 6, 2002 / SECTION 2

New York, Continued

Manhattan:
The Real America
By Frank Rich

Blame
Wall Street, Again
By Kurt Andersen

How Hipness Moves,
Block by Block
By Jim Nelson

Where the
School System
Went Disastrously
Wrong
By James Traub

Who the Heck
Is Gifford Miller?
By John Colapinto

Eloise Returns!
By Stacey D'Erasmo

Also:
Drugs as a Family
Business

The Dursts' Eccentric
Dynasty

The Triumph of the
Squats

The Downtown
Sound Resounds

Sin City Lives!

The De Facto Capital

In a time when information, culture and the fear of what might come next are what bind Americans together, New York is the real national seat — and Washington is an island off the coast of America. By Frank Rich

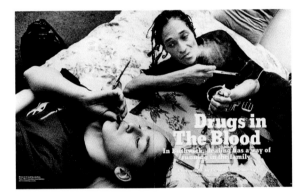

Drugs in The Blood

In Bushwick, healing has a way of running in the family.

Little Grown-Ups Live Here

A last 'Eloise' sequel is about to be published, four years after the author's death, confirming still again that Manhattan is the sandbox of the precocious. By Stacey D'Erasmo

They Are It

The Strokes are a downtown band that wants to be big — without leaving the neighborhood behind.

Photographs by Ryan McGinley
Text by Gerald Marzorati

Silver Medal Consumer Magazine: Full Issue, Series **New York Times Magazine—New York Issue**
ART DIRECTOR Janet Froelich **DESIGNER** Joele Cuyler **PHOTO EDITOR** Kathy Ryan **COUNTRY** United States

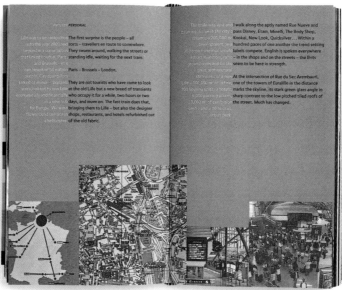

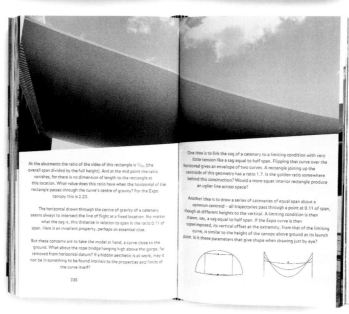

Silver Medal Special Trade Book (Image Driven) **Informal**

ART DIRECTORS Michele Jannuzzi, Richard Smith **DESIGNERS** Sebastian Campos, Edoardo Cecchin, Michele Jannuzzi, Robbie Mahoney, Richard Smith
AUTHOR Cecil Balmond **STUDIO** Jannuzzi Smith **CLIENT** Prestel **COUNTRY** United Kingdom

Cecil Balmond is an engineer, designer, mathematician, thinker and writer. This book is an account of his theory of the informal, presented as a series of interlinking stories about projects undertaken in collaboration with many of the world's foremost architects, including Rem Koolhaas, Daniel Libeskind and Alvaro Siza. Anecdote vies with analysis, science with art, with pace, tone and emphasis varying to suit individual content. Stories relating to common projects are dispersed to provide intellectual and graphical counterpoint, then visually reunited through the use of a different signature color for each project. The contents page and the cover use these colors to map the rest of the book. Underpinning the whole is a typographic treatment designed to relay the simple elegance of Balmond's ideas. Conventional text settings were abandoned in favor of an internal alignment, which softens the hard right angles of the book, and enables words, doodles, photographs and other illustrative material to be interwoven.

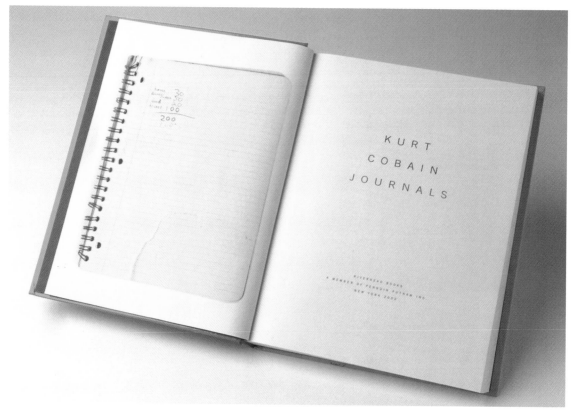

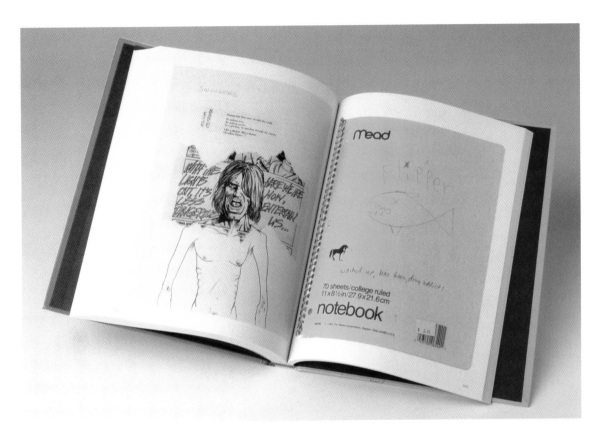

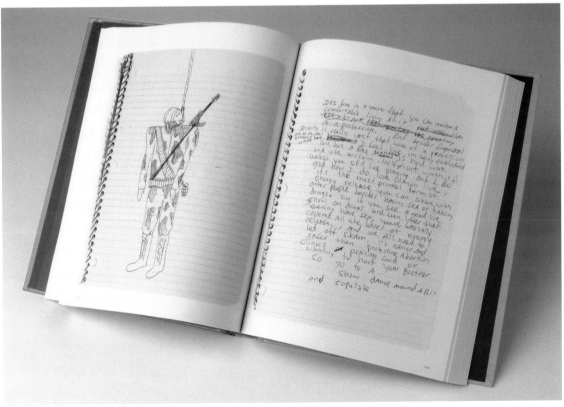

Silver Medal Special Trade Book (Image Driven) **Kurt Cobain Journals**

ART DIRECTOR Claire Vaccaro **ART DIRECTOR (JACKET)** Lisa Amoroso **DESIGNER** Claire Vaccaro **DESIGNER (JACKET)** Chip Kidd **PHOTOGRAPHER** Nick Vaccaro
PUBLISHER Riverhead Books **COUNTRY** United States

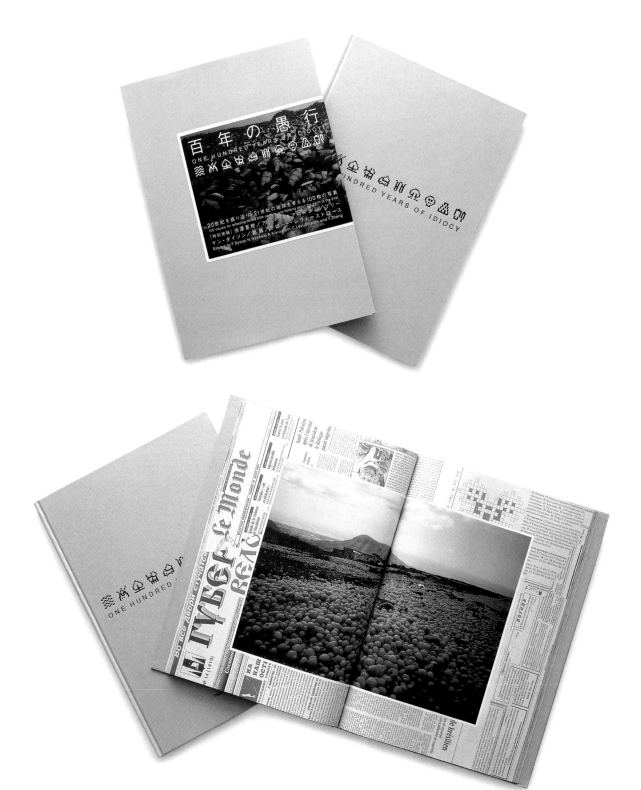

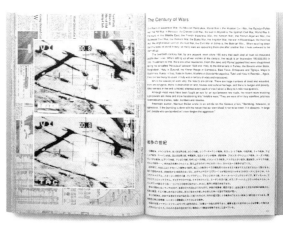

Silver Medal Special Trade Book (Image Driven) **One Hundred Years of Idiocy**

ART DIRECTOR Naoki Sato **PHOTOGRAPHY** Corbis Japan, Inc., Magnum Photos—Tokyo **EDITORIAL DIRECTOR** Tetsuya Ozaki **EDITOR** Tami Okano
PRODUCER Soichi Ueda **PRINTER** Sannichi Printing Co., Ltd. **CLIENT** Think the Earth Project **COUNTRY** Japan

In creating a photo book that summarized human idiocy in the 20th century, editorial director Tetsuya Ozaki started thinking about how we could make use of newspapers, which were the biggest news medium in the century. And we decided to use old newspapers to mount the photographs to pay respect to the photographers and the media. The layers of old newspapers in different languages with a variety of facts signifies the accumulation of facts and time. The background of text pages are given a vintage finish. Letters are processed with Photoshop for distinctive looks. Uniquely designed pictograms, symbolizing contents, keep the balance of "heavy (theme) and light (design)" and save our work from becoming "another textbook on history." Matte finish papers were chosen, as I believe their distinctive sense of touch conveys the theme better.

Silver Medal Museum/Gallery/Library Book **Alfred Stieglitz: The Key Set**

DESIGNER Derek Birdsall **EDITOR** Mary Yakush **AUTHOR** Sarah Greenough **SEPARATOR** Robert Hennessey **PUBLISHER** National Gallery of Art
COUNTRY United States

The first and most obvious requirement was to achieve reproductions as faithful as possible to the spirit of the original photographs. The 1,642 original prints were scanned at the National Gallery. Robert Hennessey finished the scans and made the duotone separations. With NGA's curator, Sarah Greenough, and editor, Mary Yakush, he devised a printing strategy using black plus five colors, plus a selective tint, that could be variously combined to approximate the range of colors in Stieglitz's platinum, palladium and gelatin silver prints. The colors used in the final printing were chosen after a series of trial proofs on Phoenix Motion Xantur paper. The second requirement was to reproduce the prints in a proportionate size. To allow two pictures per page, the whole plate (approximately 10" x 8") and larger prints are reproduced at exactly 50 percent. To avoid minuscule reproductions, quarter plate prints (approximately 4" x 5") are sized at exactly 80 percent, and prints in between at 65 percent. None of the sizes are fixed according to a grid, with the result that minute differences between prints of a similar size are accurately reproduced.

Silver Medal Newsletter/Journal/House Publication **Orange Guidelines**

ART DIRECTOR Mark Smith **DESIGNERS** Adam Browne, Rene Christoffer, David Day, Mike Reid, Mark Smith **COPYWRITER** Glyn Britton **PHOTOGRAPHERS** Michael Fair, Philip Gay **STUDIO** Innocence **CLIENT** Orange **COUNTRY** United Kingdom

A modern brand can't set its guidelines in stone and enforce them rigidly year after year. Orange regularly reviews their creative work to make sure they stay contemporary and in touch with what their customers want. Towards the end of 2002 Innocence felt that Orange's communications would benefit from an injection of humour and humility. So we produced a newspaper for the people who brief and create their communications, to remind them that it's OK to relax and have fun ideas. The newspaper format is ideal because it was quick to produce, and feels authoritative but not too permanent. Innocence designed, wrote and produced the newspaper, incorporating some existing content and creating lots of new stuff. It was fun, so we're going to do more like this in the future.

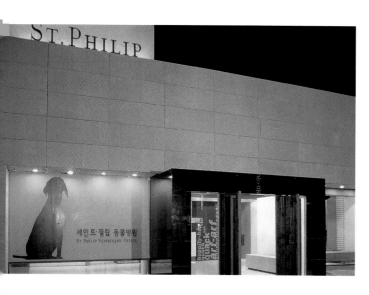

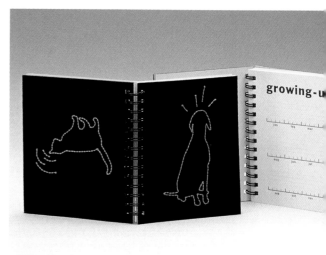

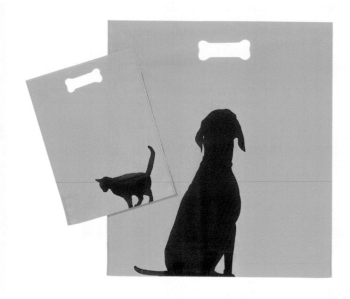

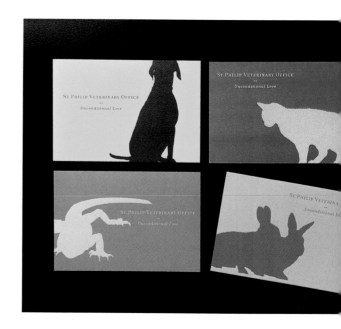

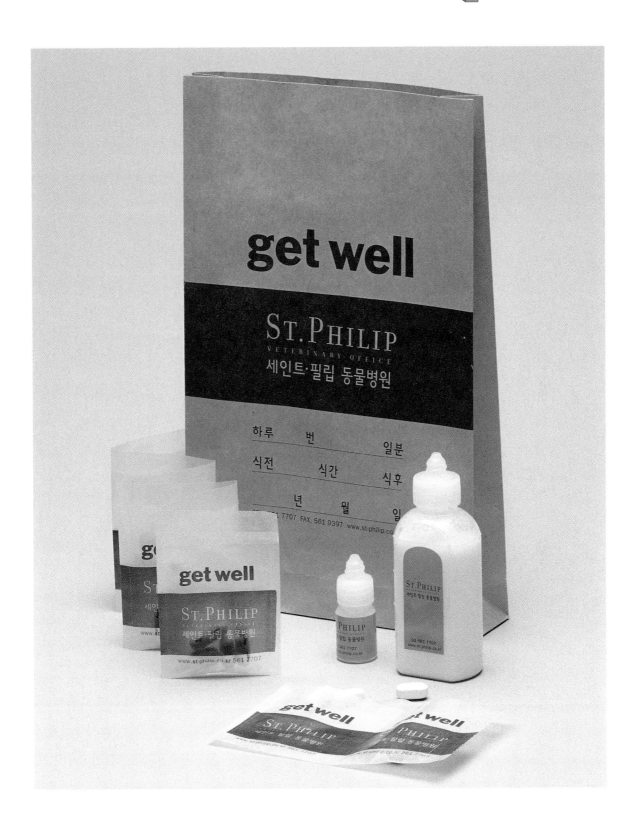

Silver Medal Corporate Identity Program **St. Philip Veterinary Office**

ART DIRECTORS Kyungsun Kymn, Eunhee Shin **DESIGNERS** Minjung Kim, Kyungsun Kymn, Eunhee Shin **COPYWRITER** Daesuk Seo **PHOTOGRAPHER** Jaehong Do
ARCHITECT Dongjin Kim **CLIENT** St. Philip Veterinary Office **COUNTRY** South Korea

The brief was to create a place to show their service with its own character, targeted at people who were eager to do anything for their pets. The emphasis was on providing a comfortable, exquisite atmosphere for both pet and owner. Based on the greeting sounds of different animals, two columns at an entrance were decorated with typography, while operating rooms were enhanced with the calming sounds of animals. A fur material was used to decorate the ceiling, producing an appropriate expanded space. Animal-based graphics cover different areas, including a hotel and a hair salon for pets. We approached the renovations with the feelings of both pet and owner in mind.

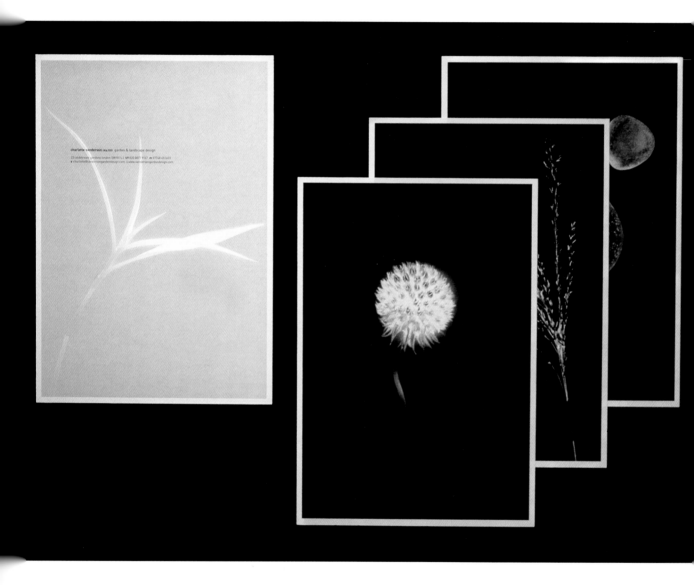

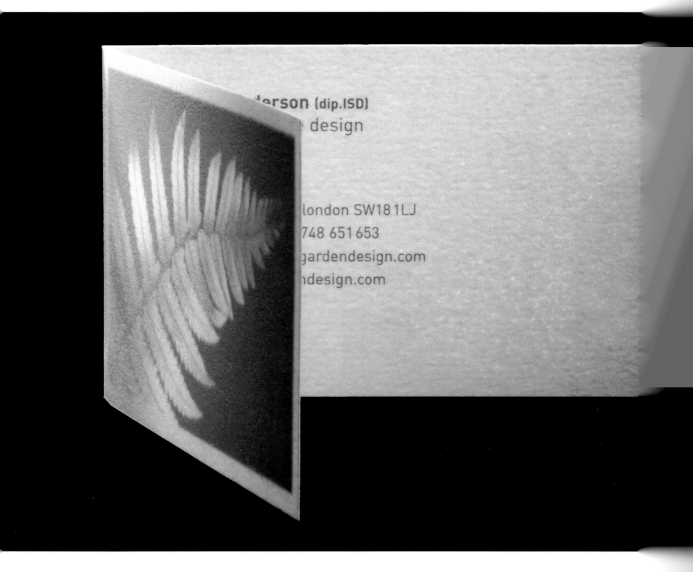

Silver Medal Stationery **Charlotte Sanderson Stationery**

DESIGNERS Jamie Ellul, Gareth Howat, Jim Sutherland **PHOTOGRAPHY** hat-trick design **CLIENT** Charlotte Sanderson **COUNTRY** United Kingdom

Sanderson Garden & Landscape Design wanted an identity that reflected their eye for detail and design-led approach. It needed to appeal to architects and housing planners, as well as direct clients. A series of photograms were created from the plants and materials they use, showing the detail and beauty of the natural objects. The images are printed onto thin paperstock to create show-through impressions which are discovered on picking up the stationery. A selection of different images were printed onto letterheads and business cards to show the diversity of their work.

Silver Medal Calendar/Appointment Book **One Year of Endless Pain**

ART DIRECTOR Barbara Schirmer **CREATIVE DIRECTORS** Kay Eichner, Michael Reissinger **COPYWRITER** Kay Eichner **PHOTOGRAPHER** Hans Starck
AGENCY Weigertpirouzwolf **CLIENT** Endless Pain Tattoo & Piercing Studio **COUNTRY** Germany

Creation of a present for the regular and future clients of Endless Pain, a famous tattoo and piercing studio at the Reeperbahn in Hamburg. The message: Endless Pain is the right address for all wanting to express themselves by excellent piercings.

E COPIED YOUR MARK THERE, BUZZ. 108:56:09 ARMSTRONG: OKAY. I'VE GOT MY WATER WIND
SE) (GARBLED) 108:57:19 ARMSTRONG: OKAY. (PAUSE) INNER VISOR DOWN. (LONG PAUSE) 108
NEED SOME LIGHT? 109:04:26 ALDRIN: IT'S UNLOCKED, YEAH. 109:04:27 ARMSTRONG: UNLOC
SURE TO BLEED SO...TO BLOW ENOUGH PRESSURE TO OPEN THE HATCH. IT'S ABOUT 0.1 (PSI)
ONG PAUSE) 109:07:33 ARMSTRONG: THE HATCH IS COMING OPEN. (PAUSE) 109:07:40 ALDRIN
9:08:55 MCCANDLESS: COLUMBIA, THIS IS HOUSTON. OVER. 109:09:01 COLLINS: COLUMBIA. (
OGER. OUT. (LONG PAUSE) 109:10:39 ALDRIN: (TO NEIL) (HAVE YOU) TURNED YOUR WATER VALV
TRONG: ALL RCU WINDOWS ARE CLEAR. (PAUSE) LM SUIT CIRCUIT IS 4.2...(CORRECTING HIMSE
BREAKER OPEN? IF I CAN SEE THAT. (PAUSE) (YOU'LL) HAVE TO LEAN THIS WAY. 109:14:48 ALC
. 109:15:45 ALDRIN: OKAY. ABOUT READY TO GO DOWN AND GET SOME MOON ROCK? 109:15:
AGAINST THE PURSE. (PAUSE) ALL RIGHT. NOW IT'S ON TOP OF THE DSKY. FORWARD AND UP
GOOD. ROLL LEFT. GOOD. (PAUSE) 109:17:54 ARMSTRONG: OKAY. NOW I'M GOING TO CHECK IN
) 109:19:16 ARMSTRONG: OKAY. HOUSTON, I'M ON THE PORCH. 109:19:20 MCCANDLESS: ROGI
09:20:56 ALDRIN: OKAY. EVERYTHING'S NICE AND STRAIGHT IN HERE. 109:20:58 ARMSTRONG:
. LOUD AND CLEAR. BREAK. BREAK. BUZZ, THIS IS HOUSTON. RADIO CHECK, AND VERIFY TV
THE OPENING - I OUGHT TO HAVE ON THE (16 MM, ONE FRAME PER SECOND, MOVIE) CAMER/
NDLESS: BUZZ, THIS IS HOUSTON. F/2 (AND)... 109:23:28 ARMSTRONG: OKAY, I'M AT THE...(LIS
LONG PAUSE) 109:24:48 ARMSTRONG: THAT'S ONE SMALL STEP FOR MAN, ONE GIANT LEAP F(
45 ARMSTRONG: THERE SEEMS TO BE NO DIFFICULTY IN MOVING AROUND AS WE SUSPECTEI
ARMSTRONG: OKAY, BUZZ, WE READY TO BRING DOWN THE (70 MM HASSELBLAD) CAMERA? 1
IOW. (LONG PAUSE) 109:27:51 ALDRIN: OKAY. I THINK YOU'RE PULLING THE WRONG ONE. 109:2
LONG PAUSE) 109:28:55 ALDRIN: OKAY. I'M GOING TO BE CHANGING THE (GARBLED, PROBABLY
ON. DID YOU COPY ABOUT THE CONTINGENCY SAMPLE? OVER. 109:32:26 ARMSTRONG: ROGE
ICULT TO DIG THROUGH THE INITIAL CRUST... 109:34:12 ARMSTRONG: THIS IS VERY INTEREST
'RETTY OUT HERE. BE ADVISED THAT A LOT OF THE ROCK SAMPLES OUT HERE - THE HARD R
HARD FOR ME TO BEND DOWN FURTHER THAN THAT. (PAUSE) 109:36:07 ALDRIN: DIDN'T KNO'
SE) THERE YOU GO. (PAUSE) 109:37:XX ARMSTRONG: CONTINGENCY SAMPLE IS IN THE POCKI
LONG PAUSE) NEIL, THIS IS HOUSTON. WE'RE GETTING A PICTURE. YOU'RE NOT IN IT AT THE
HAVING. I'LL TRY TO WATCH YOUR PLSS FROM UNDERNEATH HERE. 109:39:57 ARMSTRONG: C
OKAY. BACK IN (GARBLED) (PAUSE) NOW A LITTLE OF FOOT MOVEMENT (GARBLED) PORCH. LIT
WAY OUT. 109:41:53 ARMSTRONG: (LAUGHS) A PARTICULARLY GOOD THOUGHT. 109:41:56 AL
RIN: OKAY. I'M GOING TO LEAVE THAT ONE FOOT UP THERE AND BOTH HANDS DOWN TO ABOUT
CENT DESOLATION. (LONG PAUSE) 109:43:47 ALDRIN: (RIGHT HAND STILL ON THE LADDER) LO
A ROCK. 109:44:23 ARMSTRONG: NOTICE HOW YOU CAN KICK IT OUT. 109:44:28 ALDRIN: YEA
ARMSTRONG: NO. IT DIDN'T. 109:46:08 ALDRIN: THERE'S ABSOLUTELY NO CRATER THERE AT A
E OTHER TWO BOTH BENT OVER. (LONG PAUSE) 109:47:04 ALDRIN: (STILL NEAR THE LADDER)
E SUN HITS (GARBLED) THEY SPLIT UP ALL THE VERY LITTLE FINE PORES (GARBLED) WILL TEI
BE CAREFUL THAT YOU ARE LEANING IN THE DIRECTION YOU WANT TO GO, OTHERWISE YOU
ANALYSIS. (GARBLED) (PAUSE) (GARBLED) SOIL COMPACTS UNDERNEATH (GARBLED) COMPLET
ON, ALL LM SYSTEMS ARE GO. OVER. 109:51:46 ALDRIN: WE APPRECIATE THAT. THANK YOU. (
ST SET FOOT UPON THE MOON, JULY 1969 A.D. WE CAME IN PEACE FOR ALL MANKIND." IT H/
ENS) (GARBLED) HOW GOOD YOUR LENS IS, BUT IF YOU CAN (GARBLED) SMUDGES ON MY GLC
HAND WHEN HE WAS PULLING OUT THE CABLE. 109:55:21 ALDRIN: (TO NEIL) OKAY. HOW'S TI
ON CAMERA. (PAUSE) NEIL, LOOK AT THE MINUS-Y (SOUTH) STRUT. THE DIRECTION OF TRAVEI
E CRATER HERE...IT MAY BE... 109:57:01 ALDRIN: NOW KEEP GOING. WE'VE GOT A LOT MORE
WOULD BE BETTER. 109:57:53 ARMSTRONG: I DON'T WANT TO GO INTO THE SUN IF I CAN AV(
AY. 109:58:32 ALDRIN: OKAY. THAT'S ALL THE CABLE WE HAVE. (GARBLED) ALL THE WAY OUT. I
:13 MCCANDLESS: ROGER. YOU LOOK OKAY AS FAR AS DISTANCE GOES, NEIL. AND WE'LL LI
59:58 ARMSTRONG: OKAY. I'M GOING TO MOVE IT. (PAUSE) 110:00:10 MCCANDLESS: OKAY. THI
STRONG: ALL RIGHT. AND THEN ON BEYOND IT ABOUT 10 FEET IS AN EVEN LARGER ROCK THA
OGER. AND WE SEE THE SHADOW OF THE LM. 110:01:48 ARMSTRONG: ROGER. THE LITTLE HIL

Silver Medal Posters: Promotional **Motorola 75th Anniversary Poster**

ART DIRECTOR David Rainbird **CREATIVE DIRECTOR** Nathan Lauder **DESIGNER** Tommy Miller **STUDIO** Fibre **CLIENT** Motorola **COUNTRY** United Kingdom

2003 is the 75th anniversary of Motorola and they wanted a limited-edition poster that reflected one of their great achievements. When Neil Armstrong descended the ladder of Apollo 11 onto the surface of the Moon in 1969, his words became the most celebrated sound bite of the 20th century. Motorola equipment enabled the relay of these words from the Moon to the Earth. The glossy white poster features 31,260 words from the Apollo mission printed in silver, with the famous sound bite highlighted in red. The poster is dispatched in a silver plastic tube.

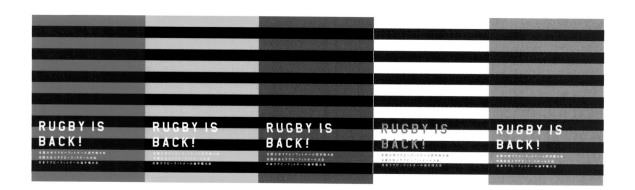

Silver Medal Posters: Transit **Rugby Is Back**

ART DIRECTOR Kenjiro Sano DESIGNER Yuki Sugiyama COPYWRITER Nobuhiro Hishiya PRINTING DIRECTOR Noboru Suzuki PRINTERS Chuo Process,
Nikko Process AGENCY Hakuhodo Inc. CLIENT Japan Rugby Football Union COUNTRY Japan

In Japan, rugby was once an overwhelmingly popular sport, but it seemed to have peaked and faded recently. In order to emphasize that rugby is indeed back,
standing tall, alive and kicking, we used the uniforms of major rugby college teams as a design motif. There were 20 varieties of posters in the same format,
printed and distributed widely.

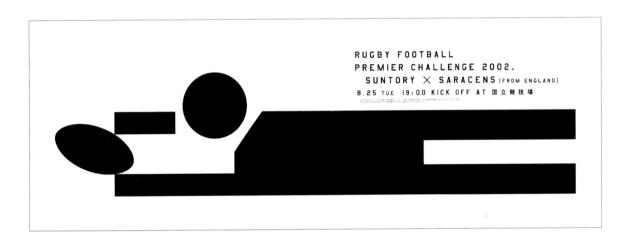

Silver Medal Posters: Transit **Rugby Pictogram**

ART DIRECTOR Kenjiro Sano **DESIGNER** Yuki Sugiyama **COPYWRITER** Nobuhiro Hishiya **PRINTING DIRECTOR** Noboru Suzuki **PRINTERS** Chuo Process, Nikko Process **AGENCY** Hakuhodo Inc. **CLIENT** Japan Rugby Football Union **COUNTRY** Japan

Our creative guideline: The poster should be instantly recognizable as depicting rugby. It should appear refined and neat, free from the sweaty and muddy sterotypical images of the sport. We kept these points in mind while designing the pictogram. It symbolizes the moment of truth in the game—a player trying to score.

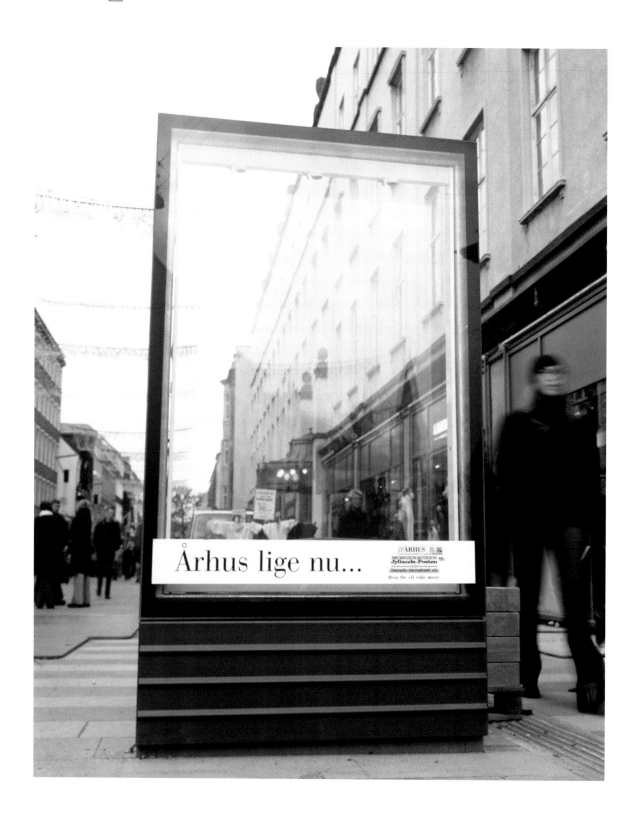

Silver Medal Posters: Transit **The City—Right Now**

ART DIRECTOR Bent Lomholt **COPYWRITER** Thomas Fisker **ACCOUNT EXECUTIVE** Louis Ebler **CLIENT** Jyllands-Posten **COUNTRY** Denmark

The current level of competition in the Danish newspaper market can only be described as intense. *Jyllands-Posten*, serving the Danish city of Aarhus, is being challenged by a new daily newspaper. This competitor, however, has failed to provide the citizens of Aarhus with a comparable standard of up-to-date local news. We realized that outdoor displays are an excellent means of reaching people in the city. How can we use such displays to provide an element of surprise? And to demonstrate that *Jyllands-Posten* is the newspaper of choice for the citizens of Aarhus? Advertising billboards usually have different ads on each side. Let's make our poster transparent. And let's use the poster to portray the city as it really is, i.e. the city—right now.

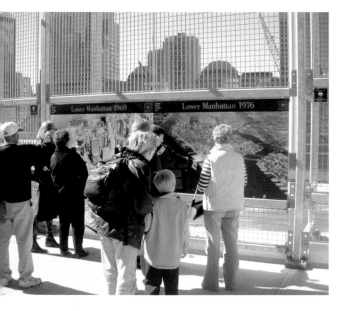

Silver Medal Environment **Ground Zero Viewing Wall**

ART DIRECTOR Michael Gericke **DESIGNER** Don Bilodeau **ARCHITECT** Voorsanger Associates **HISTORIC CURATOR** The Skyscraper Museum **LIGHTING**
Domingo Gonzalez Design **STUDIO** Pentagram Design **CLIENT** Port Authority of NY & NJ Architecture Unit **COUNTRY** United States

Working with the Port Authority of New York and New Jersey and the Lower Manhattan Development Corporation, Pentagram designed a viewing wall
at Ground Zero, the former site of the World Trade Center. For the visiting public, the wall's design provides safety, accessibility and sensitivity; for the
government agencies charged with the site's redevelopment, it provides transparency (of process) and flexibility. The wall is made of a screen-like grid
of galvanized steel that allows visitors to see directly into the 16-acre site, to contemplate the enormity of its destruction and to witness its eventual
redevelopment. The wall supports a series of large, weather-resistant fiberglass panels displaying information on the history of the World Trade Center,
the historical context of the site within Lower Manhattan, and, in a recessed bay, a listing of the names of those lost in the 9/11 attacks. The modular
design is flexible, allowing panels to be added or moved as redevelopment progresses.

Silver Medal Environment **A Flock of Words**

ART DIRECTOR Gordon Young **ART DIRECTION** Why Not Associates **DESIGNER** Gordon Young **DESIGN** Why Not Associates **CLIENT** Lancaster City Council
COUNTRY United Kingdom

Graphic designers Why Not Associates have, in collaboration with artist Gordon Young, created A Flock of Words to celebrate the bird-watching haven of
Morecambe Bay on the northwest coast of England. The project is an aspect of Tern, an arts-led regeneration project launched by the Lancaster City Council
in 1992. Its mission is to physically and spiritually refresh and re-image Morecambe and set it apart from its recent past and its competitors. A Flock of Words
is a 300-meter path of poems, traditional sayings and song lyrics that all relate to birds. It begins with the Book of Genesis and stretches from Shakespeare to
Spike Milligan. The path, which is constructed from granite, concrete, steel, brass, bronze and glass, physically connects the railway station and the seafront.
Its purpose is to provide a visual and thematic link between them, in a way that informs, entertains, educates and stimulates. It is a truly unique project that
has had all the creatives and manufacturers involved exploring new boundaries of their specialization.

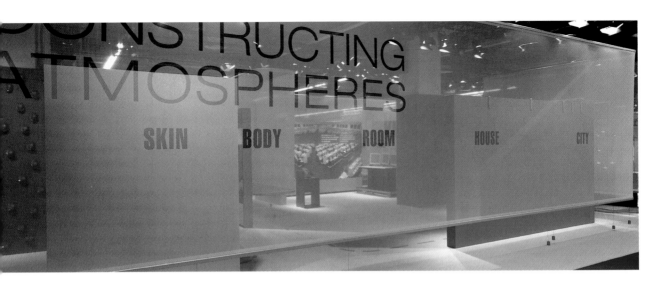

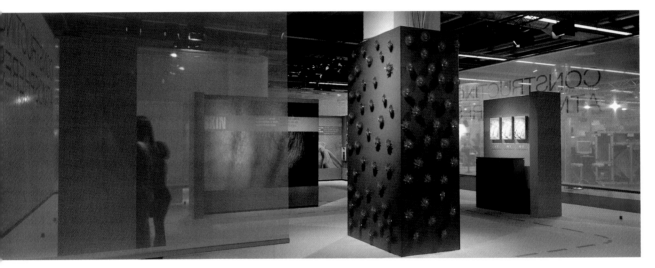

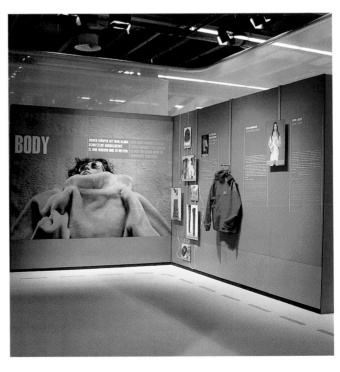

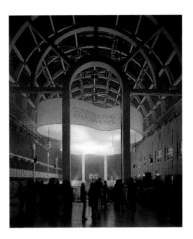

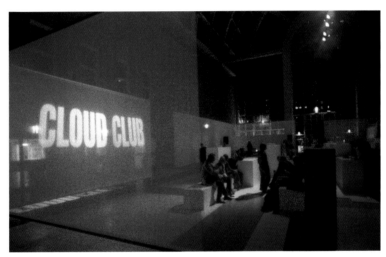

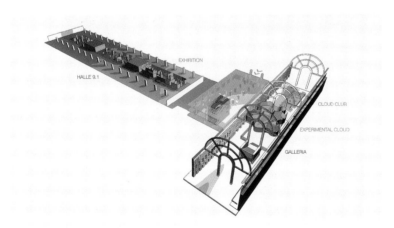

Silver Medal Trade Shows **Constructing Atmospheres**

ART DIRECTOR János Déri **ART DIRECTOR (CLOUD CLUB)** Peter Eberhard **CREATIVE DIRECTORS** Meinhard Hutschenreuther, Roland Lambrette **COPYWRITER** Andreas Siemer **ILLUSTRATOR** Damir Tomas **INTERIOR DESIGNERS** Christoph Alker, Jürgen Kloster **VIDEO DESIGNER** Sascha Neumann **SOUND DESIGNERS** Michael Kadelbach, Georg Stummer **LIGHTING DESIGNER** Jörg Ackerman **PROJECT MANAGER** Isa Rekkab **CONCEPT/WRITTEN MATERIALS** Martin Pesch **AGENCY** Atelier Markgraph **CLIENT** Messe Frankfurt **COUNTRY** Germany

"Constructing Atmospheres" was an apt name for the special show held by Messe Frankfurt at the architecture and technology fair, Light + Building 2002. The highlight of the show, which marked the integration of the "Aircontec" climate fair with a presentation on the way people perceive space and climate, was the construction of a genuine meteorological cloud inside the Galleria. The 400-cubic-meter formation was created from air strata of different humidity and temperatures. As a controlled simulation of a natural phenomenon, "Experimental Cloud" made the theme of the whole show tangible. Some of the visitors were even lucky enough to experience the cloud first-hand as they moved through it. The accompanying exhibition presented "climate skins" that protect us from environmental changes—from a single skin cell to an entire space station. By night "Experimental Cloud" turned into a striking light sculpture that hovered above the Cloud Club as the Messe contribution to Luminale, the Frankfurt festival of light and culture.

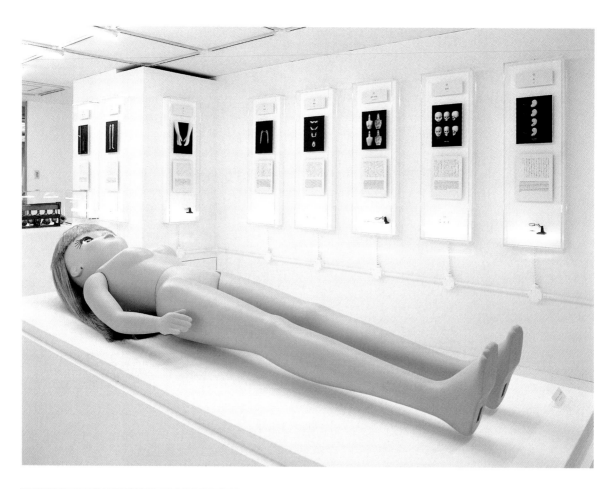

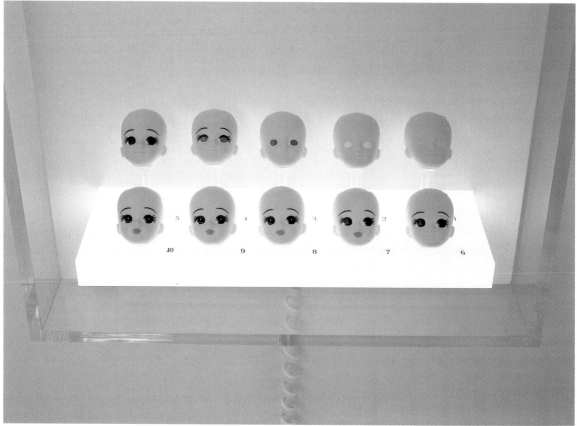

Silver Medal Gallery/Museum Exhibit/Installation **Analysis of the Massproduct Design Project**

ART DIRECTOR Taku Satoh **DESIGNERS** Shino Misawa, Taku Satoh **PHOTOGRAPHER** Ayumi Okubo **CLIENT** Japan Design Committee **COUNTRY** Japan

This project is intended to focus on mass-produced items that we see every day in Japan and dissect it from a viewpoint of design. Dissection is usually performed for living things, but it is performed here for products made by human beings. What design solution has actualized mass-produced objects that we are in contact with casually? Manufacturers themselves do not thoroughly understand all the long-term development processes that products have passed through. The purpose of this project is to confirm that the things around us are the "entrance of information" to society, as well as to verify what the design is.

Silver Medal TV Identities/Openings/Teasers **People** ▪ **Tongue** ▪ **Hands** ▪ **Ears**
ART DIRECTOR Guillermo Tragant **DESIGNER** ALT **COPYWRITER** Jose Molla **AGENCY** La Comunidad **CLIENT** MTV Networks Latin America **COUNTRY** United States

Silver Medal Animated Logo **Marvel Logo**

ART DIRECTOR Matt Tragesser **CREATIVE DIRECTORS** Kyle Cooper, Peter Frankfurt **DESIGNERS** Michael Riley, Matt Tragesser **2D ANIMATOR** Ellerey Gave
INFERNO ARTIST Nancy Highland **EXECUTIVE PRODUCERS** Chip Houghton, Phyllis Weisband **PRODUCERS** Ben Apley, Lisa Villamil **CLIENT** Marvel Studios
COUNTRY United States

Silver Medal Typography **Grand Classics**

CREATIVE DIRECTORS Nathalie De La Gorce, Laurent Fauchere **DESIGNERS** Nathalie De La Gorce, Laurent Fauchere **DIRECTOR OF VISUAL EFFECTS**
Christopher Haak **SOUND DESIGN** Sacred Noise **CLIENT** Indyssey **COUNTRY** United States

A title sequence for the Grand Classics, a monthly charity event held in New York benefiting the American Film Institute in which film luminaries like
Alan Cumming, Tim Robbins and Neil Labute screen their favorite films for guests. This opening takes the viewer on a journey of places made famous
by movies. It illustrates the fact that watching a movie is an experience that allows the viewer to travel to imaginary or real places, and to experience
different times. The letters forming the movie titles selected were used to recreate those places. The camera move we used matched those used in the
actual movie. Starting from *2001: A Space Odyssey*, we seamlessly travel to Xanadu (*Citizen Kane*), then fly across *Metropolis* to finally reach *Manhattan*,
home of the festival.

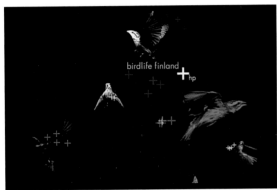

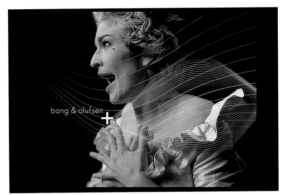

Silver Medal Typography +hp

ART DIRECTORS Kaan Atilla, Mathew Cullen **AGENCY CREATIVE DIRECTORS** Steve Luker, John Norman, Steve Simpson **DESIGNERS** John Clark, Jason Cook, Paolo de Almado, Mark Kuosi, Irene Park, Mike Slane, Mike Steinman, Brad Watanabe, Shinlin Wu **EXECUTIVE PRODUCER** Javier Jimenez **AGENCY PRODUCER** Adrienne Cummins **DESIGN FIRM** Motion Theory **AGENCY** Goodby, Silverstein & Partners **CLIENT** Hewlett-Packard Company **COUNTRY** United States

Hewlett-Packard sought to communicate its scope and innovation with simple, yet powerful graphic design laid over filmed images representing a variety of fields. In close collaboration with Goodby, Silverstein & Partners, Motion Theory set out to integrate the "+" sign into numerous environments, and to develop a visual language that could both add to the beauty of the film footage and also simultaneously convey hp's message of empowerment and possibility in a straightforward and elegant manner. In each segment, the "+" sign feels like a natural—even integral—phenomenon, representing how hp technology makes a critical difference in art, in business, and in peoples' lives. The transition to the end tag employs sweeping curves, coalescing into a sense of unity and bringing on hp's "everything is possible" tagline.

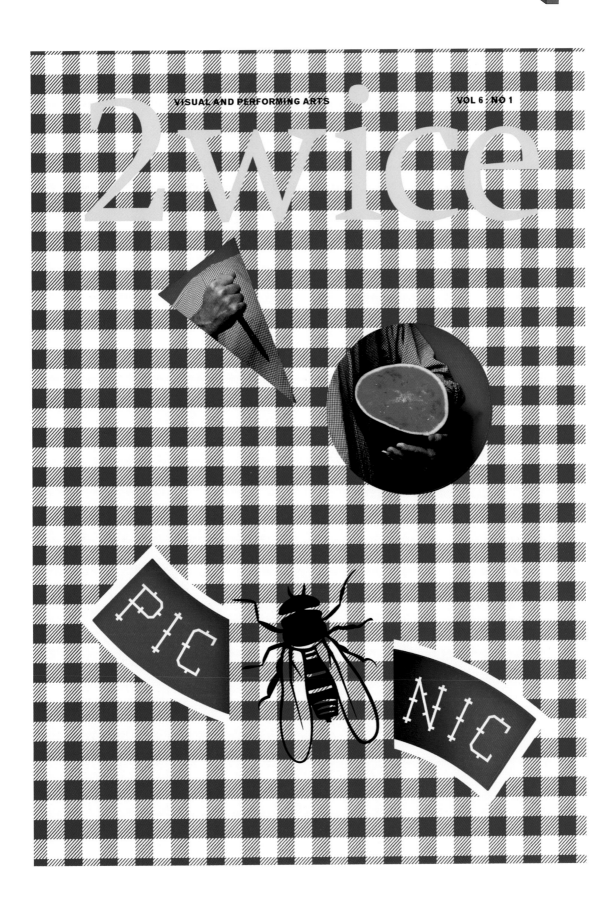

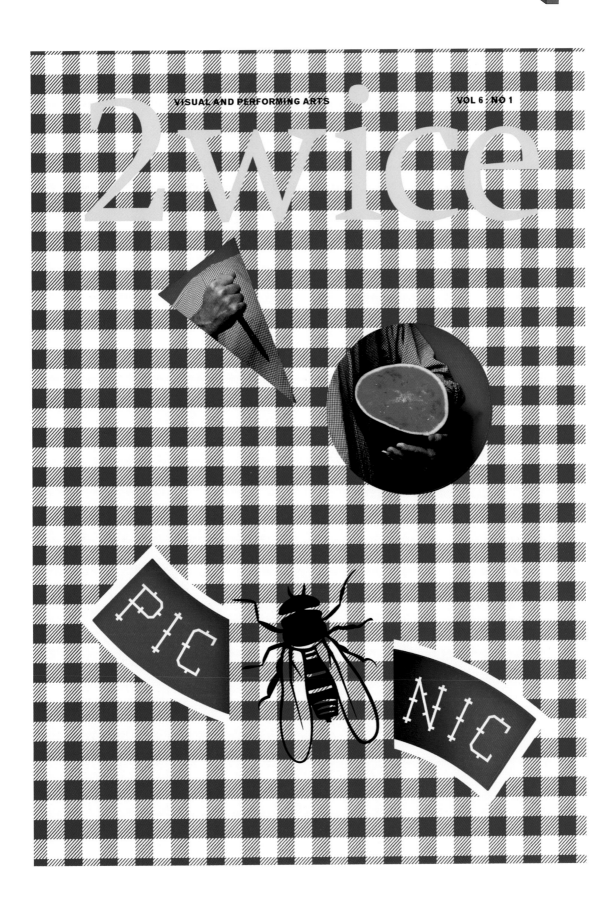

Distinctive Merit Consumer Magazine: Full Issue **2wice Picnic**

ART DIRECTOR Abbott Miller **DESIGNERS** Jeremy Hoffman, Abbott Miller **STUDIO** Pentagram Design **CLIENT** 2wice Arts Foundation **COUNTRY** United States

Distinctive Merit Special Trade Book (Image Driven) **Catalog**
ART DIRECTOR Carin Goldberg **DESIGNER** Carin Goldberg **COPYWRITER** Dorothy Globus **EDITOR** Marisa Bulzone **STUDIO** Carin Goldberg Design **CLIENT** Stewart,
Tabori & Chang **COUNTRY** United States

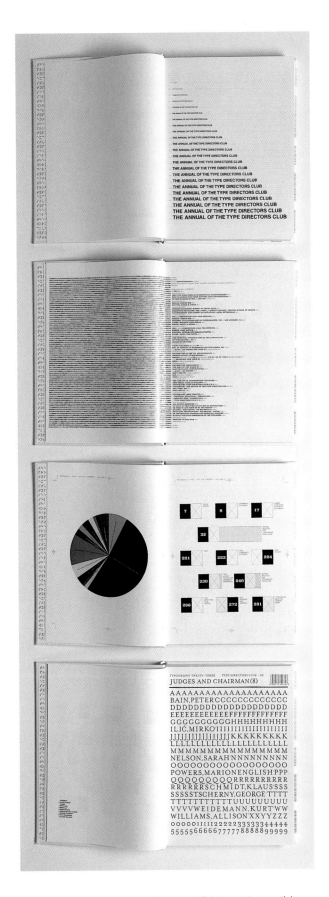

Distinctive Merit Special Trade Book (Image Driven) **Typography 23: The Annual of The Type Directors Club**

ART DIRECTORS Allison Williams, JP Williams **DESIGNER** Anisa Suthayalai **STUDIO** Design: MW **CLIENT** Type Directors Club **COUNTRY** United States

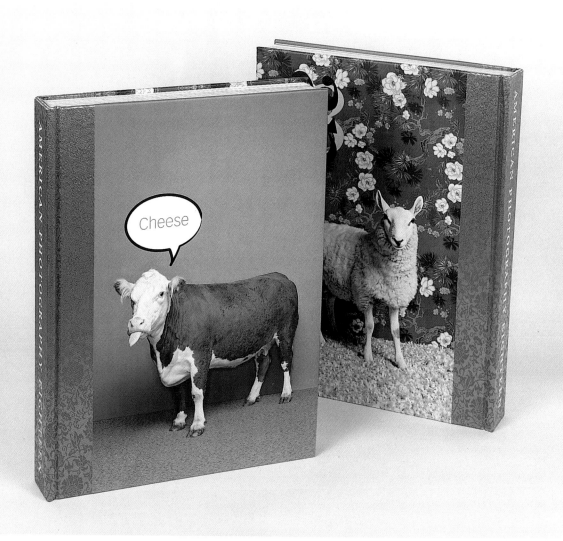

Distinctive Merit Special Trade Book (Image Driven) **American Photography 18**

ART DIRECTOR John Korpics DESIGNER John Korpics COPYWRITER Peggy Roalf PHOTOGRAPHER (COVER) Catherine Ledner CLIENT Amilus, Inc.
COUNTRY United States

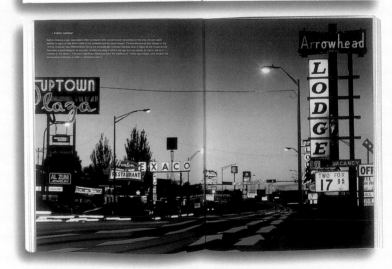

Distinctive Merit Special Trade Book (Image Driven) **American Signs: Form and Meaning on Route 66**
DESIGNER Lisa Mahar **DESIGN** Ashley Sargent, Inc. **PHOTOGRAPHER** Lisa Mahar **COUNTRY** United States

Distinctive Merit Special Trade Book (Image Driven) **Faces**

ART DIRECTOR Carin Goldberg DESIGNERS Shigeto Akiyama, Carin Goldberg ILLUSTRATOR Hanoch Piven CLIENT Pomegranate/Hanoch Piven
COUNTRY United States

Distinctive Merit Limited Edition/Private Press/Special Format Book **Make It Bigger**

ART DIRECTOR Paula Scher **DESIGNERS** Sean Carmody, Tina Chang, Keith Daigle **STUDIO** Pentagram Design **CLIENT** Princeton Architectural Press
COUNTRY United States

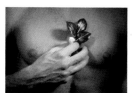

Distinctive Merit Limited Edition/Private Press/Special Format **Visionaire 39: Play**

ART DIRECTORS Greg Foley, Stephen Gan **DESIGNERS** Pierre Consorti, Jason Duzansky, Tatiana Gaz, Aoife Wasser **PUBLISHER** Visionaire **COUNTRY** United States

Distinctive Merit Museum/Gallery/Library Book **Matthew Barney: The Cremaster Cycle**
ART DIRECTOR Abbott Miller **DESIGNERS** Roy Brooks, Abbott Miller **STUDIO** Pentagram Design **CLIENT** Guggenheim Museum **COUNTRY** United States

Distinctive Merit Museum/Gallery/Library Book **Louise Bourgeois at the Hermitage**

ART DIRECTOR Takaaki Matsumoto **DESIGNERS** Takaaki Matsumoto, Thanh X Tran **AGENCY** Matsumoto Incorporated **CLIENT** American Friends of the Hermitage **COUNTRY** United States

Distinctive Merit Text/Reference/How-To Book, Series **Not For Tourists Guidebook**

ART DIRECTOR Jane Pirone **DESIGNERS** Scot Covey, John Sebastian **PUBLISHER** Not For Tourists, Inc. **COUNTRY** United States

Distinctive Merit Annual Report **Maxygen 2000 Annual Report**

CREATIVE DIRECTOR Bill Cahan **DESIGNER** Gary Williams **ILLUSTRATOR** Jason Holley **PHOTOGRAPHERS** Ann Giordano, Esther Henderson, Ray Manley, Robert Markow, John Sann **AGENCY** Cahan & Associates **CLIENT** Maxygen **COUNTRY** United States

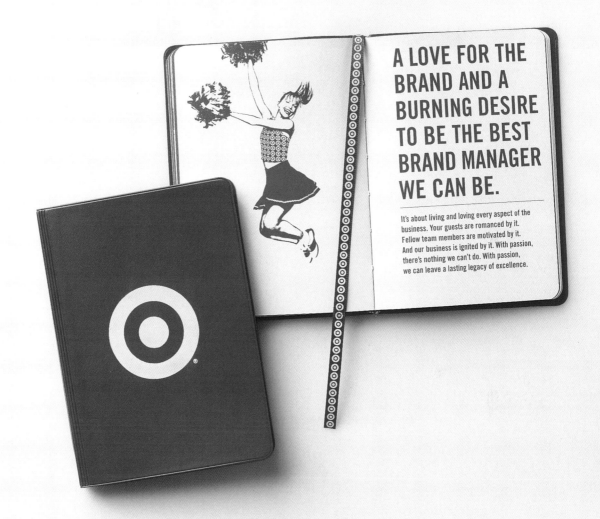

Distinctive Merit Booklet/Brochure **The Ulrich Book**

CREATIVE DIRECTOR Monica Little **DESIGN DIRECTOR** Michael Schacherer **DESIGNER** Jack Jerome **COPYWRITER** Cathy Wright **PRODUCTION DESIGNER** Donna Daubendiek **PRINTER** Litho, Inc. **DESIGN FIRM** Little & Company **CLIENT** Target Corporation **COUNTRY** United States

Distinctive Merit Booklet/Brochure **Every Lawyer's Pocket Guide to Storytelling in the Courtroom**
ART DIRECTOR Lana Rigsby **DESIGNERS** Thomas Hull, Lana Rigsby, Pamela Zuccker **COPYWRITER** Lana Rigsby **ILLUSTRATORS** Lana Rigsby, Pamela Zuccker
STUDIO Rigsby Design **CLIENT** Art of Facts **COUNTRY** United States

Distinctive Merit Booklet/Brochure **Merchant Handbook 2002**

ART DIRECTORS Alan Dye, Nick Finney, Ben Stott **DESIGNERS** Ian Pierce, Charlie Smith, Nick Vincent **ILLUSTRATORS** Tom Gauld, Brett Ryder
PHOTOGRAPHER Douglas Fry **AGENCY** NB: Studio **CLIENT** Merchant **COUNTRY** United Kingdom

Distinctive Merit Corporate Identity Standards Manual **Orange Brand Guidelines**

ART DIRECTOR Mark Smith **DESIGNERS** Adam Browne, Rene Christoffer, David Day **PHOTOGRAPHERS** Michael Fair, Mark Leary, Jason Wilde, Paul Zak
STUDIO Innocence **CLIENT** Orange **COUNTRY** United Kingdom

MoMAQNS

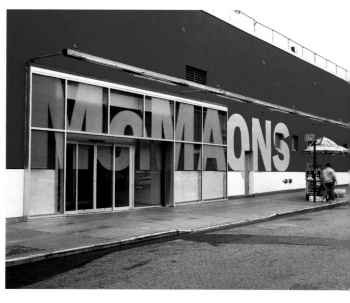

Distinctive Merit Corporate Identity Program **MoMA QNS Identity**

ART DIRECTION Base **DESIGN** Base, MoMA Department of Graphic Design **COPYWRITING** Tom Greenwood, MoMA Communications **ILLUSTRATION** Base
STUDIO Base **CLIENT** The Museum of Modern Art **COUNTRY** United States

One of the only things that we all carry with us all the time.

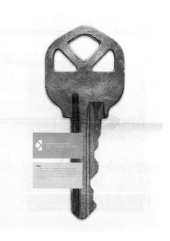

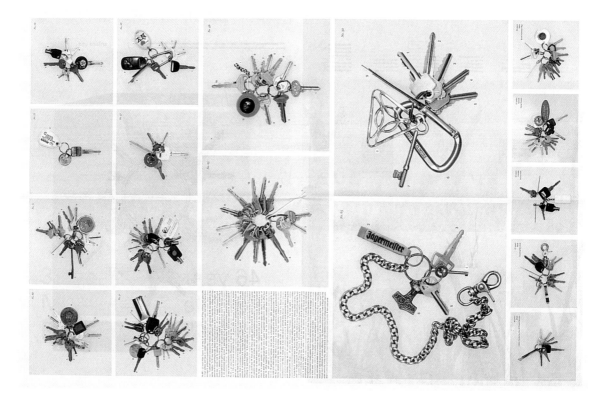

Distinctive Merit Self-Promotion: Print **Tabloid**

ART DIRECTOR John Homs **DESIGNERS** Nate Lambdin, Beth May **COPYWRITERS** Sommer Browning, Nate Lambdin, Beth May, Jo Watson
PHOTOGRAPHERS Sherry Griffin, Nate Lambdin **STUDIO** JHI **CLIENT** JHI **COUNTRY** United States

mmmml
Mestni trg 4,
Ljubljana

PRICE LIST

Item	No.	Amount
COFFEE	1x=	180,00
COFFEE WITH WHIPPED CREA	1x=	220,00
COFFEE WITH MILK	1x=	200,00
CAPUCCINO	1x=	220,00
MACHIATO	1x=	190,00
CAFE LATE	1x=	300,00
DECAF COFFEE	1x=	250,00
DECAF COFFEE WITH WHIPPE	1x=	310,00
DECAF COFFEE WITH MILK	1x=	290,00
DECAF CAFE LATE	1x=	360,00
COCOA	1x=	270,00
COCOA WITH WHIPPED CREAM	1x=	300,00
HOT CHOCOLATE	1x=	270,00
HOT CHOCOLATE WITH WHIPP	1x=	300,00
TEA	1x=	220,00
TEA WITH HONEY	1x=	260,00
TEA WITH LEMON	1x=	260,00
TEA WITH MILK	1x=	260,00
TEA WITH RUM	1x=	400,00
BLUEBERRY JUICE 0.10 LIT	1x=	160,00
BLUEBERRY JUICE (BOTT.)	1x=	330,00
STRAWBERRY JUICE 0.10 LIT	1x=	160,00
STRAWBERRY JUICE (BOTT.)	1x=	330,00
PINEAPPLE JUICE BOTT.	1x=	330,00
ORANGE JUICE 0.10 LIT	1x=	140,00
ORANGE JUICE (BOTT.)	1x=	330,00
PEACH JUICE 0.10 LIT	1x=	150,00
MULTI VITAMINE DRINK 0.5	1x=	350,00
MULTIVITAMINE JUICE (BOT	1x=	330,00
TOMATO JUICE (BOTT.)	1x=	330,00
APPLE JUICE 0.10 LIT	1x=	140,00
APPLE JUICE (BOTT.)	1x=	330,00
BANANA JUICE BOTT.	1x=	330,00
SOUR CHERRY JUICE (BOTT.	1x=	330,00
NATURAL ORANGE JUICE 0.10	1x=	220,00
LEMONADE 0.30 LIT	1x=	350,00
RADENSKA SPARKLING W 0.10	1x=	100,00
RADENSKA SPARKLING WATER	1x=	280,00
NATURAL WATER 0.50 LIT	1x=	280,00
LEMON FLAVOURED WATER	1x=	280,00
ICED TEA 0.10 LIT	1x=	130,00
COCA COLA 0.10 LIT	1x=	130,00
COCA COLA 0.25	1x=	320,00
FANTA 0.10 LIT	1x=	130,00
BITTER LEMON 0.10 LIT	1x=	130,00
BITTER LEMON (BOTT.)	1x=	320,00
TONIC WATER 0.20 LIT	1x=	260,00
TONIC WATER (BOTT.)	1x=	320,00
COCKTA 0.25	1x=	300,00
RED BULL 0.25	1x=	600,00
UNION BEER (BOTT.)	1x=	400,00
SMILE BEER 0.33	1x=	400,00
ZLATOROG BEER 0.33	1x=	400,00
DARK LASKO BEER 0.33	1x=	400,00
BECK'S (NON-ALCHOLIC)	1x=	400,00
BUDWEISER 0.33	1x=	450,00
GUINNESS 0.33	1x=	600,00
HEINEKEN 0.33	1x=	550,00
RADLER BEER 0.33	1x=	350,00
WHITE WINE 0.10 LIT	1x=	220,00
RED WINE 0.10 LIT	1x=	250,00
VINTAGE WINE 0.10 LIT	1x=	500,00
COOKED WINE 0.20 LIT	1x=	380,00
CHAMPAIGNE DRY 0.10 LIT	1x=	650,00
CHAMPAIGNE DRY 0.75 0.75 L	1x=	3.900,00
CHAMPAIGNE MEDIUM DR 0.10	1x=	650,00
CHAMPAIGNE MEDIUM DR 0.75	1x=	4.300,00
CHAMPAIGNE WITH GINGER	1x=	900,00
MARTINI BIANCO 0.10 LIT	1x=	500,00
MARTINI DRY 0.10 LIT	1x=	500,00
CANADIAN CLUB 0.03 LIT	1x=	550,00
GLEN GRANT 0.03 LIT	1x=	600,00
JACK DANIEL'S 0.03 LIT	1x=	600,00
JAMESON 0.03 LIT	1x=	600,00
JOHNNIE WALKER 0.03 LIT	1x=	600,00
LAGAVULIN 0.03 LIT	1x=	900,00
BAILEY'S 0.03 LIT	1x=	500,00
CAMPARI 0.03 LIT	1x=	450,00
CAMPARI SODA	1x=	500,00
COURVOISIER 0.03 LIT	1x=	800,00
GIN 0.03 LIT	1x=	500,00
HAVANA 0.03 LIT	1x=	500,00
JAGERMEISTER 0.03 LIT	1x=	550,00
SCHNAPPS 0.03 LIT	1x=	250,00
STOCK 0.03 LIT	1x=	350,00
STOLICHNAYA 0.03 LIT	1x=	500,00
TEQUILA 0.03 LIT	1x=	550,00
PEAR SCHNAPPS 0.03 LIT	1x=	480,00
GINGERINO	1x=	450,00
MARLBORO	1x=	430,00
GAULOISES	1x=	370,00
LIGHTER	1x=	220,00
TOAST	1x=	290,00
SENDWICH	1x=	440,00
CROISSANT	1x=	250,00
CHEWING GUM	1x=	180,00

Total SIT 42.390,00

Tax %--------Sub total----Tax included.
 20 % 41.410,00 6.901,68
 8.5 % 980,00 76,77

1 EUR = 220.00 SIT EUR 192.68

You were served by Ivan 1.10.2002
ORGANIZACIJA D.O.O.
 Corporate tax number: 88240819
 PRESERNOV TRG 1, LJUBLJANA

Distinctive Merit Menu **Price List for Salon Minimal**

ART DIRECTOR Igor Andjelic **DESIGNER** Igor Andjelic **STUDIO** Minimal **CLIENT** Minimal **COUNTRY** Slovenia

Distinctive Merit Postcard/Greeting Card/Invitation **TED Conference Invite**

ART DIRECTOR Jennifer Olsen **DESIGNER** Jennifer Olsen **COPYWRITER** Chris Anderson **PRINTER** Lithomania **STUDIO** Paper Plane Studio **CLIENT** TED
COUNTRY United States

Distinctive Merit Posters: Promotional, Series **Liquitex Poster**

ART DIRECTOR Masaaki Izumiya **COPYWRITER** Masaaki Izumiya **ILLUSTRATOR** Ryosuke Kudo **CLIENT** Bonny Corporation **COUNTRY** Japan

Distinctive Merit Posters: Public Service/Nonprofit/Educational **Kyoto Mailer**
ART DIRECTOR Michael Johnson **DESIGNER** Michael Johnson **STUDIO** Johnson Banks **CLIENT** Campaign Against Climate Change **COUNTRY** United Kingdom

Distinctive Merit Posters: Public Service/Nonprofit/Educational **Christy Doran's New Bag**

ART DIRECTOR Niklaus Troxler **DESIGNER** Niklaus Troxler **STUDIO** Niklaus Troxler Design **CLIENT** Jazz in Willisau **COUNTRY** Switzerland

Distinctive Merit Posters: Public Service/Nonprofit/Educational, Series **Analysis of the Massproduct Design Project**
ART DIRECTOR Taku Satoh **DESIGNERS** Shino Misawa, Taku Satoh **PHOTOGRAPHER** Ayumi Okubo **CLIENT** Japan Design Committee **COUNTRY** Japan

Distinctive Merit Packaging: Food/Beverage **Balsamic Vinegar**
ART DIRECTOR Garrick Hamm **DESIGNER** Garrick Hamm **AGENCY** Williams Murray Hamm **CLIENT** Heals and Sons **COUNTRY** United Kingdom

Distinctive Merit Packaging: Food/Beverage, Series **Pago La Jara & Altos de Lanzaga**

ART DIRECTOR Fernando Gutierrez **DESIGNER** Marc Catala **CLIENT** Compañía de Vinos Telmo Rodriguez **COUNTRY** United Kingdom

Distinctive Merit Packaging: Gift/Specialty Product, Series **Franc franc 10th Anniversary Starter Set**
ART DIRECTOR Masami Takahashi **DESIGNER** Masami Takahashi **CLIENT** Bals Corporation/Franc franc **COUNTRY** Japan

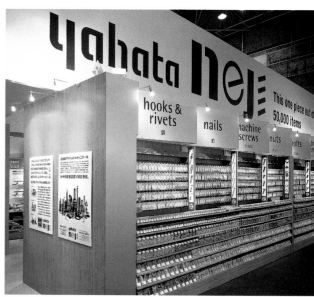

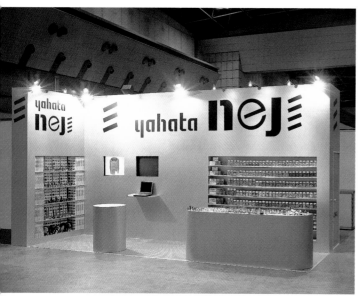

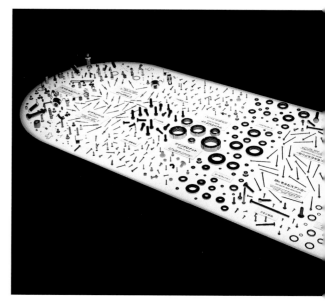

Distinctive Merit Trade Shows **Exhibition Display Signs for Yahata Neji Corporation**
ART DIRECTOR Kotaro Hirano **DESIGNERS** Takeshi Ando, Kotaro Hirano **PHOTOGRAPHER** Kotaro Hirano **CLIENT** Yahata Neji Corporation **COUNTRY** Japan

Distinctive Merit Trade Shows **Baronet Showroom**
ART DIRECTOR Louis Gagnon **DESIGNER** François Leclerc **PHOTOGRAPHERS** William Jarret, Michel Touchette **STUDIO** Paprika **CLIENT** Baronet **COUNTRY** Canada

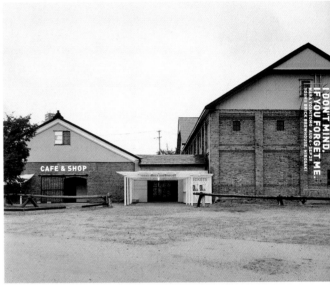

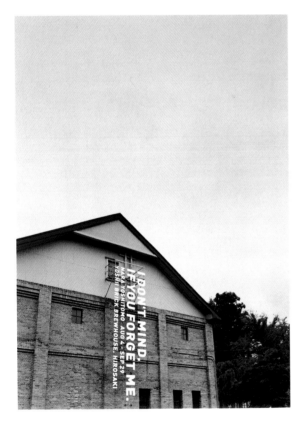

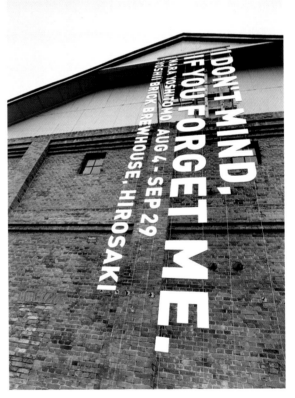

Distinctive Merit Retail/Restaurant/Office/Outdoor **I Don't Mind, If You Forget Me**

ART DIRECTOR Masayoshi Kodaira **DESIGNER** Masayoshi Kodaira **PHOTOGRAPHER** Mikiya Takimoto **STUDIO** FLAME, Inc. **CLIENT** Organizing Committee for the Nara Yoshitomo Exhibition **COUNTRY** Japan

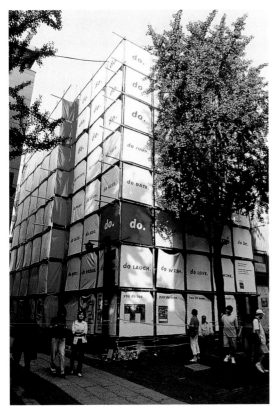

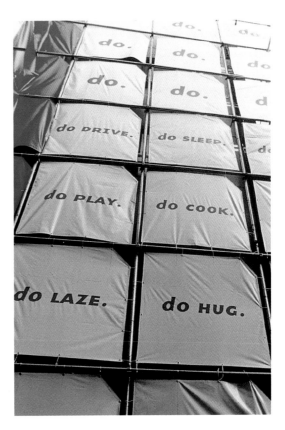

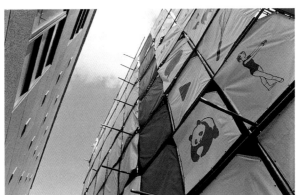

Distinctive Merit Environment **do. do. do. do. Project**
ART DIRECTOR Kyungsun Kymn **COPYWRITER** Clara Seunghei Hong **PHOTOGRAPHER** Kyungtae Kim **ARCHITECT** Dongjin Kim **CLIENT** do Art **COUNTRY** South Korea

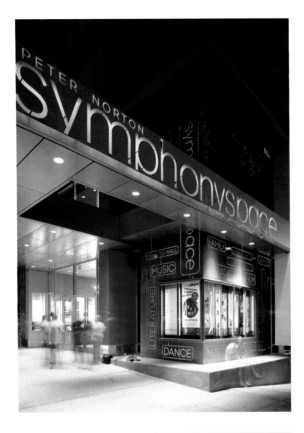

Distinctive Merit Environment **Symphony Space**

ART DIRECTOR Paula Scher **DESIGNERS** Rion Byrd, Tina Chang, Dok Chon **PROJECT ARCHITECT** James Stewart Polshek **STUDIO** Pentagram Design
CLIENT Symphony Space **COUNTRY** United States

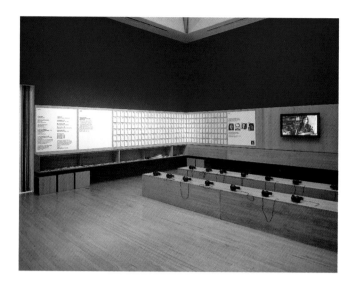

Distinctive Merit Gallery/Museum Exhibit/Installation **Turner Prize Exhibition**

ART DIRECTORS Henrik Kubel, Scott Williams **DESIGNERS** Henrik Kubel, Scott Williams **STUDIO** A2-GRAPHICS/SW/HK **CLIENT** Tate Britain
COUNTRY United Kingdom

Distinctive Merit Gallery/Museum Exhibit/Installation **Trust**

DESIGNER Anne Bush **STUDIO** Anne Bush Design **CLIENT** The Contemporary Museum at First Hawaiian Bank **COUNTRY** United States

programme preview
autumn 2002

five

channel 5
broadcasting limited
analogue licence renewal
september 2002

five

channel 5
broadcasting limited
analogue licence renewal
september 2002
part a: commitment
to programmes and
related matters

five

channel 5
broadcasting limited
analogue licence renewal
september 2002
part b: financial projection
and key commercial
assumptions

five

must see p4

documentaries p22
drama p30
entertainment p34
lifestyle p36
movies p38
music/youth/
religion p40
news/sport p44
pre−school p46

Distinctive Merit TV Identities/Openings/Teasers **Five On/Off Air Identity**

ART DIRECTORS Warren Beeby, Tony Brook DESIGNERS Nic Hughes, Sam Tootal, Chris Turner DIRECTOR OF PHOTOGRAPHY Alvin Winkler PRODUCTION
Hungry Man AGENCY Spin CLIENT Channel Five Broadcasting (Nol Davis and David Pullan) COUNTRY United Kingdom

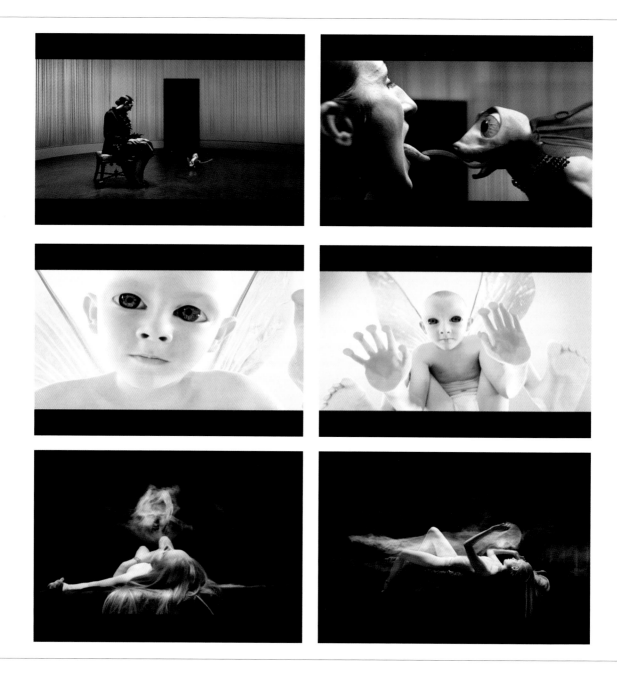

Distinctive Merit TV Identities/Openings/Teasers **Weird Pet** ▪ **Flyboy** ▪ **Vapor Lovers**

ART DIRECTORS Brian Eley, Roger Guillen, Paul Owen **COPYWRITERS** Michael Eilperin, Brian Eley, Roger Guillen, Paul Owen **DIRECTOR** Erick Ifergan
PRODUCTION RSA **AGENCY** SCI FI and Laimbie Nairn **CLIENT** SCI FI **COUNTRY** United States

Distinctive Merit TV Identities/Openings/Teasers **Gum** ▪ **Nose** ▪ **Fan**

ART DIRECTOR Guillermo Tragant **DESIGNER** Sebastian Pallares **PHOTOGRAPHER** Kino Gonzalez **STUDIO** Tragant **CLIENT** Nickelodeon Latin America
COUNTRY United States

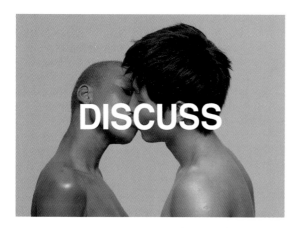

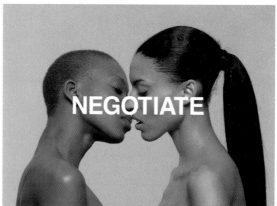

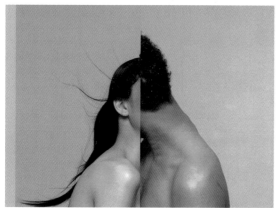

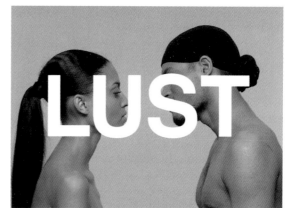

fight for your rights:
protect yourself

Distinctive Merit TV Identities/Openings/Teasers **Fight for Your Rights: Protect Yourself**

ART DIRECTORS Roger Belknap, Catherine Chesters DESIGNERS Roger Belknap, Catherine Chesters PHOTOGRAPHER Eva Mueller EXECUTIVE PRODUCERS
Jeffrey Keyton, Romy Mann CLIENT MTV Networks COUNTRY United States

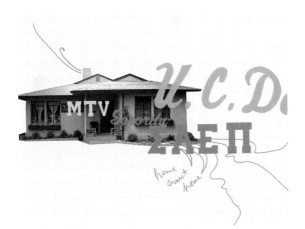

Distinctive Merit TV Identities/Openings/Teasers **Sorority Life**

ART DIRECTORS Stefanie Barth, Julie Herschbeld **DESIGNERS** Stefanie Barth, Julie Herschbeld **EXECUTIVE PRODUCERS** Jeffrey Keyton, Romy Mann
CLIENT MTV Networks **COUNTRY** United States

Merit Consumer Newspaper: Full Issue **Schauspielfrankfurt Zeitung '02**
ART DIRECTOR Sven Ritterhoff **CREATIVE DIRECTOR** Lo Breier **CLIENT** Schauspiel Frankfurt **STUDIO** P. **COUNTRY** Germany

T **Merit** Consumer Magazine: Spread **GQ—I Was Lying**
DESIGN DIRECTOR Fred Woodward **DESIGNER** Ken DeLago **PHOTOGRAPHER** Richard Burbridge **COUNTRY** United States

B **Merit** Consumer Magazine: Full Issue **ARTicles #7—The Critic**
ART DIRECTOR John Klotnia, Opto Design, Inc. **DESIGNER** Peggy Chapman **PHOTOGRAPHER** Matthew Septimus **COUNTRY** United States

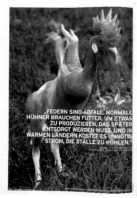

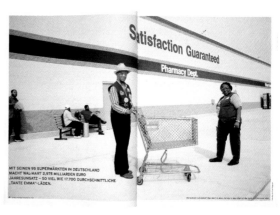

Merit Consumer Magazine: Full Issue **Greenpeace Magazine 1/03—Schöner Essen**

ART DIRECTOR (DESIGN) Bettina Rosenow **ART DIRECTOR (PHOTOGRAPHY)** Kerstin Leesch **DESIGNERS** Katja Kleinebrecht, Bettina Rosenow **EDITOR** Jochen Schild
CLIENT Greenpeace Media **AGENCY** Büro Hamburg **COUNTRY** Germany

T **Merit** Consumer Magazine: Full Issue, Series **Frame: The International Magazine of Interior Architecture and Design**

ART DIRECTOR Roelof Mulder **DESIGNER** Roelof Mulder **LITHOGRAPHER** Graphic Link **PRINTER** PlantijnCasparie **CLIENT** Frame Publishers
COUNTRY The Netherlands

B **Merit** Consumer Magazine: Cover **New York Times Magazine—Bad Love**

ART DIRECTOR Janet Froelich **DESIGNER** Nancy Harris **PHOTO EDITOR** Kathy Ryan **PHOTOGRAPHER** Donna Ferrato **COUNTRY** United States

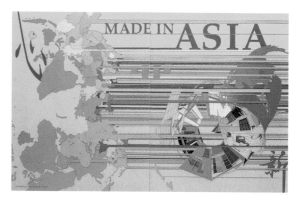

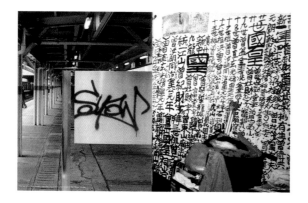
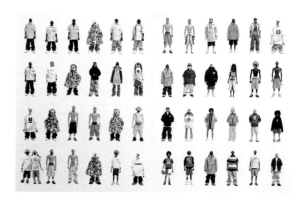

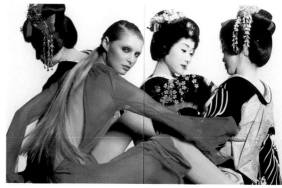

Merit Trade Magazine: Full Issue **Big 40—Made in Asia**

ART DIRECTOR Noriyuki Tanaka **DESIGNERS** Tatsuya Fukuda, Aki Miyazaki, Sachie Nakamura, Tatsuro Shibata, Noriyuki Tanaka **CREATIVE EDITOR** Koji Yoshida
CLIENT Big Magazine, Inc. **COUNTRY** Japan

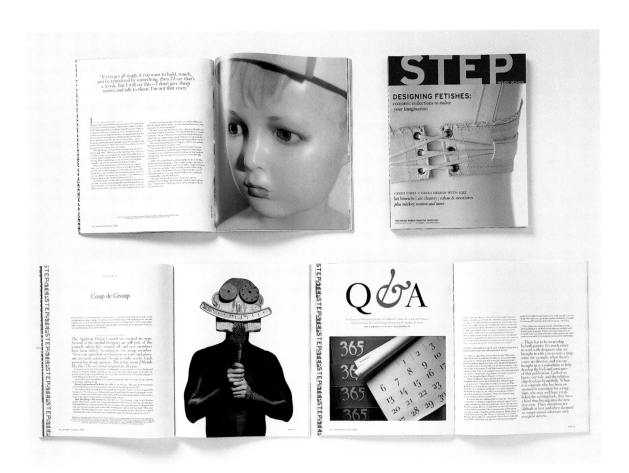

T **Merit** Trade Magazine: Full Issue **STEP Inside Design—Vol. 18, No. 6**

ART DIRECTOR Michael Ulrich CREATIVE DIRECTOR Robert Valentine DESIGNERS Kathie Alexander, Mandy Alaks Barrett STUDIO STEP Inside Design
CLIENT STEP Inside Design COUNTRY United States

B **Merit** Trade Magazine: Cover **STEP Inside Design—Vol. 18, No. 4**

ART DIRECTOR Michael Ulrich CREATIVE DIRECTOR Robert Valentine DESIGNERS Kathie Alexander, David Merideth, Judy Minn, Liddy Walseth
STUDIO The Valentine Group CLIENT STEP Inside Design COUNTRY United States

T **Merit** Book Jacket **Lullaby**
ART DIRECTOR Rodrigo Corral DESIGNER Rodrigo Corral ILLUSTRATOR Judy Lanfredi STUDIO Rodrigo Corral Design CLIENT Doubleday COUNTRY United States

B **Merit** Book Jacket, Series **Projects File 2002, Tokai University**
ART DIRECTOR Masayoshi Kodaira DESIGNER Masayoshi Kodaira PHOTOGRAPHER Sayo Nagase STUDIO FLAME, Inc. CLIENT Tokai University, Department of Architecture and Building Engineering COUNTRY Japan

AUTOBIOGRAFÍA

Cielos de espanto
ALDO ZARGANI

LOSADA

NARRATIVA

La cuestión humana
FRANÇOIS EMMANUEL

LOSADA

AUTOBIOGRAFÍA

Las palabras
JEAN-PAUL SARTRE

LOSADA

TEATRO

Después de la caída
ARTHUR MILLER
Incidente en Vichy

LOSADA

Merit Book Jacket, Series **Losada Book Covers**

ART DIRECTOR Fernando Gutiérrez **DESIGNER** Pablo Juncadella **ILLUSTRATOR** Marion Deuchars **CLIENT** Losada **COUNTRY** United Kingdom

T **Merit** Book Jacket, Series **Picasso—Style or Meaning**
ART DIRECTORS Alan Dye, Nick Finney, Ben Stott **DESIGNER** Nick Finney **AGENCY** NB: Studio **CLIENT** Phaidon Books **COUNTRY** United Kingdom

B **Merit** Special Trade Book (Image Driven) **Stankowski Photos**
ART DIRECTOR Karl Duschek **DESIGNERS** Ekkehard Beck, Lutz Haerer **COPYWRITERS** Stankowski-Stiftung, Hatje Cantz Verlag **PHOTOGRAPHER** Anton Stankowski
STUDIO Stankowski + Duschek **CLIENT** Hatje Cantz Verlag **COUNTRY** Germany

Merit Special Trade Book (Image Driven) **25 Retratos: Terry Vine Imagenes Mexicanas**
ART DIRECTOR Lana Rigsby **DESIGNERS** Lana Rigsby, Pamela Zuccker **TRANSLATOR** Raul Pavon **STUDIO** Rigsby Design **CLIENT** Terry Vine Photography
COUNTRY United States

Merit Special Trade Book (Image Driven) **A Body by John Coplans**

DESIGNER Kiki Bauer PHOTOGRAPHER John Coplans PUBLISHER Powerhouse Books COUNTRY United States

Merit Limited Edition/Private Press/Special Format Book, Series **Analysis of the Massproduct Design Project**
ART DIRECTOR Taku Satoh **DESIGNER** Shino Misawa **COPYWRITER** Minako Ikeda **CLIENT** Bijutsu Shuppan-Sha, Ltd. **COUNTRY** Japan

Merit Limited Edition/Private Press/Special Format Book **Chords No. 1-17**
ART DIRECTOR Greger Ulf Nilson **DESIGNER** Greger Ulf Nilson **PHOTOGRAPHER** Anders Krizar **AGENCY** SJWE, Reklambyran **CLIENT** Journal/Anders Krizar
COUNTRY Sweden

Merit Limited Edition/Private Press/Special Format Book **Visionaire 38: Love**
ART DIRECTORS Greg Foley, Stephen Gan **DESIGNERS** Jason Duzansky, Tatiana Gaz **COUNTRY** United States

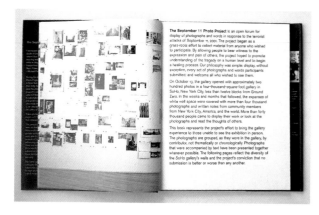

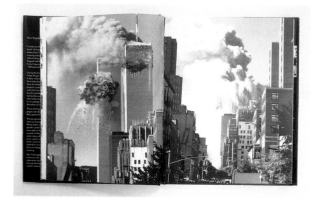

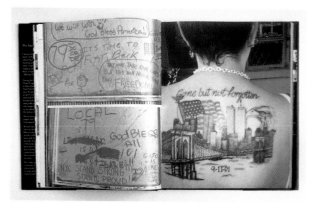

Merit Public Serice/Nonprofit Book **September 11 Photo Project Book**
ART DIRECTOR Marcos Chavez **DESIGNER** Aimee Sealfon **CLIENT** September 11 Photo Project **STUDIO** TODA **COUNTRY** United States

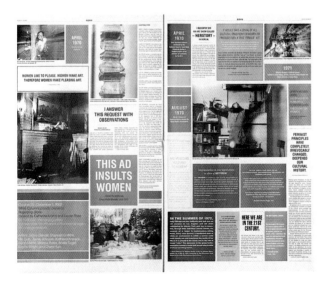

Merit Museum/Gallery/Library Book **Gloria—Another Look at Feminist Art of the 1970s.**

ART DIRECTORS Alice Chung, Karen Hsu DESIGNERS Alice Chung, Karen Hsu STUDIO Omnivore CLIENT White Columns Gallery COUNTRY United States

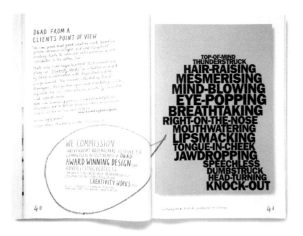

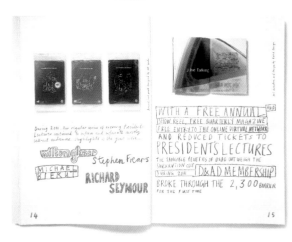

Merit Annual Report **British Design & Art Direction Annual Report '01**

ART DIRECTOR Vince Frost **DESIGNER** Vince Frost **COPYWRITER** Howard Fletcher **ILLUSTRATOR** Marion Deuchars **STUDIO** Frost Design **CLIENT** British Design & Art Direction **COUNTRY** United Kingdom

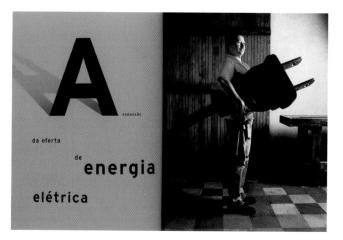

Merit Annual Report **Aneel Annual Report**

ART DIRECTOR Denis Kakazu Kushiyama **DESIGNERS** Denis Kakazu Kushiyama, Alexandre Sartori **PHOTOGRAPHER** Arnaldo Pappalardo
AGENCY Young & Rubicam—Brazil **CLIENT** Aneel **COUNTRY** Brazil

T **Merit** Annual Report **XOMA 2001 Annual Report**

ART DIRECTOR Jill Howry DESIGNER Ty Whittington PHOTOGRAPHER Dwight Eschliman CLIENT XOMA COUNTRY United States

B **Merit** Booklet/Brochure, Series **Theory—Dictionary**

ART DIRECTOR Boyoung Lee COPYWRITER Siobhan McGowen CLIENT Theory COUNTRY United States

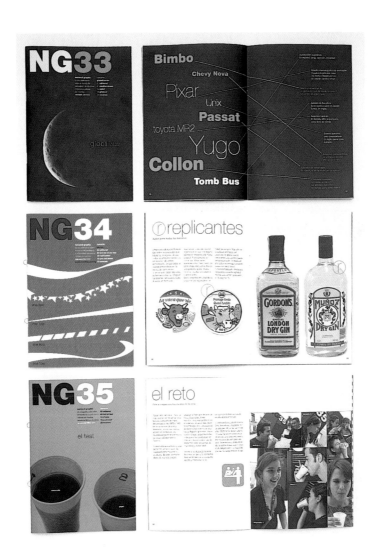

T **Merit** Booklet/Brochure **Telwares—Five Truths Brochure**

DESIGN DIRECTOR Nichole Dillon **COPYWRITER** Andy Blankenburg **PHOTOGRAPHER** Geof Kern **CLIENT** Telwares Communications, Inc. **COUNTRY** United States

B **Merit** Newsletter/Journal/House Publication, Series **National Graphic**

ART DIRECTOR Jordi Duró **DESIGNER** Lucrecia Olano **COPYWRITER** Teresa Domingo **PHOTOGRAPHER** Joan Argelés **CLIENT** Morillas Brand Design **COUNTRY** Spain

Merit Newsletter/Journal/House Publication **British Design & Art Direction—Ampersand 11/02**

ART DIRECTOR Vince Frost **DESIGNERS** Vince Frost, Matthew Willey **PHOTOGRAPHER** Matthew Donaldson **STUDIO** Frost Design **CLIENT** British Design & Art Direction **COUNTRY** United Kingdom

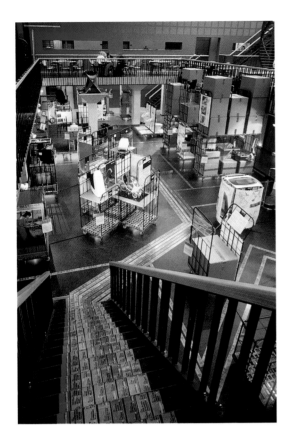

Merit Corporate Identity Program **Productmagic 2002**

ART DIRECTOR Isis Spuijbroek **DESIGNER** Isis Spuijbroek **PHOTOGRAPHER** Ralph Kåmena **STUDIO** Fabrique **CLIENT** Industrial Design Faculty, University Delft **COUNTRY** The Netherlands

Merit Corporate Identity Program **Blink**

ART DIRECTOR Mark Denton **DESIGNERS** Mark Denton, Andy Dymock **PHOTOGRAPHERS** Rob Hardy, Ian Pearce **STUDIO** Typeworks **CLIENT** Blink Productions
COUNTRY United Kingdom

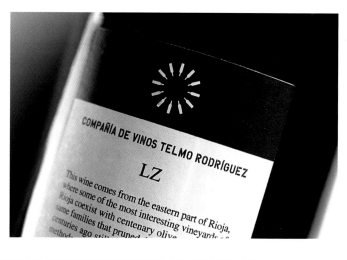

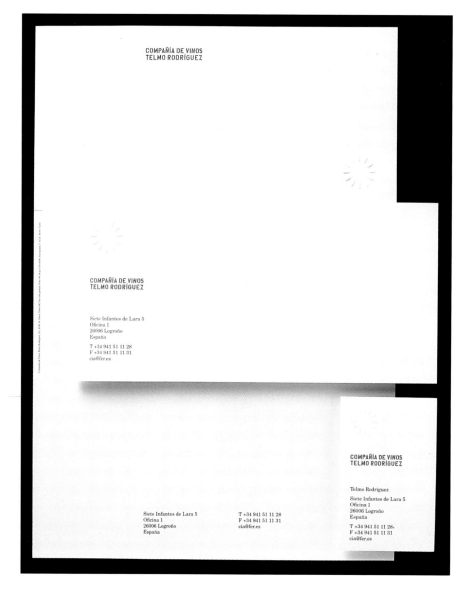

Merit Corporate Identity Program **Compañia de Vinos Telmo Rodriguez**

ART DIRECTOR Fernando Gutiérrez **DESIGNER** Pablo Juncadella **CLIENT** Compañia de Vinos Telmo Rodriguez **COUNTRY** United Kingdom

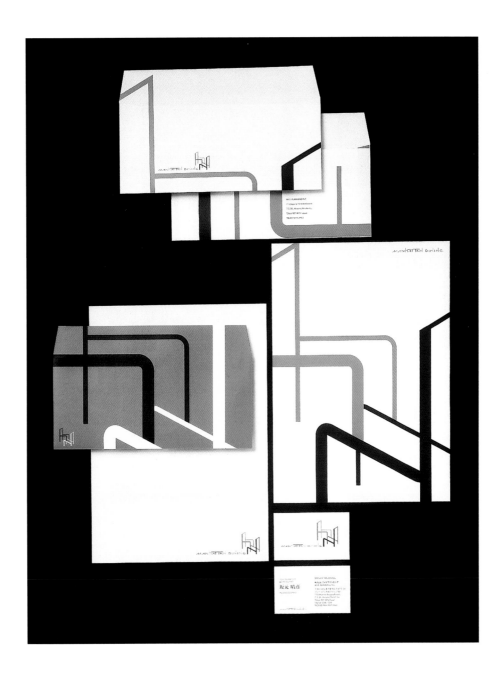

Merit Corporate Identity Program **Manhattan Dining/VI**
ART DIRECTOR Toshihiro Onimaru **DESIGNER** Toshihiro Onimaru **STUDIO** Graphics & Designing Inc. **CLIENT** Will Planning, Inc. **COUNTRY** Japan

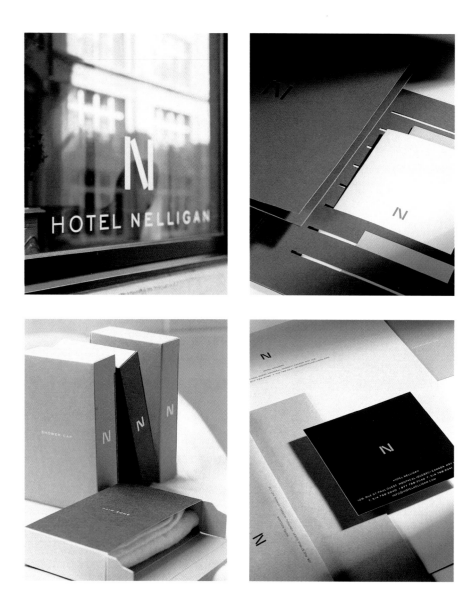

Merit Corporate Identity Program **Hotel Nelligan Identity Program**

ART DIRECTOR Louis Gagnon **DESIGNER** René Clément **PHOTOGRAPHER** Michel Touchette **STUDIO** Paprika **CLIENT** Hotel Nelligan **COUNTRY** Canada

T **Merit** Stationery **Designers Herzblut Project**

ART DIRECTORS Daniel Henry Bastian, Ulysses Voelker CLIENT Herzblut—Idealism and Experiment COUNTRY Germany

B **Merit** Stationery **Fiona Wan Personal Stationery**

ART DIRECTOR Eric Chan DESIGNERS Eric Chan, Francis Lee STUDIO Eric Chan Design Co. Ltd CLIENT Fiona Wan COUNTRY China

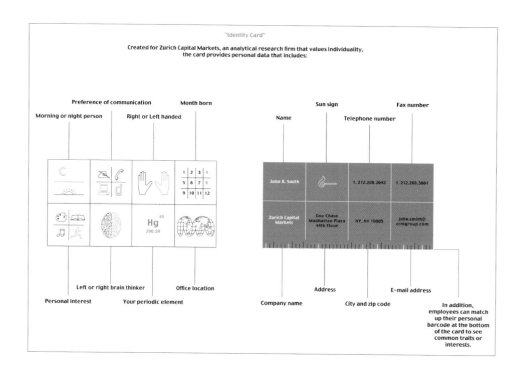

T **Merit** Stationery **Zurich Capital Markets**

ART **DIRECTOR** Michael Gericke **DESIGNER** Su Mathews **STUDIO** Pentagram Design **CLIENT** Zurich Capital Markets **COUNTRY** United States

B **Merit** Stationery **Citizen Pictures Stationery**

ART **DIRECTOR** Sharon Werner **CREATIVE DIRECTORS** Jean Kopeck, Mitch Monson **DESIGNERS** Sarah Nelson, Sharon Werner **STUDIO** Werner Design Werks, Inc.
CLIENT Citizen Pictures **COUNTRY** United States

Merit Stationery **The Knowledge**

ART DIRECTOR Ryan Wills **CREATIVE DIRECTOR** Spencer Buck **DESIGNER** Alex Bane **COPYWRITER** Spencer Buck **STUDIO** Taxi Studio **CLIENT** Taxi Studio
COUNTRY United Kingdom

Merit Logo/Trademark **Dopod**

CREATIVE DIRECTOR Charles Allan **DESIGNERS** Miu Choy, Franki Kam, Charles Scott **CLIENT** Dopod Communication Corp. **COUNTRY** Singapore

L **Merit** Logo/Trademark **Easy Inch Loss**

CREATIVE DIRECTOR Bradford Lawton **DESIGNERS** Bradford Lawton, Leslie Magee **STUDIO** The Bradford Lawton Design Group **CLIENT** Melody Nixon, Easy Inch
Loss Weight Loss Program **COUNTRY** United States

R **Merit** Logo/Trademark **Leaf Street**

ART DIRECTOR Peter Richardson **DESIGNER** Oliver Maltby **CLIENT** 3CV **COUNTRY** United Kingdom

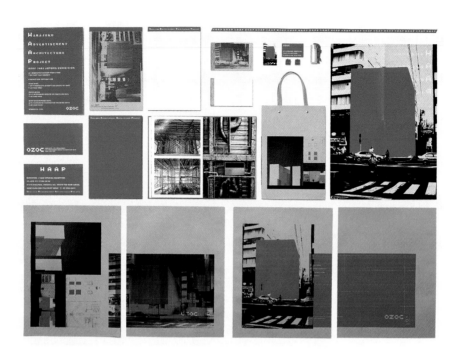

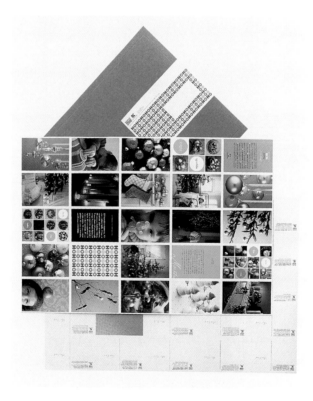

T **Merit** Complete Press/Promotional Kit **HAAP/OZOC**

ART DIRECTOR Kashiwa Sato CREATIVE DIRECTOR Taku Tada DESIGNER Yoshiki Okuse PHOTOGRAPHER Satoshi Minakawa STUDIO Samurai + Tugboat
CLIENT World Co., Ltd. COUNTRY Japan

B **Merit** Complete Press/Promotional Kit **Martha Stewart Everyday Holiday Product Announcement**

ART DIRECTORS Lorna Aragon, Heidi Posnek, Robin Rosenthal CREATIVE DIRECTOR Gael Towey DEPUTY CREATIVE DIRECTOR An Diels DESIGN DIRECTOR
Tika Buchanan PHOTOGRAPHERS Gentl & Hyers, Thibault Jeanson, Stephen Lewis, Victor Schrager SENIOR EDITOR Charlotte Barnard WRITER Georgia Andrews
AGENCY Martha Stewart Living Omnimedia CLIENT Martha Stewart Everyday COUNTRY United States

T **Merit** Self-Promotion: Print **The Chase Postcard Book**
 CREATIVE DIRECTOR Ben Casey **CLIENT** The Chase **COUNTRY** United Kingdom

B **Merit** Self-Promotion: Print **CSA Images Resource Library**
 ART DIRECTORS Charles S. Anderson, Todd Piper-Hauswirth **DESIGNERS** Charles S. Anderson, Erik Johnson, Todd Piper-Hauswirth **ILLUSTRATION** CSA Images
 PHOTOGRAPHY CSA Images **STUDIO** Charles S. Anderson Design **CLIENT** CSA Images **COUNTRY** United States

☐ **Merit** Self-Promotion: Print **UNA Dairy 2003**

DESIGNERS Hans Bockting, Julius van der Woude **TYPE DESIGNER** David Quay **STUDIO** UNA (Amsterdam) designers **CLIENTS** UNA (Amsterdam) designers, Hexspoor Binders, Veenman Printers **COUNTRY** The Netherlands

☐ **Merit** Self-Promotion: Print **Graduate 2003 Opportunities**

ART DIRECTOR Steve O'Leary **DESIGNERS** Steve Davies, Steve O'Leary, Chris Priest, Sid Tomkins **COPYWRITER** Vicki Maguire **ILLUSTRATORS** Steve Davies, Steve O'Leary, Chris Priest **PHOTOGRAPHERS** Steve O'Leary, Chris Priest **STUDIO** Watershed **CLIENT** Ogilvy **COUNTRY** United Kingdom

unpretentious

future friendly

form + function

customer reward

brain + brawn

Merit Self-Promotion: Print **Taxi Big Book**

ART DIRECTOR Jane Hope **DESIGNER** Niki Fleming **COPYWRITER** Gary McGuire **PHOTOGRAPHERS** Richard Heyfron & others **STUDIO** TAXI **CLIENT** TAXI
COUNTRY Canada

Merit Self-Promotion: Print **Newspaper**

ART DIRECTOR Antonia Henschel DESIGNER Antonia Henschel PHOTOGRAPHER Ingmar Kurth STUDIO Sign Kommunikation CLIENT Sign Kommunikation
COUNTRY Germany

Merit Corporate Promotional Video **Nike Town—Tuned Up, P2**

DESIGNER Matt Checkowski **2D ANIMATORS** Brian Castleforte, Matt Checkowski **EDITOR** Kurt Mattila **DIRECTORS** Matt Checkowski, Kurt Mattila
MUSIC Musikvergnuegen **EXECUTIVE PRODUCER** Phyllis Weisband **AGENCY PRODUCERS** Marie Foley, Kenan Smith **DIRECTOR OF PHOTOGRAPHY** Giles Dunning
CLIENT Nike **COUNTRY** United States

Merit Announcements **Otona No Mugicha Brochure**

ART DIRECTOR Kouta Sagae DESIGNERS Takanori Hirayama, Masanao Kato, Kouta Sagae ILLUSTRATOR Kouta Sagae PHOTOGRAPHER Junmaru Sayama
STUDIO Chou Design Co., Ltd. CLIENT Otona No Mugicha COUNTRY Japan

T **Merit** Postcard/Greeting Card/Invitation **Magnum Spring/Summer 2003**
ART DIRECTOR Masayoshi Kodaira **DESIGNER** Masayoshi Kodaira **STUDIO** FLAME, Inc. **CLIENT** Magnum, Inc. **COUNTRY** Japan

B **Merit** Posters: Promotional **Nike Young Directors Awards '02 Poster**
ART DIRECTOR Vince Frost **DESIGNERS** John Dowling, Vince Frost **STUDIO** Frost Design **CLIENT** Nike (UK) Limited **COUNTRY** United Kingdom

Merit Posters: Promotional **HC Ericson**

ART DIRECTOR Andreas Kittel **PHOTOGRAPHER** Mikael Olsson **AGENCY** Happy Forsman & Bodenfors **CLIENT** Röhsska Design Museum **COUNTRY** Sweden

Ⓛ **Merit** Posters: Promotional **The Kazui Press—K**
ART DIRECTOR AkihikoTsukamoto **DESIGNER** AkihikoTsukamoto **PHOTOGRAPHER** Tomoki Ida **STUDIO** Zuan Club **CLIENT** The Kazui Press Ltd. **COUNTRY** Japan

Ⓡ **Merit** Posters: Promotional **Dog Trainer**
ART DIRECTOR Larry Olson **COPYWRITER** Steve Eichenbaum **PHOTOGRAPHER** Poul Ober **CLIENT** Jeff Tinsley **COUNTRY** United States

Merit Posters: Promotional **Der Jüngste Tag**

ART DIRECTOR Helmut Rottke DESIGNER Nicole Elsenbach ILLUSTRATOR Nicole Elsenbach AGENCY Rottke Werbung CLIENT Schauspiel Essen COUNTRY Germany

R **Merit** Posters: Promotional **The 1st Korea International Poster Biennale**

ART DIRECTOR Kyungsun Kymn DESIGNERS Gi-Bong Hyun, Kyungsun Kymn CLIENT Korea Institute of Design Promotion COUNTRY South Korea

Merit Posters: Promotional, Series **Browns—A Walk Through Books, Posters**

ART DIRECTOR Jonathan Ellery **COPYWRITER** Peter Kirby **DESIGNERS** Jonathan Ellery, Kenneth Johnston, Scott Miller, Lisa Smith **STUDIO** Browns
CLIENT Gabriele Capelli Editore Sagl **COUNTRY** United Kingdom

Merit Posters: Promotional, Series **Art Is.**

ART DIRECTOR Masayuki Terashima **DESIGNER** Masayuki Terashima **CLIENT** Gallery Odori Museum **COUNTRY** Japan

Merit Posters: Promotional, Series **Kieler Woche**
ART DIRECTOR Fons Hickmann **DESIGNER** Fons Hickmann **PHOTOGRAPHER** Oliver Eltinger **STUDIO** Fons Hickmann m23 **CLIENT** City of Kiel **COUNTRY** Germany

Merit Posters: Promotional, Series **Shadow**
ART DIRECTOR Katsutoshi Kunisada **DESIGNER** Katsutoshi Kunisada **CLIENT** Katsutoshi Kunisada **COUNTRY** Japan

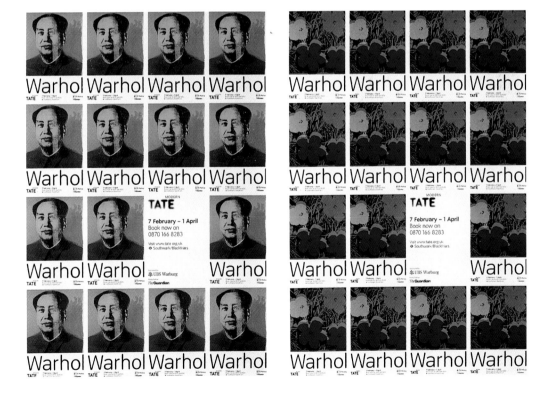

T **Merit** Posters: Promotional **Stabat Mater—Dvorak Concert**
ART DIRECTOR Urs Grünig DESIGNER Urs Grünig PRINTER Albin Uldry CLIENT Laudate Chor Switzerland COUNTRY Switzerland

B **Merit** Posters: Promotional, Series **Warhol Exhibition Poster**
ART DIRECTORS Alan Dye, Nick Finney, Ben Stott DESIGNER Alan Dye AGENCY NB: Studio CLIENT Tate Modern COUNTRY United Kingdom

Spend Halloween in the middle of nowhere and help solve
a horrendous murder. Ring Julie 832 5575 for gory details.

Merit Posters: Promotional **Finger Print Poster**
CREATIVE DIRECTOR Ben Casey **DESIGNER** Lise Warburton **CLIENT** The Chase **COUNTRY** United Kingdom

Tokyo Aoyama National Children's Castle Music Program

Merit Posters: Public Service/Nonprofit/Educational **ANA Poster**

ART DIRECTOR Takafumi Kusagaya **DESIGNERS** Takafumi Kusagaya, Miki Sekiguchi **CLIENT** ANA **COUNTRY** Japan

L **Merit** Posters: Public Service/Nonprofit/Educational **Alliance Graphique Internationale Poster**
CREATIVE DIRECTOR Jennifer Morla **DESIGNERS** Hizam Haron, Jennifer Morla **CLIENT** AGI Student Conference 2002 **COUNTRY** United States

R **Merit** Posters: Public Service/Nonprofit/Educational **Die Kahle Sängerin**
DESIGNER Stephan Bundi **STUDIO** Atelier Bundi **CLIENT** Klubb Berne **COUNTRY** Switzerland

Merit Posters: Public Service/Nonprofit/Educational **Cross Culture 1 (humanXmindXworld)**
ART DIRECTOR Hiroshi Saito **DESIGNER** Hiroshi Saito **ILLUSTRATOR** Hiroshi Saito **COUNTRY** Japan

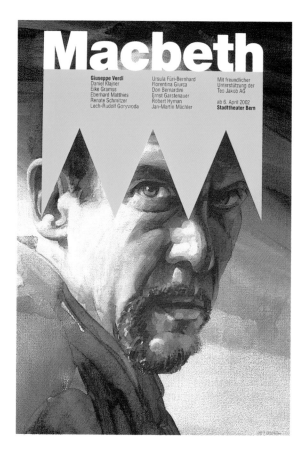

T **Merit** Posters: Public Service/Nonprofit/Educational **Toleranz**

ART DIRECTOR Pierre Mendell **DESIGNER** Pierre Mendell **ILLUSTRATION/TYPOGRAPHY** Heinz Hiltbrunner **STUDIO** Pierre Mendell Design Studio **CLIENT** Pierre Mendell Design Studio **COUNTRY** Germany

B **Merit** Posters: Public Service/Nonprofit/Educational, Series **Otona No Mugicha Poster**

ART DIRECTOR Kouta Sagae **DESIGNERS** Takanori Hirayama, Masanao Kato, Kouta Sagae **ILLUSTRATOR** Kouta Sagae **STUDIO** Chou Design Co., Ltd. **CLIENT** Otona No Mugicha **COUNTRY** Japan

Solens och vindarnas ö!

Pittoresk fornborg på Öland. Charmig atmosfär m. synliga bjälkar o. genomgående äkta material såsom kalksten o. jordgolv! Spatiös hall, m. plats för familj, djur, redskap o. förråd. Ett av över hundra objekt på utställningen *Svensk byggnadskonst under 1000 år.*

VISNING TIS–SÖN KL 13–17

ARKITEKTURMUSEET
(Skeppsholmskyrkan)

Öppet tisdag–söndag kl 13–17. Sommarlovsprogram för barn och ungdom tisdag–söndag kl 13–15. Fri entré. Arkitekturmuseet finns även på Fredsgatan 12 i Stockholm. Tel 08-587 270 00. Fax 08-587 270 70. www.arkitekturmuseet.se

Arkitektritat!

Modernt timmerhus i nyenkel stil. Öppen flexibel planlösning för den lilla familjen. Kan monteras ned och flyttas! Ett av över hundra objekt på utställningen *Svensk byggnadskonst under 1000 år.*

VISNING TIS–SÖN KL 13–17

ARKITEKTURMUSEET
(Skeppsholmskyrkan)

Öppet tisdag–söndag kl 13–17. Sommarlovsprogram för barn och ungdom tisdag–söndag kl 13–15. Fri entré. Arkitekturmuseet finns även på Fredsgatan 12 i Stockholm. Tel 08-587 270 00. Fax 08-587 270 70. www.arkitekturmuseet.se

Romantiskt 1700-tal!

Ljuvligt träslott anno 1784. Varsamt renov. med vackra detaljer o. underbar atmosfär. Som att kliva in i ett dockskåp! Ett av över hundra objekt på utställningen *Svensk byggnadskonst under 1000 år.*

VISNING TIS–SÖN KL 13–17

ARKITEKTURMUSEET
(Skeppsholmskyrkan)

Öppet tisdag–söndag kl 13–17. Sommarlovsprogram för barn och ungdom tisdag–söndag kl 13–15. Fri entré. Arkitekturmuseet finns även på Fredsgatan 12 i Stockholm. Tel 08-587 270 00. Fax 08-587 270 70. www.arkitekturmuseet.se

Merit Billboard/Diorama/Painted Spectacular, Series **1000 Years of Architecture**

ART DIRECTOR Lisa Careborg DESIGNER Lisa Careborg COPYWRITER Björn Engström AGENCY Happy Forsman & Bodenfors CLIENT Swedish Museum of Architecture COUNTRY Sweden

Girl out walking (6:12) Tunes in the blue, Making another stand > Girl out walking, Swinging arms jingle by, Followed quickly by a fly~Girl out walking, Short one's turn, To look back > Girl out walking, Not too much, Wants to look ahead so many times > Blue tunes disappear, Hiding behind the same old fears, Lives this beauty, Caught some distance, Did not catch it all at once > Girl out walking, Moon's in the blue, Making another stand > This tune is so alive, It looks really good > Girl out walking, Tunes in the blue, Not asking to be looked at by me or by you > In the end, in the end~, It's not the end, It's not the end, Just the beginning > Girl out walking, Tunes in the blue, Rolling into the vicinity, Coming down to touch you, > Look, I stretch my arms, A thousand times, One more time, I stretch my arms, A thousand times, And here~, It disappears > Swinging arms jingle by, Followed quickly by a fly > Not asking to be looked at by me or by you. **Just There** (4:34) It will burn you at the start, It will cut you everywhere, Then drop deep into your heart, Like a single salty tear > And a heart full of spite, Will come to feel regret, And this sorrow, although light, It will not forget > It's not always right, It's not completely unfair, It's not always right~, It's just there > And so that I might lift, His head to up above, Let me find the world a gift, More incorruptible than love > It's not always right, It's not completely unfair, It's not always right~, It's just there. **Schauspieler** (4:23) Sie waren Schauspieler, vor einer langen, langen Zeit, seitdem hat sich nicht viel bewegt > Du fragst vielleicht, wie kann ich dass wissen, ich spekuliere nur, wie die anderen auch > Die Vergangenheit hat lange gedauert, aber es war nie klar, was wirklich passiert ist~, bin ich frisch direkt und am Leben? > Schauspieler werden geboren, Schauspieler sterben, sie waren Schauspieler, schon vor so langer Zeit > Von der Vergangenheit in die Zukunft, reise ich mit diesem Muellwagen, und der, der hat sich umgedreht > Ich hab nicht recht, ich weiss Ich bin falsch, ist die Verwirrung dass, wie wirklich passiert ist > Unsere denkenden Freunde, beobachte unsere denkenden Freunde, Du fragst vielleicht, wie kann ich das wissen, ich spekuliere nur, wie die anderen auch > Die Vergangenheit hat lange gedauert, aber es wie nie klar, was wirklich passiert ist~, bin ich frisch direkt und am Leben? > Schauspieler werden geboren, Schauspieler sterben, genau so wie alle anderen auch > Von der Vergangenheit in die Zukunft, reise ich mit diesem Muellwagen, der hat sich umgedreht, und der Muell ist ranzig fallen.

Sex God and Money (2:45) It's a transcendental emergency, The thin air just seemed to land on me, Tulips stare at the painted sky~, Over there a spider eats a fly. > Love or perish on the grapevine, Said a far out person from another time. Around I go for another day~, It usually happens pretty much the same way > I think about sex, I think about god, I'm thinking about money > It's a beautiful day~skipping bugs, All the little insects are making love, Diamonds are floating up in the sky, Throwing down answers at the midnight dancers. > Out there they're planning the heat, That's something I know how to meet. Around I go for another day~, It usually happens pretty much the same way > I think about sex, I think about god, I'm thinking about money... **The Night of a Million DJ's** (7:21) They're all set up, in so many ways. On this night, Of a million dj's > I can remember when there were two or three, Now there's a million coming after me > Chorus Oh you dj's you're such fun to be around, And to think you spend your lives, Immersed in beautiful sound > Verse 2 Mix my mind~I can't afford to wait, Do your best to keep them up late, Rock the house~jungle them up, Hip hop their bodies till they can't stand up > Shake their mind with groovy lines, Stop, look and listen for new finds, Once there were two or three, Now there's a million coming at me > Chorus Oh you dj's you're such fun to be around, And to think you spend your lives, Immersed in beautiful sound > Oh you dj's you're such fun to be around, And to think you spend your lives, Immersed in beautiful sound. **Blue Bird Party** (6:23) Good evening and welcome to the underground place. It's the last party for the human race, My idea was to play along, Slow march~very sad song. > Heads all roll when the drummer drums. Kings, teachers, businessmen, bums. Chorus Blue Bird Party, Blue Bird Party > The organ cranks out its last tune, Before you know it~you're in another room. A guest of a guest has put you on the list, Just like that~you don't exist. It's a taxing thought, When you consider being naught > Chorus Blue Bird Party, Blue Bird Party, Is the ticket that you bought > Finally they expect no complaints. If you're very lucky you'll be hanging out with saints. Over there across that road, They're going to the last abode > Make no mistake, There is nothing you will take, Simply put, You won't be awake > Blue Bird Party, Blue Bird Party. **Sometimes** (3:33) Sometimes, you know who you are, And sometimes you don't, Sometimes you know that you are, And sometimes you don't.

Neulander

Merit Packaging: Entertainment **Neulander Promotion**
DESIGNER Mark Naden **PHOTOGRAPHER** Daniela Stallinger **STUDIO** TODA **CLIENT** Neulander **COUNTRY** United States

T **Merit** Packaging: Food/Beverage **Hot Soup**
ART DIRECTORS Hidemi Shingai, Hirofumi Watanabe CREATIVE DIRECTOR Yasuo Kono DESIGNERS Akira Tanaka, Ryo Yamagiwa CLIENT Kirin Beverage
COUNTRY Japan

B **Merit** Packaging: Food/Beverage **Cox Orange**
ART DIRECTORS Wolfgang Biebach, Sabine Skrobek COPYWRITER Lothar Hackethal AGENCY Heye & Partner CLIENT Ernst Kalff Obstbrennerei COUNTRY Germany

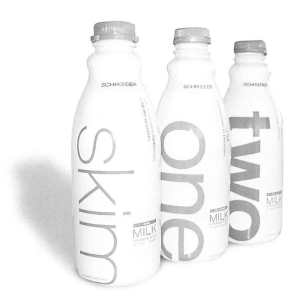

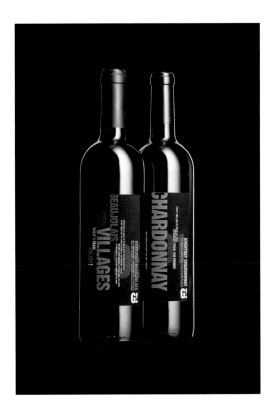

T **Merit** Packaging: Food/Beverage, Series **Schroeder Milk Packaging**
ART DIRECTOR Brian Adducci DESIGNERS Dan Baggenstoss, Kathy Suranno COPYWRITER Rob Dewey STUDIO Capsule CLIENT Schroeder Milk
COUNTRY United States

B **Merit** Packaging: Food/Beverage, Series **Geronimo Wine Bottle Labels**
ART DIRECTOR Domenic Lippa DESIGNER Domenic Lippa COPYWRITER Domenic Lippa TYPOGRAPHER Domenic Lippa STUDIO Lippa Pearce
Design Ltd. CLIENT Geronimo Inns COUNTRY United Kingdom

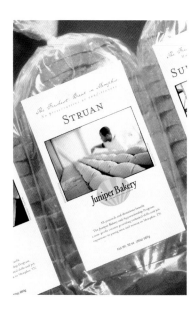 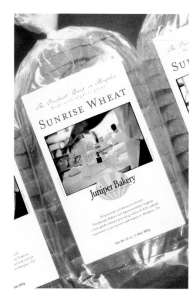

T **Merit** Packaging: Food/Beverage, Series **Bread Packaging**

ART DIRECTOR Brian Dixon **CREATIVE DIRECTOR** Gary Backaus **DESIGNER** Brian Dixon **COPYWRITER** Justin Dobbs **PHOTOGRAPHER** Trey Clark **CLIENT** Juniper Bakery and Apprenticeship **COUNTRY** United States

B **Merit** Packaging: Food/Beverage **Smart Water**

ART DIRECTOR Aunnop Boonthong **CREATIVE DIRECTOR** Douglas Lloyd **CLIENT** Energy Brands, Inc. **COUNTRY** United States

Merit Packaging: Food/Beverage, Series **Fernando de Castilla Sherries**
ART DIRECTOR Graham Shearsby **DESIGNER** Antonia Hayward **ACCOUNT DIRECTOR** Giles Darwin **CLIENT** Fernando de Castilla **COUNTRY** United Kingdom

T **Merit** Packaging: Gift/Specialty Product **100% Generosity Bag**
DESIGN AND ART DIRECTION Rafael Esquer **DESIGNERS** Jay Miolla, Jörg Scheuerpflug, Heike Sperber, Wendy Wen **COPYWRITER** Gregory Gross
PRODUCTION SUPERVISOR Wendy Wen **PRINTER** Joe Prestino **STUDIO** @radical.media **CLIENT** @radical.media **COUNTRY** United States

B **Merit** Packaging: Gift/Specialty Product, Series **Shiki Paper Bag**
ART DIRECTOR Shuichi Nogami **DESIGNER** Shuichi Nogami **CLIENT** Shiki Co., Ltd. **COUNTRY** Japan

Merit Packaging: Gift/Specialty Product, Series **Martha Stewart Everyday Baby Baby Packaging**

ART DIRECTORS Lorna Aragon, Soyoung Oh, Pam Purser, Effie Tsu, Teresa Yeung **CREATIVE DIRECTOR** Gael Towey **DEPUTY CREATIVE DIRECTOR** An Diels
DESIGN DIRECTOR Tika Buchanan **PHOTOGRAPHER** Maura McEvoy **SENIOR EDITOR** Charlotte Barnard **WRITER** Elizabeth Frankenberger **AGENCY** Martha Stewart
Living Omnimedia **CLIENT** Martha Stewart Everyday **COUNTRY** United States

Merit Wayfinding Systems/Signage/Directory **Museum of Glass**

ART DIRECTOR Kit Hinrichs **DESIGNERS** David Asari, Lynn Bohannon, Myrna Newcomb **PHOTOGRAPHERS** Barry Robinson, Lara Swimmer
STUDIO Pentagram Design **CLIENT** Museum of Glass **COUNTRY** United States

T **Merit** Wayfinding Systems/Signage/Directory **Brooklyn Academy of Music Landmark Sign**
 ART DIRECTOR Michael Bierut **DESIGNERS** Trish Solsaa, Bob Stern **STUDIO** Pentagram Design **CLIENT** Brooklyn Academy of Music **COUNTRY** United States

B **Merit** Window Display/Merchandising **Sliding Door**
 ART DIRECTOR Stefan Schulte **COPYWRITERS** Niels Holle, Steffen Steffens **CLIENT** Daimler Chrysler AG **COUNTRY** Germany

Merit Window Display/Merchandising **Pleats Please Window Display**
ART DIRECTOR Sayuri Shoji DESIGNERS Shinji Saito, Sayuri Shoji PHOTOGRAPHER Yasuaki Yashinaga STUDIO Sayuri Studio, Inc. CLIENT Issey Miyake, Inc.
COUNTRY Japan

Merit Trade Shows **Pre-Safe Exponate**

ART DIRECTORS Tobias Kollmann, Wolfram Schaeffer **DESIGNERS** Matthias Bohner, Tobias Kollmann **FILM** Michael Salzbrenner **ACCOUNT EXECUTIVE**
Dirk Landauer **STUDIO** Design Hoch Drei **CLIENT** Daimler Chrysler AG **COUNTRY** Germany

Merit Retail/Restaurant/Office/Outdoor **The L!BRARY Initiative**

ART DIRECTOR Michael Bierut **DESIGNER** Michael Bierut, Rion Byrd **STUDIO** Pentagram Design **CLIENT** Robin Hood Foundation **COUNTRY** United States

Merit Gallery/Museum Exhibit/Installation **Eurostar First Class Passenger Business Lounges**
DESIGN GBH & Starck Design **CLIENT** Eurostar **COUNTRY** United Kingdom

Merit Gallery/Museum Exhibit/Installation **Ottoman Bank Museum**

ART DIRECTOR Bülent Erkmen DESIGNERS Ömer Akin, Emre Çikinoglu INDUSTRIAL DESIGNER Yesim Bakirküre ARCHITECT Ihsan Bilgin
VIRTUAL DESIGN CONSULTANT Mehmet Budak CLIENT Garanti Bank COUNTRY Turkey

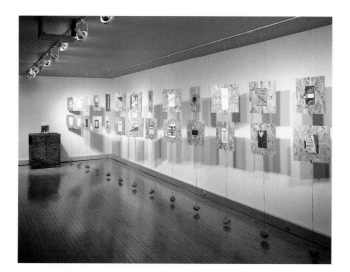
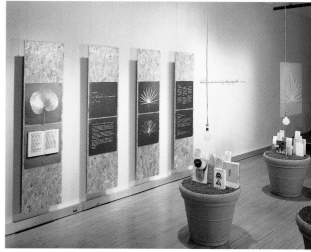
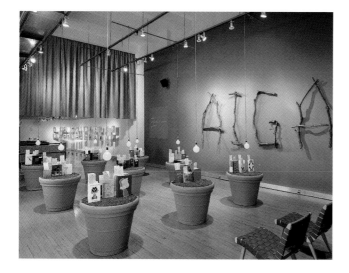

Merit Gallery/Museum Exhibit/Installation **AIGA 50 Books/50 Covers**

EXHIBIT DESIGNERS Jonathan Alger, Emanuela Frigerio **ART DIRECTOR (PRINT)** Emanuela Frigerio **PHOTOGRAPHER (PRINT)** Dave Hoffman **CLIENT** AIGA
COUNTRY United States

Merit Gallery/Museum Exhibit/Installation **Do It Yourself: Home Improvement in 20th-Century America**

ART DIRECTOR Abbott Miller **DESIGNERS** James Hicks, Jeremy Hoffman, Abbott Miller **STUDIO** Pentagram Design **CLIENT** National Building Museum, Smithsonian Institute **COUNTRY** United States

Merit Gallery/Museum Exhibit/Installation **Curiosity Perfume Exhibition—Perfume x Perform**
ART DIRECTOR Gwenael Nicolas **CLIENT** Self Exhibition **COUNTRY** Japan

 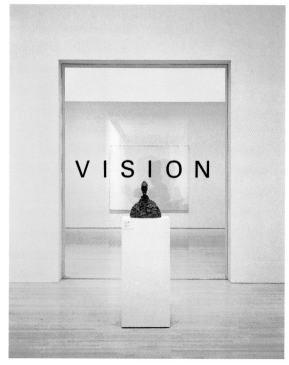

Merit Gallery/Museum Exhibit/Installation **Display Signs for Special Exhibitions**

ART DIRECTOR Kotaro Hirano DESIGNERS Takeshi Ando, Kotaro Hirano PHOTOGRAPHER Kotaro Hirano ARCHITECTS Taniguchi and Associates
CLIENT Toyota Municipal Museum of Art COUNTRY Japan

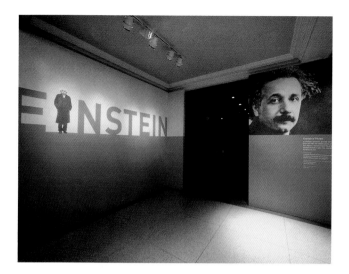

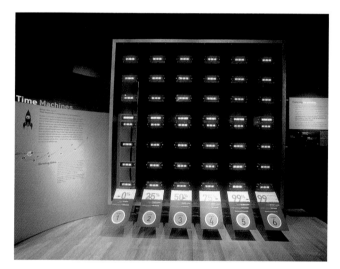

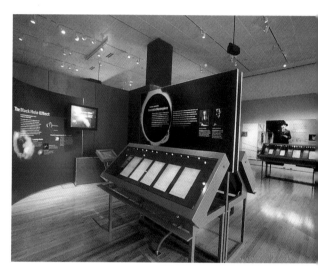

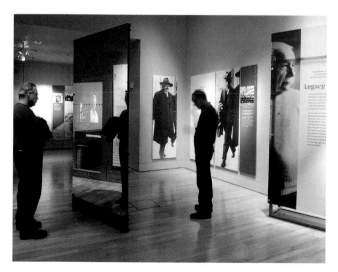

Merit Gallery/Museum Exhibit/Installation **Einstein**

DESIGNERS Craig Stout, Shani Tow, Olga Zhivov **EXHIBIT DESIGNER** Tim Martin **SENIOR EXHIBITION DEVELOPER** Joel Sweimler **EXHIBITION DEVELOPER**
Alan Draeger **ASSISTANT DIRECTOR OF EXHIBITION DESIGN** Tim Nissen **ASSISTANT DIRECTOR OF GRAPHIC DESIGN** Stephanie Reyer **ASSISTANT EDITORIAL DIRECTOR**
Lauri Halderman **LIGHTING DESIGNER** David Clinard **CURATOR** Michael Shara **EXECUTIVE PRODUCER** Geralyn Abinader **COUNTRY** United States

Merit TV Identities/Openings/Teasers **Made**

ART DIRECTORS Stefanie Barth, Julie Herschbeld DESIGNERS Stefanie Barth, Julie Herschbeld EXECUTIVE PRODUCERS Jeffrey Keyton, Romy Mann
CLIENT MTV Networks COUNTRY United States

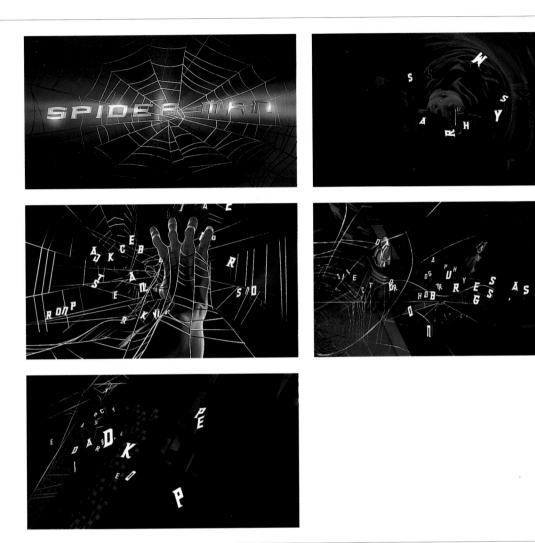

Merit Cinema: Opening Title Sequence **Spider-Man Main Titles**

DESIGNERS Ahmet Ahmet, Kyle Cooper, Charles Khoury, Ben Lopez **3D ANIMATORS** Asa Hammond, Charles Khoury, Ben Lopez **INFERNO ARTIST** Rod Basham **DIRECTOR** Kyle Cooper **EDITOR** Carsten Becker **EXECUTIVE PRODUCERS** Peter Frankfurt, Chip Houghton **PRODUCERS** Keith Bryant, Phyllis Weisband **PRODUCTION** Columbia Pictures **COUNTRY** United States

Merit Animation **Nike Scorpion—Medley**

AGENCY ART DIRECTOR Eric Cruz **ART DIRECTORS** Mathew Cullen, Michael Jakab **AGENCY CREATIVE DIRECTORS** John Jay, Sumiko Sato **DESIGNER** Kaan Atilla
AGENCY COPYWRITER Barton Corley **EXECUTIVE PRODUCER** Javier Jimenez **AGENCY PRODUCER** Kenji Tanaka **EDITOR** Mark Hoffman **DESIGN AND PRODUCTION**
Motion Theory **AGENCY** Wieden + Kennedy—Tokyo **CLIENT** Nike **COUNTRY** United States

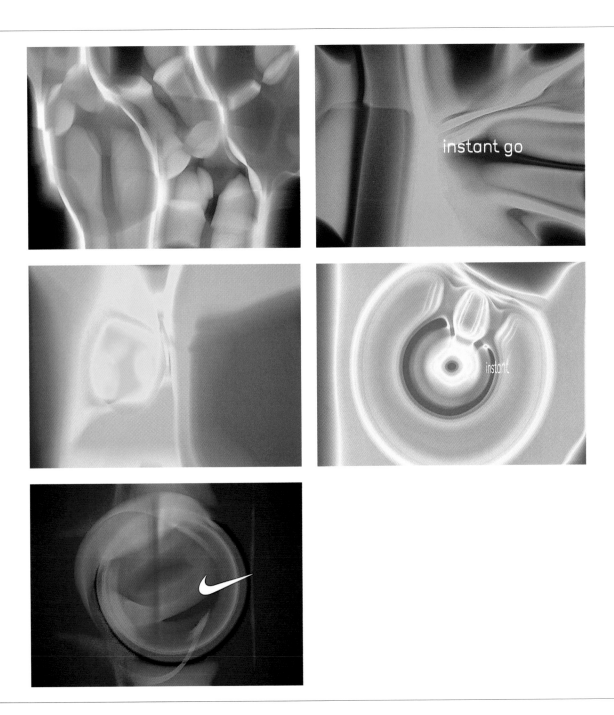

Merit Animation **Nike Presto—Techno**

AGENCY ART DIRECTOR Eric Cruz **ART DIRECTORS** Mathew Cullen, Philip Shtoll **AGENCY CREATIVE DIRECTORS** John Jay, Sumiko Sato **AGENCY COPYWRITER** Barton Corley **EXECUTIVE PRODUCER** Javier Jimenez **AGENCY PRODUCER** Kenji Tanaka **DESIGN AND PRODUCTION** Motion Theory **AGENCY** Wieden + Kennedy—Tokyo **CLIENT** Nike **COUNTRY** United States

hotography/illustration

Château Haut-Brion 1979

Mousse au chocolat

Caille, à la truffe noire

Moules marinières

Truite fumée au citron

Cuisses de grenouille

Asperges blanches, sauce béarnaise

Pâté de canard à l'ancienne

Silver Medal Magazine Editorial **Instant Carnage**
PHOTOGRAPHER Kenji Toma **FOOD STYLIST** Victoria Granoff **CLIENT** BEople **COUNTRY** United States

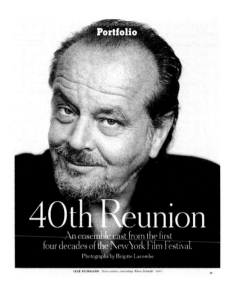

Portfolio

40th Reunion

An ensemble cast from the first
four decades of the New York Film Festival.

Photographs by Brigitte Lacombe

JACK NICHOLSON Three entries, including 'About Schmidt' (2002).

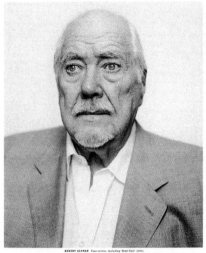

ROBERT ALTMAN Four entries, including 'Short Cuts' (1993).

EMILY WATSON Two entries, including 'Breaking the Waves' (1996).

PENELOPE CRUZ Two entries, including 'All About My Mother' (1999).

PEDRO ALMODOVAR Five entries, including 'Talk to Her' (2002).

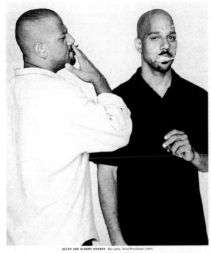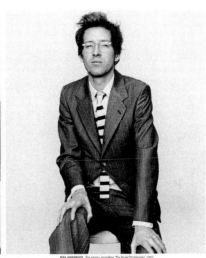

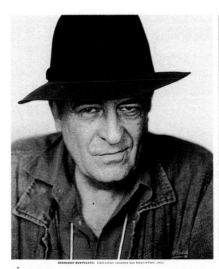

Distinctive Merit Magazine Editorial **40th Reunion—Portfolio**

ART DIRECTOR Janet Froelich **PHOTO EDITOR** Kathy Ryan **PHOTOGRAPHER** Brigitte Lacombe **DESIGNER** Joele Cuyler **CLIENT** The New York Times Magazine
COUNTRY United States

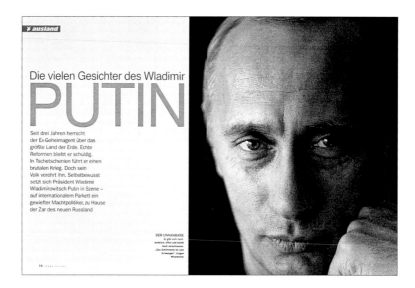

Die vielen Gesichter des Wladimir

PUTIN

Seit drei Jahren herrscht
der Ex-Geheimagent über das
größte Land der Erde. Echte
Reformen bleibt er schuldig.
In Tschetschenien führt er einen
brutalen Krieg. Doch sein
Volk verehrt ihn. Selbstbewusst
setzt sich Präsident Wladimir
Wladimirowitsch Putin in Szene –
auf internationalem Parkett ein
gewiefter Machtpolitiker, zu Hause
der Zar des neuen Russland

DER UNNAHBARE
Er gibt sich nach
denklich, offen und bleibt
doch verschlossen.
„Das Schlimmste ist sein
Schweigen", klagen
Mitarbeiter

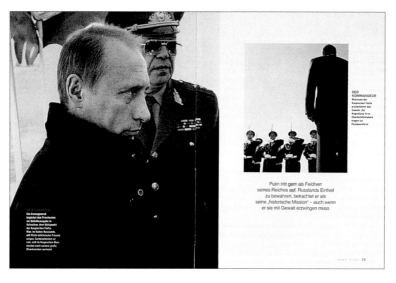

DER STRATEGE
Ein Armeegeneral
begleitet den Präsidenten
zur Befehlsausgabe in
Aulschin, dem Stützpunkt
der Kaspischen Flotte.
Nun, im Sинne Russlands,
will Putin militärische Präsenz
zeigen. Tschetschenien ist
nah, und im Kaspischen Meer
werden noch weitere große
Ölvorkommen vermutet

DER
KOMMANDEUR
Matrosen der
Kaspischen Flotte
präsentieren das
Gewehr. Zur
Begrüßung ihres
Oberbefehlshabers
tragen sie
Paradeuniform

Putin tritt gern als Feldherr
seines Reiches auf. Russlands Einheit
zu bewahren, betrachtet er als
seine „historische Mission" – auch wenn
er sie mit Gewalt erzwingen muss

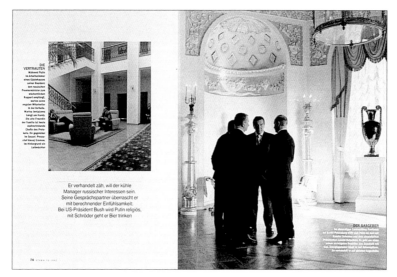

DIE
VERTRAUTEN
Während Putin
im Arbeitszimmer
eines Gästehauses
seiner russischen
Premierminister zum
wöchentlichen
Rapport empfängt,
wartet seine
engste Mitarbeiter
in der Vorhalle.
Marina Jentaljewa
hängt am Handy.
Die alte Freundin
der Familie ist heute
stellvertretende
Chefin des Proto
kolls. Ihr gegenüber
im Sessel: Presse
chef Alexej Gromow.
Im Hintergrund ein
Leibwächter

Er verhandelt zäh, will der kühle
Manager russischer Interessen sein.
Seine Gesprächspartner überrascht er
mit berechnender Einfühlsamkeit:
Bei US-Präsident Bush wird Putin religiös,
mit Schröder geht er Bier trinken

DER GASGEBER

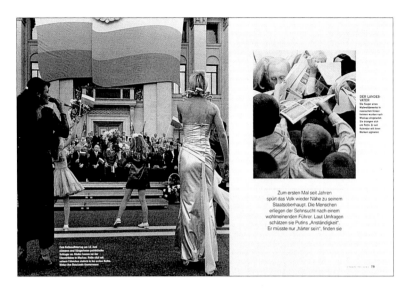

Distinctive Merit Magazine Editorial **Putin**

ART DIRECTOR Tom Jacobi **PHOTOGRAPHER** Konrad R. Müller **DESIGNER** Andreas Fischer **COUNTRY** Germany

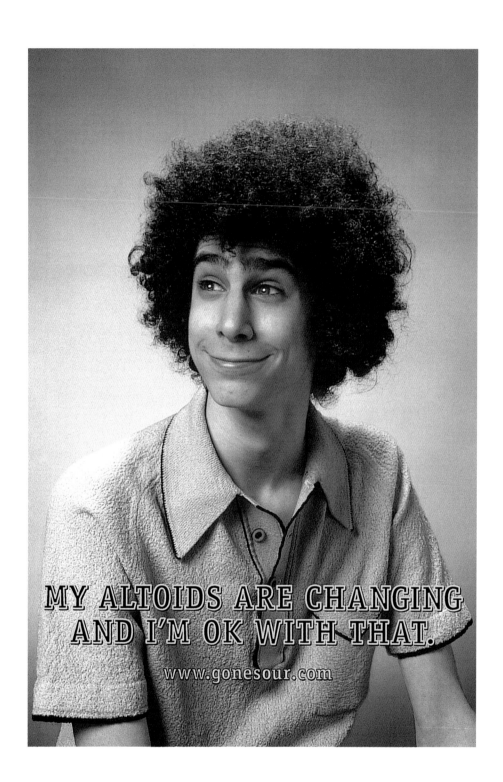

Distinctive Merit Magazine Advertisement **OK with That**

ART DIRECTOR Noel Haan **EXECUTIVE CREATIVE DIRECTORS** Mark Faulkner, Steffan Postaer **CREATIVE DIRECTORS** Noel Haan, G. Andrew Meyer
PHOTOGRAPHER Tony D'Orio **COPYWRITER** G. Andrew Meyer **AGENCY** Leo Burnett Company **CLIENT** Kraft—Altoids Sours **COUNTRY** United States

Distinctive Merit Miscellaneous **Chair & Dustbin**
ART DIRECTOR Paul Foster **PHOTOGRAPHER** Tim Flach **CLIENT** Getty Images **COUNTRY** United Kingdom

Distinctive Merit Miscellaneous, Series **Monkey Series**
PHOTOGRAPHER Tim Flach **COUNTRY** United Kingdom

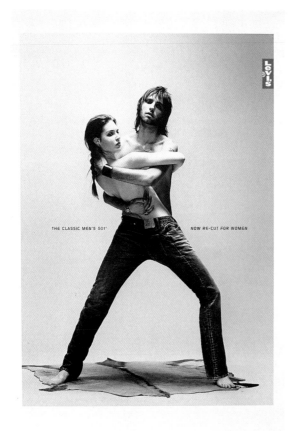

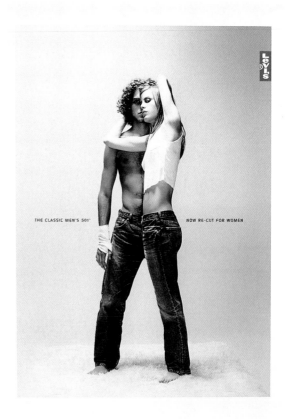

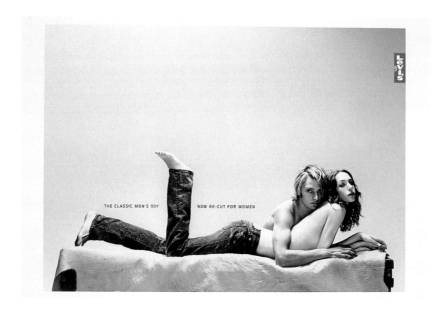

Merit Magazine Advertisement, Series **Hugging** ▪ **Standing** ▪ **Lying**

ART DIRECTOR Alex Lim **CREATIVE DIRECTOR** Steve Elrick **PHOTOGRAPHER** Nadav Kander **STYLIST** Mark Anthony **HAIR** Asashi **MAKE UP** Liz Pugh
CLIENT Levi Strauss **COUNTRY** United Kingdom

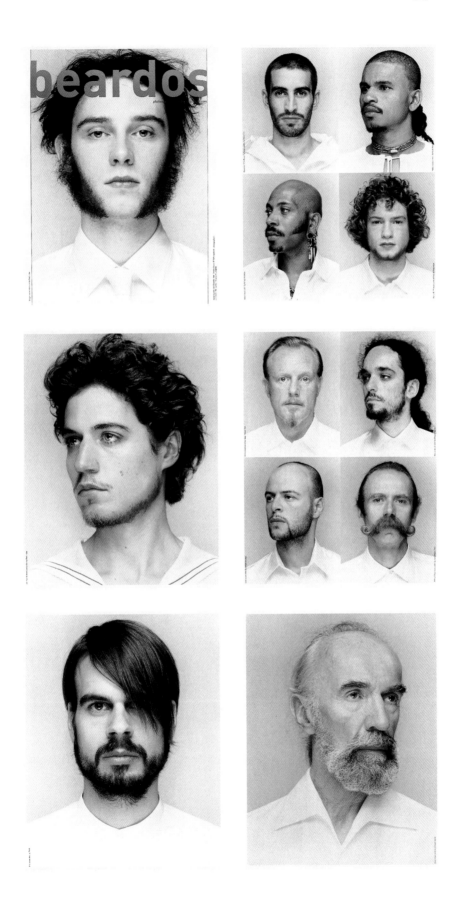

Merit Magazine Editorial **Beardos**
ART DIRECTOR Andreas Laeufer **PHOTOGRAPHER** Axel Hoedt **CLIENT** Tank Magazine **COUNTRY** United Kingdom

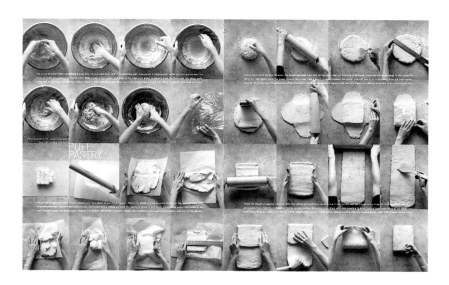

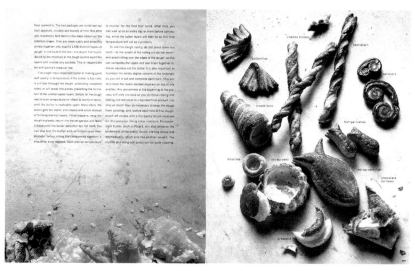

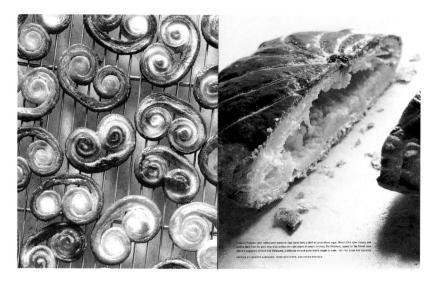

Merit Magazine Editorial **Puff Pastry**

ART DIRECTOR James Dunlinson **PHOTO EDITOR** Stacie McCormick **PHOTOGRAPHER** Hans Gissinger **FOOD EDITORS** Jennifer Aaronson, Susan Spungen
CLIENT Martha Stewart Living **COUNTRY** United States

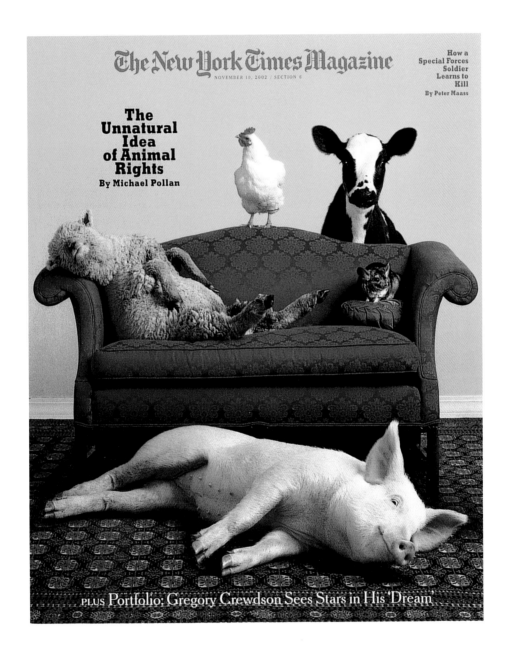

Merit Magazine Cover **Animal Rights**

ART DIRECTOR Janet Froelich **PHOTO EDITOR** Kathy Ryan **PHOTOGRAPHER** William Wegman **DESIGNER** Janet Froelich **COUNTRY** United States

Merit Corporate/Institutional **Video Music Awards Book**

ART DIRECTOR Stacy Drummond **CREATIVE DIRECTORS** Stacy Drummond, Jeffrey Keyton **PHOTOGRAPHER** Dewey Nicks **DESIGNER** Stacy Drummond
PRODUCER Stephanie Nicks **CLIENT** MTV Networks **COUNTRY** United States

Merit Online **Stevesimonphoto.com**

ART DIRECTOR Marilyn Simms **CREATIVE DIRECTOR** Christine Samuel **PHOTOGRAPHER** Steve Simon **WEB MASTER** Curt Quentien **AGENCY** Red Eye Inc.
COUNTRY United States

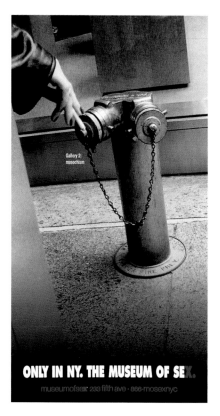

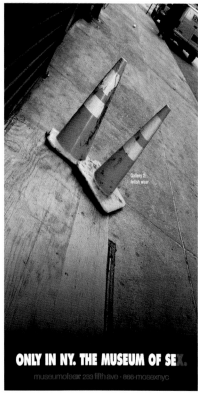

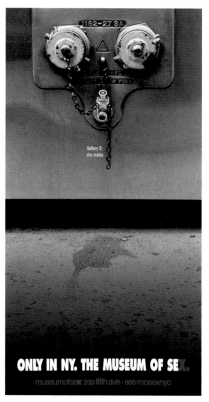

MULTIPLE AWARDS SEE ALSO ADVERTISING

Merit Miscellaneous **Bondage** ▪ **Oral Fixations** ▪ **Fetish Wear** ▪ **Transsexuals** ▪ **Masochism**

ART DIRECTOR Earl Cavanah CHIEF CREATIVE OFFICER Gary Goldsmith EXECUTIVE CREATIVE DIRECTOR Dean Hacohen CREATIVE DIRECTORS Earl Cavanah, Lisa Rettig-Falcone PHOTOGRAPHER Lisa Rettig-Falcone COPYWRITER Lisa Rettig-Falcone AGENCY LOWE—New York CLIENT Museum of Sex COUNTRY United States

Merit Miscellaneous **Baby Doll**
PHOTOGRAPHER Tim Flach **COUNTRY** United Kingdom

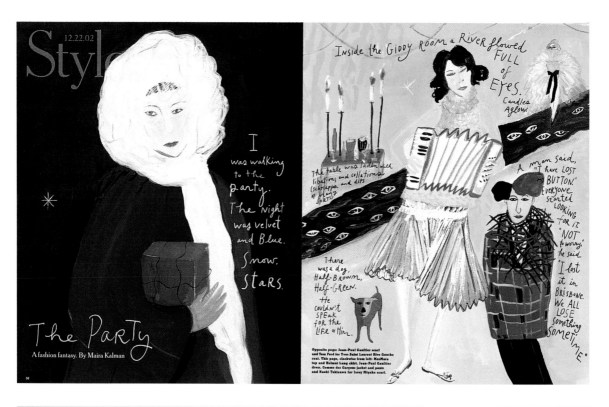

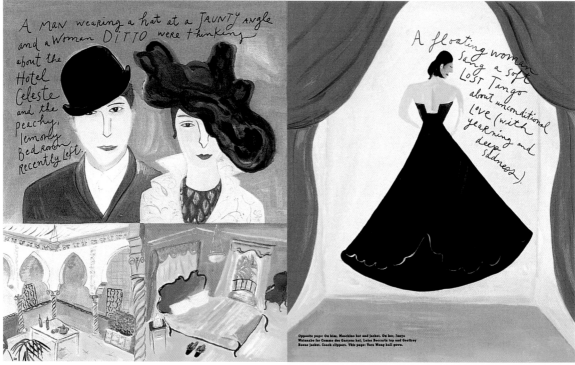

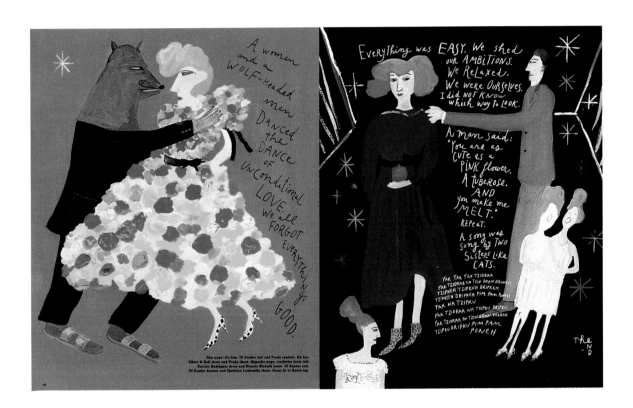

Gold Medal Magazine Editorial **The Party**

ART DIRECTOR Janet Froelich **ILLUSTRATOR** Maira Kalman **DESIGNER** Janet Froelich **STYLE EDITOR** Andy Port **CLIENT** The New York Times Magazine
COUNTRY United States

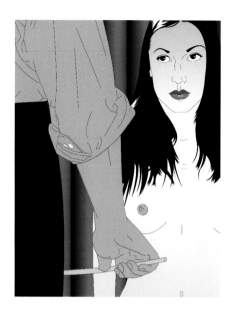

Silver Medal Book **The Sex Book**

ART DIRECTOR Suzi Godson **ILLUSTRATOR** Peter Stemmler **DESIGNER** Suzi Godson **STUDIO** Unlimited **CLIENT** Cassel Illustrated **COUNTRY** United States

Though sex is a subject that fascinates everyone, the sex book market seemed to be one area of publishing that had completely eluded contemporary design. I felt sure that much of the stigma attached to buying books about sex was due to the fact that they were so damn ugly. The wealth of cheesy charcoal drawings and embarrassing photography employed to illustrate them suggested that their target market was bearded hippies or soft porn models, not people like you and me. As a writer I wanted to explore the subjects of sex, health and sexuality in a frank, funny and accessible way. As a designer I wanted to collaborate with someone who could take sex into the 21st century and create visuals that made people proud to own such a beautiful book. Peter Stemmler's images manage to make the sex truly sexy, while their pop punch makes the subject less threatening. The book has now been translated into 13 foreign languages and a large part of its success is due to the strength of Peter's illustrations.

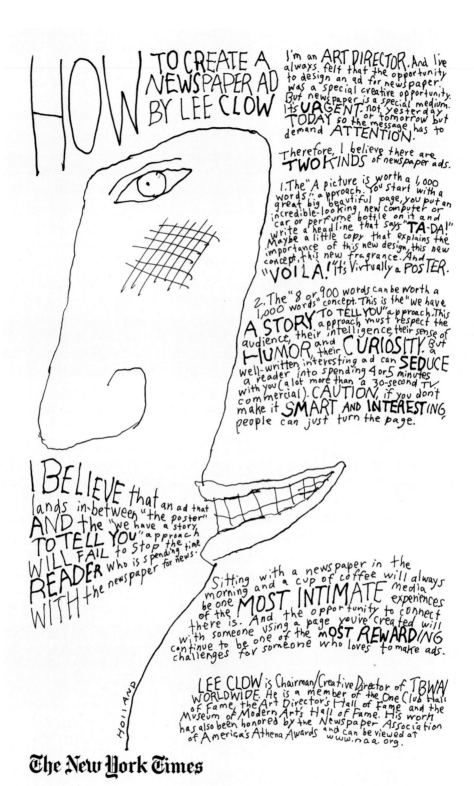

The New York Times

Distinctive Merit Newspaper Advertisement **How to Create a Newspaper Ad**

ART DIRECTORS Mark Braddock, Michael Wright ILLUSTRATOR Brad Holland COPYWRITERS Lee Clow, Alon Shoval CLIENT The New York Times
COUNTRY United States

The Remote Controllers

On Internet sites like Television Without Pity, fans post passionate responses to their favorite shows. Writers and producers are taking this advice seriously — and turning TV into an interactive medium at last.

By Marshall Sella

Illustrations by Paul Davis

WHY DOES SYD ALWAYS WEAR RED LIPSTICK IN CAPTIVITY? sweet P

SYDNEY IS LOOKING TOO HOT IN HER UNDERCOVER OUTFITS. HER ITALIAN EURO-TRASH THING THIS WEEK WOULD HAVE EVERYONE IN THE PLACE STARING AT HER. ISN'T THE POINT OF BEING A SPY TO BE INCONSPICUOUS? —mark 30

DAMN, WHEN DID "ALIAS" BECOME "C.S.I."? ALL THAT FACE-CHOPPING WAS GROSS. tygman23

'On our show, there's a character named Will that we thought people would love,' says J.J. Abrams, the creator of 'Alias.' 'But on the message boards, people thought he was an idiot! . . . So we line-tuned the way he was presented.'

Ten years ago, the producers of 'Charmed' were on the fence about bringing back a character named Cole for its next season. The Internet message boards' lust for him was a deciding factor.

WHERE DID CARMELA'S THING FOR FURIO COME FROM? I UNDERSTAND IT'S BEEN SIXTEEN MONTHS (THREE SEASONS), BUT I DON'T REMEMBER IT. AND THERE WAS NO INDICATION CARMELA EVEN HAD THE HOTS FOR HIM. UNLESS I'M WRONG, IT SIMPLY HER MARRIAGE AND EVENTUALLY VULNERABLE TO POSITIVE ATTENTION FROM A MAN. BUT WHY NOT THIS FLIRTATION WITHOUT ANY BUILD-UP? Princess Louie

JED'S HOLIER-THAN-THOU ATTITUDE IS GETTING BEYOND OLD. IF HE DOESN'T WANT TO BE BOTHERED WITH THE MORE UNPLEASANT RESPONSIBILITIES THAT COME WITH BEING PRESIDENT, WHY IS HE EVEN RUNNING? Monco

Merit Magazine Editorial **The Remote Controllers**

ART DIRECTOR Janet Froelich **ILLUSTRATOR** Paul Davis **DESIGNER** Nancy Harris **CLIENT** The New York Times Magazine **COUNTRY** United States

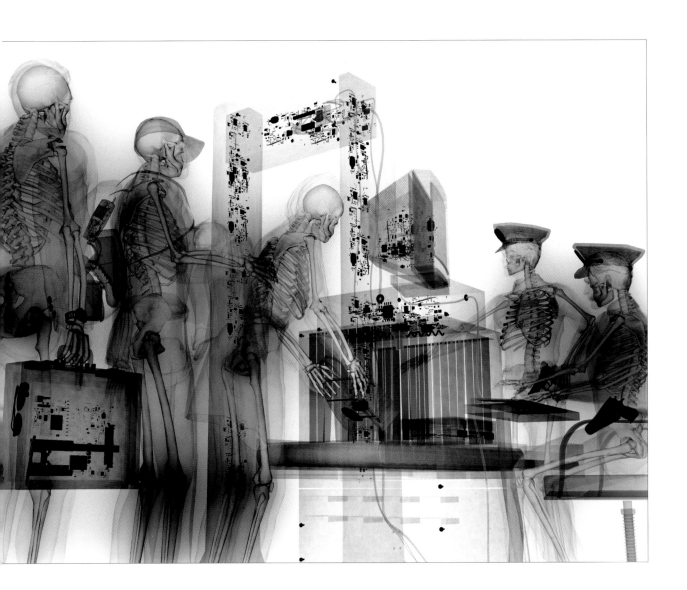

Merit Newspaper Editorial **Not Much Has Changed in a System That Failed**
ART DIRECTOR Tom Bodkin **ILLUSTRATOR** Mirko Ilic **DESIGNER** Gigi Fava **CLIENT** The New York Times **COUNTRY** United States

Merit Magazine Cover **Let the Fur Fly**

ILLUSTRATOR Ana Juan **ART EDITOR** Françoise Mouly **CLIENT** The New Yorker **COUNTRY** United States

Merit Corporate/Institutional **Fourth Estate Catalogue 2002**

ART DIRECTOR Vince Frost ILLUSTRATOR Marion Deuchars DESIGNER Vince Frost STUDIO Frost Design CLIENT Fourth Estate Publishing Limited
COUNTRY United Kingdom

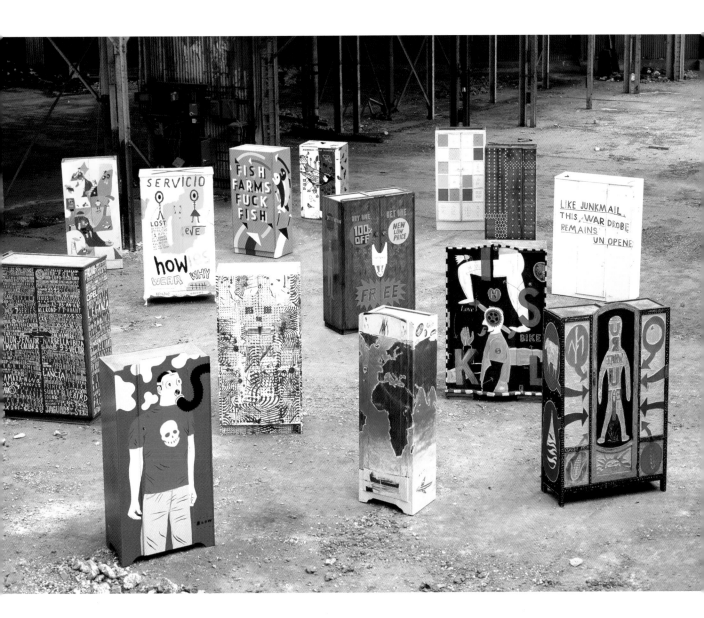

Merit Miscellaneous, Series **Howie's Wardrobes**

ART DIRECTOR Phil Carter **DESIGNERS** Phil Carter, Neil Hedger **ILLUSTRATORS** Richard Beards, Paul Blow, Brian Cairns, Graham Carter, Phil Carter, Paul Davis, Marion Deuchars, Aldous Eveleigh, Jeff Fisher, Nicola McClements, Roderick Mills, Andrew Mockett, Sam Piyasena, Eduardo Rosso, Nicky Skinner, Ian Wright **PHOTOGRAPHER** John Millar **STUDIO** Carter Wong Tomlin **COUNTRY** United Kingdom

student

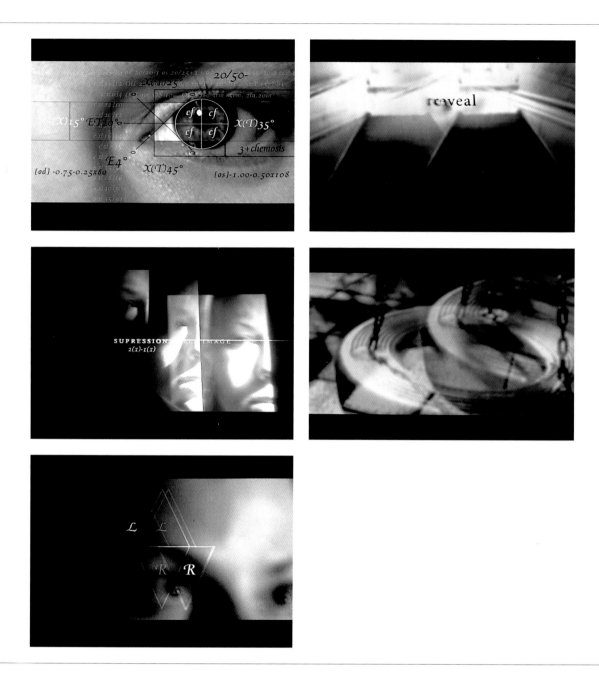

Gold Medal Art Video **All That I Perceive**

ART DIRECTOR Lindsay Daniels **DESIGNER** Lindsay Daniels **PHOTOGRAPHER** Lindsay Daniels **INSTRUCTORS** Mark Fox, Michael Vanderbyl
SCHOOL California College of Arts & Crafts **COUNTRY** United States

The trauma of an unsuccessful eye surgery and three months of double vision provided me a different visual and mental perspective leading me to realize that going about one way of seeing forever is like going about one way of thinking. My objective in this video was to communicate how this temporary, yet drastic change in perception allowed me to see a unique visual terrain inspiring a different way of thinking. The marriage of sound and image gave me the tools to most effectively and accurately communicate what I was seeing in the world. Using ordinary spaces, such as a tire swing or escalator, showed how beautiful mundane things can be if viewed differently. I developed a second visual language by refracting light to create images. All That I Perceive is a unique combination of film and design that served as my senior thesis at CCAC in San Francisco.

Silver Medal Consumer Magazine: Full Issue **FISHWRAP**

ART DIRECTORS Mark Aver, Leigh Okies **CONTRIBUTORS** Aaron Amaro, Oksana Badrak, Daniel Chang, Travis Chatham, Trinie Dalton, Ben Grieme, Jana Haney, Davina Henderson, Jason Hernandez, Tracy Sunrize Johnson, Christopher Kahl, Soyoung Kim, Theo Morrison, Rene Neri, Souther Salazar, Hansen Smith, Rachell Sumpter, Paul Yeh **INSTRUCTORS** Christian Clayton, Jason Holly, Lisa Wagner-Holly, Benjamin Weissman **SCHOOL** Art Center College of Design **COUNTRY** United States

FISHWRAP (Volume 2) is a collaborative literary publication (combination magazine, mini-zine, poster/book-jacket, DVD) written, designed and produced by a single class of students at the Art Center College of Design. The publication combines the talents of student writers, designers and artists who collaborated both inside and outside of their chosen major (i.e., graphic designer as writer, illustrators and photographers working on one image, etc.). Each issue of FISHWRAP has a theme. The theme of Volume 2 is "sickness."

Silver Medal Limited Edition/Private Press/Special Format Book **Student Poetry Journal—Fire**

ART DIRECTOR Hwa Lee **DESIGNERS** Alia Chughtai, Ben Kutil, Hwa Lee **INSTRUCTOR** Lew Fifield **SCHOOL** Maryland Institute College of Art **COUNTRY** United States

The project was to create a milestone issue of the MICA Student Poetry Journal, taking it to an upgraded level from a stapled handout to a formal publication that deserves the name of the institution. The design therefore had to be such that the new issue manifest itself to be distinguished from all previous ones, while maintaining the continuity of the annual. The art direction created to achieve this goal was "The New Fire Is Born from the Ashes of Old Fire." The task that followed was to define design criteria for the ashes and the fire. One possible strategy seemed to be strictly forbidding the use of explicit images or color schemes to represent fire. The material for the external components of the book, as well as color schemes and typefaces, was selected so that the tangible part of the book conveys the fragility and volatility of ashes, thereby leaving the title "Fire" to be perceived through the poetry itself. Limited budget (hence limited production) assigned for the project made it possible, or necessary, for the student designer to commit herself to have the packaging and cover for the entire production hand-made.

Destination
EXPRESS SERVICE BETWEEN BOSTON > NEW YORK >
PHILADELPHIA > WASHINGTON DC

TRAFFIC JAM

acela

Silver Medal Consumer Magazine: Spread, Campaign **Acela**

ART DIRECTOR Jason Stefanik **COPYWRITER** Jason Stefanik **INSTRUCTOR** Ted Royer **SCHOOL** Adhouse **COUNTRY** United States

The goal was to find an elegant way to convey Acela's speed and superiority over other forms of transportation in the northeast corridor. Acela was not only faster than the other options, but it turns what is normally an abysmal commute into something beautiful and efficient. Having traveled this route by car, bus and plane, the thought of seeing all the hassles and inconveniences that come with them speed past you, as you sit back and relax, seemed the most powerful solution.

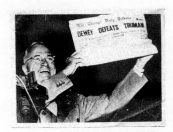

Silver Medal Consumer Magazine: Spread, Campaign **The Whole Story**

ART DIRECTOR Bonnibel Fonbuena **COPYWRITER** Dustin Ballard **INSTRUCTOR** Sean Thompson **SCHOOL** University of Texas at Austin **COUNTRY** United States

As advertising students, we have the luxury of choosing our own client. History is one of those inherently powerful topics. Our challenge with the History Channel campaign was to overcome the belief that history is merely a collection of irrelevant facts. Our goal was to reveal a greater truth, and we did this quite literally. By altering recognizable photographs, we attempted to use the power of imagination to illustrate how the History Channel digs beneath the surface of familiar subjects. History is inevitably skewed over time, particularly with well-known stories. The History Channel was positioned as being a watchdog to correct these misconceptions.

Distinctive Merit Consumer Magazine: Full Page **Crispix—Granny**

ART DIRECTOR Brandon Mugar **COPYWRITER** Nathan Frank **SCHOOL** Miami Ad School—San Francisco **COUNTRY** United States

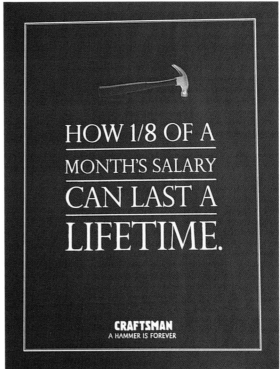

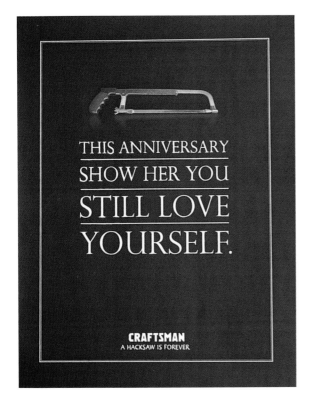

THIS ANNIVERSARY SHOW HER YOU STILL LOVE YOURSELF.

CRAFTSMAN
A HACKSAW IS FOREVER

HOW 1/8 OF A MONTH'S SALARY CAN LAST A LIFETIME.

CRAFTSMAN
A HAMMER IS FOREVER

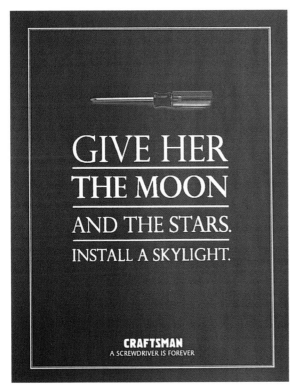

GIVE HER THE MOON AND THE STARS. INSTALL A SKYLIGHT.

CRAFTSMAN
A SCREWDRIVER IS FOREVER

Distinctive Merit Consumer Magazine: Full Page, Campaign **Craftsman Lifetime Guarantee**

ART DIRECTORS Hunter Fine, Brandon Mugar **COPYWRITER** Nathan Frank **INSTRUCTOR** Matt Elhardt **SCHOOL** Miami Ad School—San Francisco **COUNTRY** United States

Distinctive Merit Consumer Magazine: Full Page, Campaign **Academy of Art College—Artists**

ART DIRECTOR Philip Hertel **COPYWRITER** Chris Bull **INSTRUCTORS** Jim Lessor, Susan Treacy **SCHOOL** Miami Ad School—San Francisco **COUNTRY** United States

Distinctive Merit Consumer Magazine: Spread, Campaign **K2—Skin ▪ Blood ▪ Bone**

ART DIRECTOR Jamin Hoyle **COPYWRITER** David Povill **PHOTOGRAPHER** Jamin Hoyle **INSTRUCTOR** Pat Burnham **SCHOOL** VCU Adcenter **COUNTRY** United States

Distinctive Merit Interactive Kiosk/Installation **Swarm: An Interactive Painting**

DESIGNER Daniel Shiffman **INSTRUCTORS** Philip Galanter, Danny Rozin **SCHOOL** Tisch School for the Arts NYU **COUNTRY** United States

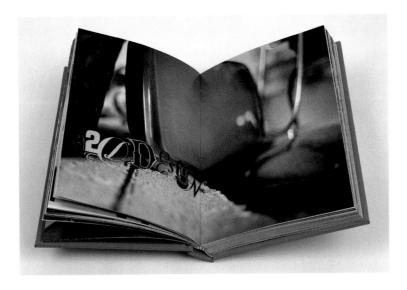

Distinctive Merit Public Service/Nonprofit Book **Cranbrook Academy of Art Graduate Studies Catalogue**
DESIGNERS Catelijne van Middelkoop, Dylan Nelson **PHOTOGRAPHER** Ryan Pescatore Frisk **SCHOOL** Cranbrook Academy of Art **COUNTRY** United States

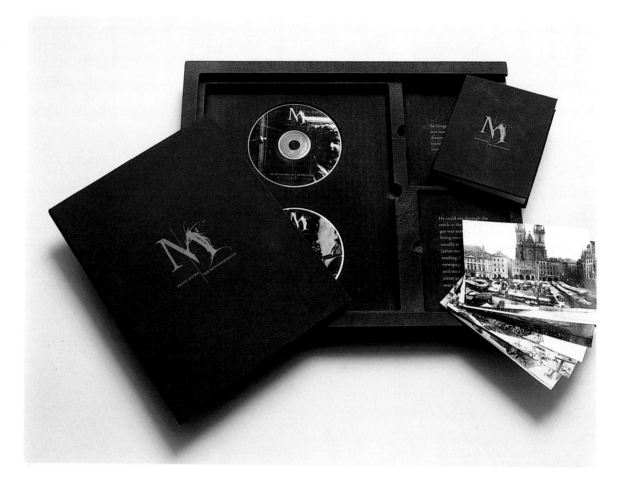

Distinctive Merit Corporate Identity Program **Franz Kafka Exhibition Materials**
ART DIRECTOR Evan Dennis **DESIGNER** Evan Dennis **COPYWRITER** Evan Dennis **ILLUSTRATOR** Evan Dennis **INSTRUCTOR** Dermot MacCormack
SCHOOL Tyler School of Art **COUNTRY** United States

Distinctive Merit Corporate Identity Program **Coney Island Graphic Identity**

ART DIRECTOR Lauren Kangas **DESIGNER** Lauren Kangas **PHOTOGRAPHERS** Arthur Felligg (Courtesy of the International Center of Photography, New York), Lauren Kangas **INSTRUCTOR** Paula Scher **SCHOOL** School of Visual Arts **COUNTRY** United States

Distinctive Merit Logo/Trademark **Route 66 Diner Logo**

DESIGNER Christian Helms INSTRUCTOR Ted Fabella SCHOOL Portfolio Center COUNTRY United States

Distinctive Merit Posters: Promotional **The Innovative Circle**

DESIGNER Leif Parsons **ILLUSTRATOR** Leif Parsons **INSTRUCTOR** N. Blechman **SCHOOL** School of Visual Arts **COUNTRY** United States

Distinctive Merit Posters: Promotional **Bodyface**
ART DIRECTOR Kiki Katahira **DESIGNER** Kiki Katahira **INSTRUCTOR** Stefan Sagmeister **PHOTOGRAPHER** Kiki Katahira **SCHOOL** School of Visual Arts
COUNTRY United States

Distinctive Merit Posters: Public Service/Nonprofit/Educational **Series of Posters for Aidshilfe**

ART DIRECTORS Nicolas Markwald, Nina Neusitzer **COPYWRITERS** Nicolas Markwald, Nina Neusitzer **PHOTOGRAPHERS** Nicolas Markwald, Nina Neusitzer
INSTRUCTOR Uwe Loesch **SCHOOL** Bergische Universität Wuppertal **COUNTRY** Germany

AMERICAN SOLDIERS

Distinctive Merit Posters: Public Service/Nonprofit/Educational **American Soldiers Can Die**

ART DIRECTOR Lanny Sommese **DESIGNER** Courtney Bailey **INSTRUCTOR** Lanny Sommese **SCHOOL** Pennsylvania State University **COUNTRY** United States

Distinctive Merit Packaging: Entertainment **Frank Sinatra—The Way You Look Tonite**
DESIGNER Nicole Caputo **INSTRUCTOR** Rymn Massand **SCHOOL** School of Visual Arts **COUNTRY** United States

Distinctive Merit Packaging: Food/Beverage **Hotter Than...**
ART DIRECTOR Kristin Sommese **DESIGNER** Summer Daughenbaugh **COPYWRITER** Summer Daughenbaugh **PHOTOGRAPHER** Dick Ackley
INSTRUCTOR Kristin Sommese **SCHOOL** Pennsylvania State University **COUNTRY** United States

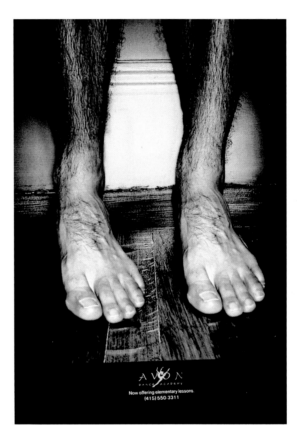

L **Merit** Consumer Magazine: Full Page **Kryptonite Bike Locks**

ART DIRECTOR Ken Lin **COPYWRITER** Pete Albores **INSTRUCTOR** Todd Lamb **SCHOOL** Miami Ad School—San Francisco **COUNTRY** United States

R **Merit** Consumer Magazine: Full Page **Two Left Feet**

ART DIRECTOR Humberto Jiron **COPYWRITER** Humberto Jiron **INSTRUCTOR** James Gleeson **SCHOOL** Academy of Art College **COUNTRY** United States

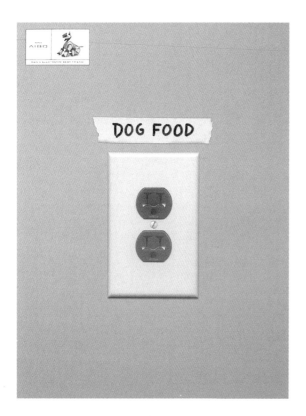

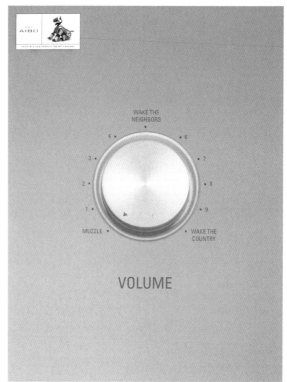

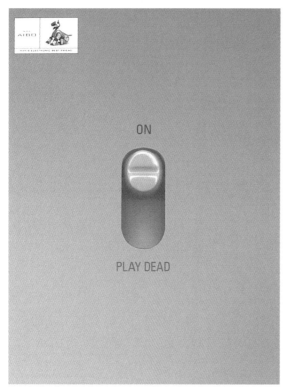

Merit Consumer Magazine: Full Page **Electrical Outlet** • **Switch** • **Volume**
ART DIRECTOR Matthew Herr **COPYWRITER** Matthew Herr **PHOTOGRAPHER** Matthew Herr **INSTRUCTORS** Mike Campbell, Jack Mariucci
SCHOOL School of Visual Arts **CLIENT** Sony Aibo **COUNTRY** United States

Merit Consumer Magazine: Spread, Campaign **Shakespeare in the Park**

ART DIRECTORS Kamal Collins, Mark Infusino **COPYWRITER** Adam Kanzer **PHOTOGRAPHER** Scott Cirlin **INSTRUCTOR** Ron Seichrist **SCHOOL** Miami Ad School
COUNTRY United States

Merit Consumer Magazine: Spread, Campaign **Folgers**

ART DIRECTOR Matthew Arnold **COPYWRITER** Lane Fearing **DESIGNER** Matthew Arnold **INSTRUCTOR** Coz Cotzias **SCHOOL** VCU Adcenter **COUNTRY** United States

Thin is in. **Panasonic** Flat screen TV.

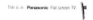

Thin is in. **Panasonic** Flat screen TV.

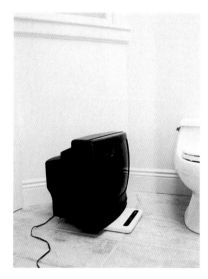

Thin is in. **Panasonic** Flat screen TV.

Merit Consumer Magazine: Spread, Campaign **Panasonic Flat Screen TV**

ART DIRECTOR Teija Kuosku **COPYWRITER** Teija Kuosku **DESIGNER** Teija Kuosku **SCHOOL** Academy of Art College **COUNTRY** United States

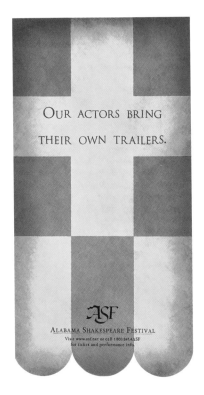

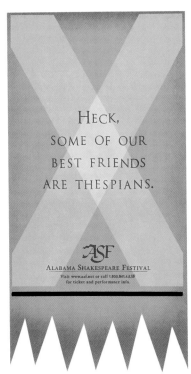

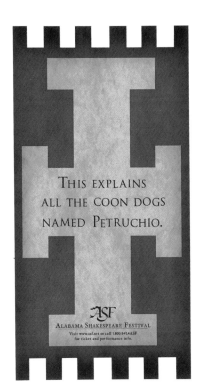

Merit Consumer Magazine: Spread, Campaign **Alabama Shakespeare Festival**

ART DIRECTOR Mark Miller **COPYWRITER** Lana Bridger **INSTRUCTOR** Norm Grey **SCHOOL** The Creative Circus **COUNTRY** United States

Merit Consumer Magazine: Advertorial, Campaign **Goop Handcleaner**

ART DIRECTOR Svetoslav Nikolov **COPYWRITER** Brian Wiesenthal **INSTRUCTOR** Kit Kramer **SCHOOL** Miami Ad School **COUNTRY** United States

Merit Trade Magazine: Less than a Full page, Campaign **Flight Schools of Florida**
ART DIRECTOR Floh Weckert **COPYWRITER** Martin Peters **INSTRUCTOR** David Garcia **SCHOOL** Miami Ad School **COUNTRY** United States

T **Merit** Trade Magazine: Spread **BIC—Highway**

ART DIRECTOR Timur Yevtuhov COPYWRITER Timur Yevtuhov ILLUSTRATOR Timur Yevtuhov PHOTOGRAPHER Timur Yevtuhov INSTRUCTOR Sal Devito
SCHOOL School of Visual Arts COUNTRY United States

B **Merit** Posters: Transit **Famous Dave's—Remote**

ART DIRECTORS Jay Dorsey, Tiger Porter COPYWRITER Matt Bottkol PHOTOGRAPHERS Jay Dorsey, Tiger Porter INSTRUCTOR James Clunie
SCHOOL Brainco—The Minneapolis School of Advertising COUNTRY United States

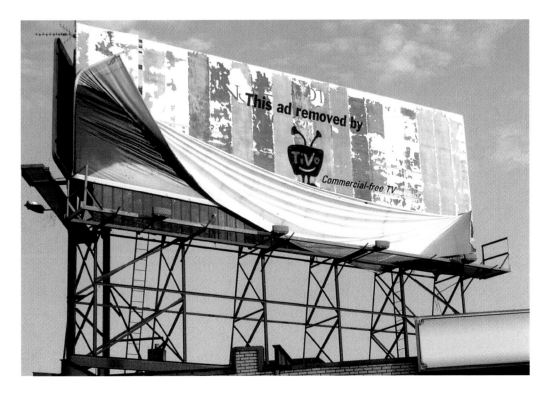

T **Merit** Posters: Transit **Quick, Think of an AD!**

ART DIRECTOR Hunter Fine **COPYWRITER** Peter Albores **INSTRUCTOR** Lori Nygaard **SCHOOL** Miami Ad School—San Francisco **COUNTRY** United States

B **Merit** Billboard/Diorama/Painted Spectacular **Billboard**

ART DIRECTOR Derek Till **COPYWRITER** John Neerland **INSTRUCTOR** Brock Davis **SCHOOL** Brainco—The Minneapolis School of Advertising **COUNTRY** United States

Afford luxury
you don't even understand.

hotels.com

PUT YOURSELF IN A BETTER PLACE

Merit Mixed Media Advertising Campaign **hotels.com**
ART DIRECTOR Elaine Leung **COPYWRITER** Chantal Panozzo **INSTRUCTOR** Coz Cotzias **SCHOOL** VCU Adcenter **COUNTRY** United States

New Haven Line
Yale GDMFA Exhibition May 18 through May 28, 2002

Between Stations

New Haven, CT — Grand Central Terminal, NY

Out the window of the 4:52 to Grand Central, the power wires above the tracks rise and fall like waves. Twelve black lines against the grey sky oscillate in unison, occasionally breaking formation, the wires scatter, around an overpass, towards the horizon, gone only to reappear a moment later.

Woody Guthrie and Hank Williams wrote songs about old steam engines, not the ones we ride these days. They strummed wooden guitars, and shouted rhymes over the track noise. When Chuck Berry plugged-in, he imitated the chugging of a locomotive not a steady hum of a southbound commuter express.

As Milford, Stratford, and Bridgeport move past the window choreographed electrical delivery can be seen through each window. MetroNorth's wires move like songs, a 28-track album from New Haven, Connecticut, to Grand Central.

For project information visit scanography.org

Electrical wires seen from the train window are video taped and set against a grid of frequencies. Compositional patterns existing in MetroNorth's wiring system are translated and made audible in real time using the MAX/MSP environment. *Between Stations* continues in the American musical tradition of performers who believed that they heard music while riding the trains, wrote lyrics and created sounds to share the vibrations inside their heads. *Between Stations* enables the railway's song to be heard with a minimum of human intervention.

Each stretch of track has its own compositional character and its own sound because the electrical structure varies with each stretch of land.

Trk 1 New Haven, CT to Milford, CT 0:10:03
Trk 2 Milford, CT to Bridgeport, CT 0:25:16
Trk 3 125 Street to G.C.T. 0:13:56
Trk 4 Rye to Port Chester 0:03:12

Merit Hybrid/Art/Experimental **Between Stations**

ART DIRECTOR Glen Cummings INSTRUCTORS Lisa Strausfeld, Matthew Suttor SCHOOL Yale University School of Art COUNTRY United States

Merit Book Jacket **Gertrude Stein 123**

DESIGNER Boris Rapaport **INSTRUCTORS** Carin Goldberg, Paula Scher **SCHOOL** School of Visual Arts **COUNTRY** United States

Merit Special Trade Book (Image Driven) **Lauter!?**

DESIGNER Marcus Chwalczyk **INSTRUCTOR** Monika Hagenberg **SCHOOL** Fachhochschule Niederrhein, Krefeld **COUNTRY** Germany

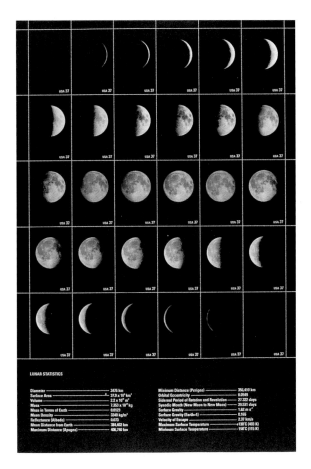

L **Merit** Postage Stamp **Phases of the Moon**

DESIGNER Tatyana Gorodetskaya **INSTRUCTOR** James Victore **SCHOOL** School of Visual Arts **COUNTRY** United States

R **Merit** Posters: Promotional **Poster for National Building Museum**

DESIGNER Susan H. Park **INSTRUCTOR** Carin Goldberg **SCHOOL** School of Visual Arts **COUNTRY** United States

Merit Posters: Public Service/Nonprofit/Educational **The Limey** • **Mulholland Drive** • **Code Unknown**
DESIGNER Emily Lessard **INSTRUCTOR** Scott Stowell **SCHOOL** Yale University School of Art **COUNTRY** United States

Merit Posters: Public Service/Nonprofit/Educational **Poster Series for David Tartakover Lecture at the Cooper Union**
DESIGNER Jennifer Carrow **INSTRUCTOR** Philippe Apeloig **SCHOOL** The Cooper Union **COUNTRY** United States

CORPORATE MEMBERS

Adobe Systems, Inc.
The Alternative Pick
AOL Time Warner Book
 Group
Aquent, Inc.
Charlex
The Eastman Kodak
 Company
Eliran Murphy Group
Frankfurt, Kurnit, Klein &
 Selz
Gale Group
Getty Images
GoCard
Merkley, Newman, Harty
 and Partners
M-Real Alliance USA
 Corporation
PictureQuest
Quebecor World
R/GA
@radical.media
Scholz & Volkmer Interme-
 diales Design
Shiseido Company, Ltd.
St. Martin's Press

UNITED STATES

Bob Abbatecola
Cornelia Adams
Gaylord Adams
Phil Adams
Sean Adams
Peter Adler
Charles S. Adorney
Carol Alda
Peggy Altenpohl
Charles Altschul
Jack Anderson
Gennaro Andreozzi
Kristine Angell
Frank Anselmo
Lia Aran
Jayson Atienza
David Atlas
Abe Atri
Jennifer Aue
Hae Auh
Blanca Aulet
Chika Azuma
Jeff M. Babitz
Dominick Baccollo
Robert O. Bach
Kristina Backlund
Eric Bacon
Ronald Bacsa
Charles H. Baer
Priscilla Baer
Robert Baiocco
Georgette F. Ballance
Adam Bank
Giorgio Baravalle
Brian Barclay
Amiyr Barclift
Mimi Bark
Richard Baron

Susan Barr
Don Barron
Robert Barthelmes
Frederick Basilio
Mary K. Baumann
Chris Bean
Allan Beaver
Wesley A. Bedrosian
Edward J. Bennett
Lou Berceli
John Berg
Jennifer Bergamini
Terry Berkowitz
Walter L. Bernard
Robin Bernstein
Colleen Berta
Robert Best
Mary Lynn Blasutta
R. O. Blechman
Robert H. Blend
John Bloch
Laurie Boczar
Carol Bokuniewicz
William Bolls
Joe Bonadio
John Borge
Jean Bourges
Jeroen Bours
Harold A. Bowman
Mary Boyko
Rick Boyko
Fred J. Brauer
Al Braverman
Ann Breaznell
Chris Breen
Jay Brenner
Lynn D. Breslin
Kristi Bridges
Danny Bright
Ed Brodsky
Ruth Brody
Claire Brown
Bruno E. Brugnatelli
Janice Brunell
Paul Buckley
William H. Buckley
Gene Bullard
Christopher Buonocore
Jennifer Burak
Red Burns
D. Tyler Bush
Chris Byrnes
Stephanie Cabrera
Bill Cadge
Jodi Cafritz
Nicholas Callaway
Bryan G. Canniff
Louis A. Cannizzaro
Gregg Carlesimo
Thomas Carnase
Susan Carolonza
David Carter
Chris Casarona
Diana Catherines
Tina Marie Cecere-Hunter
David Ceradini
Creighton Chamberlain

Andrew Chang
Anthony Chaplinsky Jr.
Lina Chen
Mark Chen
Mei Ling Chen
So-Hee Cheong
Ivan Chermayeff
Bruce Chesebrough
Deanne Cheuk
Susan Chiaravalle
Steve Chiarello
John Chuang
Shelly Chung
Stanley Church
Charles Churchward
Seymour Chwast
John Cianti
Scott Citron
Herbert H. Clark
Thomas F. Clemente
Michael Cohen
Peter Cohen
Rhonda Cohen
Stacy Cohen
Jack Cohn
Karen Cohn
Jeff Cole
Alisa Coleman-Ritz
Chris Collins
Michael Collins
Michael Coman
Kelly Conlin
Elaine Conner
Dana Cooper
Andrew Coppa
Jennifer Corsano
Andres Felipe Cortes
Jeffrey Cory
Gary Cosimini
Sheldon Cotler
Susan Cotler-Block
Kit Cowan
Phyllis Richmond Cox
Robert Cox
Sally Crabb
Wendy Crandall
Meg Crane
Gregory Crossley
Bob Crozier
Mathew Cullen
Kilsy Curiel
Alison Davis Curry
Christine Curry
Ethel R. Cutler
Adriana Cutolo-Beyer
Pier Nicola D'Amico
Michelle D'Elia-Smith
Kyle Daley
David Davidian
J. Hamilton Davis
Jill Davis
Paul B. Davis
Randi B. Davis
Faith E. Deegan
Cecilia DeFreitas
Stuart deHaan
Gretchen Deitelhoff

Joe Del Sorbo
Sarah Delson
Laura Des Enfants
David Deutsch
John F. Dignam
Karla DiRosa
Jeseka Djurkovic
Benjamin Donaldson
Michael Donovan
Louis Dorfsman
Marc Dorian
Cheri Dorr
Kay E. Douglas
Stephen Doyle
Donald H. Duffy
Joe Duffy
Bernard Eckstein
Noha Edell
Peter Edgar
Geoffrey Edwards
Andrew Egan
Nina Eisenman
Stanley Eisenman
Karen M. Elder
Judith Ellis
Lauren Elvers
Vincent Enche
Lori Ende
David Epstein
Lee Epstein
Shirley Ericson
Suren Ermoyan
Elke Erschfeld
Charles Eshelman
Rafael Esquer
Brad Essex
Hillary Evans
Ted Fabella
Kathleen Fable
Simon Fairweather
Michael Fenga
Isabela Ferreira
Megan Ferrell
Kim Findlay
Stan Fine
Blanche Fiorenza
Carl Fischer
Nick Fischer
Gill Fishman
Donald P. Flock
Patrick Flood
Ian Forbes
Tara Ford
Melanie Forster
David Foster
Susan Foulds
John Fraioli
Judy Francis
Michael Frankfurt
Stephen O. Frankfurt
Bill Freeland
Christina Freyss
Ken Friedland
Ruby Miye Friedland
Michael K. Frith
Jamey Fry
Neil Fujita

Ken Fukuda
Angela Fung
Sabrina Funk
Leonard W. Fury
Mindy Gale
Dave Galligos
Danielle Gallo
Brian Ganton Jr.
Gino Garlanda
Martina Gates
Marlaina Gayle
Tom Geismar
Steff Geissbuhler
Tricia Gellman
Alexander Gelman
Evgenia Gennadiou
Frank Germano
Amanda Giamportone
Kurt Gibson
Porter Gillespie
Frank C. Ginsberg
Sara Giovanitti
Bob Giraldi
Nin Glaister
Milton Glaser
Jacob Glazer
Maureen R. Gleason
Julia Glick
Marc Gobé
Bryan Godwin
Bill Gold
Roz Goldfarb
Jason Goldsmith
Mort Goldstrom
Joanne Goodfellow
Marlowe Goodson
Jonathan W. Gottlieb
Michael W. Gottlieb
Jean Govoni
Gerry Graf
Tony Granger
Michael Gray
Jeff Greenbaum
Karen L. Greenberg
Robert Greenberg
Abe S. Greiss
Jack Griffin
Glenn Groglio
Emily Grote
Raisa Grubshteyn
Victoria Grujicic
Olga Gutierrez de la Rosa
Gwen Haberman
Robert Hack
Bob Hagel
Kurt Haiman
Elisa Halperin
Everett Halvorsen
Lisa Faye Hames
India Hammer
Leslie Hammond
Marie Haniph
Katherine Harbison
Sam Harrison
Stephan M. Hart
Blaise Hayward
Amy Hecht

Amy Heit
Steven Heller
Tammy Helm
Noah Hendler
Alexis Henry
Randall Hensley
Erin Herbst
Craig Hern
Kristine Ford Herrick
Kathie Hewitt
Marcus Hewitt
Kristin Higgins
Andy Hill
Chris Hill
Bill Hillsman
Lorin Hirose
Andy Hirsch
Steve Hirsch
Harvey Hoffenberg
Marilyn Hoffner
Barry K. Holland
Sandy Hollander
Steve Horn
Daniel Hort
Michael Hortens
Roy Hsu
Tiffany Huang
Jonathan Hudson
Douglas Huffmyer
Manabu Inada
Rei Inamoto
Miro Ito
Christina Jackson
Harry Jacobs
Sharona Jacobs
Ashwini M. Jambotkar
John E. Jamison
Hal Jannen
Patricia Jerina
Paul Jervis
Haley Johnson
John Johnston
Joson
Angelo Juliano
Vasken Kalayjian
Ric Kallaher
Joanna Kalliches
Judy Kalvin
Jon Kamen
Walter Kaprielian
Caroline Keavy
Michael Keeley
Sean Keepers
Iris Keitel
Nancy Kent
Jim Kenty
Claire Kerby
Lisa Kereszi
Candice Kersh
Paul Kiesche
Satohiro Kikutake
Chris Kim
Evelyn Kim
Greg Kinch
Amy Kindred
Anthony King
Susan Kirshenbaum

Fedor Kisselgoff
Judith Klein
Hilda Stanger Klyde
Andrew Kner
Henry O. Knoepfler
Nani Kohler
Elaini Kokkinos
Ray Komai
Yafit Koren
Kati Korpijaakko
Anja Kroencke
Erika Kuecker
Peter Kuhn
Melissa Kuperminc
Rick Kurnit
Sasha Kurtz
Anthony La Petri
Stephanie LaFleur
Scott Lahde
Greg Lakloufi
Robin Landa
Ted Lane
David Langley
Lisa LaRochelle
Anastasia Lavish
Nicholas Law
Amanda Lawrence
Mark M. Lawrence
Sal Lazzarotti
Jonathan Leder
Gregory B. Leeds
Kevin Leicinger
Ann Lemon
Maru Leon
Paula Lerner
Rick Levine
Richard S. Levy
Sari S. Levy
Huy Iu Lim
Patricia Lindgren
Steven Liska
Sarabeth Litt
Deborah Livingston
Douglas Lloyd
Rebecca Lloyd
Christopher Lockhart
George Lois
Kenneth Loo
Monica Lopez
Miriam Lorenten
George Lott
Ruth Lubell
Marc Lucas
Antonia Ludes
Diane Luger
Ronnie Lunt
Jason Macbeth
Richard MacFarlane
Eva Machauf
David H. MacInnes
Staci MacKenzie
Carol Dietrich Macrini
Phillip Madanire
Victoria Maddocks
Elizabeth Maertens
Samuel Magdoff
Lou Magnani

Jay Maisel
John Mamus
Michael Manfredi
Romy Mann
Jean Marcellino
Sarah Marden
David R. Margolis
Leo J. Marino, III
Jack Mariucci
Pam Mariutto
Andrea Marquez
Julie Lamb Marsh
Marzena
Joel Mason
Coco Masuda
Paige Mattson
Susan Mayer
Marce Mayhew
William McCaffery
Gillian McCarthy
Scott McDermott
Colin McGreal
Kevin McKeon
Greg McLendon
Linda McNair
Matt McNelis
Gabriel Medina
Nancy A. Meher
Stacy Arezou Mehrfar
Michael Meluso
Cheryl Mendelson
Parry Merkley
Suzan Merritt
Jeffrey Metzner
Jackie Merri Meyer
Joachim Meyer
Madeleine Michels
Eugene Milbauer
Gregory Miller
Lauren J. Miller
Sarah Miller
Steven A. Miller
John Milligan
Wendell Minor
Michael Miranda
Patrick Mitchell
Susan L. Mitchell
S.A. Modenstein
Christine Moh
Sakol Mongkolkasetarin
Joseph Montebello
Mark Montgomery
Jacqueline C. Moorby
Diane Moore Behrens
Noreen Morioka
Minoru Morita
Allison Morris
Alyssa Morris
William R. Morrison
Joann Morton
Deborah Moses
Louie Moses
Thomas Mueller
Kristen Mulvihill
Ann Murphy
Brian Murphy
Colleen Sargent Murphy

Anthony M. Musmanno
Joseph Nardone
Wylie H. Nash
Barbara Nessim
Susan Newman
Maria A. Nicholas
Mary Ann Nichols
Davide Nicosia
Joseph Nissen
Yoji Nobuto
Yuko Nohara
David Norian
Barbara J. Norman
Roger Norris
George Noszagh
David November
Robert Nuell
John O'Callaghan
Sylvia O'Donnell
Christa M. O'Malley
Bill Oberlander
A. R. Ogbu
John Okladek
Yukako Okudaira
Lisa Orange
Segal Orit
Jose Luis Ortiz
Gary E. Osius
Frank Oswald
Nina Ovryn
Bernard S. Owett
Erol Ozlevi
Onofrio Paccione
Frank Paganucci
Sebastian Pallares
Brad Pallas
Sam Park
Michael Paterson
Chee Pearlman
Brigid Pearson
B. Martin Pedersen
Ariel Peeri
Christine Perez
Darrin Perry
Harold A. Perry
Victoria I. Peslak
Fredrik Peterhoff
Christos Peterson
Robert Petrocelli
Theodore D. Pettus
Robert Pfeifer
Anh Tuan Pham
Allan A. Philiba
Alma Phipps
Jacqueline Piantini
Ney Pimentel
Ernest Pioppo
Jane Pirone
Mary Pisarkiewicz
Robert Pliskin
Brenda Ponnay
Neil Powell
Dan Poynor
Monica E. Pozzi
Don Puckey
Maryalice Quinn
Doug Raboy

Maria Ragusa-Burfield
Brad Ramsey
Laura J. Rathsam
Amy Rau
Ronald T. Raznick
Barbara Reed
Samuel Reed
Geoff Reinhard
Herbert Reinke
Robert Reitzfeld
Dorothy Remington
Joseph Leslie Renaud
David Rhodes
Rick P. Riccardi
Stan Richards
Hank Richardson
Laura Riera
Alison Jo Rigney
Lianne Ritchie
Arthur Ritter
Paul Ritter
Joseph Roberts
Bennett Robinson
Tania Rochell
Harlow Rockwell
Susan Roderick
Roswitha Rodrigues
Adita Rodriguez
Nelson Rodriguez
Alejandro Rodriguez
Gonzalez
Juan Carlos Rodriguez
Pizzorno
Brian Rogers
Andy Romano
Dianne M. Romano
Charlie Rosner
Michael Ross
Peter Ross
Richard J. Ross
Arnold Roston
David Baldeosingh Rotstein
Alan Rowe
Mort Rubenstein
Randee Rubin
Henry N. Russell
Don Ruther
Thomas Ruzicka
Paul Ryan
Stewart Sacklow
Stefan Sagmeister
Tatsuhiro Saido
Randy Saitta
Robert Saks
Robert Salpeter
James Salser
George Samerjan
Christopher Sams
Sandro
Robert Sawyer
David J. Saylor
Sam Scali
Ernest Scarfone
Wendy Schechter
Paula Scher
Randall Scherrer
Andrew Schirmer

Klaus F. Schmidt
Trish Daley Schmitt
Jonathan Schoenberg
Clem Schubert
Eileen Hedy Schultz
Sally Schweitzer
Stephen Scoble
Holly Elizabeth Scull
William Seabrook, III
J.J. Sedelmaier
Ilene Segal
Leslie Segal
Christian Seichrist
Pippa Seichrist
Ron Seichrist
Sheldon Seidler
Tod Seisser
Kimberly Selber, Ph.d.
Audrey Shachnow
Kaushal R. Shah
Tom Sheehan
Teresa Shelley
Keiko Shimizu
Martin Shova
Kirsten Siddall
Karen Silveira
Louis Silverstein
Rich Silverstein
Milton Simpson
Barbara Singer
Craig Singer
Leslie Singer
Leonard Sirowitz
Anne Skopas
Robert Slagle
Cliff Sloan
Richard Smaltz
Smari
Carol Lynn Smith
Dawn Smith
James C. Smith
Meghan Smith
Virginia Smith
Eugene M. Smith Jr.
Steve Snider
Dewayne A. Snype
Martin Solomon
Russell L. Solomon
Harold Sosnow
Jethro Soudant
Shasti O'Leary Soudant
Andy Spangler
Harvey Spears
Heike Sperber
Erik Spiekermann
Udo Spreitzenbarth
Jim Spruell
Aeon Stanfield
Mindy Phelps Stanton
Brian Stauffer
Craig Steele
Dean Stefanides
Liz Steger
Robert Steigelman
Karl Steinbrenner
Jeff Stevens

Monica Stevenson
Daniel E. Stewart
Gerald Stewart
Richard Stewart
Colleen Stokes
Erica Stoll
Bernard Stone
Michael Storrings
Lizabeth Storrs
D.J. Stout
Peter Strongwater
William Strosahl
Dean Sullivan
Scott Szul
Virginia Taddoni
Barbara Taff
Anthony Taibi
Jeet Tailor
Penny Tarrant
Melcon Tashian
Jack G. Tauss
Blake Taylor
Tracey Taylor
Mark Tekushan
Jonathan Tessler
Rick Thompson
Korapin Thupvong
Jerry Todd
Joey Tong
Flamur Tonuzi
Nicholas E. Torello
Damian Totman
Guillermo Tragant
Victor Trasoff
Jakob Trollback
Joseph P. Tully
Olivia Turner
Anne Twomey
Julia Vakser
Vassil Valkov
Stephan Valter
David Vargas
Carlos Vazquez
Michael R. Vella
Amy Vernick
Jeanne Viggiano
Nikki Villagomez
Jovan Villalba
Frank A. Vitale
Dorothy Wachtenheim
Jurek Wajdowicz
Sonia Walker
Hannah Wallace
Joseph O. Wallace
Helen Wan
Min Wang
Yong Zhi Wang
Dorene Warner
Michael Warren
Catsua Watanabe
Dawn Waters
Jessica Weber
Alex Weil
Roy Weinstein
Bruce Weiser
Jeff Weiss

Marty Weiss
Art Weithas
Charles Wells
Renetta Welty
Wendy Wen
Robert Shaw West
Richard Wilde
Peggy Willett
Allison Williams
Kevin Wolahan
Alan Wolan
Jay Michael Wolf
Juliette Wolf Robin
Nelson Wong
Ilia Wood
Fred Woodward
Megumi Soleh Yamada
Naomi Yamamoto
Lucy Yang
Takehiko Yasui
Peter Yates
Henry Sene Yee
Ira Yoffe
Zen Yonkovig
Yeo J. Yoon
Linda Zacks
Efrat Zalishnick
Farida Zaman
David Zander
David Zeigerman
Maxim Zhukov
Mikael T. Zielinski
Lloyd Ziff
Carol Zimmerman
Cynthia L. Zimpfer
Bernie Zlotnick
Alan H. Zwiebel

AUSTRALIA
Kathryn Dilanchian
Jason Loucas
Alexander James Musson
Rocco Ragone
Helmut Stenzel

AUSTRIA
Tibor Bárci
Mariusz Jan Demner
Helmut Klein
Lois Lammerhuber
Silvia Lammerhuber
Franz Merlicek
Roland A. Reidinger

BRAZIL
Gustavo Borja Ferreira
Raquel Paoliello
Samy Jordan Todd

CANADA
Mark Buchner
Rob Carter
Claude Dumoulin
Louis Gagnon
Peter K.C. Ho
Jean-Piere Lacroix

Stephanie Power
Jason Recker
Ric Riordon
Mark Walton

CHILE
Manuel Segura Cavia

CHINA
Sandy Choi
David Chow
Martin Tin-yau Ko
Wang Xu
Clement Yick
Han Jia Ying
Noel Yu

DENMARK
Bent Lomholt
Peter Strange

FINLAND
Kirsikka Manty
Kari Piippo

FRANCE
Yvonne Brandt-Cousin

GERMANY
Heike Brockmann
Thomas Ernsting
Harald Haas
Reiner Hebe
Oliver Hesse
Felix Holzer
Armin Jochum
Claus Koch
Olaf Leu
Friederike Mojen
Ingo Mojen
Lothar Nebl
Gertrud Nolte
Alexander Rehm
Andreas Rell
Achim Riedel
Hans Dirk Schellnack
Anette Scholz
Beate Steil
Andreas Uebele
Johannes Van Meel
Michael Volkmer
René von Falkenburg
Oliver Voss
Oliver Wenz

GREECE
Rodanthi Senduka

IRELAND
Eoghan Nolan

ISRAEL
Dan Reisinger

ITALY
Titti Fabiani

Yotto Furuya
Gianfranco Moretti
Mirko Nesurini
Milka Pogliani
Maurizio Sala

JAPAN
Kan Akita
Takashi Akiyama
Masuteru Aoba
Hiroyuki Aotani
Katsumi Asaba
Norio Fujishiro
Shinsuke Fujiwara
Shigeki Fukushima
Osamu Furumura
Mikae Hamakawa
Keiko Hirata
Kazunobu Hosoda
Kogo Inoue
Hiroaki Iokawa
Masami Ishibashi
Mitsuo Ishida
Shoichi Ishida
Yasuyuki Ito
Tetsuro A. Itoh
Toshio Iwata
Kenzo Izutani
Takeshi Kagawa
Hideyuki Kaneko
Satoji Kashimoto
Mitsuo Katsui
Yasuhiko Kida
Katsuhiro Kinoshita
Hiromasa Kisso
Takashi Kitazawa
Kunio Kiyomura
Pete Kobayashi
Ryohei Kojima
Pepie Krakower
Arata Matsumoto
Takaharu Matsumoto
Takao Matsumoto
Shin Matsunaga
Iwao Matsuura
Kuniaki Miyasaka
Koji Mizutani
Keisuke Nagatomo
Hideki Nakajima
Jun Nakazawa
William Ng
Katsunori Nishi
Oseko Nobumitsu
Shuichi Nogami
Sadanori Nomura
Yoshimi Oba
Toshiyuki Ohashi
Gaku Ohsugi
Akio Okumura
Toshihiro Onimaru
Hiroshi Saito
Toshiki Saito
Hideo Saitoh
Akira Sato
Naoki Sato
Koichi Shimagami

Hidemi Shingai
Norito Shinmura
Shunzaku Suguira
Zempaku Suzuki
Yutaka Takahama
Matsumoto Takahara
Masami Takahashi
Shigeru Takeo
Masakazu Tanabe
Hiroshi Tanaka
Soji George Tanaka
Norio Uejo
Katsunori Watanabe
Masato Watanabe
Yoshiko Watanabe
Akihiro H. Yamamoto
Yoji Yamamoto
Masayuki Yoshida
Kaoru Zama

MALTA
Edwin Ward

MEXICO
Felix Beltran
Luis Ramirez

THE NETHERLANDS
Pieter Brattinga

NEW ZEALAND
Guy Pask

PAKISTAN
Shahud R. Shami

PORTUGAL
Eduardo Aires

RUSSIA
Feigin Leonid
Dmitry Pioryshkov

SINGAPORE
Hal Suzuki
Noboru Tominaga
Kim Chun Wei

SOUTH KOREA
Bernard Chung
Dong-Sik Hong
Jong In Jung
Kwang Kyu Kim
Kum Jun Park

SPAIN
Jaime Beltran
Ricardo Bermejo Ros

SWEDEN
Theodor Jikander
Kari Palmqvist

SWITZERLAND
Stephan Bundi
Bilal Dallenbach

Martin Gaberthuel
Moritz Jaggi
Andréas Netthoevel
Manfred Oebel
Dominique Anne Schuetz
Martin Spillmann
Hans G. Syz

THAILAND
Araya Choutgrajank

UNITED KINGDOM
Jonathan Ellery
Garrick Hamm
Agathe Jacquillat
Tomi Vollauschek

STUDENT MEMBERS
Lorraine Abraham
Elsie Aldahondo
Maria Alevrontas
Songul Aslanturk
Marie Bailey
Sarah Berk
Mattias Boivie
Michelle Branham
James Brown
Chavy Broyde
Millie Burns
Jamie Calvo
Jennifer Carrow
Zi Ying Chen

Kathryn Cho
Andreas Chrysafi
Jinju Chung
Nicole Cota
Glen Cummings
Gregory Davis
Angela Denise
Kristie M. DiCostanzo
Christian Drury
Albert Dungca
Marcelo Ermelindo
Agnieszka Flowers
Glen Fruchter
Josefina Fuster
Jed Grossman
Adriana Guzman
Sugie Hiromi
Jennifer Holst
Melissa Hutton
Hwasun Kang
Jessica Kelley
Jennifer Kim
Moon Sun Kim
Akane Kodani
Sang-Jun Koo
Pan Lau
Kayee Antonette Law
Brian Lightbody
Beng Yew Loh
Roy Lopez
Yu Lu
Joseph Madsen

Annie Mararova
Svetlana Martynova
Ann McBride
Sharon McCue
Ewelina Mrowiec
Carolyn Mueller
Nam-Phuong Nguyen
Reuben Orter
Carole Otypka
Joseph Outten
Ivan Paric
Ji Hyun Park
Daniel Philipson
Eric Rojas
Rachel Schoenberg
Melissa Sclafani
Kyu-Chang Shin
Cynthia Solis
Denise Sommer
Bingxin Su
Bhavana Sujan
Nicolaus Taylor
Klitos Teklos
Nathan Thompson
Jose Valdez
Pedro Vargas
Daniel Velasquez
Adam M. Vohlidka
Christina Waldt-Lord
Dona Yim
Stacey Zhou
Qi Zhou

The School for Design & Art Direction, Media Architecture, Writing,
Advertising Art Direction, Photography & Illustration
125 Bennett Street, Atlanta, GA 30309
Call 1.800.255.3169 ext.19 /visit www.portfoliocenter.com

We aint not school—
we just look that

good!

passion

"I waited for the higher light," says Getty Images photographer Martin Barraud.
Advertising. Design. Editorial. Film. News. Sport. Passion.
gettyimages.com

THE NEW SCHOOL OF DESIGN IS NOW IN SESSION.

AQUENT

Close your Quark file. Open your mind. Time to rethink the purpose of Design. It's not dressing up the page. It's shaping brands. Molding market leaders. Delivering business results. It's all about Return on Creative. We believe so deeply in this new school of Design thought, we've built a new kind of creative services company to make it a reality. And we've formed three dynamic services to help our clients achieve the highest return on their creative investments. **Aquent's Talent Agency,** to deliver the right talent, right when you need it. **Aquent Solutions,** to keep your marketing and creative processes working at peak efficiency. And **Aquent's MBT Group,** the first global technology consulting firm focused on creative services. Visit us online or call us today, and keep your mind open to change. Because once you learn what Return on Creative can mean for your company and your career, you're never going back to your old school.

SWEET

THIS IS THE STUFF

THAT DREAMS ARE MADE OF.

No matter what you go through in your waking hours, there's always time left over for dreams. Thanks for entrusting yours to film.

© Eastman Kodak Company, 2003
Kodak is a trademark of Eastman Kodak Company.

Creative Printers Since 1915

enterprise

627 GREENWICH ST.
NEW YORK, NY 10014-3392
PHONE:212.741.2111
FAX:212.633.2865

ALL UNDER ONE ROOF

The Benjamin & William Hort Building
digital & conventional pre-press
1-6 color sheet-fed printing
mailing, bindery and the only
heat-set 6 color web in Manhattan
and now...digital & variable Printing

GRAPHICS & DESIGNING

Takanori Aiba
Toshihiro Onimaru

GRAPHICS & DESIGNING INC.
G&D Alchemic House, 3-3-1, Shirokanedai,
Minato-ku, Tokyo, 108-0071 JAPAN
TEL.81-3-3449-1541 FAX.81-3-3449-1542
http://www.GandD.co.jp

SAPPI HAS ASSEMBLED THE FINEST, BROADEST

SELECTION OF PRINTING PAPERS AVAILABLE.

WITH BRAND LEADERS IN EVERY GRADE. AND

THE FINISHES, SHADES AND WEIGHTS YOU

SEEK. AT SAPPI, THE CHOICE IS ALWAYS YOURS.

THE SAPPI LINEUP:

McCOY STROBE LUSTRO VINTAGE NORTHWEST

OPUS AERO SOMERSET BELGRADE

sappi

FOR MORE INFORMATION AND SAMPLES, CALL

1.800.882.IDEA OR VISIT US AT WWW.SAPPI.COM